LIBRARY OF THE ARCHAEOLOGICAL SOCIETY AT ATHENS NO 349

ANTONIS KOTSONAS

THE SANCTUARY OF HERMES AND APHRODITE AT SYME VIANNOU

VII

THE GREEK AND ROMAN POTTERY

Volume 2

THE ARCHAEOLOGICAL SOCIETY
AT ATHENS

INSTITUTE FOR THE STUDY
OF THE ANCIENT WORLD

ATHENS AND NEW YORK
2024

LIBRARY OF THE ARCHAEOLOGICAL SOCIETY AT ATHENS NO 349

ANTONIS KOTSONAS

THE SANCTUARY OF HERMES AND APHRODITE AT SYME VIANNOU

VII

THE GREEK AND ROMAN POTTERY

Volume 2

With a contribution by Eleni Nodarou

THE ARCHAEOLOGICAL SOCIETY AT ATHENS

INSTITUTE FOR THE STUDY OF THE ANCIENT WORLD

ATHENS AND NEW YORK
2024

© Archaeological Society at Athens
Panepistimiou Avenue, GR 10672 Athens
Tel. (0030) 210 3609689
secr@archetai.gr – www.archetai.gr

© 2024 Institute for the Study of the Ancient World
New York University

All rights reserved

NEW YORK UNIVERSITY PRESS
New York
www.nyupress.org

References to Internet websites (URLs) were accurate at the time of writing.
Neither the author nor New York University Press is responsible for URLs that may have expired or changed since the manuscript was prepared.

ISBN: 9781479830053 (hardback)

For Library of Congress Cataloging-in-Publication data, please contact the Library of Congress.

New York University Press books are printed on acid-free paper, and their binding materials are chosen for strength and durability. We strive to use environmentally responsible suppliers and materials to the greatest extent possible in publishing our books.

Manufactured in the United States of America 10 9 8 7 6 5 4 3 2 1

Also available as an ebook.

Cover illustration (Volume 2): Domed lid/shield P7

Design by Katerina Boukala-Karkagianni

ISAW Monographs

ISAW Monographs publishes authoritative studies of new evidence and research into the texts, archaeology, art history, material culture, and history of the cultures and periods representing the core areas of study at NYU's Institute for the Study of the Ancient World. The topics and approaches of the volumes in this series reflect the intellectual mission of ISAW as a center for advanced scholarly research and graduate education whose aim is to encourage the study of the economic, religious, political, and cultural connections between ancient civilizations, from the Western Mediterranean across the Near East and Central Asia, to China.

Roger S. Bagnall and Giovanni R. Ruffini, *Ostraka from Trimithis, Volume 1* (Amheida I) (2012)

George Hatke, *Aksum and Nubia: Warfare, Commerce, and Political Fictions in Ancient Northeast Africa* (2013)

Jonathan Ben-Dov and Seth Sanders (eds.), *Ancient Jewish Sciences and the History of Knowledge in Second Temple Literature* (2014)

Anna L. Boozer, *A Late Romano-Egyptian House in the Dakhla Oasis: Amheida House B2* (Amheida II) (2015)

Roger S. Bagnall, Nicola Aravecchia, Raffaella Cribiore, Paola Davoli, Olaf E. Kaper, and Susanna McFadden, *An Oasis City* (2016)

Roger S. Bagnall, Roberta Casagrande-Kim, Cumhur Tanrıver, *Graffiti from the Basilica in the Agora of Smyrna* (2016)

Rodney Ast and Roger S. Bagnall, *Ostraka from Trimithis, Volume 2* (Amheida III) (2016)

Nicola Aravecchia, *'Ain el-Gedida: 2006–2008 Excavations of a Late Antique Site in Egypt's Western Desert* (Amheida IV) (2019)

Roger S. Bagnall and Alexander Jones, *Mathematics, Metrology, and Model Contracts: A Codex From Late Antique Business Education (P.Math.)* (2020)

Clementina Caputo, *The House of Serenos, Part I: The Pottery* (Amheida V) (2020)

Jonathan Valk and Irene Soto Marín (eds.), *Ancient Taxation: The Mechanics of Extraction in Comparative Perspective* (2021)

Hélène Cuvigny, *Rome in Egypt's Eastern Desert* (2021)

Paola Davoli, *The House of Serenos, Part II: Archaeological Report on a Late-Roman Urban House at Trimithis* (Amheida VI) (2022)

Sofie Schiødt, Amber Jacob, and Kim Ryholt (eds.), *Scientific Traditions in the Ancient Mediterranean and Near East* (2023)

Antonis Kotsonas, *The Sanctuary of Hermes and Aphrodite at Syme Viannou VII: The Greek and Roman Pottery* (2024)

Maria Grazia Masetti-Rouault, Ilaria Calini, Robert Hawley and Lorenzo d'Alfonso (eds.), *Between the Age of Diplomacy and the First Great Empire: Ancient Western Asia Beyond the Paradigm of Collapse and Regeneration (1200-900 BCE)* (2024)

Table of Contents

Volume 1

Acknowledgements	xv
Abbreviations	xix
List of Figures	xxi
List of Tables	xlvii
Part I. Syme Viannou and its Greek and Roman Pottery: The Site and the Material	1
1. The Sanctuary of Syme Viannou and the Study of its Greek and Roman Pottery	3
1.1. Introduction to Greek Sanctuaries and their Pottery	3
1.2. Introduction to the Sanctuary of Syme Viannou	6
1.3. Previous Work on the Greek and Roman Pottery from Syme Viannou	13
1.4. Previous Work on Greek and Roman Pottery from Cretan Sanctuaries	16
1.5. The Scope and the Methodology of the Present Study	19
1.6. Notes on Chronology	24
2. The Greek and Roman Pottery from the Sanctuary of Syme Viannou: Ceramics and Contexts	27
2.1. Introduction	27
2.1.1. Contextual Information	27
2.1.2. Catalogue Entries	30
2.1.3. Tables with Cross-Joins	33
2.2. The Area of the Altar	34
2.3. The Terraces and the Water Channel	128
2.3.1. Introduction	128
2.3.2. The East Part of the Terraces	132
2.3.3. The Water Channel	172
2.3.4. The Central Part of the Terraces (First Section)	180
2.3.5. The Central Part of the Terraces (Second Section)	239
2.3.6. The West Part of the Terraces	259
2.4. The Central and South-Central Part of the Podium	267

2.5. The Area of the Protoarchaic Hearth	296
2.6. The West Part of the Enclosure	317
2.7. The North Part of the Enclosure and the Podium	323
2.7.1. Introduction	323
2.7.2. Northeast Part of the Enclosure (Trenches K46 and Λ46, and Baulks K/Λ46-47 and K46/K47)	323
2.7.3. North-Central Part of the Enclosure and the Podium (Trench I47)	324
2.7.4. North Part of the Podium (Trench K47 and Baulks K47/K48 and I47/K47)	324
2.8. Building E and its Immediate Surroundings	343
2.8.1. Introduction	343
2.8.2. Building E (Trench Λ47)	343
2.8.3. The Immediate Surroundings of Building E (Baulks Λ47/Λ48, Λ/M47-48, K47/Λ47)	345
2.9. Building C-D and its Immediate Surroundings	375
2.10. Material of Unknown or Uncertain Find Context	407

Volume 2

Part II. Greek and Roman Pottery and Cult Practice at the Sanctuary of Syme Viannou	429
3. The Fabric of Cult: Local and Imported Fabrics, and the Politics of Cult at Syme Viannou	431
3.1. Introduction	431
3.2. Previous Work on Ceramic Fabrics from Syme Viannou	433
3.3. Macroscopic Fabric Groups and Loners of Greek and Roman Pottery from Syme Viannou	435
3.3.1. Macroscopic Fabric Group A: Red Micaceous Fabric ("Lyktos/Lyttos Fabric")	438
3.3.2. Macroscopic Fabric Group B: Brown-red, Non-micaceous Fabric	441
3.3.3. Macroscopic Fabric Group C: Pink or Reddish Yellow Fabric with Dark and Red Inclusions	442
3.3.4. Macroscopic Fabric Group D: Pink Fabric with Varied Inclusions and Porous Surface	445
3.3.5. Macroscopic Fabric Group E: Fine Pale Fabric with Very Few Dark Inclusions	445
3.3.6. Macroscopic Fabric Group F: Fine Pale Fabric with Very Few Red and Dark Inclusions ("East Cretan Cream Ware")	446
3.3.7. Macroscopic Fabric Group G: Fine Red Fabric Turning Gray	

 on the Exterior ("Unguentaria Fabric") 447
 3.3.8. Macroscopic Fabric Group H: Fine, Soft, Reddish Yellow Fabric with Few Inclusions 447
 3.3.9. Macroscopic Fabric Group I: Fine Orange Fabric with Red Inclusions 448
 3.3.10. Macroscopic Fabric Group J: Fine, Soft, Pink Fabric ("Black Gloss Fabric") 448
 3.3.11. Macroscopic Fabric Loners from Crete 449
 3.3.12. Macroscopic Fabric Loners from Overseas 450
 3.3.13. Vessels of Indeterminate Fabric 450
 3.3.14. Summary 450
 3.4. Cretan Fabrics at Syme Viannou: Pots and Politics 452
 3.5. Foreign Fabrics and Overseas Connections at Syme Viannou and Other Cretan Sanctuaries 471
 3.6. Conclusion: Ceramic Fabric and the Provenance of Pots and People that Reached Syme Viannou from the Early Iron Age to the Roman Period 478

4. Ceramic Form and Function at Syme Viannou 481
 4.1. Introduction 481
 4.2. Deep Open Vessels of Small Size (Bell Skyphoi, Cups, Kantharoi, Skyphoi, and Other) 486
 4.3. Deep Open Vessels of Large to Medium Size (Cauldrons, Dinoi, and Kraters) 498
 4.4. Shallow Open Vessels of Small Size (Bowls, Dishes, Plates, and Trays) 502
 4.5. Shallow Open Vessels of Large to Medium Size (Basins, Kalathoi, Lekanai, and Other) 505
 4.6. Open Vessels of Uncertain Shape and Function 507
 4.7. Slow-Pouring Vessels (Aryballoi, Unguentaria, and Other) 508
 4.8. Fast-Pouring Vessels (Hydriai, Jugs/Juglets, Lagynoi, Oinochoai, and Other) 510
 4.9. Storage Vessels (Amphoras and Amphoriskoi, Pithoi, and Other) 512
 4.10. Closed Vessels of Uncertain Shape and Function 517
 4.11. Cooking Vessels (Baking Trays, Chytrai, Cooking Jugs, Lopades, and Other) 517
 4.12. Domed Lids/Shields and Related Vessels (Conical Lids, Discs) 520
 4.13. Kernoi and Ring Kernoi 526
 4.14. Miscellaneous Vessels 533
 4.15. Conclusion: Ceramic Form and Function at Syme Viannou and Other Cretan Sanctuaries from the Early Iron Age to the Roman Period 538

5. Synthesis: The Greek and Roman Pottery from Syme Viannou in Context 547
 5.1. Introduction 547
 5.2. The Protogeometric Period 548

5.3. The Geometric and Protoarchaic Periods	552
5.4. The Archaic and Classical Periods	558
5.5. The Hellenistic Period	565
5.6. The Roman Period	570
5.7. After the Roman Period	573
6. Appendix: Petrographic Analysis of Greek and Roman Pottery from Syme Viannou (by Eleni Nodarou)	575
6.1. The Present Study and Previous Analyses	575
6.2. Petrographic Fabric Groups	582
6.2.1. Coarse and Semi-Coarse Fabrics	583
6.2.2. Fine Fabrics	588
6.2.3. Small Petrographic Fabric Group and Loners	591
6.3. Petrographic Fabric Groups and Pottery Consumption at Syme Viannou	596
6.4. Ceramic Regionalism in Central and East Crete: Aspects of Continuity and Change	598
6.5. Descriptions of the Coarse and Semi-Coarse Petrographic Fabric Groups	599
Λεπτομερής περίληψη στα ελληνικά (Detailed Summary in Greek)	607
References	623

Part II.

Greek and Roman Pottery and Cult Practice at the Sanctuary of Syme Viannou

3
The Fabric of Cult:
Local and Imported Fabrics,
and the Politics of Cult at Syme Viannou

3.1. Introduction

Fabric is the first of the two key attributes of pottery which help convey "the whole romance of humanity" according to the archaeologist Armand Dupont in *Death in the Clouds*.[1] Together with Chapter 6 (the Appendix) which presents the results of the petrographic analysis by Eleni Nodarou, Chapter 3 in this volume offers an integrated approach to the fabrics of the Greek and Roman pottery from Syme Viannou, studies the provenance of this pottery, and evaluates the significance of this material for understanding the relations of the site with different Cretan communities. The approach pursued here is the most original methodological contribution of the present work given the current state of the research on ceramic fabrics from Greek sanctuaries.

As noted in Section 1.4, the fabrics of the Greek and Roman pottery from Cretan sanctuaries are understudied and typically receive minimal – if any – attention in final publications. Kommos presents a notable, albeit partial exception, as the pottery fabrics from this sanctuary have received brief macroscopic description and have attracted analytical research. More specifically, the final publication of the Greek and Roman sanctuary of Kommos included a chapter on the chemical analysis of a small group of Phoenician EIA vessels,[2] while later publications presented comprehensive petrographic and chemical analyses of Greek PAR transport amphoras and Phoenician EIA transport jars found at the site.[3] Nevertheless, this research remains focused on material dating from the earliest phase of the sanctuary and only covers some classes of imports. This means that the copious Cretan EIA to ROM pottery found at the site and some major classes of imports (including nearly all the fine ware imports of EIA date, and the later Greek and Roman imports of both fine and coarse wares) have hitherto received no analytical research.

1. Christie 1974, 211 ("texture" is the term used by Dupont).
2. Jones R. E. 2000.
3. See respectively: de Domingo and Johnston 2003; Gilboa, Waiman-Barak and Jones 2015.

Petrographic analysis has been applied to pottery from a few more Cretan sanctuaries. Indeed, Nodarou has sampled LM IIIC pottery from both the urban sanctuary and the settlement of Karphi.[4] Nodarou and I currently also collaborate on the study of the largely PAR material from the sanctuary of Timios Stavros by the peak of Psiloritis (Mt. Ida).[5] Petrographic work has also been conducted on Minoan pottery from peak sanctuaries, including Filioremos (by Nodarou),[6] and Vrysinas and Keria (by Georgia Kordatzaki).[7] Lastly, analytical work has been conducted on Minoan clay figurines from the sanctuary of Juktas,[8] and on clay ritual equipment from a LM IIIC shrine at Kavousi Vronda.[9]

Outside of Crete, the number of projects which integrate macroscopic and analytical work on ceramics from Greek sanctuaries is meagre and mostly of fairly narrow chronological scope. Macroscopic, petrographic, and chemical analysis has been applied to AR and CLAS pottery from the sanctuary of Apollo on Aegina.[10] Petrographic work has been conducted on HEL material from the Panhellenic sanctuary of Zeus at Nemea in the context of a study which situates ceramic production and distribution at the site in the broader regional context.[11] Other relevant work is known only from preliminary reports. A short report is available on the project of petrographic and chemical analyses of Neolithic to EIA pottery from the peak sanctuary of Mt. Lykaion in Arcadia,[12] and a comparable approach is reported (in unpublished papers) for the G-AR pottery from the sanctuary at Lousoi (in Arcadia) and Olympia.[13]

This overview suggests that integrated approaches to the fabric of pottery from Greek sanctuaries remain rare even though they have received increasing attention in the last two decades. Against this state of the research, Syme Viannou emerges as the first Cretan sanctuary which has received a systematic program of fabric characterization of Greek and Roman pottery, and perhaps also the first such sanctuary anywhere in the Greek world.[14] The exceptional state of the research on the ceramic fabrics from the site is complemented by the work of Nodarou and her collaborators on clay figurines (see Section 3.2).[15] In Section 3.3, I identify ten MFGs on the Greek and Roman pottery from Syme Viannou and I chart their spatial and temporal distribution at the sanctuary. Particular attention is given to the evidence these MFGs provide on the association of the site with communities of central and east Crete (Section 3.4),

4. Nodarou and Iliopoulos 2011. See also her forthcoming study of materials from Chalasmenos (briefly reported in Chlouveraki et al. 2010) and Kephala Vasilikis.
5. For this sanctuary, see Kritzas 2006.
6. Nodarou, pers. comm.
7. Kordatzaki 2007; 2016 (Vrysinas); Kordatzaki, pers. comm. (Keria).
8. Nodarou, pers. comm.
9. Day et. al. 2006.
10. Klebinder-Gauss 2012.
11. Graybehl 2014 (the work focuses on pottery from houses and a kiln, which was located near the sanctuary and probably catered to the needs of visitors).
12. Kordatzaki et. al. 2016.
13. Fragnoli 2020; Lang and Rathossi 2020.
14. The earlier collaboration of Nodarou and myself for the publication of a burial assemblage from Eleutherna is among the first applications of archaeological science to a large body of ceramics from a cemetery of the post-prehistoric Aegean (Kotsonas 2008, 71; Nodarou 2008, 345).
15. Nodarou et al. 2008 (wheelmade animal figurines); Nodarou and Rathossi 2008 (solid animal figurines and vessel attachments). The potential relevance of chemical analysis is discussed in Section 1.5.

as well as on the overseas imports which reached the sanctuary and their significance for the understanding of the "fabric of cult" at the site (Section 3.5).

3.2. Previous Work on Ceramic Fabrics from Syme Viannou

The fabrics of the pottery and the other classes of ceramics from the sanctuary of Syme Viannou have attracted considerable – albeit varied – attention. The following overview covers both macroscopic observations and analytical research.

As noted in Section 1.3, Kanta identified specific intra-island imports at the sanctuary, but these identifications were apparently based on morphological properties and included no reference to fabric. More specifically, she argued that the LPAR ring vase P129 may have originated from Aphrati, while two HEL vases, a cylindrical cup (P617), and a medallion bowl may have come from Lato.[16] On this basis, Kanta assumed that visitors from these sites came to Syme Viannou.

Much more emphasis to fabric was given by Erickson who studied AR-CLAS pottery (especially cups) from Syme Viannou.[17] Erickson proposed that pottery from the site was dominated by a certain fabric in the AR-MCLAS period, but this was replaced by a different fabric in the LCLAS period.[18] In his view, the later fabric, which he associated with Lyktos/Lyttos, is previously unattested at Syme Viannou and wholly replaces the earlier fabric which he associated with Aphrati.[19] On this basis, Erickson concluded that during the 6th and 5th centuries BCE the sanctuary of Syme Viannou was serving Aphrati, but from the 4th century BCE Lyktos/Lyttos seized control of the site, which may have fallen close to the border between this city and Hierapytna.[20] Erickson also identified pottery imports from elsewhere on Crete and also from overseas at Syme Viannou. This includes two 5th century BCE cups "in fine pale red fabric (Munsell 2.5YR 6/8)" which he ascribed to Gortyn and took as indications for Gortynian visitors to the sanctuary.[21] He also recognized a lamp of similar date as originating from Gortyn or Knossos,[22] and two Corinthian aryballoi of the early 6th century BCE.[23] The two aryballoi were the first overseas imports identified among the Greek and Roman pottery from Syme Viannou. Given the scarcity of imports, Erickson argued for the purely local appeal

16. Kanta 1991, 498, 500. For P129 see Section 1.3, and Erickson 2002, 81.
17. Erickson 2002.
18. Erickson 2002, 82.
19. Erickson 2002, 83.
20. Erickson 2002, 46-48, 79-85. In a more recent work, Erickson (2010a, 270) considers that Syme Viannou "functioned as a frontier sanctuary for the community at Aphrati until the end of the 5th century."
21. Erickson 2002, 48, 74 nos 109-110, 80-81 (the quote is from page 48). Erickson's no. 109 is identified with P278 of my catalogue. The clay of P278 (which is also attested on the MHEL-LHEL cup P366) is unlike the Gortynian fabric with which I am familiar (Kotsonas 2019a, 597).
22. Erickson 2002, 68, 69 no. 85.
23. Erickson 2002, 74 nos 107 and 108 (600-550 BCE).

of the sanctuary in the AR and CLAS periods.[24] As he noted, "The provisional historical picture presented here, dependent chiefly upon my study of the pottery, indicates a small rural sanctuary under the political control of the principal nearby polis, attracting visitors from further afield rarely, if at all."[25] This "provisional" conclusion, and the other important perspectives Erickson introduced into the study of AR and CLAS pottery from Syme Viannou are revisited below in the light of my broader and diachronic study of ceramics fabrics at the site.

In the two decades that followed Erickson's study, the fabrics of the Greek and Roman pottery from Syme Viannou did not receive any discussion.[26] These decades nonetheless saw the development of several important contributions to the study of fabrics on other classes of ceramics from the site, including BA pottery, and BA and EIA figurines.

In a preliminary report on the Minoan pottery from Syme Viannou, Christakis identified major shifts in the fabric and the provenance of Protopalatial and Neopalatial material. More specifically, he reported that imports from the Pediada are copious and amount to about 57% of the material in the MM IB assemblages, while imports from north central Crete are represented by only a few vases at the time.[27] Imports from the Pediada decreased dramatically from the MM IIA period, during which the pottery from the sanctuary largely came from the wider area around it, with only a few imports from other parts of the island (including north central Crete).[28] A broadly local production is thought to have persisted into the MM III period.[29] These macroscopic observations and interpretations remain to be confirmed by analytical work, including the hitherto unpublished pilot project of ceramic analysis of Minoan pottery from Syme Viannou which Christakis organized in collaboration with Nodarou.[30]

More work has been conducted on the fabric of the terracotta figurines from Syme Viannou. Indeed, Lebessi has provided brief descriptions of the four MFGs which occur on Minoan to Classical anthropomorphic figurines.[31] These are as follows: 1) a fine, orange clay with yellowish tinge is attested on 38.75% of the figurines and on samples dating from both the second and the first millennium BCE; 2) a clay of similar color but coarse, with ample white, brown-red or brown-black, gray and dark inclusions occurs on 33.75% of the finds; 3) a reddish to red, friable clay, with inclusions similar to those of group 2, is attested on 14.50% of the material; and 4) a red micaceous but otherwise fine clay with laminated breaks occurs on 12.91% of the material. Furthermore, Sporn briefly described two MFGs represented among HEL clay figurines. As she noted, "the bulk of the material is of very fine and pale clay common in all parts of Crete. There is some material from the Pediada, very deeply burnt clay with stone

24. Erickson 2002, 74.
25. Erickson 2002, 81.
26. This excludes my discussion of a single fragmentary cup of the late 7th century BCE (P690) which I attributed to a Gortynian workshop (Kotsonas 2019a; the vase is also mentioned in Lebessi 1984, p. 463, pl. 234γ; Kanta 1991, 500, 502 fig. 40:b).
27. Christakis 2013, 170–171, 177. Syme Viannou has yielded the largest assemblage of Minoan pottery from the Pediada found anywhere outside this region.
28. Christakis 2013, 172, 173, 177.
29. Christakis 2013, 177.
30. On the project see Archontaki 2012, 28 fn. 96; Christakis 2013, 170.
31. Lebessi 2021, 153.

inclusions, but they seem to become rarer after the Archaic period."[32] Sporn added that a few figurines are in a different East Greek fabric, perhaps from the area of Smyrna.[33]

More information is available on the fabrics of two classes of LM IIIC-AR figurines from Syme Viannou which have been the subject of petrographic analysis by Nodarou and her collaborators.[34] According to a preliminary report, hollow animal figurines (mostly bovines) from Syme Viannou can be ascribed to three PFGs.[35] Two of these PFGs (one dating to the LM IIIC-SMIN period and another dating to the G period) are considered to originate from the area around the sanctuary, while the third PFG (of the G period) is taken to derive from further afield. Petrographic analyses were also conducted on 20 samples from solid animal figurines and – to a much lesser extent – vessel attachments which date primarily to the G and – to a lesser extent – the PAR period but also include a few earlier, Minoan pieces.[36] The analysis identified as many as ten PFGs, most of which, however, include single samples.[37] These groups are compatible with the varying geology of the broader area around the sanctuary,[38] but the high variation they display may be indicative of the output of workshops from a larger part of central and east Crete.[39] The work in question concluded by emphasizing the need to extend this type of analysis to pottery of varied shape and date from the sanctuary of Syme Viannou.[40] The following section, in association with Chapter 6, are conceived as contributions in this direction.

3.3. Macroscopic Fabric Groups and Loners of Greek and Roman Pottery from Syme Viannou

In this section, the discussion of the different MFGs identified on Greek and Roman pottery from Syme Viannou is organized as follows: the heading for each MFG gives the code, which is basically a letter of the alphabet (from A to J), with the alphabetic sequence generally proceeding from coarser to finer groups, and from larger groups to smaller ones. Some MFGs (A, B and C) are divided into sub-groups depending on their coarseness, starting with coarse ware (e.g. B1) and ending in fine ware (e.g. B3). Exceptionally, I designate a certain variation of MFG A1 as A1a. The heading of each MFG also includes a brief reference to its main characteristics.

32. Sporn 2018, 132–133.
33. Sporn 2018, 133.
34. Nodarou et al. 2008 (wheelmade animal figurines); Nodarou and Rathossi 2008 (solid animal figurines and vessel attachments).
35. Nodarou et al. 2008.
36. Nodarou and Rathossi 2008. For the macroscopic properties of the fabrics of the 20 pieces sampled see Muhly 2008, 118–120.
37. Nodarou and Rathossi 2008, 166–169. See also Muhly 2008, 119–120.
38. Nodarou and Rathossi 2008, 169.
39. Muhly 2008, 119–120, 140.
40. Nodarou and Rathossi 2008, 170.

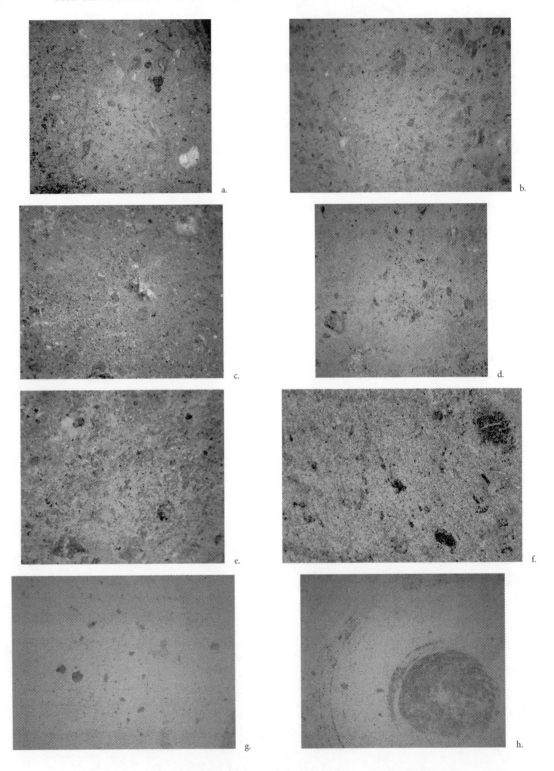

Figure 3.1: MFGs A1, A1a, A2, B1, B2, B3, C1, C2, from left to right, and from top to bottom. Dino-Lite photographs.

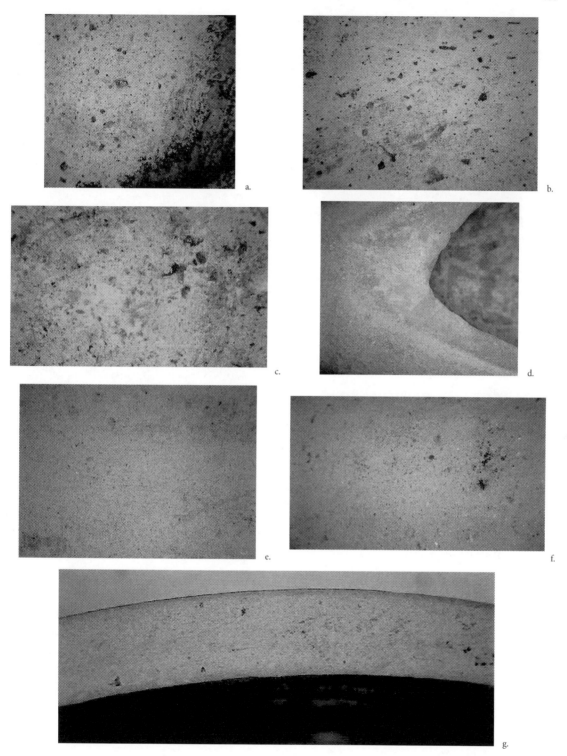

Figure 3.2: MFGs D, E, F, G, H, I, J, from left to right, and from top to bottom. Dino-Lite photographs.

438 The Sanctuary of Hermes and Aphrodite at Syme Viannou VII

Occasionally, there is a parenthesis providing a shorthand term for the MFG which is placed in brackets because it involves assumptions which remain to be confirmed. This term can be based on names and characterizations other scholars have used for this fabric (including "Lyktos/Lyttos fabric," "Aphrati fabric," "East Cretan Cream Wear") or is introduced by me to highlight a specific morphological property of vases made in this fabric ("unguentaria fabric," "black gloss fabric").

The heading of each MFG is followed by a list of the pieces which are assigned macroscopically to it – the so-called members. Possible members are listed separately given the uncertainty involved. The introductory section closes with references to the chronological range of the MFG and the spatial distribution of its members in the different areas of the sanctuary.

The discussion of each MFG begins with the description of the fabric, including the color of the matrix, the hardness, the feel, the fracture, the voids, and the inclusions. Until recently, the inclusions seen on the clay of ceramic finds from Syme Viannou had not received any macroscopic description,[41] even though this attribute is essential for the macroscopic characterization of ceramics and its correlation to analytical, especially petrographic characterization.

The discussion of each MFG proceeds with a reference to the different vessel shapes represented and the surface treatment of the vessels. Lastly, where applicable, each MFG is associated with the PFGs identified by Nodarou for the Greek and Roman pottery from Syme Viannou, with the PFGs identified by Nodarou and Rathossi for the EIA solid animal figurines,[42] and with the macroscopic fabric groups identified by Lebessi and Sporn for BA to HEL anthropomorphic terracottas from Syme Viannou.[43]

The discussion closes with three groups of pottery which were not assigned to any MFG: the numerous fabric "loners" (vessels that display fabrics rarely seen at the site) which come from within Crete (Section 3.3.10); the few "loners" from overseas which are mostly Attic and Corinthian (Section 3.3.11); and the overfired or burnt material, the fabric of which resists secure identification (Section 3.3.12).

3.3.1. Macroscopic Fabric Group A: Red Micaceous Fabric ("Lyktos/Lyttos Fabric")

MFG A1: coarse, red, micaceous fabric (Figure 3.1a).

Members: P19, P23, P36, P48, P49, P64, P82, P100, P107, P133, P141, P143, P157, P158, P168, P172, P174, P175, P186, P187, P196, P206, P207, P229, P237, P244, P246, P263, P266, P276, P279, P281, P286, P291, P293, P296, P306, P315, P318, P334, P345, P347, P376, P377, P394,

41. Contrast Lebessi 2021, 153, with, e.g., Erickson 2002; Muhly 2008, 118–120; Christakis 2014; Zarifis 2020.
42. Nodarou and Rathossi 2008.
43. Lebessi 2021, 153.

P398, P399, P402, P403, P453, P465, P474, P515, P528, P539, P550, P551, P552, P554, P555, P556, P563, P566, P568, P569, P571, P591, P609, P613, P618, P625, P650, P651, P681, P688, P694, P697, P705, P749, P753, P781, P789, P799, P836, P839, P841, P844, P863

Possible members: P864

Date range: EIA to ROM

Findspots: The Area of the Altar, the Terraces and the Water Channel, the Central and South-Central Part of the Podium, the Area of the Protoarchaic Hearth, the North Part of the Enclosure and the Podium, Building E and its Immediate Surroundings, Building C-D and its Immediate Surroundings, the Material of Unknown or Uncertain Find Context

This MFG includes 88 members and one possible member. The matrix is light red (2.5YR 6/6 to 6/8, or 7/8) to reddish yellow (5YR 6/6 to 7/6) and the surfaces present a similar color range, from light red (2.5YR 6/6 or 7/8) to reddish yellow (5YR 6/6 to 7/6). A few pieces are reddish brown (5YR 5/4) and red (2.5YR 5/6). Several examples (e.g., P206, P286, P555) are overfired. In these cases, the matrix is light red (2.5YR 6/6) or has turned gray (10YR 5/1), while the surfaces are partly or fully turned to gray (10YR 5/1) or dark gray (7.5YR 4/1). The fabric is soft, of smooth feel and hackly fracture (but smooth fracture appears on a few examples). Voids – specifically vughs – are very few and present random orientation. Non-plastic inclusions are common to dominant and present moderate sorting. Particles of silver mica are predominant to dominant, and the same applies to small (0.5-2 mm), dull white, sub-angular to sub-rounded inclusions. A range of other inclusions of sub-angular to sub-rounded form is attested in smaller quantities. Small (0.5-2 mm), dull dark inclusions are common; small to large (1-5 mm), dull red-brown inclusions are common to few; small to large (1-5 mm), mostly sub-angular, shiny, gray to gray-brown schist flakes are few to very few; and small (0.5-2 mm), dull pinkish to buff sub-angular inclusions are very few. MFG A1 occurs on plain ware, especially cups and cooking vessels. The exterior of these vessels is smoothed and the interior is roughly smoothed.

MFG A1 is associated with PFG 2, and partly with PFG 3 (see Chapter 6). Solid terracotta animal figurines from Syme Viannou were produced in a similar PFG.[44] MFG A1 can also be associated with a MFG identified on anthropomorphic terracottas from Syme Viannou.[45]

MFG A1a: coarse, red, micaceous fabric with many red inclusions (Figure 3.1b).

Members: P50, P51, P52, P130, P262, P280, P419, P478, P559, P560, P561, P562, P567, P762, P838

Date range: PAR to HEL

Findspots: The Area of the Altar, the Terraces and the Water Channel, the Central and South-Central Part of the Podium, the Area of the Protoarchaic Hearth, the North Part of the Enclosure and the Podium, Building C-D and its Immediate Surroundings, the Material of

44. Nodarou and Rathossi 2008, 172–174, fabric group 3. Also, Muhly 2008, 119.
45. Lebessi 2021, 153, fabric group 4. The red fabric mentioned in Sporn 2018, 133 is perhaps also relevant.

Unknown or Uncertain Find Context

This MFG includes 15 members. The matrix is light red (2.5YR 6/6 to 6/8, or 7/8) to reddish yellow (5YR 6/6 to 7/6), and the surfaces present a similar color range. One piece shows a grey (2.5YR 5/1) fabric (P838) because of the conditions of firing. This is a soft fabric of smooth feel and hackly fracture (but smooth fracture occurs on some examples). Voids, specifically vughs, are very few (though P838 has considerably more) and present random orientation. Non-plastic inclusions are common to dominant and present moderate sorting. Particles of silver mica are dominant. Dull red-brown inclusions of small to large size (0.5-5 mm), and small (0.5-2 mm) dull white inclusions are frequent and range from sub-angular to sub-rounded. Small (0.5-2 mm) dull dark inclusions are rare to few, whereas small (0.5 mm), sub-angular, shiny schist flakes of gray to red color are rare, if any. MFG A1a occurs on plain ware, both open (cups, lekanai, kernoi, and individual kalathoi and cauldrons) and closed vessels in addition to cooking vessels and discs. The external and internal surfaces are smoothed; cooking jugs carry horizontal grooves on the neck and P478 shows impressed decoration on the shoulder.

MFG A1a is associated with PFG 3 (see Chapter 6). Solid terracotta animal figurines from Syme Viannou were produced in a similar PFG.[46] MFG A1a can also be associated with a MFG identified on anthropomorphic terracottas from Syme Viannou.[47]

MFG A2: semi-coarse, red, micaceous fabric (Figure 3.1c).

Members: P32, P89, P134, P142, P259, P274, P292, P300, P313, P327, P380, P382, P389, P477, P499, P500, P553, P557, P558, P765, P774, P837, P850

Possible members: P284, P490, P773

Date range: PG to MROM

Findspots: The Area of the Altar, the Terraces and the Water Channel, the Central and South-Central Part of the Podium, Building C-D and its Immediate Surroundings, the Material of Unknown or Uncertain Find Context

This MFG includes 23 members and three possible members. The matrix is light red (2.5YR 6/8 to 7/8) to reddish yellow (5YR 6/6 to 7/6) and presents no variation on the surface. A gray core is uncommon. The fabric is soft, of smooth feel and smooth fracture. Voids, specifically vughs, are very few and present random orientation. Non-plastic inclusions are rare to very few and well-sorted. Particles of silver mica are dominant. Other inclusions remain small (0.5-1 mm) angular to sub-rounded. Dull dark inclusions are common, dull white inclusions are common to few, and dull buff or pinkish inclusions are few. MFG A2 occurs on plain ware, especially cups, fast-pouring vessels, and cooking vessels. The surfaces are smoothed.

MFG A2 is associated with PFG 3 (see Chapter 6). Solid terracotta figurines from Syme

46. Nodarou and Rathossi 2008, 172–174, fabric group 3. Also, Muhly 2008, 119.
47. Lebessi 2021, 153, fabric group 4. The red fabric identified on HEL figurines (Sporn 2018, 133) is perhaps also relevant.

Viannou were produced in a similar PFG.[48] Also, MFG A2 can be associated with a MFG identified on anthropomorphic terracottas from Syme Viannou.[49]

3.3.2. Macroscopic Fabric Group B: Brown-red, Non-micaceous Fabric

MFG B1: Coarse, brown-red, non-micaceous fabric (Figure 3.1d).

Members: P21, P39, P45, P68, P188, P242, P277, P330, P341, P344, P353, P401, P427, P491, P546, P564, P565, P614, P624, P633, P636, P704, P845

Possible members: P445, P600, P626

Date range: PG to HEL

Findspots: The Area of the Altar, the Terraces and the Water Channel, the Central and South-Central Part of the Podium, the Area of the Protoarchaic Hearth, Building E and its Immediate Surroundings, the Material of Unknown or Uncertain Find Context

This MFG includes 23 members and three possible members. The matrix is light reddish brown (5YR 6/4), with the light red (2.5YR 6/6) matrix of P614 being exceptional. The surfaces are of the same color as the matrix (5YR 6/4) but they can also be pink (5YR 7/4), light red (2.5YR 6/6) or reddish yellow (5YR 7/6). A dark brown core appears occasionally. The fabric is soft, of mostly rough feel and hackly fracture (P353 is exceptional in showing a smooth fracture). Voids (mostly vughs but also vesicles) are few to common and present random orientation. Non-plastic inclusions are frequent to common, moderately sorted, and small in size (0.5-2 mm). Dull brown (dark brown to red-brown) inclusions, angular to sub-rounded, are dominant to frequent; dull white inclusions, angular to sub-rounded, are few; and shiny schist flakes of gray color are very rare, if any. The MFG in question consists predominantly of lekanai of medium to large size. The external and – to a lesser extent – the internal surfaces are smoothed, while a few pieces carry incised (P242, P277, P344) or stamped (P546) decoration, or grooving (P626, P633). MFG B1 is associated with PFG 1 (see Chapter 6).

MFG B2: Semi-coarse to semi-fine, brown-red, non-micaceous fabric (Figure 3.1e).

Members: P482, P497, P498, P529, P531, P545, P639

Date range: PG to AR

Findspots: The Terraces and the Water Channel, the Central and South-Central Part of the Podium

This MFG includes seven members. The matrix is light reddish brown (5YR 6/4) and the surfaces are of similar color, but can also be pink (5YR 7/4, 7.5YR 7/4), or reddish yellow (5YR 7/6). A gray to gray-brown core appears occasionally. The fabric is soft, of smooth feel

48. Nodarou and Rathossi 2008, 172–174, fabric group 3. Also, Muhly 2008, 119.
49. Lebessi 2021, 153, fabric group 4. The red fabric identified on HEL figurines (Sporn 2018, 133) is perhaps also relevant.

and predominantly hackly fracture (though a few pieces show a smooth fracture). Voids (mostly vughs but also vesicles) are very few to common and present random orientation. Non-plastic inclusions are frequent to common, moderately sorted, and small in size (0.5-2 mm). Dull brown (dark brown to red-brown) inclusions, angular to sub-rounded, are dominant to frequent; dull white inclusions, angular to sub-angular, are few; and shiny schist flakes of gray color are very rare, if any. This MFG consists predominantly of lekanai and trays with smoothed surfaces, but bell skyphos P639 is dipped and the sizeable closed vessels P529 and P531 carry painted decoration. There is a possible incised potter's mark on P482.

MFG B3: Fine, brown-(red), non-micaceous fabric (Figure 3.1f).

Members: P69, P74, P101, P386, P530, P537, P575, P754, P792

Possible members: P211

Date range: G to AR

Findspots: The Area of the Altar, the Terraces and the Water Channel, the Central and South-Central Part of the Podium, Building E and its Immediate Surroundings, Building C-D and its Immediate Surroundings

This MFG includes nine members and one possible member. The matrix is light brown (5YR 6/4) or pink (5YR 7/4) and the surfaces are usually of the same color. Exceptions include the internal surface of P575 and the upper/external surface of P386 which are pink (7.5YR 7/4). P74 has a pink (7.5YR 7/3) exterior and a light pink (7.5YR 7/4) interior, P792 has a light brown (7.5YR 6/4) exterior, and P754 is overfired. The fabric is soft, of smooth feel and predominantly smooth fracture (though a few pieces show a hackly fracture). Voids (mostly vughs but also vesicles) are typically few (but common on P69) and present random orientation. Non-plastic inclusions are rare to very rare, dull dark, moderately sorted, and small in size (0.5-1 mm). This MFG occurs on vessels of small to medium size, both open (cups and a kotyle) and closed (aryballoi and a medium-sized vessel) as well as domed lids/shields. Surfaces are smoothed and occasionally (P69, P74, P754, P792), the external surface is polished. Painted decoration is applied to all pieces. MFG B3 is associated to some extent with PFG 6 (see Chapter 6).

3.3.3. Macroscopic Fabric Group C: Pink or Reddish Yellow Fabric with Dark and Red Inclusions

MFG C1: Semi-coarse to semi-fine, pink or reddish yellow fabric with dark and red inclusions and voids (Figure 3.1g).

Members: P24, P25, P34, P35, P58, P63, P65, P66, P67, P77, P78, P81, P83, P94, P95, P103, P109, P111, P112, P113, P115, P119, P124, P126, P128, P129, P159, P166, P181, P189, P194, P210, P282, P340, P346, P348, P352, P357, P370, P409, P432, P442, P447, P460, P464, P501, P506, P532, P534, P572, P576, P579, P596, P602, P627, P628, P629, P630, P632, P640, P647,

P653, P654, P685, P689, P698, P701, P707, P710, P711, P715, P718, P719, P720, P722, P723, P724, P726, P729, P730, P731, P732, P733, P734, P737, P738, P739, P740, P744, P745, P746, P756, P810, P811, P812, P813, P818, P827

Possible members: P417

Date range: PG to HEL

Findspots: The Area of the Altar, the Terraces and the Water Channel, the Central and South-Central Part of the Podium, the Area of the Protoarchaic Hearth, the West Part of the Enclosure, the North Part of the Enclosure and the Podium, Building E and its Immediate Surroundings, Building C-D and its Immediate Surroundings, the Material of Unknown or Uncertain Find Context

This MFG includes 98 members and one possible member. The matrix can be pink (5YR 8/4, or 2.5YR 7/4), light red (2.5YR 7/6), or reddish yellow (2.5YR 7/6). A few pieces have a core of light reddish brown (5YR 6/4) or light red (2.5YR 6/6) color, but most show a gray core, which is either light greenish gray (GLEY 2 7/10 BG, or GLEY 2 7/5 BG) or rarely greenish gray (GLEY 2 6/10G). Surfaces are usually pink (5YR 8/4 or 7.5YR 7/4 to 8/4) and occasionally reddish yellow (5YR 7/6). The fabric ranges from very soft to hard, the feel from powdery to smooth, and the fracture from smooth to hackly (through the fracture of P811 is laminated). Voids (mostly vughs but also vesicles) are frequent to dominant on most pieces (but few to rare on P111), and they present random orientation.

Non-plastic inclusions are common to frequent (but fewer on P111), sub-angular to sub-rounded. They are moderately sorted and show great variation in size (0.5-5 mm). Dull dark inclusions are dominant to frequent, dull light red-brown inclusions are few to rare, and shiny schists of light red to pink color are very few to rare, if any. MFG C1 occurs on closed vessels (especially large ones, but also on a ring vase) and more often on open vessels (bell skyphoi, kraters, lekanai, and kernoi). The external surface of these vessels is smoothed and often shows slip and painted decoration. The internal surface is almost always smoothed, and occasionally carries black slip (coating on P348, band on P128). P357 shows an incised mark on the underfoot.

MFG C1 is associated with PFG 5 (see Chapter 6). It can also be tentatively associated with a MFG identified on anthropomorphic terracottas from Syme Viannou.[50]

MFG C2: Fine, soft, pink or reddish yellow fabric with a few dark and, rarely, red inclusions ("Aphrati fabric") (Figure 3.1h).

Members: P6, P7, P14, P15, P16, P17, P22, P26, P27, P28, P29, P30, P37, P40, P42, P44, P46, P55, P59, P60, P61, P73, P75, P76, P79, P80, P84, P90, P93, P96, P97, P98, P99, P102, P104, P105, P106, P108, P110, P114, P118, P121, P122, P123, P127, P131, P132, P135, P136, P137, P139, P140, P145, P146, P151, P152, P153, P154, P155, P156, P170, P176, P177, P178, P179, P180, P183, P184, P185, P192, P193, P195, P197, P199, P200, P201, P204, P208, P209, P212,

50. Lebessi 2021, 153, fabric group 2.

P213, P214, P215, P218, P220, P221, P222, P226, P227, P228, P232, P236, P238, P243, P250, P251, P252, P253, P254, P255, P256, P257, P258, P261, P264, P268, P270, P271, P272, P273, P285, P289, P290, P294, P295, P297, P302, P304, P308, P309, P312, P316, P317, P320, P321, P322, P323, P324, P325, P328, P332, P333, P335, P336, P337, P343, P349, P350, P358, P362, P363, P364, P365, P371, P373, P374, P375, P378, P385, P390, P396, P407, P415, P416, P425, P428, P429, P431, P433, P434, P435, P436, P437, P446, P448, P450, P451, P454, P455, P458, P462, P463, P467, P468, P469, P470, P471, P473, P479, P481, P483, P486, P487, P488, P489, P492, P493, P494, P495, P496, P502, P503, P504, P505, P507, P508, P509, P510, P511, P512, P513, P516, P519, P520, P522, P523, P524, P525, P526, P535, P536, P538, P541, P542, P543, P547, P548, P549, P573, P574, P578, P580, P581, P582, P583, P584, P585, P586, P587, P588, P589, P590, P593, P594, P595, P599, P601, P603, P604, P605, P606, P607, P608, P610, P611, P612, P619, P620, P621, P622, P623, P631, P634, P635, P637, P638, P641, P642, P643, P644, P646, P648, P655, P657, P658, P659, P660, P661, P662, P663, P664, P665, P667, P668, P669, P670, P671, P672, P673, P674, P675, P676, P677, P678, P679, P684, P687, P691, P692, P693, P695, P696, P700, P702, P703, P706, P708, P709, P712, P713, P716, P717, P721, P725, P727, P728, P735, P736, P742, P743, P747, P748, P750, P752, P755, P757, P758, P760, P763, P766, P768, P772, P778, P786, P788, P798, P800, P801, P802, P809, P814, P815, P816, P817, P819, P820, P821, P822, P823, P824, P825, P826, P828, P829, P830, P831, P833, P834, P835, P840, P843, P851, P853, P857

Possible members: P85, P171, P205, P331, P361, P392, P540, P615, P846

Date range: PG to MROM

Findspots: The Area of the Altar, the Terraces and the Water Channel, the Central and South-Central Part of the Podium, the Protoarchaic Hearth, the West Part of the Enclosure, the North Part of the Enclosure and the Podium, Building E and its Immediate Surroundings, Building C-D and its Immediate Surroundings, the Material of Unknown or Uncertain Find Context

This MFG includes 354 members and nine possible members. The matrix is usually pink (5YR 7/4 to 8/4, or 7.5YR 8/4 to 8/3), light red (2.5YR 6/6), or reddish yellow (2.5YR 7/6). More rarely, it appears light red (2.5YR 7/6 to 7/8) or reddish yellow (5YR 7/6), in which case it usually shows a bluish gray core. The surfaces are very pale brown (10YR 8/3 to 8/4) or pink (7.5YR 7/4 to 8/4) and rarely reddish yellow (5YR 7/6). There is a consistent association between light red (2.5YR 7/6) or reddish yellow (2.5YR 7/6) matrix and pink (5YR 8/4 or 7.5YR 8/4) surfaces. The fabric ranges from very soft to soft (and rarely hard) and the feel from powdery to smooth, while the fracture is smooth. Voids, specifically vesicles, are very few to few and present random orientation. Non-plastic inclusions are very few to few, small in size (0.5-1 mm) and sub-angular to sub-rounded. Dull dark inclusions are very few, if any, and dull red inclusions are very few and mostly missing. MFG C2 is attested on bell skyphoi, cups, lekanai, closed vessels, kernoi and domed lids/shields. The external and occasionally the internal surface are smoothed. Dull slip is often attested on the exterior and the interior; linear or other decoration remains uncommon (P98, P99, P127, P511).

The Fabric of Cult: Local and Imported Fabrics, and the Politics of Cult 445

MFG C2 is associated with PFG 5 (see Chapter 6). It can also be tentatively associated with a MFG identified on anthropomorphic terracottas from Syme Viannou.[51]

3.3.4. Macroscopic Fabric Group D: Pink Fabric with Varied Inclusions and Porous Surface

MFG D: Pink fabric with varied inclusions and porous surface (Figure 3.2a).

Members: P1, P2, P3, P4, P8, P9, P10, P11, P12, P38, P41, P70, P116, P202, P203, P379, P443, P456, P592, P666

Possible members: P5, P125, P283, P329, P426

Date range: PG-CLAS[52]

Findspots: The Area of the Altar, the Terraces and the Water Channel, the Central and South-Central Part of the Podium, the North Part of the Enclosure and the Podium

This MFG includes 20 members and five possible members. The matrix is nearly always pink (5YR 7/4 to 8/4) and often shows a gray (5YR 5/1 to 6/1) core. The exterior is pink (7.5YR 7/4 to 8/4), more rarely darker pink (5YR 8/4), and exceptionally very pale brown (10YR 8/4). The fabric is soft, with smooth and occasionally rough feel, and smooth to hackly fracture. Voids (primarily vughs and some vesicles) are common to dominant. Non-plastic inclusions are common, sub-angular to (mostly) sub-rounded, of small to medium size (0.5-3 mm) and moderately sorted. Dark inclusions are dominant to frequent, while white and light brown to light red-brown inclusions are very rare to very few. MFG D is represented by cups, skyphoi, and bell skyphoi. The external surface of these vases is typically smoothed, while several specimens have simple decoration in dark slip, including dipping (P283).

3.3.5. Macroscopic Fabric Group E: Fine Pale Fabric with Very Few Dark Inclusions

MFG E: Fine pale fabric with very few dark inclusions (Figure 3.2b).

Members: P13, P43, P62, P91, P92, P120, P164, P303, P326, P368, P406, P413, P441, P457, P461, P472, P480, P485, P649, P775

Possible members: P56, P191, P217, P359, P367, P430, P484, P784

Date range: PG to HEL

Findspots: The Area of the Altar, the Terraces and the Water Channel, the North Part of the

51. Lebessi 2021, 153, fabric group 1. The "very fine and pale" fabric of HEL figurines (Sporn 2018, 132) is perhaps also relevant.

52. Though note that P329 is HEL.

Enclosure and the Podium, Building C-D and its Immediate Surroundings, the Material of Unknown or Uncertain Find Context

This MFG includes 20 members and eight possible members. Macroscopic and petrographic (see PFG 8 in Chapter 6) observations suggest that MFG E is related to MFG F, which is later in date. The matrix of MFG E is pink (7.5YR 7/4 and rarely 8/4), while the surfaces are very pale brown (10YR 8/3 to 8/4) and – more rarely – pink (7.5YR 8/4). The fabric is soft to very soft, with smooth to powdery feel and smooth fracture. Voids (vesicles and vughs) are very rare and in random orientation. Non-plastic inclusions are very rare, and any dull dark inclusions are of small size (0.5-2 mm) and well-sorted to very well-sorted. This MFG is represented by bell skyphoi and small pouring vessels. The exterior surface is smoothed, with the same applying to the interior of the open vessels. Some pieces carry dull dark slip (P43, P413, P430, P457, P461). Several vessels made in this MFG carry incised marks rendered before firing (P368, P461, P480, and perhaps P413). MFG E is associated with PFG 8 (see Chapter 6).

3.3.6. Macroscopic Fabric Group F: Fine Pale Fabric with Very Few Red and Dark Inclusions ("East Cretan Cream Ware")

MFG F: Fine pale fabric with very few red and dark inclusions (Figure 3.2c).

Members: P144, P149, P240, P247, P249, P269, P338, P387, P397, P405, P411, P423, P466, P645, P854

Possible members: P223, P769

Date range: HEL to ROM[53]

Findspots: The Area of the Altar, the Terraces and the Water Channel, the West Part of the Enclosure, Building C-D and its Immediate Surroundings, the Material of Unknown or Uncertain Find Context

This MFG includes 15 members and two possible members. Macroscopic and petrographic (see PFG 8 in Chapter 6) observations suggest that MFG F is related to MFG E, which is earlier in date. The matrix of MFG F is pale yellow (2.5Y 8/3) or very pale brown (10YR 8/3 to 8/4), while the surfaces are pale yellow (2.5Y 8/3 to 8/4) or very pale brown (10YR 8/3 to 8/4). The fabric is mostly soft to very soft, with powdery to smooth feel and smooth fracture. Voids are rare and limited to small vesicles in random orientation. Non-plastic inclusions are rare (but common in the coarse fraction), small in size (1-2 mm) and very well-sorted. Both dull red and dull dark inclusions are attested. MFG F is mostly represented by cups (including inscribed cups) and – to a much lesser extent – by small to medium-sized pouring vessels. Large vessels of other shapes are poorly attested. The exterior is smoothed and – very rarely (P466) – coated in dull dark slip. The interior is roughly smoothed or coated in light red slip (P338, P645). MFG F is associated with PFG 8 (see Chapter 6).

53. Note that the MFG includes the (CLAS)-HEL P645, and the LCLAS-EHEL P144.

3.3.7. Macroscopic Fabric Group G: Fine Red Fabric Turning Gray on the Exterior ("Unguentaria Fabric")

MFG G: Fine red fabric turning gray on the exterior (Figure 3.2d).

Members: P86, P87, P88, P241, P248, P299, P311, P356, P422, P790, P859, P860, P861

Date range: HEL

Findspots: The Area of the Altar, the Terraces and the Water Channel, Building C-D and its Immediate Surroundings, Material of Unknown or Uncertain Find Context

This MFG includes 13 members and is remarkably consistent. The matrix is red (2.5YR 5/6) to light red (2.5YR 6/6 to 6/8), while the surfaces range between grayish brown (10YR 5/2), gray (10YR 6/1), and light brownish gray (10YR 6/2). The fabric is soft to hard, with smooth feel and smooth to hackly fracture. Voids (vesicles and vughs) are few and show random orientation. Non-plastic inclusions are rare to few, with dull white inclusions being few to rare and dull dark inclusions being rare if they exist at all. These inclusions are small in size (0.5-1 mm), angular to sub-angular. The MFG in question occurs exclusively on unguentaria. Unguentaria made in other fabrics are also attested, but the vast majority of the specimens from Syme Viannou belong to MFG G. Exterior surfaces are roughly smoothed, with incised lines on P860. MFG G is associated with PFG 7 (see Chapter 6). The narrow spatial distribution of vessels made in MFG G is remarkable.

3.3.8. Macroscopic Fabric Group H: Fine, Soft, Reddish Yellow Fabric with Few Inclusions

MFG H: Fine, soft, reddish yellow fabric with few inclusions (Figure 3.2e).

Members: P216, P231, P372, P381, P408, P759, P761, P764, P770, P780, P783, P794, P795, P805, P807, P808

Possible members: P803, P804, P806

Date range: HEL to ROM[54]

Findspots: The Terraces and the Water Channel, Building C-D and its Immediate Surroundings

This MFG includes 16 members and three possible members. The matrix is predominantly reddish yellow (5YR 7/6 to 7/8), but there are several pieces with a pink (5YR 7/4 or 7.5YR 7/4) matrix. The surfaces are reddish yellow (5YR 7/6) or pink (5YR 8/4) and are often not matching in color. The fabric is soft (only a few pieces are hard fired), of powdery to smooth feel and smooth to hackly fracture. Voids, specifically vesicles and vughs, are commonly attested, but they can range from few to frequent; their orientation is random. Non-plastic inclusions are rare to few, with dull dark inclusions being few to rare and dull white inclusions

54. But note that jug P759 is LPAR/EAR.

being very few to rare. The inclusions are small (≤2 mm), rounded to sub-angular, and moderately sorted. MFG H is commonly attested on large closed vessels, especially amphoras. The exterior surface is smoothed, which is also usually the case for the interior. Most pieces carry ribbing on the exterior and a few (P381, P783) show incised wavy lines. MFG H is associated to some extent with PFG 6 (see Chapter 6).

3.3.9. Macroscopic Fabric Group I: Fine Orange Fabric with Red Inclusions

MFG I: Fine orange fabric with red inclusions (Figure 3.2f).

Members: P31, P57, P234, P235, P239, P319, P339, P388, P393, P400, P410, P439, P440, P452, P683, P686, P714, P741, P787

Possible members: P225, P444, P475

Date range: PAR to HEL

Findspots: The Area of the Altar, the Terraces and the Water Channel, the North Part of the Enclosure and the Podium, Building E and its Immediate Surroundings, Building C-D and its Immediate Surroundings

This MFG includes 19 members and three possible members. The matrix is light red (2.5YR 7/6 to 6/6) and, more rarely, yellowish red (5YR 7/6). The surfaces typically show the color of the matrix and are yellowish red (5YR 7/6) on rare instances. The core is light red (2.5YR 7/6 to 6/6) and turns gray very rarely. This is a soft fabric of smooth feel and smooth fracture. Voids, specifically vesicles and vughs, are rare and present random orientation. Non-plastic inclusions are rare to very rare and they are moderately sorted. They consist of: small (0.5-1 mm), angular to sub-angular inclusions of dull red color which are rarely attested, if at all, and rare dull white particles, which are, however, missing from most specimens. Open and closed vessels of small size as well as domed lids/shields are made in this MFG. Surfaces are typically smoothed. Several pieces (e.g., P388, P393, P683) are fully coated in slip, while others preserve slip on the exterior (e.g., P439). Further decorative elaboration, whether painted (P235 and P319) or grooved (P686), is uncommon. MFG I is associated to some extent with PFG 6 (see Chapter 6).

3.3.10. Macroscopic Fabric Group J: Fine, Soft, Pink Fabric ("Black Gloss Fabric")

MFG J: Fine, soft, pink fabric (Figure 3.2g).

Members: P47, P53, P54, P147, P148, P161, P162, P230, P233, P245, P265, P287, P298, P301, P305, P354, P355, P395, P414, P449, P476, P527, P533, P699, P767, P776, P791, P793, P797, P847, P848, P849, P852, P855, P856, P858

Possible members: P617

Date range: (PAR) to HEL[55]

Findspots: The Area of the Altar, the Terraces and the Water Channel, the Central and South-Central Part of the Podium, the Area of the Protoarchaic Hearth, Building E and its Immediate Surroundings, Building C-D and its Immediate Surroundings, Material of Unknown or Uncertain Find Context

This MFG includes 36 members and one possible member. The matrix of nearly all specimens is pink (5YR 7/4 to 8/4), but a few examples show a reddish yellow (5YR 7/6) or light red (2.5YR 6/6) matrix. Several pieces have a blue-gray core. This is a soft fabric of powdery to smooth feel and smooth to hackly fracture. Voids, specifically vesicles and vughs, are non-existent to rare and present random orientation. Non-plastic inclusions, dark or reddish brown, are very few to non-existent. These inclusions are small in size (≤1 mm), rounded to sub-angular, and moderately sorted. The MFG in question is commonly attested on HEL cups and kantharoi, but it is also found on other open and closed forms of small size which are rarer at Syme Viannou. The exterior of these vessels – and, in the case of open vessels, the interior as well – is almost always coated in black gloss. One piece carries incised lines (P355). MFG J is associated to some extent with PFG 6 (see Chapter 6).

3.3.11. Macroscopic Fabric Loners from Crete

The Cretan pottery from Syme Viannou includes a considerable number (47) of pieces or pairs of pieces which display idiosyncratic fabrics and are called macroscopic fabric loners. Most of these pieces are of indeterminate provenance: P71 and P117 (which show similar fabric), P33, P138, P160, P163, P165, P167, P190, P219, P224, P260 (the fabric of which is related to MFG I), P267, P275, P307, P360, P369, P384, P391, P412, P420, P421, P424, P514, P570, P652, P680, P682, P751, P771, P777 (related to MFG A1), P779 and P785 (which show similar fabric), P796, P832 (the fabric of which is related to – but does not match – MFGs A1 and B1), P842, P862, P865 (the fabric of which recalls MFG F). A few other pieces, however, can be localized to specific parts of the island with varying degrees of confidence: P418 is Knossian,[56] P342 and P351 probably come from Knossos or north central Crete, while P18, P383, P521, and P690 may be Gortynian. I remain skeptical over the assumed Gortynian provenance of P278 and P366.[57]

55. Nearly all the pieces are HEL, except for P414 which is LG-(AR), P449 which is LPAR-EAR, and P533 which is LPAR.

56. P418 is a Knossian Medusa bowl; a second such piece found at Syme Viannou is illustrated in Kanta 1991, 500 fig. 42, but could not be located by the author.

57. On the provenance of P278 from Gortyn see Erickson 2002, 48, 74 no. 109, 80-81. The clay of P278 (which is also attested on P366) is unlike the Gortynian fabric with which I am familiar (Kotsonas 2019a, 597).

3.3.12. Macroscopic Fabric Loners from Overseas

The handful of overseas imports (seven ?), which mostly come from Corinth and Attica, are not assigned to any MFG. All three Corinthian fragments (P182, P517, P656) belong to Early to Middle Corinthian aryballoi. Attic pieces include the LAR-ECLAS kylix P459 and the small open vessel P518 which may be Attic, whereas two more Attic vessels (a kantharos and a medium-sized vessel) are among the inscribed material which will be published by Kritzas. There is also the EHEL/MHEL kantharos P314 which probably originates from the Greek Mainland, and P169 which probably represents a Laconian transport amphora and is certainly an off-island import, as confirmed by petrographic analysis (see Chapter 6). The petrographic analysis also indicated that there may be two more off-island imports.[58]

3.3.13. Vessels of Indeterminate Fabric

Fifteen pieces are overfired or burnt to an extent that prohibits the macroscopic identification of their fabric. This includes: P20, P72, P150, P173, P198, P288, P310, P404, P438, P544, P577, P597, P598, P616, P782.

3.3.14. Summary

Following the detailed descriptions of the ten MFGs which are identified in the Greek and Roman pottery from Syme Viannou, I offer some synthesizing comments which rely partly on Figure 3.3:[59] The ten MFGs account for circa 92% of the material published in this work (786 of 865 pieces), while the remaining 8% (69 of 865 pieces) includes overseas imports (which amount to 1%), Cretan fabric loners, and overfired or burnt pieces. Approximately half of the material included in this study (462 pieces) is assigned to MFG C, while MFG A comes second with 130 specimens. The remaining eight MFGs include circa 10 to 40 pieces. More specifically, MFGs B and J include circa 40 specimens each, while the remaining six MFGs (D, E, F, G, H, I) include circa 13 to 28 pieces each. If MFGs E and F (which are probably related to one another) are taken together, the total of their specimens (47) is comparable to the number of specimens assigned to MFGs B and J.

The ten MFGs represented at Syme Viannou cover periods of varied length. MFGs A and C are attested throughout the Greek and Roman period (EIA to ROM), while most other

58. This includes the EIA bell krater P680, about the foreign provenance of which I remain sceptical (the piece is discussed in Section 3.3.11), and the LHEL unguentarium P234, which is assigned to MFG I.

59. Figure 3.3a quantifies the full range of Greek and Roman pottery catalogued in this work (for ceramic quantification see Orton and Hughes 2013, 203–218; for the quantification of Greek pottery, see Theurrillat, Verdan and Kenzelmann Pfyffer 2011; for the quantification of pottery from Greek sanctuaries, see Stissi 2002, 232–258; 2009, 30–34). I hold that this quantification is very close to the minimum number of vessels represented at Syme Viannou except for the fragments of kernoi, as noted in Section 4.13. To compensate for this, I provide the alternative Figure 3.3b, which takes in the estimated minimum number of kernoi.

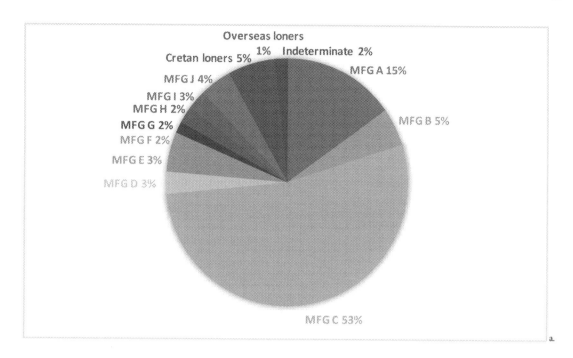

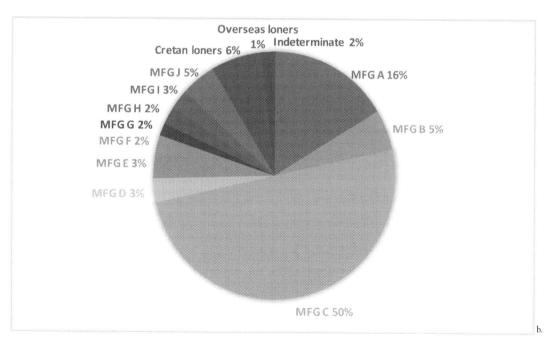

Figure 3.3: The representation of the ten MFGs and of the other fabric groupings identified on the Greek and Roman pottery from Syme Viannou (including possible members of the different MFGs). Figure 3.3a counts every piece catalogued as one vessel, while Figure 3.3b counts the kernoi according to the minimum number of individual vessels represented (which results in a considerable drop in the representation of MFG C).

groups persist for half a millennium to a full millennium (MFGs B, D, E, F, H, I and J), and only MFG G is period-specific (HEL). A considerable range of MFGs is identifiable already in the PG period (MFGs A, B, C, D and E). Two new MFGs are introduced in the PAR period (MFGs I and J), and one MFG (D) does not outlast the CLAS period. The broadest range of MFGs appears in the HEL period when nine of the ten MFGs are represented (A, B, C, E, F, G, H, I, J). This range shrinks markedly in ROM times when four MFGs are attested (A, C, F, H), most of them – except MFG H – rather thinly. Most of these patterns are rendered in Figure 3.4.[60] This figure divides the time-span covered in this study in periods of varying length which are shaped by established ideas concerning the archaeology of Syme Viannou and the history and archaeology of Crete, as explained in Chapter 5. The broad quantification presented by this graph is qualified further below, especially in Section 3.5 (with Figure 3.5) and Chapter 5.

One third of the specimens assigned to the ten MFGs (circa 270 of 865 pieces) are coarse to semi-coarse (MFGs A, B1 and B2, C1, and D), while the remaining two thirds are fine to semi-fine.[61] All the MFGs which are introduced from the PAR period onward (F, G, H, I, J) are fine to semi-fine. The characterization of the finest material (including pieces from MFGs C2, B3, H, and J) would benefit from chemical analysis.

3.4. Cretan Fabrics at Syme Viannou: Pots and Politics

A late 1nd century BCE inscription from the sanctuary of Diktynna in west Crete states that a slave produced pottery for the site.[62] Such epigraphic documentation does not exist for Syme Viannou, which leaves open the question of the attachment of one or more potters or workshops to the sanctuary. Kanta has argued for on-site production of ceramics during the Minoan period based on the quantity of communion cups and conical cups recovered, as well as on the discovery of potter's wheels.[63] More recently, Archontaki argued that a certain workshop located in the area around the sanctuary supplied visitors with both communion cups and other pottery, as deduced from morphological similarities identified on a

60. Figure 3.4a and 3.4b quantify the individual pieces catalogued in this study according to the methodology which is explained in the previous fn. A vessel which is dated broadly to two different periods, e.g., PAR-AR, is counted here as 0.5 for each period. This principle is retained when dating to one of the two periods is more likely (e.g., PAR-(AR)). Vessels of indeterminate date are not included. When a vessel is dated broadly to around the beginning or the end of the period under discussion (e.g., LM IIIC-PG, or LROM-EBYZ), I count 0.5 for either the PG or the ROM period.

61. This division is intended as a rough approximation, since fabric coarseness presents a continuum, rather than any sharp bi-modal division.

62. *I.Cr.* II.xi.3, lines 4–5. Catherine Morgan (1999, 325 fn. 99) took a 2nd century BCE inscription from Lebena (*I.Cr.* II.xvii.2) to record provisions for the payment of wages to potters making vessels for the sanctuary. However, this reading is questionable since the inscription basically inventories vessels and other equipment held in the sanctuary (see, e.g., Sokolowski 1969, 244–245 no. 144). I thank Angelos Chaniotis for his advice on this inscription. For epigraphic evidence on the connection between pottery workshops and sanctuaries, see Risser 2015, 93.

63. Kanta 1991, 484.

The Fabric of Cult: Local and Imported Fabrics, and the Politics of Cult

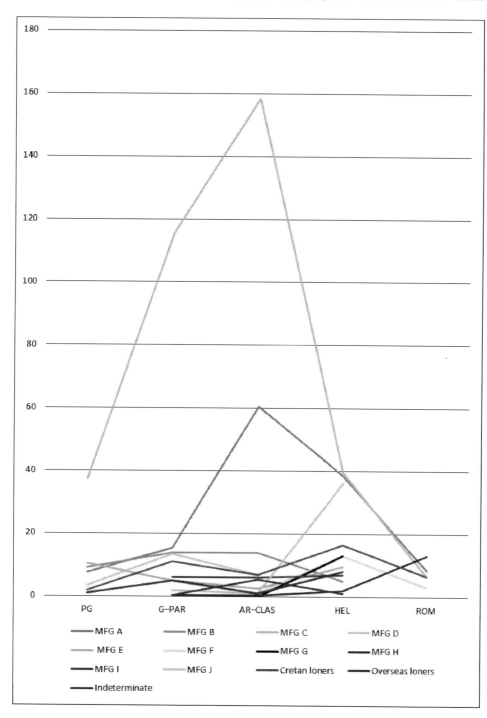

Figure 3.4a: Diachronic representation of the ten MFGs and other fabric groupings identified in the Greek and Roman pottery from Syme Viannou, counting catalogued pieces as vessels. Possible MFG members are included.

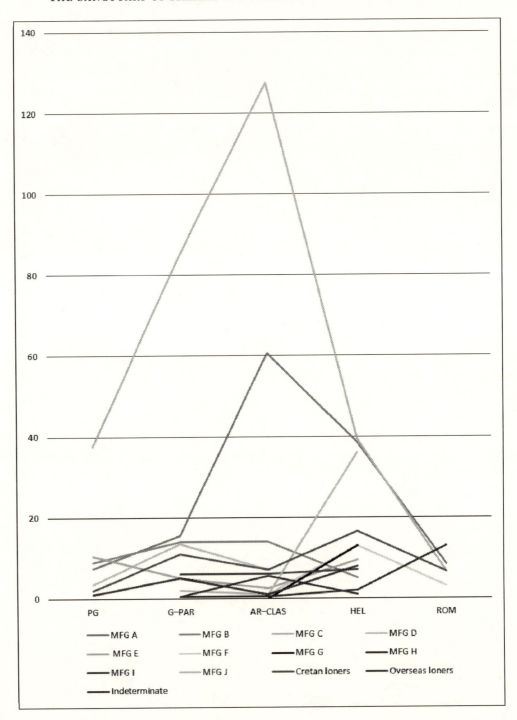

3.4b: Diachronic representation of the ten MFGs and other fabric groupings identified in the Greek and Roman pottery from Syme Viannou, with kernoi counted according to the minimum number of individual vessels. Possible MFG members are included.

range of vessels.⁶⁴ The attachment of one or more potters or workshops to the sanctuary of Syme Viannou is unlikely to have persisted into the Greek and Roman period. This broad time span has yielded no evidence for pottery manufacture at the sanctuary itself, while "evidence for on-site production of terracottas ... is [also] lacking."⁶⁵ Erickson argued against the production of ceramics at the sanctuary during the AR and CLAS periods on account of the absence of any kilns and of any standardized equipment.⁶⁶ I concur that localized production at the sanctuary cannot be assumed for any part of the Greek and Roman period in light of the wide range of fabrics represented and the relatively low number of pots dating from this very broad chronological span. The 865 pieces of Greek and Roman pottery from Syme Viannou which are published in this work pale in comparison to the quantity of Minoan pottery found at the site, with the Minoan communion cups alone amounting to several thousand pieces. Accordingly, the provision of the sanctuary with Greek and Roman pottery must have adhered to models other than those which operated in Minoan times. As Erickson has noted, it is not easy to know whether the pottery produced at a given site came to the sanctuary in the hands of potters who set up stalls at festival time and sold their wares to visitors, or whether the visitors themselves procured the material at their hometowns and transported it themselves.⁶⁷ Both models could have operated at different times, and also at the same time.

The circulation of Cretan pottery within the island is already identifiable in the beginning of the EIA, but increased over time and reached a peak from the end of the 8th to the mid-7th century BCE according to my evaluation.⁶⁸ This pattern is identifiable in different contexts and not least in sanctuaries. For example, a number of Knossian and other Cretan imports of different shape and SMIN to PAR date have been identified at Kommos,⁶⁹ a few Knossian and other Cretan PG to EPAR imports are known from the Psychro cave,⁷⁰ while a few EIA pieces are known from the two published Gortynian sanctuaries. This includes two PG open vessels from the Armi Hill,⁷¹ and an EPAR domed lid/shield from the acropolis sanctuary.⁷² Erickson has traced the circulation of Cretan pottery within the island during the AR and CLAS periods,⁷³ but the issue has not been investigated enough for the HEL and ROM

64. Archontaki 2012, 28–29.
65. Muhly 2008, 118.
66. Erickson 2002, 80.
67. Erickson 2002, 80. Lefèvre-Novaro (2014, 122) embraces the second possibility. Comparable considerations have been raised with reference to the bronzes from Syme Viannou, with the notable difference that the sanctuary has yielded considerable traces of bronzeworking which probably date to the EIA (Lebessi 1983, 366; 1985b, 200–201; 2002b, 185–192; Kanta 1991, 484; Schürmann 1996, 193–194; Muhly 2008, 140; Muhly and Muhly 2018, 548–549). On-site stone-working of Minoan vessels is also probable, see Lebessi 1983, 366; 1984, 461; 2002b, 191; Kanta 1991, 484. For the festivals at Syme Viannou, see Lebessi 1983; 1985b, 194–197; 2002b, 186. For festivals and fairs in ancient Greece, see Kowalzig 2020.
68. Kotsonas 2008, 236–256; 2017a.
69. Johnston 1993, 350 (perhaps Knossian); Callaghan and Johnston 2000, 215–216 no. 17, 219–220 nos 51 and 58, 226–227 nos 132 and 148 (no. 132 is considered to be Knossian, and this is also probable for no. 148); Johnston 2000, 224; 2005, 313 no. 7, 316 no. 17, 318–319 no. 27, 321 no. 31, 324 no. 51.
70. Watrous 1996, 43 nos 126–127, 43 no. 129 (the last two pieces are probably Knossian).
71. Anzalone 2013, 245 no. 52 (PGB krater), 248 no. 114 (LPG cup).
72. Johannowsky 2002, 12 no. 41.
73. Erickson 2010a, *passim*.

periods.

The state of the research on the circulation of Cretan pottery within the island has been revolutionized by the evidence from Syme Viannou, where as much as 99% of the Greek and Roman pottery may derive from elsewhere in Crete. Most of MFGs identified above cannot be given a specific provenance because of the current state of the research. However, some hypotheses have been – or can be – developed for specific MFGs, specifically A, C2, and F, as discussed below.

Erickson has argued that during the AR-MCLAS period, the ceramic assemblage from Syme Viannou was dominated by a fabric which he describes as "a fine clay of chalky consistency fired to a very pale brown color (Munsell 10YR 8/3)" that "contains very few inclusions visible to the naked eye. It is soft and powdery. The color occasionally borders on reddish yellow (Munsell 7.5YR 7/6)."[74] This description fits our MFG C2, as confirmed by the examination of specific vessels discussed by Erickson. Erickson noted that the same fabric is identifiable on pottery from Aphrati – which is located northwest of Syme Viannou – and from the small HEL coastal sanctuary of Myrtos Pyrgos, which is located southeast of Syme Viannou and was also dedicated to Hermes and Aphrodite.[75] On this basis, and after briefly entertaining the possibility that the fabric in question may represent the output of the ancient city of Biannos/Biennos (Viannos),[76] Erickson concluded that this fabric comes from Aphrati (also because of morphological similarities between pottery from this site and from Syme Viannou).[77] Lastly, Erickson noted that the fabric in question "totally" disappeared from the sanctuary after the MCLAS period.[78]

Erickson's ideas on pots and politics at Syme Viannou during the AR and CLAS periods have proven influential,[79] but invite some reconsideration in light of the present study of the full range of Greek and Roman pottery. This study has confirmed that Erickson was right in noting the predominance of the fine pale brown fabric at Syme Viannou, but not in reporting that the fabric disappeared from the site in the course of the CLAS period. Indeed, MFG C2 was shown here to have been used from the PG to the MROM period (see above, especially Figure 3.4). I am also skeptical about Erickson's association of the MFG in question with a fabric from Myrtos Pyrgos (see above). Additionally, I fear that a fine fabric like the one described by Erickson (or my MFG C2) is not distinctive enough to be associated exclusively with any specific community.[80] Indeed, a similar fabric is attested on fine ware PAR-AR pottery from Lyktos/Lyttos.[81]

74. Erickson 2002, 46 with fn. 15.
75. Erickson 2002, 46. On HEL Myrtos Pyrgos see Eiring 2000; Cadogan and Chaniotis 2010, 294–301; Lebessi 2021, 188–189.
76. On Biannos/Biennos (Viannos) see Hood, Warren and Cadogan 1964, 83; Kitchell 1977, 337–359; Sjögren 2003, 159; Perlman 2005, 1154.
77. Erickson 2002, 46–47, based on the description of a fabric from Myrtos Pyrgos provided in Eiring 2000, 54.
78. Erickson 2002, 83.
79. Lebessi and Stefanakis 2004, 197; Chaniotis 2009, 62; Coutsinas 2013, 353–354; Lefèvre-Novaro 2014, 117–118; Drillat 2022, 10, 18. Contra Sjögren 2003, 66 fn. 321.
80. Cf. Sporn 2018, 132, who notes that "the bulk of the material [of HEL figurines from Syme Viannou] is of very fine and pale clay, common in all parts of Crete."
81. This includes finds from an older excavation by Giorgos Rethemiotakis (1986, 222. I thank Rethemiotakis for

The Fabric of Cult: Local and Imported Fabrics, and the Politics of Cult 457

Lyktos/Lyttos was considered as the source of a different fabric identified by Erickson, which he described as having "silver mica and a dark reddish-brown hue (Munsell 2.5YR 5/6 to 5YR 5/4)."[82] This fabric matches the fabric seen on 3rd century BCE pottery from Lyktos/Lyttos according to Erickson, citing the corroborating views of Peter Callaghan and Maria Englezou who studied HEL pottery from the site.[83] The descriptions of these scholars fit the characteristics of MFG A from Syme Viannou, and the relevant pieces discussed by Erickson have been assigned to this MFG. Erickson noted that the red micaceous fabric was introduced to Syme Viannou in the LCLAS period and was "completely without precedent" at the site.[84] He also argued that this fabric "totally replaces" the above-mentioned AR-MCLAS fabric,[85] adding that "the change is abrupt and complete."[86]

I believe Erickson rightly connected the fabric in question to Lyktos/Lyttos and I have argued in support of this in previous studies.[87] I also suspect that this fabric was probably not exclusive to Lyktos/Lyttos, but was used over much of the plain of Pediada, which, however, must have been largely controlled by this powerful city.[88] Vases made in red micaceous fabric (MFG A) reached Syme Viannou from the EIA to the ROM period, and – *contra* Erickson – they were not first introduced in LCLAS times (see above, especially Figure 3.4). Nevertheless, MFG A nearly monopolizes the LCLAS pottery from Syme Viannou.[89] This pattern recalls the copious deposition at the sanctuary of pottery from the Pediada in the MM IB period.[90]

The representation of MFGs A and C in the 6th to 4th centuries BCE is explored in Figure 3.5, which provides a higher resolution than Figure 3.4. This resolution is achieved through: a) the division of time into shorter periods, namely the AR (circa 120 years), the ECLAS-MCLAS (circa 80 years), and the LCLAS (circa 80 years); and b) the inclusion of vessels

allowing me to examine pottery from the PAR-AR burials he excavated) as well as finds from current fieldwork (Kotsonas, Chaniotis and Sythiakaki 2021; forthcoming).

82. Erickson 2002, 48.

83. Erickson 2002, 48 fn. 21, quoting Callaghan and Jones 1985, 14, and Maria Englezou (pers. comm.). For Englezou's study of the material from Lyktos/Lyttos see Englezou 2000 (with particular reference to fabric on page 66); 2005, 94–110.

84. Erickson 2002, 83.

85. Erickson 2002, 83.

86. Erickson 2002, 82.

87. Kotsonas 2011b, 141; 2012b, 162–165; 2013, 243–244; 2019c, 2–3 n. 1; Kotsonas et al. 2018, 64–66. Also, Ximeri 2021, 81–82. The fabric in question is not the only one seen on tableware from Lyktos/Lyttos, as noted very briefly, albeit explicitly, in Englezou 2000, 66. The two fabrics mentioned by Englezou probably correspond to those which are commonly attested on the PAR-AR pottery from the new fieldwork at the site (Kotsonas, Chaniotis and Sythiakaki 2021; forthcoming), even if the red micaceous fabric is clearly predominant during this period. A similar micaceous fabric identified at Knossos has been assigned to an off-island source, possibly in the Cyclades (Boileau and Whitley 2010, 233–234), but I remain unconvinced (see my publications cited above).

88. For the attestation of what is probably the same fabric on the northwest part for the Pediada, see Erickson 2017, 287–288: "The other fabric ranges from red (2.5YR 5–6/6 or 2.5YR 6/8, light red) to slightly brown (5YR 6/6, light red). This fabric generally has smaller inclusions than the brown/limestone ware, and these include quartz, silver mica, and silver mica schist. Also occasionally present are shiny black particles (biotite ?). A version of this red micaceous fabric has a much higher mica content (and smaller mica particles)." For the territorial extent of Lyktos/Lyttos, see Kotsonas 2019b, 434–435.

89. The only other MFG that is attested on LCLAS pottery from Syme Viannou is C2, which is, however, represented by only one piece (P696).

90. Christakis 2013, 170–171, 177.

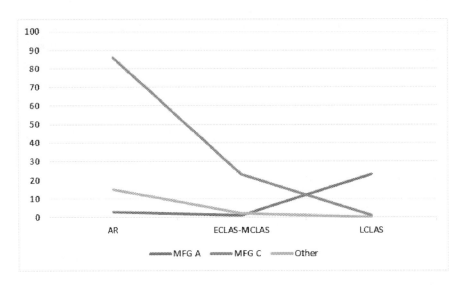

Figure 3.5: The representation of MFGs A and C, and of other MFGs and fabric groupings among the pottery assigned specifically to the AR, the ECLAS-MCLAS, and the LCLAS periods.

which can be dated specifically to one of the three phases in question.[91] The means that vessels which are dated more broadly (e.g., PAR-AR, CLAS, MCLAS/LCLAS) are excluded, and thus the material of the 6th to 4th centuries BCE is underrepresented. However, these methodological choices yield a crisper impression of the marked decrease in the quantity of pottery deposited at Syme Viannou during the CLAS period, and the marked shift in the representation of MFGs A and C in the LCLAS period. It is worth emphasizing, however, that in the HEL period MFG C returns with force, and the two MFGs in question are represented very similarly in the HEL and ROM periods (see Figure 3.4).

The last MFG which can be tentatively connected to a certain city is F, which dates from the HEL and ROM periods. This MFG is represented primarily by cups, including a considerable number of examples which are not published here because they are inscribed. Significantly, one of these cups is inscribed post-firing with a reference to Priansos.[92] A comparable fabric is attested on HEL material from a sanctuary at Myrtos Pyrgos which is also dedicated to Hermes and Aphrodite. This site is located over two hours southeast of Syme Viannou, roughly half way to Hierapytna.[93] Some of the pottery from Myrtos Pyrgos is reported to show a "soft, powdery, and very pale" fabric.[94] A characteristic example is an inscribed cup which is made in soft, fine, pale yellow (2.5Y 8/2 to 8/3) clay with very few small to medium-sized dark inclusions, and individual red and white inclusions.[95] Vogeikoff-

91. This excludes vessels dated more broadly, e.g., PAR-AR, LAR-ECLAS, or CLAS.
92. Lebessi 1985b, 17 fn. 4.
93. Kalomenopoulos 1894, 325 (Kalami to Myrtos).
94. Eiring 2000, 54 (fabric A of HEL Myrtos Pyrgos); cf. Cadogan and Chaniotis 2010, 298. Erickson (2002, 46–47) associated this fabric with his "Aphrati fabric." I find, however, that the fabric described by Eiring corresponds to MFG F from Syme Viannou, while Erickson's "Aphrati fabric" is identified with MFG C2 from Syme Viannou.
95. I thank Gerald Cadogan and Conor Trainor for allowing me to examine the four HEL inscribed cups from Myrtos Pyrgos. The description provided above derives from my own study of the cup published in Cadogan and

Brogan has argued that the "very pale" fabric which is found on pottery from Myrtos Pyrgos is also attested on Mochlos, naming this fabric the East Cretan Cream Ware.[96] Elsewhere, she has noted that it is a "yellow, soft, and silty fabric in several hues depending on the degree of firing. The most distinctive hue is a pale green (Munsell 2.5YR 8/2)."[97] Another publication by Vogeikoff-Brogan reports that "macroscopically, the fabric is soft and powdery, with its color varying from beige to light green (Munsell 10YR 8/2)."[98] More recently, Scott Gallimore has distinguished between a fine and a coarse fraction of the East Cretan Cream Ware, which are both very pale brown (10YR 8/4) to pale yellow (2.5Y 8/2), and contain varying quantities of white, black, and red inclusions.[99] Petrographic analysis conducted by Vogeikoff-Brogan and her collaborators has indicated that "the clay resources employed for the fabric originated near the Myrtos Valley, at the western edge of the Hierapetra Plain, not far from the city of ancient Hierapytna. For a type of ware like the ECCW [East Cretan Cream Ware] to have enjoyed such wide distribution, it must have been produced en masse by a large production center, one that should have been located at Hierapytna."[100] This has been largely confirmed by Gallimore's recent study of Hierapytna in the HEL and ROM periods, which has shown that the East Cretan Cream Ware "is by far the most common fabric type for Hellenistic vessels" in the 2nd and 1st centuries BCE.[101] The connection between Hierapytna and the sanctuary of Syme Viannou has not received much attention previously. The ancient city is argued to have controlled Biannos/Biennos (Viannos) for part of the HEL period,[102] but this argument has been dismissed and Hierapytna's westward expansion is considered to "not have continued too far past Myrtos,"[103] or to have extended up to the area that lies between Biannos/Biennos (Viannos) and Syme Viannou.[104]

Notwithstanding the possible or probable association of a few MFGs identified at Syme Viannou (A, C2 and F) with specific Cretan communities, most of the MFGs in question cannot be localized with any precision given the current state of the research. However, it is

Chaniotis 2010, 299 no. 4; cf. Eiring 2000, 54 pl. 27a1: fabric A. I find that the other three cups are made in Eiring's (2000, 54) fabric B, which is "hard fired, darker pinkish buff with some dark and white grits and voids in the surface." Note, however, that Cadogan and Chaniotis (2010, 298) ascribe cup no. 3 to Eiring's fabric A.

96. Vogeikoff 2000, 70–72; Vogeikoff-Brogan 2014, 28–29, 69–70. MFG E at Dreros (Kotsonas forthcoming) may include pieces from this ware.

97. Vogeikoff 2000, 70.

98. Vogeikoff-Brogan 2014, 29.

99. Gallimore (2015, 72) provides the following description "*ECCW Fine Fabric.* Soft, very pale brown (10YR 8/4) to pale yellow (2.5Y 8/2), with a granular break and smooth, powdery feel. Rare, fine to small, subrounded to angular, tabular, milky white inclusions; rare, fine to small, subrounded, tabular, black inclusions; a few pieces preserve rare, fine to small, subrounded, tabular, red inclusions. Red or black slip tends to be preserved. Provenance: Region of Hierapytna, East Crete. *ECCW Coarse Fabric.* Soft to medium hard, very pale brown (10YR 8/4) to pale yellow (2.5Y 8/2), with a granular break and smooth to rough, powdery feel. Few to frequent, small to medium, subrounded to angular, tabular, milky white inclusions; few to frequent, small to medium, subrounded, tabular, black inclusions; rare, small, subrounded to rounded, tabular to spherical, red inclusions. Black or red slip occasionally preserved. Provenance: Region of Hierapytna, East Crete."

100. Vogeikoff-Brogan 2014, 70. Cf. Vogeikoff-Brogan et al. 2004, 328–329, 331; 2008, 330.

101. Gallimore 2015, 72 (see also pages 71–90, 262–263).

102. van Effenterre and van Effenterre 1994, 114. Followed by Coutsinas 2013, 352–353.

103. Gallimore 2015, 25–26.

104. Guizzi 2001, 318–319.

reasonable to consider that the provenance of most – if not all – of these MFGs should be sought in the southeast part of central Crete (Heraklion prefecture) and the southwest part of east Crete (Lassithi prefecture). This impression draws indirect support from the attestation of only a handful of pots from Knossos and Gortyn (see above), which lie well beyond the area in question.[105] Direct support for the sub-regional provenance of the bulk of the pottery from Syme Viannou is provided by the HEL inscribed ceramics and other finds from the site, which mention visitors from different Cretan cities located southeast, southwest, west, and northwest of the sanctuary, including (clockwise) Hierapytna, Priansos, Arkades, Datala, Knossos, Lyktos/Lyttos.[106] Of these six cities, only Knossos is well beyond the sub-region surrounding Syme Viannou, as explained further below.

The inscribed city ethnics indicate the origins of the visitor or visitors who offered the pots to the sanctuary; however, they cannot settle the question of the provenance of the vessels themselves, since the inscriptions are rendered post-firing. It is possible that the pot and the person who inscribed and dedicated it came from the same place; alternatively, it is conceivable that a visitor to Syme Viannou acquired a pot along the way, or from a stall that was set up at the sanctuary and was supplied with products from one or more workshops which were located elsewhere on Crete, after which they inscribed it with their name and city ethnic. The first scenario finds support from a cup which is inscribed with a reference to an individual from Knossos and is made in a fabric that may well be Knossian, whereas the second scenario (or set of scenarios) finds support from a cup that mentions Priansos and is made in MFG F, which is identified with the East Cretan Cream Ware and is ascribed to Hierapytna. There is also the case of a coarse vessel which is a fabric loner and carries an inscription that refers to Hierapytna.

The question of provenance of ceramics found at Syme Viannou and of the connection of the site with different Cretan communities can be further explored by a study of the potential itineraries which connected these communities to the sanctuary. The topic has been investigated by Vyron Antoniadis and myself in a study which integrates historical documentation and computational prediction – specifically Least Cost Path (LCP) analysis – to calculate the length and duration of ancient travels to and from Syme Viannou.[107] Historical documentation on travels made by foot before the advent of major mechanized transport and road-building projects is provided especially by the archaeologist John Pendlebury who traveled extensively around Crete in the interwar period,[108] and also by the Greek military officer of the late 19th

105. The Greek and Roman ceramic sequences of these two sites are exceptionally well studied, which facilitates the identification of their products.

106. Lebessi 1972, 202 (Lyktos/Lyttos, Arkades, Knossos); 1973a, 191 (Datala), 197 (Arkades); 1981b, 4–5 (Datala, Lyktos/Lyttos, Arkades, Knossos); 1985b, 17 fn. 4 (Priansos, Hierapytna), 146 (Arkades); 2009, 532–533; 2021, 189 (Knossos, Hierapytna). Tylissos is also mentioned in a few publications (Lebessi 1976b, 13; Schürmann 1996, 193 fig. 2), but Charalambos Kritzas kindly informed me that there is no inscription referring to this city. On the location and the history of these cities see Perlman 2005, 1152, 1155–1157, 1165–1166, 1169–1170, 1175–1177, 1188–1189. For some of the personal names known from the inscriptions from Syme Viannou see Chaniotis 1988, 33 fn. 56.

107. Antoniadis and Kotsonas forthcoming.

108. Pendlebury 1939, 7–15, 20–23. Pendlebury recorded his travel times across Crete extensively, as shown by unpublished writings of his which are kept in the Archive of the British School at Athens. PEN_02.05.001.015 is the only document which is closely relevant to the present study.

The Fabric of Cult: Local and Imported Fabrics, and the Politics of Cult 461

Figure 3.6: Map showing LCPs – calculated by three different functions – leading to the sanctuary of Syme Viannou from different Cretan poleis associated with it on epigraphic, numismatic and other grounds, by Vyron Antoniadis. Sources: European Space Agency, Sinergise (2021). Copernicus Global Digital Elevation Model. Distributed by OpenTopography. https://doi.org/10.5069/G9028PQB. Accessed: 2022-08-27; © OpenStreetMap contributors; Basemap data Source: Legal Entity of Public Law Hellenic Cadastre, Operational Programme Competitiveness, Entrepreneurship and Innovation 2014-2020 (EPAnEK).

and early 20th century Nikostratos Kalomenopoulos.[109] These individuals documented travels made by foot over much of Crete, including travels across the area of Syme Viannou (though not to the site itself, which was discovered in 1972).[110]

Computational prediction – specifically LCP analysis – integrates Digital Elevation Models, which contain elevation data from satellite-based measurement of the earth's current morphology, with formulas (rules of thumb) for estimating the duration of travel on foot, which were initially developed for hikers in the late 19th and early 20th century, and were implemented in the last decades as slope-dependent functions in GIS software-algorithms and in programming languages.[111] The most popular of these functions for calculating travel time

109. Kalomenopoulos 1894, especially 323–325, 342–343.

110. Kalomenopoulos and Pendlebury (see the previous two fns) describe itineraries which cross the modern village of Kalami, which lies only 10 km south of the sanctuary (though at a considerably lower elevation). Prent (2005, 567; based on Lebessi 1992b, 268) estimates that the walking distance from Syme Viannou to Kalami is over an hour.

111. Terrain steepness is one of the major factors affecting the crossing of the landscape by travelers.

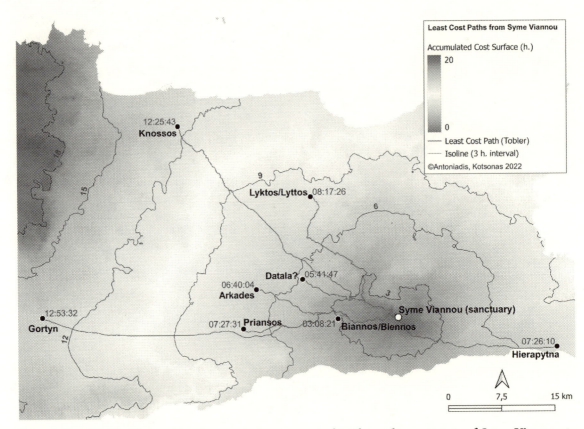

Figure 3.7: Map showing LCPs and accumulated cost surface from the sanctuary of Syme Viannou to different Cretan poleis associated with it on epigraphic, numismatic and other grounds. The figures are calculated by Vyron Antoniadis and Antonis Kotsonas on the basis of Tobler's function. Sources: European Space Agency, Sinergise (2021). Copernicus Global Digital Elevation Model. Distributed by OpenTopography. https://doi.org/10.5069/G9028PQB. Accessed: 2022-08-27; © OpenStreetMap contributors.

in antiquity are those by Waldo Tobler and Erick Langmuir,[112] while Joaquín Márquez-Pérez, Ismael Vallejo-Villalta and José Álvarez-Francoso have produced a modified version of Tobler's function.[113] Estimates for travel times deduced from LCPs and historical documentation, which rely on the experience of hikers and military personnel, may not be entirely representative of actual travel times of the diverse groups of ancient people, from mature male magistrates to young maidens, who visited the sanctuary of Syme Viannou.[114] However, the experience of modern hikers and military personnel need not have been very different from that of a large part of the ancient population, particularly given the routine engagement of this population with hiking.

Antoniadis and I use this integrated approach to travels to/from Syme Viannou from/ to the six cities which are known epigraphically to have been homes of visitors to the sanctuary

112. Langmuir 1984; Tobler 1993; Márquez-Pérez et al. 2017.
113. Márquez-Pérez et al. 2017. See also Seifried and Gardner 2019, 403–404. For a detailed discussion of these formulas, see Antoniadis and Kotsonas forthcoming.
114. Lebessi 2009, 532–533.

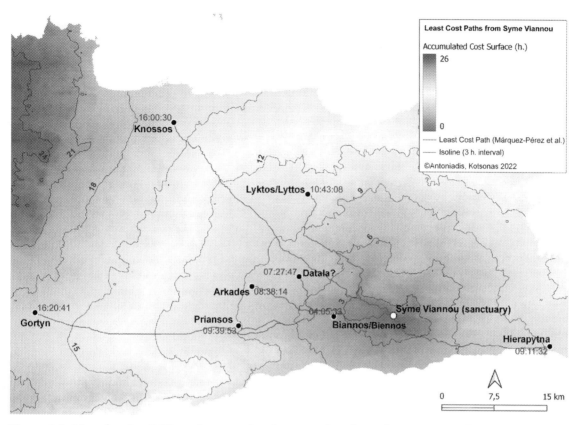

Figure 3.8: Map showing LCPs and accumulated cost surface from the sanctuary of Syme Viannou to different Cretan poleis associated with it on epigraphic, numismatic and other grounds. The figures are calculated by Vyron Antoniadis and Antonis Kotsonas on the basis of the function created by Márquez-Pérez et al. Sources: European Space Agency, Sinergise (2021). Copernicus Global Digital Elevation Model. Distributed by OpenTopography. https://doi.org/10.5069/G9028PQB. Accessed: 2022-08-27; © OpenStreetMap contributors.

(through the attestation of city ethnics). This includes (clockwise) Hierapytna, Priansos, Arkades, Datala, Knossos, and Lyktos/Lyttos. In addition to these six cities, the maps we produced include Gortyn and Biannos/Biennos (Viannos). A few pottery vessels from Gortyn have been identified at Syme Viannou (see above), and this city is among the very few Cretan cities which are represented in the admittedly thin and largely HEL to EROM numismatic record from Syme Viannou.[115] The other three Cretan cities which are represented by coins (Hierapytna, Knossos, Lyktos/Lyttos) are among those which are known epigraphically to have been connected to Syme Viannou. There is no epigraphic, numismatic or other direct evidence which connects Biannos/Biennos (Viannos) to the sanctuary, but this site was located very near Syme Viannou and has yielded PAR to ROM surface material.[116] It is uncertain if Biannos/Biennos (Viannos) was independent before the HEL period,[117] but Didier Viviers has

115. Lebessi and Stefanakis 2004, 188–190 nos 1–4 and 9–16, 194, 196–199.

116. On Biannos/Biennos (Viannos), see Hood, Warren and Cadogan 1964, 83; Kitchell 1977, 337–359; Sjögren 2003, 159; Perlman 2005, 1154.

117. Perlman 2005, 1154; Coutsinas 2013, 353.

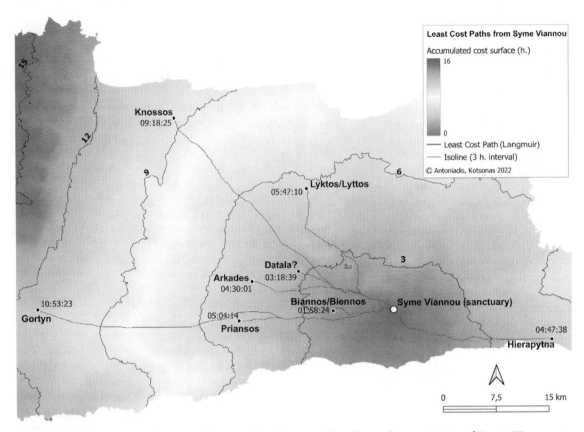

Figure 3.9: Map showing LCPs and accumulated cost surface from the sanctuary of Syme Viannou to different Cretan poleis associated with it on epigraphic, numismatic and other grounds. The figures are calculated by Vyron Antoniadis and Antonis Kotsonas on the basis of the function created by Langmuir. In this formula, time is in seconds, which we converted into hours. Sources: European Space Agency, Sinergise (2021). Copernicus Global Digital Elevation Model. Distributed by OpenTopography. https://doi.org/10.5069/G9028PQB. Accessed: 2022-08-27; © OpenStreetMap contributors.

hypothesized that it controlled the sanctuary in the 8th to 6th centuries BCE.[118] In any case, people from this community are likely to have visited Syme Viannou.

The LCPs which could have been taken by people traveling from the above-mentioned cities to the sanctuary of Syme Viannou are illustrated on Figure 3.6.[119] On the contrary, the maps of Figures 3.7 to 3.9 show the accumulated surface and LCPs for travelers leaving the sanctuary to return to their communities.[120] This figure shows that travelers from the Pediada

118. Viviers 1994, 256; Kitchell (1977, 348–349 fn. 133) was uncertain on this.

119. The prevailing hypothesis is that Arkades was located in the area of modern Ini (Perlman 2005, 1152), and that Priansos was located in the area of Kastelliana (Perlman 2005, 1185). For the uncertain identification of Datala with Aphrati, see Perlman 2005, 1152.

120. The map of Figure 3.6 integrates 24 different accumulated cost surfaces for computing all 24 LCPs (i.e., the travel time from each of the eight Cretan cities to the sanctuary at Syme Viannou, as calculated by all three different functions mentioned above). On the contrary, only a single accumulated cost surface is used in the maps of Figures 3.7 to 3.9 (which record travel time from the sanctuary to the eight different cities according to each function).

and north central Crete most likely approached Syme Viannou from the northwest, though the valley of Emparos,[121] but the Lyktians/Lyttians had the option of a shorter, highland route, along the western edge of the Lassithi Mountains. Travelers from the Mesara are likely to have approached the sanctuary from the west via Biannos/Biennos (Viannos),[122] while the Hierapytnians are likely to have reached Syme Viannou from the southeast. The formulas – except the one by Langmuir – suggest that the main modern route to the site, which is from the south, i.e., from the village of Kato Syme, was probably not favored in antiquity. The reverse LCPs, from Syme Viannou to all aforementioned cities, largely follow the same routes.

It is reasonable to think that the practical advantages of the LCPs shown in Figures 3.6 to 3.9 were appreciated in antiquity, but we should also accommodate the possibility that the preferred access routes to a cult site like Syme Viannou were determined by other considerations as well, which can range from the availability of rest-stops and way-stations, to notable features in a broader cultic landscape. For example, travelers from Hierapytna to Syme Viannou may have taken a small detour to visit the HEL sanctuary at Myrtos Pyrgos, which is located roughly halfway between the two sites and was dedicated to Hermes and Aphrodite, similarly to the sanctuary of Syme Viannou. Alternatively, Myrtos Pyrgos could have served the disembarkation of travelers arriving by boat, either from Hierapytna or from Gortyn (via the harbor of Lebena).[123] Any visitors traveling by boat could also have landed on other parts of the south coast of Crete that lie closer to the sanctuary. Nevertheless, any estimate of LCPs to Syme Viannou which involve a sea journey remains very difficult. The same problem applies to the possibility that travelers used carts and wagons for indeterminate parts of the journey to the sanctuary across lowland areas.

Having laid out the different routes possibly taken by people from the above-mentioned Cretan cities when visiting the sanctuary, it is worth estimating the duration of traveling along them, and comparing these estimates against relevant evidence deduced from historical documentation. This comparison is facilitated by Tables 3.1 and 3.2 which provide data that pertains to both the historical routes and the LCPs marked in Figures 3.6 to 3.9.[124] The tables suggest that the distance and the travel time between the sanctuary and the different cities mentioned above varies greatly. Located two and a half to three hours west of Syme Viannou, the small city of Biannos/Biennos was clearly the closest to the sanctuary. Travelers from Datala (if Datala is to be placed at Aphrati) took four and a half hours to reach the site through the Emparos valley.[125] It took six to six and a half hours for people from Arkades to reach the sanctuary through the same pass, and a similar duration is estimated for the travels of people from Priansos who

121. On this pass, see Lebessi 1984, 463; Zarifis 2007, 47.
122. Cf. Drillat 2022, 9–10 fig. 8.
123. The maritime route to Syme Viannou from Gortyn via the port of Lebena is not particularly advantageous since walking from the former to the latter site is four and a half hours (Pendlebury 1939, 20) or more.
124. These tables raise a number of methodological issues, which receive detailed treatment in Antoniadis and Kotsonas forthcoming.
125. Lebessi (1984, 463) has noted that the distance between Aphrati and Syme Viannou is easily covered in four to five hours.

Table 3.1: Travel times – estimates for the LCPs, in addition to historical documentation – for the routes which extend to the sanctuary of Syme Viannou from the different Cretan poleis associated with it on epigraphic, numismatic and other grounds, by Vyron Antoniadis and Antonis Kotsonas.

Travel times to Syme Viannou (sanctuary) from:	Estimates based on predictive models and the functions proposed by different scholars			Estimates based on accounts by travelers of the late 19th – early 20th century	
	Tobler	Márquez-Pérez et al.	Langmuir	Kalomenopoulos	Pendlebury
Knossos	13:30:35	17:14:43	11:21:23	10:05:00	N/A
Lyktos/Lyttos	08:43:14	11:12:47	06:46:10	07:30:00	N/A
Datala	06:10:31	07:57:13	04:36:12	04.30:00	N/A
Arkades	07:29:01	09:33:11	06:20:23	N/A	N/A
Priansos	08:13:34	10:31:42	06:38:36	06:10:00	06:40:00
Gortyn	13:46:24	17:19:41	12:55:58	13:10:00	12:15:00
Hierapytna	08:18:23	10:37:58	07:16:52	N/A	N/A
Biannos/Biennos	03:33:30	04:33:37	02:59:12	02:20:00	N/A

Table 3.2: Travel times – estimates for the LCPs, in addition to historical documentation – for the routes which extend from the sanctuary of Syme Viannou to the different Cretan poleis associated with it on epigraphic, numismatic and other grounds, by Vyron Antoniadis and Antonis Kotsonas.

Travel times from Syme Viannou (sanctuary) to:	Estimates based on predictive models and the functions proposed by different scholars			Estimates based on accounts by travelers of the late 19th – early 20th century	
	Tobler	Márquez-Pérez et al.	Langmuir	Kalomenopoulos	Pendlebury
Knossos	12:25:43	16:00:30	09:18:25	N/A	N/A
Lyktos/Lyttos	08:17:26	10:43:08	05:47:10	N/A	N/A
Datala	05:41:47	07:27:47	03:18:39	N/A	N/A
Arkades	06:40:04	08:38:14	04:30:01	N/A	N/A
Priansos	07:27:31	09:39:53	05:04:14	N/A	N/A
Gortyn	12:53:32	16:20:10	10:53:23	N/A	N/A
Hierapytna	07:26:10	09:11:32	04:47:38	05:00:00	07:00:00
Biannos/Biennos	03:08:21	04:05:33	01:58:24	N/A	N/A

reached Syme Viannou through a different route which crossed the area of Biannos/Biennos. Travel times from the more powerful cities of Lyktos/Lyttos and Hierapytna were approximately seven hours, while well over ten hours were needed for travelers from Knossos and Gortyn – the island's most prominent powerhouses for most of the Greek and Roman period. For the longer itineraries, additional time was probably involved, as real-world travel for long distances typically requires extra time for rest-stops and even overnight stays. The return trip of the travelers (i.e., from the sanctuary to their cities) was much shorter – roughly by one to two hours – largely because of the steep-sloping terrain in the area around Syme Viannou. These different estimates for the duration and length of the routes to/from Syme Viannou are suggestive of the time and energy which ancient people invested in traveling to the sanctuary, and indicate the significance of this travel for the broader cultic experience of the travelers. Clearly, traveling to and from the sanctuary from all cities mentioned above, except for Biannos/Biennos, would have involved at least one overnight stay. Those spending the night at the sanctuary itself could have set up tents in the plateau which lies east of the core part of the site and remains unexplored archeologically. This plateau covers an area of 3200 m² and could accommodate ca. 400 persons.[126]

The epigraphic and ceramic evidence from Syme Viannou, which sheds light on the connection of the site to different communities, has also been involved in broader discussions concerning the interregional role of the sanctuary. This issue is revisited below in light of a broader range of evidence, but especially of the MFGs identified in the present study.

Lebessi and her collaborators have argued that the sanctuary of Syme Viannou assumed a regional role from the EIA to the HEL period: "In the first millennium the votive objects ... give no hint that Syme was dependent on a particular Cretan city-state;"[127] the site "had only loose and periodic connections with secular authority."[128] Indirect support for this idea has been deduced from finds of the EIA and the AR period: "In the first half of the first millennium the thematic, iconographic and stylistic analysis of the main categories of votives indicates that cult activity comprised maturation rituals with participants from the upper social strata of many Cretan cities and communities."[129]

Prent has questioned the idea that Syme Viannou was independent throughout the EIA.[130] She has pointed out that the construction of the second phase of the Altar and of Terraces I and II during the late 8th and the early 7th century BCE (developments which have since been slightly downdated) could be connected to "a take-over or an intensification of control, quite likely by one of the neighboring communities."[131] Prent associated this development with the introduction of a new type of offering, namely bronze cut-out plaques which "are highly distinctive for the sanctuary and were first dedicated in the early 7th century BCE, i.e., the period in which building activities began, or shortly afterwards."[132] Within this

126. Zarifis 2007, 307–308 (see also pages 182, 218–219, 247, 304, 312).
127. Lebessi, Muhly and Olivier 1995, 76.
128. Lebessi, Muhly and Olivier 1995, 76–77.
129. Lebessi, Muhly and Olivier 1995, 77, with reference to Lebessi 1985b, 188–198. The same notion is identifiable in Schürmann 1996, 192–194; Lebessi 2002b, 192; Muhly 2008, 119–120, 140.
130. Prent 2005, 574–576.
131. Prent 2005, 574.
132. Prent 2005, 575.

approach, the technical and stylistic homogeneity of these plaques is indicative of the output of a single workshop.¹³³ Prent also observed that the mouldmade female terracottas which were deposited at Syme Viannou during the 7th century BCE are "more typically at home in the suburban sanctuaries belonging to individual poleis, where they represent a certain standardization of votive behavior."¹³⁴ She therefore concluded that some of the changes circa 700 BCE can be interpreted in two different ways: "One possibility is that they represent a sudden appropriation of the sanctuary by an individual community after a period of shared use and 'loose control.' Alternatively, the changes may reflect a mere formalization of a long-existing and stable relationship with one and the same community, perhaps in an attempt to protect local interests in the wake of Syme's growing interregional appeal."¹³⁵ Prent concluded that the first of these possibilities is more likely. This conclusion is not far from the hypotheses of Viviers and Erickson that either Biannos/Biennos or Afrati controlled the sanctuary around this time.¹³⁶

Prent's idea that the political status of the sanctuary was not static throughout the EIA is not unreasonable, and the notable changes she identifies circa 700 BCE can be extended to the pottery. As I explain in Chapter 4, this period saw a notable increase in the deposition of ceramics at the site, including scores of domed lids/shields which were rare in earlier decades. Nevertheless, Prent's idea was recently challenged by Papasavvas, who offered alternative interpretations to the developments she highlighted.¹³⁷ Papasavvas offered economic or technological – rather than political – explanations for the developments in question and observed that the scale of investment of energy and resources, which is represented by the construction of the Terraces at Syme Viannou, indicates that people from different communities were involved at the cult. This notion finds support in the broad range of MFGs identified on the pottery of Syme Viannou after circa 700 BCE, which cannot be easily reconciled with the hypothesis of a single Cretan community assuming control of the sanctuary at the time. The range of MFGs represented at Syme Viannou was considerably broad already in the PG period (MFGs A, B, C, D, E) but increased by the introduction of two new MFGs in the PAR period (I and J). Although these two new MFGs are represented too thinly at the time to be indicative of any political development, they are suggestive of the growing connections of the sanctuary with different communities.

The broad range of Cretan fabrics seen on EIA pottery from Syme Viannou is not matched by any published Cretan EIA sanctuary, where local – as opposed to regional – wares seem to make up the vast majority of the assemblage. This applies both to urban and suburban sanctuaries, such as the sanctuary of Demeter at Knossos and the sanctuaries on the acropolis and Armi hills at Gortyn, but also to the extra-urban sanctuary of Kommos (see above). However, this impression is partly shaped by the poor state of the research on the topic. The potential role of research biases is indicated by the recent identification of as many as five

133. Prent 2005, 574–575. *Contra* Chaniotis 2006, 202; 2009, 62.
134. Prent 2005, 575.
135. Prent 2005, 575.
136. Viviers 1994, 256; Erickson 2002, especially 79–81.
137. Papasavvas 2019, 245, 249.

MFGs on the EIA pottery from the sanctuary on the west acropolis of Dreros, which served primarily the local community.[138] In any case, the notable MFG variation which is seen on EIA pottery from Syme Viannou is comparable to the variation seen on the fabrics of EIA solid animal figurines from the site.[139] Taken together, the fabrics of the different ceramic artifact classes from the site do not support the idea of any special connection between the sanctuary and a single Cretan community at any part of the EIA.

The relationship of the sanctuary of Syme Viannou with specific Cretan communities in the AR to LCLAS periods has been discussed by Erickson. As mentioned above, the scholar has argued – based on the macroscopic identification of two pottery fabrics – that during the 6th and 5th centuries BCE the sanctuary served Aphrati, but from the 4th century BCE Lyktos/Lyttos took over Aphrati and seized control of the sanctuary.[140] This line of argument led Erickson to the broader conclusion that the AR-CLAS pottery from Syme Viannou "indicates a small rural sanctuary under the political control of the principal nearby polis."[141]

Erickson's ideas have proven popular.[142] However, the argument that the sanctuary had an exclusive relationship with any specific community during the AR and CLAS periods does not find much support in the present study of the MFGs of the pottery from Syme Viannou. I have shown that the two fabrics discussed by Erickson do not appear in distinct phases but rather throughout the EIA-ROM period, while they also co-exist with several other fabrics, which are, admittedly, less common to far less common. Indeed, the range of MFGs identified on PAR pottery from the sanctuary persisted to the CLAS period (but group D did not outlast it). Notwithstanding the range of MFGs identified on AR-MCLAS pottery from Syme Viannou, the near monopoly of MFG A on LCLAS material from the site could be taken to support Erickson's idea for a closer relationship between Syme Viannou and Lyktos/Lyttos. Nevertheless, this assumption is undermined by the thin attestation of this MFG during the 2nd century BCE, when magistrates from Lyktos/Lyttos were probably involved at the sanctuary, as deduced from epigraphic evidence.[143] Likewise, the fabric Erickson associated with Aphrati (which matches my MFG C2) cannot be taken to present any exclusive association with this site. This is because the fabric is not particularly diagnostic and is perhaps also attested at other sites.

In the HEL period the sanctuary of Syme Viannou had an interregional role, as proposed by Lebessi on the basis of the graffiti mentioned above.[144] The idea has received considerable support,[145] and Angelos Chaniotis has further raised the possibility that the sanctuary was the

138. Kotsonas forthcoming. For comparative purposes, I note that only two local MFGs were identified on the PG-PAR pottery from the EIA cemetery of Eleutherna (Kotsonas 2005, 65–67; 2008, 54–55), but as many as nine MFGs were identified on Knossian pottery of the same period (Kotsonas et al. 2018, 64; Kotsonas 2019c).
139. Nodarou and Rathossi 2008. Cf. Muhly 2008, 118–120. Four of the twenty terracottas sampled date to the 7th century BCE and represent three different petrographic fabric groups, namely 1 (no. 270), 3 (nos 149 and 243), and 5 (no. 177); see Nodarou and Rathossi 2008, 155–167.
140. Erickson 2002, 46–48, 79–85. On the capture of Aphrati, see also Kotsonas 2002, 58–61.
141. Erickson 2002, 81.
142. Lebessi and Stefanakis 2004, 197; Chaniotis 2009, 62; Lefèvre-Novaro 2014, 117–118.
143. *SEG* 50 937; Kritzas 2000, 88–96; Chaniotis 2009, 62. See also below.
144. Lebessi 1981b, 4; Lebessi, Muhly and Olivier 1995, 76.
145. Erickson 2002, 82 fn. 114.

focus of an amphictyony of different cities located in the wider area; it was also situated on land of its own, hence the name Sacred Mountain (*Hieron Oros*) which Ptolemy (*Geography* 3.17.4) may have applied to this part of Crete.[146] In arguing so, Chaniotis does not exclude the possibly that a single city administered the sanctuary, which would have included electing the priest, organizing the sacrifice and the festival, maintaining the buildings, and protecting the dedications. Yet, Chaniotis's ideas have attracted skepticism.[147] The discussion is complicated by the publication of an inscription of the second century BCE which reports that the magistrates (*kosmoi*) of a certain tribe (Lasinthioi) were responsible for some building activity at the sanctuary; since this tribe is only attested at Lyktos/Lyttos, the magistrates are identified as citizens of this city.[148] On this basis, Kritzas hypothesized that Lyktos/Lyttos controlled the sanctuary in the LHEL and ROM periods.[149] Chaniotis has elaborated upon this interpretation; as he noted, "in ancient Greece the ethnic name is used in inscriptions which refer to persons who are outside the territory of their city. The fact that the Lyttian magistrates did not find it necessary to mention their ethnic name indicates (but does not necessarily prove) that at this point the sanctuary was under the control of Lyttos – or that Lyttos had a claim to the sanctuary."[150] However, Chaniotis also added that "the control or the claim may well be a temporary development ... even if in the late Hellenistic period the sanctuary was part of the territory of Lyttos, this does not mean that that had always been the case."[151] An alternative, weak hypothesis, has the smaller city of Biannos/Biennos (Viannos) – which lies very close to Syme Viannou – control the sanctuary at the time;[152] it is uncertain, however, if this city was independent (or if it was controlled by Lyktos/Lyttos).[153]

Ceramic fabrics cannot settle this discourse, but the notable peak in the variety of MFGs seen on HEL pottery from Syme Viannou indicates that the sanctuary had considerable appeal to people from different communities at the time. Indeed, two new MFGs are introduced (G and H), and this brings the total of MFGs represented in this period to nine (A, B, C, E, F, G, H, I, J), which surpasses the number of city ethnics inscribed on HEL finds from the sanctuary. This observation does not entail that the different MFGs can be identified with individual cities, but takes the notable increase of these groups as a proxy for the notable increase in the interregional appeal of the site. The MFGs identified from the HEL pottery from Syme Viannou do not support any exclusive association of the site with Lyktos/Lyttos, as deduced from the above-mentioned inscription. Indeed, MFG A, which is associated with Lyktos/Lyttos, is only thinly represented at the sanctuary at the time. Conversely, a different community, probably Hierapytna, was perhaps increasingly connected to Syme Viannou in the course of the HEL period, as indicated by MFG F.

146. Chaniotis 1988, 33–34; 1996, 128–130; 2001, 324–325; 2006, 202; 2009, 61.
147. Lebessi 2009, 522; 2021, 189. Also, Sporn 2002, 88–89; Prent 2005, 573.
148. *SEG* 50 937; Kritzas 2000, 88–96; Chaniotis 2009, 62.
149. Kritzas 2000, 95–96.
150. Chaniotis 2009, 62.
151. Chaniotis 2009, 62; cf. 2006, 202.
152. Kitchell 1977, 348–349 fn. 133.
153. Viviers 1994, 256; Perlman 2005, 1154; Coutsinas 2013, 353.

The political affiliation of Syme Viannou from the transition to ROM period onward has received little attention. Manolis Stefanakis has argued on numismatic evidence that the sanctuary was controlled by Knossos, as head of the Cretan *koinon*, in the third quarter of the first century BCE – specifically in the 30s BCE.[154] The limited number and varied date of the Knossian ceramic imports identified at Syme Viannou neither support nor contest this idea. Notwithstanding the possibility of a short-lived association of the sanctuary with Knossos, Chaniotis considers that the Roman conquest of Crete initiated the decline of the interregional role of the site because it interrupted the maturation rituals held there.[155] Lebessi once hypothesized that these rituals may have persisted into the ROM period, during which, however, they lost their civic/communal role and were run privately by select families;[156] however, more recently, she has also entertained the possibility that these rituals were interrupted by the Roman conquest.[157] The study of the MFGs also indicates notable changes at the site in ROM times: nearly half of the MFGs represented in the HEL period did not outlast it (which goes hand in hand with the reduction in the number of vases found at the site); MFGs B, E, G, and I disappeared, and only A, C, F, H, and J persisted. This is the narrower MFG range seen at Syme Viannou since the PG-G period. It is perhaps indicative that MFG C (specifically C2) – which was by far the commonest MFG at the site through the EIA-HEL period – nearly vanished. In the MROM-LROM periods, the range of MFGs shrank further and only H is amply represented. This development represents a climax in the trajectory of decline which characterized the last centuries of the site.

3.5. Foreign Fabrics and Overseas Connections at Syme Viannou and Other Cretan Sanctuaries

The sanctuary of Syme Viannou commands a view of the south coast of Crete and the Libyan Sea.[158] A rugged mountain path connects the site to the nearest section of the coast. This section, however, presents a straight coastline and provides no safe anchorage.[159] An alternative gateway is presented by a 7th century BCE and later coastal site located further west, at Keratokampos Kastri.[160] Nevertheless, overseas imports found at the sanctuary need not have arrived there via neighboring coastal sites; they could have reached any Cretan coast and be transported to Syme Viannou overland.

154. Lebessi and Stefanakis 2004, 199, 200.
155. Chaniotis 2009, 65.
156. Lebessi 1985b, 197; Lebessi and Stefanakis 2004, 186–187.
157. Lebessi 2021, 191, 202.
158. On the viewsheds see Lebessi 2021, pl. D.
159. Lefèvre-Novaro 2014, 125.
160. Sjögren 2003, 86, 160.

The published material from the sanctuary of Syme Viannou includes an unimpressive number of imports from overseas. Indeed, Lebessi and Muhly observed that "neither in the second nor in the first millennium does this wealth of material include many imports."[161] Most of the imports known to date come from elsewhere in the Mediterranean rather than the Aegean. The prehistoric imports are limited to a stone vessel which comes from Egypt and dates from the early 3rd millennium BCE and a Cypriot (?) bronze ingot of the mid-2nd millennium BCE.[162] More numerous are the EIA imports from the Eastern Mediterranean, which are mostly bronzes. These include: an Egyptian bronze jug with lotus handle dated to the 10th to 8th centuries BCE;[163] a bronze sistrum which is Egyptianizing but was probably produced in the Levant and dates from the 9th to the 7th or 6th century BCE;[164] a North Syrian bronze harness of the 9th to 7th century BCE (?);[165] two Cypriot bronze rod tripod of the 10th to 8th centuries BCE;[166] and a faience scarab from a Phoenician or a Phoenicianizing Greek workshop of 750-600 BCE.[167] Other classes of material from Syme Viannou which suggest indirect, albeit notable connections with the Eastern Mediterranean (specifically Egypt) during the 1st millennium BCE include a series of bronze cut-out plaques of the 7th century BCE which seem to follow Egyptian iconographic prototypes probably transmitted by the export of Egyptian illustrated papyri to Crete;[168] and five HEL spearheads carrying an incised BE, which is taken to refer to the Ptolemaic queen Berenice II.[169] Lastly, there are several EBYZ lamps of North African type which may be imports from Tunisia or Cretan imitations.[170] There is no reason to assume that the imported objects were brought to Syme Viannou by people originating from elsewhere in the Mediterranean since the sanctuary is removed from the coast, while neither this site nor any other Cretan sanctuary assumed the major interregional, political, and economic role of centers like Olympia or Delphi.[171]

The list of previously identified Aegean imports to Syme Viannou is much shorter and is basically limited to two Corinthian aryballoi of the early 6th century BCE published by

161. Lebessi and Muhly 2003, 96. The reference to "virtually no foreign imports" (in Muhly and Muhly 2018, 546) is exaggerated. Some of the imports mentioned in this paragraph are also discussed in Lebessi 2000b; Lefèvre-Novaro 2014, 125.

162. Stone vessel: Karetsou, Andreadaki-Vlazaki and Papadakis 2000, 47 no. 67; Lebessi 2000b, 175; Lebessi and Muhly 2003, 96. Ingot: Karageorghis et al. 2014, 286 no. 5.

163. Matthäus 2011, 114.

164. Lambropoulou 1999; Karetsou, Andreadaki-Vlazaki and Papadakis 2000, 363–364 no. 398; Lebessi 2000b, 176; Lebessi and Muhly 2003, 96–97.

165. Lebessi 1992a, 218.

166. Karageorghis et al. 2014, 284 nos 1–2; also, Papasavvas 2001, 247 no. 38, 249 no. 47. Syme Viannou has also produced EIA bronze stands of Cypriot style but of Cretan manufacture (Papasavvas 2001, 254–255 nos 54 and 56; Karageorghis et al. 2014, 285 nos 3–4).

167. Karetsou, Andreadaki-Vlazaki and Papadakis 2000, 331–332 no. 351; Lebessi 2000b, 176–177; Lebessi and Muhly 2003, 97–98.

168. Lebessi 2000b, 178–182; Lebessi and Muhly 2003, 98–100; Karetsou, Andreadaki-Vlazaki and Papadakis 2000, 365–369 nos 400–408. Followed by Jones D. W. 2000, 115.

169. Karetsou, Andreadaki-Vlazaki and Papadakis 2000, 370 no. 409; Lebessi 2000b, 182.

170. Vogeikoff-Brogan 2020, 128 nos 137–145 (6th, 7th and perhaps 8th centuries CE).

171. Lebessi 2000b, 176, 182. Kommos probably developed into a hub for Greek traders during the 7th century BCE, see especially Johnston 1993; Callaghan and Johnston 2000; Csapo, Johnston and Geagan 2000; de Domingo and Johnston 2003. Kommos was frequented by the Phoenicians in the 10th and 9th centuries BCE; see above and also Jones R. E. 2000; Bikai 2000; Gilboa, Waiman-Barak and Jones 2015.

Erickson,[172] a number of HEL terracottas from Smyrna and East Greece identified by Sporn,[173] and a few ROM lamps of uncertain provenance studied by Vogeikoff-Brogan.[174] Other classes of material from the sanctuary, especially clay and bronze figurines and bronze cut-out plaques of the EIA, show stylistic correspondences with material from the central and the southern Greek Mainland, but they do not include any actual imports.[175]

The paucity of previously published imported material at Syme Viannou has been deemed particularly important in arguments on the character of cult practice at the site. Reflecting on this, Lebessi and Muhly noted: "Syme's remote and mountainous location cannot serve as an adequate explanation for this phenomenon. It is much more likely that the explanation for the scarcity of foreign objects is to be found in the rituals practiced at the site, which, however, they may have evolved during the sanctuary's long existence, must have always referred to the Cretan society and its concerns."[176] In a similar vein, Erickson noted that "the extreme paucity of imports" among the AR-CLAS pottery from Syme Viannou is suggestive of "the local character of the sanctuary."[177] These arguments are revisited below on the basis of the number and range of a) pottery imports identified in the present study, and b) pottery imports at other Cretan sanctuaries of the Greek and Roman period.

My study identified no more than nine imported vessels of the period in question at Syme Viannou. This figure is very low in absolute terms but almost quintuples the total of imported pottery vessels previously known from Syme Viannou and considerably increases the total of Aegean imports identified at the site. All the imported vessels come from elsewhere in the Aegean (probably the southern Greek mainland) and show strong patterning with respect to provenance, chronology, and shape range. Nearly all these vessels are either Corinthian or Attic pieces and date to the AR and CLAS periods, even if the Corinthian pieces are earlier in date than the Attic ones. Furthermore, the earlier imports, of the (PAR)-AR period are limited to closed vessels, including aryballoi P182, P517, and P656, and the transport amphora P169. However, the LAR to HEL imports are small open vessels (P314, P459, P518) (there are no certain ROM imports). None of the foreign shapes and types represented shows any special connection to ritual.

The Aegean provenance of all the pottery imports (excluding lamps) identified at the site contrasts with the provenance of a number of bronzes and other non-ceramic finds from the Eastern Mediterranean. Cypriot and Phoenician pottery is amply represented in EIA Crete, but nearly all relevant finds come from burials.[178] The sole exception is the sanctuary of Kommos which has yielded abundant Phoenician and a few Cypriot vessels of the EIA.[179] Although the

172. Erickson 2002, 74 nos 107 and 108 (600–550 BCE).
173. Sporn 2018, 133.
174. For possibly imported lamps of the EROM-MROM period see Vogeikoff-Brogan 2020, 111 no. 60, 116 and 122 no. 102, 125 nos 125–126.
175. Lebessi 1985b, 108–162 *passim*; 2002b, 209–267; 2021, *passim*; Schürmann 1996, 195–214 and *passim*; Muhly 2008, 133–143; 2013.
176. Lebessi and Muhly 2003, 96; cf. Muhly and Muhly 2018, 546.
177. Erickson 2002, 74.
178. See the overview of Phoenician and Cypriot pottery in Crete in Kotsonas 2008, 284–288. For the Cypriot material, see also Karageorghis et al. 2014.
179. Cypriot: Johnston 1993, 370; Callaghan and Johnston 2000, 298–299; Johnston 2005, 348 no. 140, 358–359

paucity of Eastern Mediterranean pottery at Syme Viannou is perhaps unsurprising, this does not apply to the discovery of a single piece of the so-called Creto-Cypriot pottery class (the lekythion/oinochoe P822). This is because the class in question, which encompasses pouring vessels of Cretan manufacture that copy the style of Cypriot vessels, especially of Black-on-Red ware, is widely attested in the central and east part of Crete during the 8th and 7th centuries BCE.[180]

The pottery imports from Syme Viannou invite for a reconsideration of the hypothesized relation of ceramic and other imports to cult practice at the site. This regards specifically the idea of Lebessi and Muhly that the paucity of imports indicates that local cult practice "must have always referred to the Cretan society and its concerns,"[181] and Erickson's argument for "the local character of the sanctuary."[182] Although I do not wish to question that cult practice at Syme Viannou was shaped primarily by local and regional considerations (rather than by ideas and concerns introduced from overseas), I believe that the number of imports is no reliable proxy for the character of the "fabric of cult." This number is probably more indicative of broader patterns in the circulation and consumption of ceramics in Crete, as one can conclude from the following overview of Greek and Roman pottery imports in Cretan sanctuaries, which covers fully published sites but also extends to sites known only from preliminary reports.

The imported pottery identified from published Cretan sanctuaries which were used for much of the Greek and Roman period (and are thus more directly comparable to Syme Viannou) presents a diverse picture. The circa 550 G-HEL pieces of pottery from the sanctuary on the acropolis of Gortyn included only nine imports from Attica, Corinth and East Greece which date from the late 9th to the 6th century BCE.[183] The 200 pieces of LM IIIC to LHEL pottery published from the sanctuary on the Armi hill of Gortyn included only one overseas import.[184] Likewise, the assemblage of G-MHEL pottery from the sanctuary on the west acropolis of Dreros, which is of similar size, produced only two overseas imports.[185] Ceramic imports at the sanctuary of Demeter at Knossos are more numerous but present notable fluctuation over time. The earlier material incudes a few 8th century BCE – mostly Attic – pieces, and a single Argive (?) 6th century BCE piece.[186] Attic imports return with force from the mid-5th to the mid-4th century BCE and include black gloss and – to a considerably lesser

nos 179–181, 361 no. 184, 372 no. 234; Karageorghis et al. 2014, 238–240 nos 84–90. Phoenician: Johnston 1993, 370–371 nos 64A/3:84 and 65A3/2:86; Bikai 2000; Csapo, Johnston and Geagan 2000, 108 no. 1; Johnston 2000, 197 nos 10–11; Johnston 2005, 357 nos 173–174; Jones R. E. 2000; Karageorghis et al. 2004, 241 nos 92–94; Gilboa, Waiman-Barak and Jones 2015. Data from Kotsonas 2008, 284–288.

180. Creto-Cypriot vessels are common in Central Crete, but they remain poorly attested in the west part and the east end of the island (Kotsonas 2008, 68). On this class of material see also Kotsonas 2011b, 141–144; 2012b, 165–170; 2013, 244–246.

181. Lebessi and Muhly 2003, 96.

182. Erickson 2002, 74.

183. Johannowsky 2002, 54 no. 347 (Attic, late 9th century BCE), 54 nos 348–349 (East Greek, 7th century BCE), 62 no. 401 (Corinthian, 7th century BCE), 68 no. 425 (Corinthian, 7th century BCE), 107 nos 639–641 (Attic, 6th century BCE), 107 no. 642 (East Greek, 6th century BCE).

184. Anzalone 2013, 243 no. 10 (late 9th century BCE cup).

185. Kotsonas, forthcoming. The pieces are an East Greek transport amphora and an Attic (?) cup.

186. Coldstream 1973b, 21 nos A31–A33 (G), 52 nos K1–K3 (G), 53 no. K5 (AR).

extent – red-figure pieces.¹⁸⁷ A comparable number of imports appears in the ROM period, especially between the late 1st and the mid-2nd century CE, and includes fine wares of varied provenance (terra sigillata) and lamps.¹⁸⁸

A notable exception to this pattern is presented by Kommos, which has yielded a considerable number of overseas imports – especially EIA fine wares and transport containers – the latter class surpassing by far the total of early transport amphoras from the rest of EIA Crete taken together.¹⁸⁹ However, the experts who published the material from Kommos warned that: "imports are rare and their relative frequency in the catalogue is the result of a natural statistical bias to inventory all pieces that are recognized as such."¹⁹⁰ In any case, from the AR period onward, imports at Kommos declined sharply and remained in low figures until the end of the HEL period. As such, "just a few imports" date to the 6th and 5th centuries BCE and these are mostly from transport amphoras.¹⁹¹ "From the [second half of the] fifth and early

187. Coldstream 1973b, 22 nos B1–B3, 25–26 nos C1–C11, 29 nos D1–D3, 31–32 nos E1–E3, 39–42 nos H1–H53, 53 nos K7–K10.

188. Coldstream 1973b, 46–48 nos J1–J7 and J11–J16, 51–52 nos J40–J51, 55 nos K30–K31.

189. *Aeginetan*: Callaghan and Johnston (2000, 298) refer to "burnished micaceous cooking pots" and Alan Johnston, pers. comm., confirms they are Aeginetan. *Argive monochrome ware*: Johnston 2005, 343 nos 118–119. *Attic*: Johnston 1993, 357–358; 2005, 313 nos 5–6 (Attic or Euboean), 324 no. 48, 331 no. 78 (mostly uncertain cases), 362–363 nos 192–196; Callaghan and Johnston 2000, 219 no. 55, 223 nos 101 and 103, 226–227 nos 139 and 144, 235 no. 229, 244–245 nos 330 and 335, 248–249 nos 382–384 and 393–394; Csapo, Johnston and Geagan 2000, 119 no. 35 (uncertain case) and no. 36, 122–123 no. 56; De Domingo and Johnston 2003, 32, 37–38, 44. *Attic or Cycladic*: Callaghan and Johnston 2000, 217 no. 34, 219 nos 46 and 53, 221 no. 70, 223–224 nos 94 and 112, 228 nos 154 and 158–160, 233 no. 212. Also cf. a few possibly Attic pieces: Johnston 2005, 313 nos 5–6, 324 no. 48, 331 no. 78. *Corinthian*: Johnston 1993, 350–351 nos 50–52, 370; 2000, 223; 2005, 326–328 nos 58–60 and 64, 341 no. 108 (doubtful case), 343–344 nos 120–125, 364 no. 200, 387 no. 295, 389; Callaghan and Johnston 2000, 299–300, 333 n. 12; Csapo, Johnston and Geagan 2000, 120–121 nos 42 and 50, 123 no. 59 (all three are uncertain cases); De Domingo and Johnston 2003, 33, 38–39, 44. *Cycladic*: Callaghan and Johnston 2000, 222–224 nos 91, 99 and 108, 233 no. 202, 245 no. 340; Csapo, Johnston and Geagan 2000, 109 no. 2, 118 no. 30, 121 no. 46 (all three are uncertain cases); Johnston 2000, 197 nos 12–13; 2005, 331 no. 76, 336 no. 94. *Cypriot*: Johnston 1993, 370; Callaghan and Johnston 2000, 298–299; Johnston 2005, 348 no. 140, 358–359 nos 179–181, 361 no. 184, 372 no. 234; Karageorghis et al. 2014, 238–240 nos 84–90. *East Greek*: Johnston 1993, 351–356, 362–370, 373 nos 147–148; 2000, 199 no. 17, 218–219 nos 108 and 110, 223 (references to several vases, including nos 135–137); 2005, 335–336 nos 88–91, 339 no. 100, 341 nos 109–111, 353–355 nos 158, 162 and 165–166, 357–358 no. 175, 365–371 nos 201–227, 387 no. 294; Callaghan and Johnston 2000, 233 nos 202 and 207, 235–236 nos 220–222, 226, 233, 236 and 238, 240 no. 270, 243–248 nos 314–328, 333–334, 336, 341, 343, 358–359, 370, 385–389; Csapo, Johnston and Geagan 2000, 121 nos 34 and 38–39, 123–124 nos 61, 66, 67, 71 and 74; De Domingo and Johnston 2003, 30–36, 41–43. *East Greek (?)*: Csapo, Johnston and Geagan 2000, 121–124 nos 46, 52–53, 55, 57, 58, 60, 65, 68–70, 72–73; Johnston 2000, 222 no. 132. *Euboean*: Johnston 2005, 313 nos 5–6 (Attic or Euboean), 331 no. 75. See also Callaghan and Johnston 2000, 239; Johnston 2000, 224. *Laconian*: Johnston 1990; 1993, 358–362 nos 81–99; 2005, 364 nos 198–199 (from personal inspection, I consider no. 198 to be a doubtful case); Csapo, Johnston and Geagan 2000, 120 no. 37, 122 no. 54, 123 nos 62–63; De Domingo and Johnston 2003, 32, 37, 43. *North Aegean*: Csapo, Johnston and Geagan 2000, 123 no. 58 (uncertain case); Johnston 2000, 197 no. 12 (at least two pieces, for the identification of which as North Aegean products see Kotsonas 2012a, 263 no. 579); 2005, no. 228. *Phoenician*: Johnston 1993, 370–371 nos 64A/3:84 and 65A3/2:86; Bikai 2000; Csapo, Johnston and Geagan 2000, 108 no. 1; Johnston 2000, 197 nos 10–11; 2005, 357 nos 173–174; Jones R. E. 2000; Karageorghis et al. 2014, 241 nos 92–94; Gilboa, Waiman-Barak and Jones 2015. *Thapsos Class*: Callaghan and Johnston 2000, 242 nos 300–301, 333 n. 12; Johnston 2005, 331 no. 77. Data from Kotsonas 2008, 256–288; 2012a, 296–297 fns 1449 and 1458.

190. Callaghan and Johnston 2000, 298.

191. Callaghan and Johnston 2000, 299. Csapo, Johnston and Geagan 2000, 130–131 no. 89 (Samian amphora) and no. 90 (Mendean amphora); Johnston 2005, 371 no. 229 (North Aegean ? amphora), 241 no. 374 (Laconian krater), 383 no. 278 (Corinthian A amphora) and no. 279 (Koan amphora), 384 no. 281 (North Aegean amphora). A Laconian krater, a Mendean amphora and a Corinthian type A or B amphora are mentioned briefly in Johnston

fourth century imports are largely confined to Attic BG [black gloss] pottery and rare lamps and transport amphoras. The latter continue to appear very sporadically in later centuries, as demonstrated best by the few Rhodian stamped handles found. The record of identifiable imports, certainly from outside the island, between the fourth and first century B.C., is indeed meager."[192] Ceramic imports at Kommos increase during the ROM period and include terra sigillata vessels from the Eastern and the Central Mediterranean as well as Knidian lamps.[193]

Another exception to the general paucity of imports at Cretan sanctuaries used during the Greek and Roman period is presented by the cave sanctuary of Lera on the north coast of west Crete.[194] This site has yielded only a few Corinthian and East Greek ceramic imports of PAR-AR date,[195] but these are followed by dozens of Attic imports (which carry red-figure, black gloss and stamped decoration) in the CLAS period.[196] HEL imports are much fewer and largely of unspecified provenance, while ROM imports include a few East Greek transport amphoras and an Attic lamp.[197]

The record of ceramic imports from a sanctuary deposit of the late 7th to 5th century BCE at Olous, on the north coast of East Crete, is comparable in some respects. A preliminary report on this material discusses eight Corinthian small vessels of the 6th and 5th centuries BCE, a dozen Attic black figure cups and skyphoi, and one Attic black figure lekythos of the late 6th and early 5th centuries BCE.[198] However, the report also indicates that there are many more Corinthian vessels with linear decoration (especially kotyliskai), Attic black gloss and red-figure pieces, East Greek pottery, and a number of terracottas imported from some of the areas in question.[199]

The evidence from Kommos, Lera, and Olous demonstrates the correlation between coastal locations and large numbers of imported vessels deposited in Cretan sanctuaries. This correlation, however, requires some qualification in light of the evidence from other sites which are not fully published. A case in point is the Inatos cave sanctuary on the south coast of

1993, 340 n. 6.

192. Callaghan and Johnston 2000, 299. The Attic material, which is black gloss and dates to the late 5th and especially the 4th century BCE, includes a lekane, a krater, two lekythoi, and a number of skyphoi and other small open vessels mostly dating to the 4th century BCE (a late 5th century BCE skyphos is the only red-figure piece known from the site). See, Callaghan and Johnston 2000, 333 n. 17 with reference to the pieces on pages 253–255 nos 422, 431, 438, 440, 257 no. 454, 262–263 nos 502–503 and 512–515; Csapo, Johnston and Geagan 2000, 128–129 nos 80 and 82; Johnston 2005, 373–374 nos 235–236 and 240, 376–377 nos 251–254 and 256–257, 379 no. 264). The HEL material includes a few transport amphoras from Rhodes, Kos, and possibly other regions (Callaghan and Johnston 2000, 333 n. 18, with reference to page 273 nos 620–621; Csapo, Johnston and Geagan 2000, 131–132 nos 92–94; Johnston 2005, 384–385 nos 283 and 285).

193. Csapo, Johnston and Geagan 2000, 132 nos 97–98 (Knidian lamps) and no. 99 (terra sigillata); Hayes 2000a, 314–316 nos 1–16 (terra sigillata); Hayes 2000b, 327–328 nos 60–62 (possibly imported lamps), 329 nos 72–76 (Knidian lamps).

194. Guest-Papamanoli and Lambraki 1980.

195. Guest-Papamanoli and Lambraki 1980, 215 nos A7–A10. For a PG Argive/Cycladic import see Guest-Papamanoli and Lambraki 1980, 213 no. A2.

196. Guest-Papamanoli and Lambraki 1980, 216–221.

197. Guest-Papamanoli and Lambraki 1980, 225, 227–228 (HEL), 218–229 (ROM).

198. Apostolakou and Zografaki 2006; cf. Brisart 2014, 263–265.

199. Erickson (2017, 230) notes that Olous yielded "scores of Attic black drinking cups datable to ca. 500–480 B.C." Some of this material is on display at the Archaeological Museum of Agios Nikolaos.

central Crete. This site has yielded a high number of imported small finds in exotic materials which largely date from the late 7th and early 6th centuries BCE (including numerous scarabs and faience pendants in the form of different deities, one faience vessel, three ivory figurines and at least two ostrich eggs),[200] and is thus considered as one of the very few interregional sanctuaries in EIA Crete (together with Syme Viannou and the Idaean Cave);[201] yet it has produced only a handful of imported pots, including a few Corinthian aryballoi of the 7th century BCE and a few ROM amphoras and perhaps lamps.[202] Likewise, the Idaean Cave, an interregional sanctuary which was probably the most famous cult place of Crete, has yielded a votive assemblage which was rich in imported bronzes, ivories, faience artifacts, and other materials, but was apparently poor in ceramic imports.[203] Although the pottery from the site remains largely unpublished, the numerous preliminary reports available to date only mention two Corinthian kotylai.[204] Nevertheless, the lamps found at the site, which are fully published, include a considerable number of ROM imports from Corinth, Attica, Asia Minor, Italy, and Egypt.[205]

This overview of Greek and Roman pottery imports in Cretan sanctuaries allows for a more nuanced appreciation of the imported pieces identified at Syme Viannou. Indeed, the absolute paucity of pottery imports from Syme Viannou in the EIA appears less striking when compared to the dearth of such finds in all other long-lived Cretan sanctuaries, with the notable exception of Kommos. Syme Viannou recalls the two other long-lived interregional sanctuaries of EIA Crete – the Idaean Cave and the Inatos cave – in producing bronze, faience and other imports from the Eastern Mediterranean but hardly any ceramic imports from either that area or from the Aegean. Remarkably, the earliest Aegean ceramic imports known from these three Cretan sanctuaries are dominated by small vases which originate from Corinth and date to the 7th and the early 6th century BCE.

The number of pottery imports of AR and – to a lesser extent – CLAS date identified at Syme Viannou calls for a reconsideration of Erickson's impression of an "extreme paucity of imports" at the site.[206] My reconsideration relies on the preceding overview which established that other Cretan sanctuaries also show a low number of such imports in this period. Indeed, only Lera and Olous are known to have produced a considerably higher number of AR and CLAS pottery imports than Syme Viannou. The sanctuary of Demeter at Knossos also received numerous imports during the same period, but these basically date from the mid-5th century BCE onward. The number of AR and CLAS pottery imports known from Syme Viannou is comparable to the number of pieces of such date identified at Kommos (where imports decrease dramatically after circa 600 BCE), and surpasses the numbers reported from other

200. Kanta and Kontopodi 2011b; Wilkinson 2011.
201. Prent 2005, 604–606.
202. Grigoropoulos 2011, 80–83 nos 76e and 79; Kanta and Kontopodi 2011a, 76 no. 69, 78 nos 72–73.
203. Sakellarakis 1988; Sakellarakis and Sapouna-Sakellaraki 2013. On the bronze vessels see also Matthäus 2000; 2011; on the ivories see Sakellarakis 1992; on the faience objects see Psaroudakis 2012–2013. On the interregional role of the Idaean Cave see Jones D. W. 2000, 109–114; Prent 2005, 559–604; Pappalardo 2012, *passim*.
204. Sakellarakis 1988, 191 (no date is offered, but this is presumably late 8th or 7th century BCE).
205. Sapouna 1998, 108–116.
206. Erickson 2002, 74.

Cretan sanctuaries. Hence, although unimpressive in absolute terms, the number of AR and CLAS pottery imports at Syme Viannou is symptomatic of broader, island-wide patterns and need not be indicative of the isolation of the site or, more broadly, of the local "fabric of cult."

The Corinthian aryballoi of the AR period, which are represented by three specimens at Syme Viannou, are not common over most of Crete where earlier, Protocorinthian aryballoi are much more widely attested.[207] However, a sizeable group of Corinthian aryballoi and other unguent vessels of the 7th to mid-6th centuries BCE has been found at the cemeteries of Aphrati and Lyktos/Lyktos.[208] Corinthian imports may have reached these sites through the same network given their proximity and inland location as well as the varied links they present especially in the 6th century BCE. Later in the AR and into the CLAS periods, imports at Syme Viannou present a shift from Corinthian unguent vessels to Attic drinking vessels. This shift is also identifiable at the acropolis of Gortyn, Lera, and perhaps Olous (see above), and is well known from sanctuaries in other parts of the Greek world.[209]

The paucity of HEL pottery imports at Syme Viannou is paralleled by all other Cretan sanctuaries.[210] ROM ceramic imports are somewhat more common in Cretan sanctuaries and they typically include terra sigillata bowls, transport amphoras, and lamps. Lamps are the only possible ceramic imports at Syme Viannou during the ROM period.[211]

3.6. Conclusion: Ceramic Fabric and the Provenance of Pots and People that Reached Syme Viannou from the Early Iron Age to the Roman Period

The wide-ranging macroscopic and analytical characterization of the fabrics of a large assemblage of Greek and Roman pottery and other ceramic finds from Syme Viannou is rather exceptional for the state of the research on ancient sanctuaries. This condition has generated novel and important insights into the "fabric of cult" at Syme Viannou, which are summarized below. Emphasis is given to two issues which receive considerable attention in previous

207. Kotsonas 2008, 262–263.

208. On Aphrati see Levi 1927–1929; on the Corinthian imports from the site see Biondi 2013. On Lyktos/Lyttos, see Kotsonas 2019b; Kotsonas, Sythiakaki and Chaniotis 2021; forthcoming; Petrakos 2021; 2022. On the PAR-AR cemetery at Lyktos Alonas, see Kotsonas, Sythiakaki and Chaniotis forthcoming; Petrakos 2022, 45–46.

209. Stissi 2002, 251, 252–254; 2009, 30–34. On Attic imports in AR-CLAS Crete see Erickson 2005; 2010a. The patterns traced by Erickson need to be reconsidered in the light of the discovery of copious Attic AR-CLAS imports at Lyktos/Lyttos (Kotsonas, Sythiakaki and Chaniotis 2021, 45; forthcoming; Petrakos 2021; 2022, 40), the publication of little-known finds from west Crete (Tzanakaki 2018), and the identification of previously overlooked material from sites like Knossos (Paizi 2023).

210. On Attic imports in HEL Crete see Laftsidis 2018, 714–715.

211. For possibly imported lamps of the EROM-MROM period see Vogeikoff-Brogan 2020, 111 no. 60, 116 and 122 no. 102, 125 nos 125–126. For possibly imported lamps of the EBYZ period see Vogeikoff-Brogan 2020, 128 nos 137–145 (6th, 7th and perhaps 8th centuries CE).

literature, namely the question of the community or communities which were associated with – and perhaps controlled – the sanctuary at different times, and the flow of overseas imports to the site.

My study of the Greek and Roman pottery from Syme Viannou has identified ten MFGs and correlated them to the eight PFGs described by Nodarou in Chapter 6. Additionally, a range of fabric loners were identified macroscopically and petrographically. One third of the specimens assigned to the ten MFGs of the Greek and Roman pottery are made in coarse to semi-coarse fabrics, while the remaining two thirds are fine to semi-fine ones. Fine to semi-fine vessels are attested through the Greek and Roman periods, but coarse specimens largely disappear in ROM times. Additionally, all the MFGs which were introduced from the PAR period onward (F, G, H, I, J) are fine to semi-fine. More than half of the material published here is assigned to MFG C, while MFG A comes second with 130 specimens. The remaining eight MFGs are represented much more thinly, by 13 to 40 pieces.

I argue that the pottery dedicated to Syme Viannou in the Greek and Roman period was not produced at the site and its immediate vicinity, which contrasts with the pattern of local production that is well attested for the sanctuary for part of the 2nd millennium BCE. As much as 99% of the Greek and Roman pottery found at Syme Viannou may derive from elsewhere in Crete, especially from the central and east parts of the island. Overseas imports make up only 1% and all of them probably come from the southern Greek mainland. Ceramic imports from further away were not identified at the site despite the attestation of a number of Eastern Mediterranean imports made in other materials. Although the percentage of pottery imports from overseas is meager, this is rather typical for the ceramic record of most Cretan sanctuaries, with the notable exception of Kommos, Lera, and Olous, which are all coastal.

The range of MFGs represented at Syme Viannou lends support to the identification of the site as an interregional sanctuary, which has been previously proposed by Lebessi and her collaborators for the EIA to the HEL period.[212] This range (MFGs A, B, C, D, E) is broad from the early first millennium BCE, as demonstrated by PG pottery, which indicates that the sanctuary attracted people from different communities already at this stage. Overseas imports at the site are attested in this period but they are limited to a few bronzes from the Eastern Mediterranean. The range of MFGs remained stable during the G period and increased considerably in the PAR period (with the introduction of MFGs I and J). This development calls into question Prent's hypothesis that a specific community assumed control of the sanctuary from around 700 BCE.[213] Instead, the interregional appeal of the sanctuary seems to have grown in this period during which overseas imports slightly increased but were largely limited to a few bronzes from the Eastern Mediterranean.

The AR and CLAS periods are characterized by stability in the range of MFGs represented. This finding undermines Erickson's idea over the control of the site by Aphrati in the AR-MCLAS period, and Lyktos/Lyttos in the LCLAS period.[214] However, the LCLAS pe-

212. Lebessi, Muhly and Olivier 1995, 76–77. The same notion is found in Lebessi 1985b, 188–198; Schürmann 1996, 192–194; Lebessi 2002b, 192; Muhly 2008, 119–120, 140.
213. Prent 2005, 574–576.
214. Erickson 2002.

riod is characterized by the remarkable preponderance of MFG A, which can be associated with Lyktos/Lyttos. During the AR and CLAS periods, imports from the Eastern Mediterranean disappeared from Syme Viannou but imported pottery from the southern Aegean was represented by more than individual pieces for the first and only time during the historical period.

Overseas imports – including metal, terracotta, and perhaps ceramic pieces – are thinly attested in the HEL period which witnessed the broadest range of MFGs (A, B, C, E, F, G, H, I, J) identified at Syme Viannou during the Greek and Roman periods. This pattern matches the HEL epigraphic record from the sanctuary which documents that it attracted people from numerous communities in central and east Crete, including Hierapytna, Priansos, Arkades, Knossos, Lyktos/Lyttos, and Datala. The argument of Kritzas that Lyktos/Lyttos controlled the sanctuary in the LHEL and ROM periods – which relies on epigraphic grounds[215] – and the hypothesis of Stefanakis that the sanctuary was briefly controlled by Knossos in the LHEL/EROM period – which is based on numismatic evidence[216] – could not be confirmed by the study of the pottery fabrics.

The ROM period is a phase of decline for the sanctuary, which must have lost its interregional role at the time. This conclusion can be deduced from the remarkable decrease in the range of MFGs represented (A, C, F, J, H); by the predominance of a single MFG (H), which nearly monopolizes the ceramic record of the MROM and LROM periods; and by the paucity of overseas imports – whether ceramic or other – dating from the period which is atypical for prominent Cretan sanctuaries.

215. Kritzas 2000, 95–96.
216. Lebessi and Stefanakis 2004, 199, 200.

4
Ceramic Form and Function at Syme Viannou

4.1. Introduction

Form is one of the two key attributes of pottery which help convey "the whole romance of humanity," according Armand Dupont in *Death in the Clouds*.[1] Studies of pottery from Greek sanctuaries typically place emphasis on vessel form and are often structured according to vessel shape, as this attribute relates to functional properties (such as capacity, accessibility and the manipulation of content) and provides a convenient yardstick for organizing the study of the material and pursuing its interpretation.[2] A notable example of this approach is offered by the publication of the pottery from the acropolis sanctuary at Gortyn, which treats vessel shape as fundamental to both the catalogue and the associated discussion of the pottery.[3] Other primary publications of Cretan sanctuaries, however, combine discussions focused on vessel shape with context-based catalogues, as demonstrated by the publications of Kommos, and the sanctuaries on the Armi hill of Gortyn and the west acropolis of Dreros.[4]

The usability of ceramic classifications based on vessel shape depends on the state of preservation of the material, and diminishes when the pottery is too fragmentary to be securely attributed to specific vessel shapes. High fragmentation is attested for a considerable part of the material from Syme Viannou, which is why the following analysis is structured according to broad functional categories (e.g., storage or cooking vessels) and treats shape as a secondary aspect of the taxonomy. As Morgan has noted, this method "allows for sherd material to be included to the greatest extent and all wares to be approached equally from the outset."[5] "Naturally, multi-purpose vessels slip between functional categories,"[6] but the

1. Christie 1974, 211 ("design" is the term used by Dupont).
2. Rice 1987, 207–226; Horejs, Jung and Pavúk 2010; Orton and Hughes 2013, 81–86.
3. Gortyn acropolis: Johannowsky 2002. Kommos: Callaghan and Johnston 2000, 300–301.
4. Kommos: Callaghan and Johnston 2000, 300–301. Gortyn Armi: Anzalone 2013, 232–235. Dreros west acropolis: Kotsonas forthcoming.
5. Morgan 2011, 16; cf. Verdan 2013:I, 111.
6. Morgan 2011, 16; cf. Verdan 2013:I, 112.

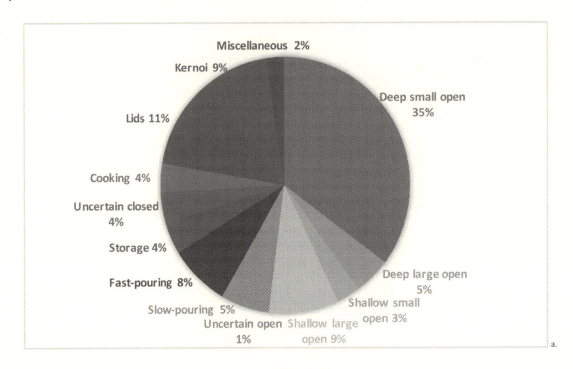

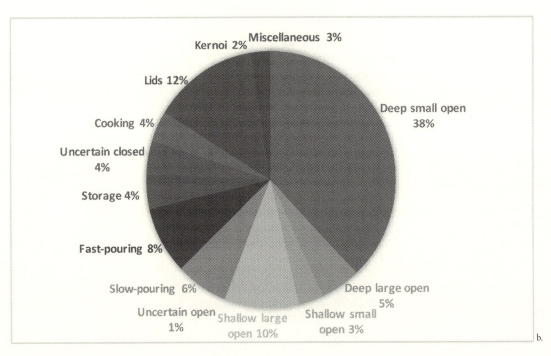

Figure 4.1: The representation of different functional categories among the Greek and Roman pottery from Syme Viannou. Figure 4.1a counts every piece catalogued as one vessel, while Figure 4.1b counts the kernoi according to the minimum number of individual vessels represented.

exercise generally helps promote the integration of the bulk of the material into the study of the function of pottery in sanctuaries.

The discussion of the different functional categories which is pursued in this chapter first treats open vessels (deep and shallow) and then closed vessels (pouring and storage), generally progressing from shorter to taller forms (Sections 4.2 to 4.10). Cooking vessels (Section 4.11) and specialized vessels related to votive and ritual behavior (Sections 4.12 to 4.14) come last. This structure is fairly common in discussions of Cretan pottery.[7]

The Greek and Roman pottery from Syme Viannou covers a wide range of shapes and functional categories, as is often the case with long-lived sanctuaries.[8] The present chapter and Figure 4.1 demonstrate that more than a third of this pottery is deep open vessels of small size (especially cups).[9] This pattern perpetuates a local tradition which can be traced back to the second millennium BCE but persisted into the first, despite the notable reduction in the quantity of vessels deposited at the site. The other shapes are represented much more thinly, and no class amounts to more than one tenth of the material. The single exception concerns the lids, especially the domed lids/shields. The other classes which are well-represented include the shallow large open vessels (lekanai etc.) and the fast-pouring vessels (kraters etc.). Kernoi are attested by many fragments but these probably represent much fewer vessels (compare Figure 4.1a and 4.1b). All other classes of pottery, including the entire shape repertory of closed vessels, are attested more thinly. This broad overview is qualified and explored further in the different sections of the present chapter.

The individual sections provide comprehensive analysis of the fabric, the form, the date range, and the spatial distribution of the Greek and Roman pottery from Syme Viannou. The analysis includes systematic comparisons of the patterns identified at the site with those seen in other published assemblages from Cretan sanctuaries which are large in size and either range from the EIA to the ROM period, or cover a considerable part of this time-span. The assemblages in question come from Kommos, the sanctuary of Demeter at Knossos, the sanctuaries on the acropolis and Armi hills of Gortyn, and the cult site on the west acropolis of Dreros (see Section 1.4). Comparisons from other less well published Cretan sanctuaries are also introduced where appropriate – especially in the analysis of rarer and more exceptional vessel types.

The identification of different functional categories of pottery at Syme Viannou, including the classes of exceptional vessels mentioned above, invite for some reflection on the important but elusive distinction between "functional vessels sacralized by being deposited or perhaps deliberately broken after use, from votive pottery – either vessels used to hold gifts or those offered as votives in their own right."[10] Sanctuary pottery may also include pieces

7. Cf. Coldstream and Eiring 2001; Eiring 2001; Forster 2001. But note that Coldstream 2001 basically uses a reverse sequence.

8. Cf. Stissi 2002, 248.

9. Figure 4.1a quantifies the full range of Greek and Roman pottery catalogued in this work. I hold that this quantification is very close to the minimum number of vessels represented at the site, except for the fragments of kernoi, as explained in Section 4.13 and Chapter 6 fn. 60. To compensate for this, I provide the alternative Figure 4.1b, which takes in the estimated minimum number of kernoi.

10. Morgan 1999, 325. Cf. Sjögren 2003, 52; Patera 2012, 99–100; Smith 2021, 209. On the ancient Greek

Figure 4.2: MG bronze figurine from Syme Viannou (Archaeological Museum of Heraklion no. 4357).

used in the daily activities of resident or non-resident staff, or pieces broken accidentally by visitors and left behind.[11] Inscriptions, iconography, and undisturbed find contexts can help determine the function of pottery found in sanctuaries, but such evidence remains rare in Greek archaeology.[12]

The archaeology of Syme Viannou provides relatively poor epigraphic, iconographic, and contextual evidence for distinguishing the different roles of pottery vessels found at the site. Closed assemblages of EIA to ROM pottery are missing, while relevant epigraphic and iconographic evidence is limited, ambiguous, and only concerns cups and related vessels. Erickson has observed that "a few of the unpublished inscribed cups from Kato Symi [which largely date to the HEL period and are under study by Kritzas] appear to be dedications."[13] However, treating these inscriptions as a criterion for distinguishing between vessels offered as dedications and vessels with ritual or utilitarian functions is questionable since the writing on these cups was rendered at some unspecified moment after their manufacture. Indeed, one cannot exclude the possibility that these vessels were first used for libations or feasts at the site and were then inscribed and offered to the divinity. Iconographic evidence is provided by several offerings from the site, including: a) a bronze cut-out plaque which shows a man holding a cup/jug;[14] b) two bronze male figurines of the 8th century BCE, one holding a bowl

terminology for votive offerings see Patera 2012, 17–53; on the terminology in English see Osborne 2004, 5.

11. Simon 1986, 314; Stissi 2002, 240; 2003, 77–78; 2009, 26.

12. Simon 1986, 317; Stissi 2002, 240–241. Inscriptions can further help determine whether vessels were dedicated in their own right or for their content (Simon 1986, 315–316; Stissi 2002, 241; 2009, 29).

13. Erickson 2010a, 260.

14. Lebessi 1985b, 26, 122–123 no. A11.

and another holding what looks like a Neopalatial communion cup (Figure 4.2);[15] and c) eight clay figurines of the 9th to 6th centuries BCE, which show men (?) holding bowls,[16] and a ninth piece which shows a man holding a cup.[17] A comparable late 8th century BCE clay figurine from Haghia Triada holds a conical cup,[18] a clay figurine of the 6th century BCE from Praisos holds a bowl,[19] while a late 7th century BCE vase from the acropolis sanctuary of Gortyn shows an incised figure holding a kantharos on the one hand and a sacrificial animal on the other.[20] These iconographies are taken to indicate the use of drinking vessels in ritual practice, especially in libations (rather than as votives).[21] However, it would be precarious to use this scant evidence, which largely comes from a specific period (PG to AR) and sub-region (south-central Crete), to extrapolate the function of the copious cups (and related vessels) from Syme Viannou which make up more than a third of the pottery finds of the Greek and Roman period.

Notwithstanding these uncertainties, the morphology of some classes of vessels from Syme Viannou is broadly suggestive of their role as votive offerings. A case in point is provided by the domed lids/shields, which date from the G-(AR) period and are amply documented at the site and also at a few other Cretan sanctuaries (Section 4.12). These sanctuaries have yielded very little – if any – evidence for lidded storage vessels, which indicates that the domed lids/shields found at these sites were not used as vessel covers (as is often the case with examples of the shape found in Cretan tombs) but as votive offerings. This inference is corroborated by the morphological similarities of these vessels with the miniature bronze shields which were found at some of these sanctuaries and clearly served as votives (see Section 4.12). A votive use is also probable for the few miniature vessels from Syme Viannou which are too small to fulfill the formal function of their shapes.[22]

The complex morphology of the numerous kernoi and the few ring kernoi from Syme Viannou (Section 4.13) suggests they were ritual vessels or perhaps votives, but excludes their association with feasting and everyday activities taking place at the sanctuary.[23] The exclusive attestation of these vessels in Cretan cult sites is telling in this respect. A group of miscellaneous vessels (Section 4.14) includes specimens from shapes which are poorly represented at Syme Viannou but which are regularly (though not exclusively) found in Cretan sanctuaries, occasionally in large numbers. The elaborate morphology of some of these vessels (plastic vase and ring vases) lends support to their role as votive offerings, but their use in ritual practice

15. Lebessi 2002b, 81–86, 219–222 no. 17 (with cup), 92–94, 223 no. 21 (with bowl). On the figurine with the cup, see also Lebessi 1977, 407–409 pl. 215a; 1981b, 24 pl. 3b. Also, Kanta 1991, 485; Prent 2005, 347 fn. 762; Archontaki 2012, 29–30.
16. Lebessi 2021, 12–13, 31–32 nos 34 and 39–41, 41 nos 101–102, 23 and 43 nos 118–119.
17. Lebessi 2021, 19–20, 39–40 no. 91. The piece is also mentioned in Erickson 2010a, 261 fn. 122.
18. D'Agata 1999b, 162, 165 no. D5.9; cf. Lebessi 2002b, 221 fig. 147.
19. Halbherr 1901, 380–381 fig. 7; cf. Lebessi 2021, 23.
20. Johannowsky 2002, 72 no. 477.
21. Johannowsky 2002, 72 no. 477; Lebessi 2002b, 222, 223; 2021, 12–13, 23, 116–117, 132, 139–140, 148.
22. Cf. Morgan 1999, 325. On miniature pottery from Greek sanctuaries, see Ekroth 2003; Barfoed 2018; Pemberton 2020. The miniature pottery from Syme Viannou includes three cups (P10, P11, P62; see Section 4.2), three aryballoi (P92, P649, P792; see Section 4.7) and a hydria (P19; see Section 4.8).
23. Cf. Simon 1986, 315.

cannot be excluded.²⁴ In any case, the poor representation of these shapes at Syme Viannou through most of the Greek and Roman period suggests that they represent non-regular votive or ritual behavior.

It is impossible to determine the precise role of the remaining vast majority of the EIA-ROM vessels from Syme Viannou (Sections 4.2 to 4.11) since they belong to shapes and types which are commonly found in Cretan sanctuaries, settlements, and cemeteries. Notwithstanding undeniable uncertainties, I am inclined to think that, at Syme Viannou, these vessels were largely used for the storage (Section 4.9), preparation (Section 4.11 on cooking vessels and perhaps Section 4.5 on food processing vessels), manipulation (Sections 4.3 on mixing vessels, and perhaps Sections 4.7 and 4.8 on pouring vessels), and the consumption of food and drink (Sections 4.2 and 4.4) during rituals held at the site. A number of fragments cannot be attributed to specific shapes (Sections 4.6 and 4.10), but could have been used for the storage, manipulation, and consumption of food and drink. Some of the vessels from Syme Viannou – especially the shallow open vessels of large to medium size, or the slow-pouring vessels (Sections 4.5 and 4.7 respectively) – could have served the offering of solid and liquid commodities to the gods. In any case, the Greek and Roman pottery from the site is largely missing the kind of morphological elaboration which would enhance the possibility that the vases are "votives in their own right."²⁵ A possible exception is provided by the only vessel from the site which carries figural decoration. This is a LPAR cup which was probably produced in Gortyn (P690) and shows a male figure – Hermes (?) – who is striding and is holding a staff.²⁶ This imagery recalls the iconography of different votive offerings found at the sanctuary of Syme Viannou and may thus be related to local cult practice, perhaps to the festival of the *Dromeia* which may have been celebrated at the site.²⁷

4.2. Deep Open Vessels of Small Size (Bell Skyphoi, Cups, Kantharoi, Skyphoi, and Other)

Bell skyphoi: P12, P13, P14, P34, P90, P91, P125, P192, P198, P204, P250, P348, P357, P358, P368, P369, P392, P413, P446, P457, P461, P462, P463, P473, P479, P480, P481, P483, P485, P486, P487, P488, P489, P495, P496, P501, P502, P503, P519, P520, P573, P594, P619, P637, P639, P677, P678, P679

24. Cf. Simon 1986, 317.
25. Morgan 1999, 325.
26. Kotsonas 2019a, 617–618. See also Lebessi 1984, 463 pl. 234γ; Kanta 1991, 500, 502 fig. 40:b.
27. As noted in Kotsonas 2019a, 617–618, the relevant votive offerings from Syme Viannou include PAR to HEL bronze cut-out plaques and terracotta figurines showing Hermes holding the caduceus (Lebessi 1985b, 155–159; 2002b, 153, 257), a silver and a bronze scepter of the LG-EPAR period (Lebessi 1974, 225–226 pl. 168:c; 2001), as well as a LM IA or LM IB-early golden ring showing a runner (Lebessi, Muhly and Papasavvas 2004). On the possible celebration of the *Dromeia* at Syme Viannou, see: Lebessi 1985b, 182, 193–194; also, Prent 2005, 584; Kotsonas 2019a, 618.

Cups: P5, P20, P24, P27, P28, P29, P30, P38, P44, P46, P53, P60, P61, P63, P79, P101, P102, P103, P104, P105, P110, P111, P131, P132, P139, P140, P141, P142, P145, P147, P148, P149, P150, P151, P152, P153, P154, P155, P156, P170, P171, P172, P175, P176, P180, P183, P184, P186, P187, P197, P205, P206, P209, P211, P214, P215, P220, P227, P228, P236, P239, P245, P251, P252, P253, P254, P255, P256, P258, P265, P270, P273, P274, P275, P278, P283, P290, P302, P305, P309, P310, P317, P325, P328, P329, P333, P335, P336, P343, P355, P363, P364, P365, P366, P373, P374, P375, P379, P382, P387, P388, P395, P407, P410, P411, P415, P416, P433, P449, P450, P468, P469, P470, P471, P472, P474, P476, P511, P512, P515, P518, P523, P526, P527, P535, P536, P538, P540, P541, P542, P543, P544, P548, P549, P550, P553, P554, P555, P556, P557, P558, P582, P583, P584, P585, P586, P587, P588, P589, P601, P602, P603, P604, P605, P606, P608, P611, P612, P613, P615, P616, P617, P634, P635, P641, P642, P643, P644, P650, P651, P655, P657, P660, P662, P663, P664, P665, P666, P672, P673, P674, P676, P682, P683, P687, P690, P691, P692, P693, P695, P696, P702, P703, P708, P709, P714, P757, P758, P760, P779, P782, P785, P786, P788, P801, P813, P819, P833, P834, P835, P840, P847, P848, P849, P850, P851, P852, P853, P854, P855

Cups, miniature handleless: P10, P11, P62

Cups/Other shapes: P85 (cup/kantharos), P143 (cup/jug), P162 (kantharos/cup), P207 (cup/jug), P244 (cup/jug), P291 (cup/jug), P313 (cup/jug), P324 (cup/skyphos), P400 (cup/jug), P499 (cup/jug), P551 (cup/jug), P552 (cup/jug), P590 (cup/kantharos), P609 (cup/jug), P610 (cup/krater), P778 (cup/kotyle), P797 (cup/kantharos), P841 (cup/jug), P856 (cup/kantharos)

Kantharoi: P47, P191, P233, P298, P301, P314, P354, P843

Skyphoi: P1, P2, P3, P4, P814

Other: P459 (kylix), P537 (kotyle)

The sanctuary of Syme Viannou received copious deep open vessels of small size already in the prehistoric period, as evidenced especially by Neopalatial communion cups and LM III kylikes and deep bowls.[28] Although the absolute number of such vessels decreased markedly during the late 2nd millennium BCE (when the thousands of Neopalatial specimens gave way to a smaller LM III assemblage), deep open vessels of small size remained the most dominant class of pottery from the sanctuary throughout most of its life. As Kanta noted, "although the amount of pottery found is dramatically reduced in Greek times, drinking vessels remain common."[29] Indicative of this development is the identification of 306 pieces of small deep open vessels of the historical period at the sanctuary of Syme Viannou. The group makes up more than a third of the Greek and Roman pottery from the sanctuary (even though it is basically limited to the pre-ROM period) and includes bell skyphoi, various types of cups, kantharoi, skyphoi ("of Mainland type"), a single kotyle, and a number of vessels that may belong to cups or other

28. Kanta 1991, 482, 490, 494. On the Neopalatial communion cups, see Archontaki 2012; cf. Prent 2005, 347.
29. Kanta 1991, 482.

shapes.³⁰ The importance of this shape repertory for the site is confirmed by the attestation of PG-AR figurines which represent individuals holding deep open vessels of small size (see Section 4.1).

When found in sanctuaries, cups and related vessels are taken to have been used for feasting and the pouring of libations, but the two activities cannot be easily distinguished in the archaeological record,³¹ and both could have been followed by the dedication of the vessels (see also section 4.1).³² At Syme Viannou, the offering of libations during the Greek period is indicated by the bothros on the Altar,³³ and also by the deposition of numerous kernoi (see Section 4.13).³⁴ Water from the nearby spring may have served these libations.³⁵ Additionally, feasting is indicated by the quantity of animal bone and the limited marine remains excavated at the site,³⁶ by the considerable number of cooking vessels (see Section 4.11), and perhaps also by the deep open vessels, the kraters (see Section 4.3), and the small shallow open vessels (see Section 4.4) found there. The idea that cups and related vessels at Syme Viannou "were used more likely as containers for food and drink than as dedications in their own right" has been supported by Erickson.³⁷ However, at Syme Viannou and other Greek sanctuaries, small, deep open vessels may have been "used to pour a single libation before being dedicated."³⁸ The possibility that certain vessels served more than one role has also been entertained by Erickson: "although a few of the unpublished inscribed cups from Kato Symi appear to be dedications, most apparently served a utilitarian function and were presumably left behind after acquiring a secondary importance as symbols of the festivities."³⁹ These notes are indicative of the potential dedicatory, utilitarian, and ritual roles of deep open vessels of small size at Syme Viannou.

The majority of the cups and related vessels discussed in this section are made in MFG C2. A range of other MFGs are represented by much fewer specimens. This includes MFGs A1, A2, B2, B3, C1, D, E, F, I, and J.⁴⁰ There are also a few pieces of uncertain fabric (P20, P150,

30. On Cretan bell skyphoi, see Coldstream 2001, 51; Kotsonas 2008, 187-194. On cups, see Coldstream 2001, 55-57; Coldstream and Eiring 2001, 78-80; Eiring 2001, 92-97; Englezou 2005, 149-165; Kotsonas 2008, 197-215; Laftsidis 2018, 632-634, 651-660, 691-693. On kantharoi, see Coldstream and Eiring 2001, 80; Eiring 2001, 97-98; Englezou 2005, 166-186; Laftsidis 2018, 608-609, 629-630, 661-664, 694-695. On kotylai, see Coldstream 2001, 55; Kotsonas 2005, 195. On skyphoi, see Coldstream 2001, 53-55; Kotsonas 2008, 196-197.

31. Stissi 2002, 242, 248 fn. 1180; 2009, 25.

32. Stissi 2002, 248 fn. 1180.

33. Lebessi and Muhly 1990, 327.

34. Cf. Prent 2005, 347; Lefèvre-Novaro 2014, 116.

35. Kanta 1991, 483.

36. On the animal bone see: Nobis 1988; Trantalidou 2010; 2013, 63, 78; 2017, 638, 640-641, 650, 653, 667 fig. 13; Lebessi 2021, 181-182. On the marine remains, see Lebessi and Reese 1986. On iconographic evidence for animal sacrifice at the site, see Lebessi 1985b, 126-136. On the different rituals involving the offering of meat in Greek sanctuaries, see Ekroth 2017a.

37. Erickson 2010a, 260 fn. 117. On the possible use of cups and related vessels not only for drinking but also for eating see Morgan 1999, 322-323.

38. Stissi 2002, 248 fn. 1180.

39. Erickson 2010a, 260.

40. MFG A1: P141, P143, P175, P186, P187, P206, P207, P244, P274, P291, P474, P515, P550, P551, P552, P554, P555, P556, P609, P613, P650, P651, P841; MFG A2: P142, P274, P283, P313, P382, P499, P553, P557, P558, P850; MFG B2: P639; MFG B3: P101, P211 (?), P537; MFG C1: P24, P34, P63, P103, P348, P357, P501, P602, P813; MFG D: P1, P2, P3, P4, P5 (?), P38, P125 (?), P329 (?), P283 (?), P379; MFG E: P13, P91, P191 (?), P368, P413, P457, P461, P472, P480,

P198, P310, P544, P616, P782) and a few fabric loners (P275, P278, P314, P366, P369, P459, P518, P682, P779, P785).

Cups and related vessels made in MFGs C2 were commonly attested in all the areas of the sanctuary, but in some areas (the Area of the Altar, the Terraces and the Water Channel, Building C-D and its Immediate Surroundings) they are accompanied by a range of specimens made in other MFGs.[41] Exceptionally, the material from the Central and South-Central Part of the Podium includes a considerable number of cups and related vessels made in MFG A, though still the majority of them are made in MFG C2; this patterning may have chronological significance, as noted in Section 5.4. Lastly, the cups and related vessels from areas in the northern part of the sanctuary and some areas of its central part (the Area of the Protoarchaic Hearth, the West Part of the Enclosure, the North Part of the Enclosure and the Podium, and Building E and its Immediate Surroundings) are made almost exclusively in MFG C2.

The cups and related vessels from Syme Viannou are typically monochrome, mostly fully coated, and much more rarely dipped (dipping is commonly applied only to PG bell skyphoi). Plain examples remain rare. Roughly one out of ten specimens are plain,[42] but the group of plain pieces may include specimens which were originally monochrome. It is perhaps indicative that a large fraction of the plain cups is made in MFG A, but one or two cups (P382 and perhaps P474) made in this MFG preserve traces of dark slip, which raises the possibility that more of these vessels were originally slipped. More elaborate decorative schemes remain extremely rare among the cups and related vessels from Syme Viannou. They are limited to a few LG-PAR pieces with pattern painted decoration (P170, P511, P523, P819), to a few PAR and HEL pieces which show coating and incising (P154, P354, P355, P449, P690), and to single pieces which combine coating and relief decoration (P314: EHEL/MHEL), or carry stamped decoration (P609: AR-CLAS) and grooving (P62: ECLAS-MCLAS). Nearly all the cups and related vessels which carry elaborate decoration come from the Terraces and the Water Channel. Monochrome specimens predominate in all areas of the sanctuary, but plain examples are exceptionally common in the Central and South-Central Part of the Podium (where they are nearly half as many as the monochrome examples). The predominance of monochrome and plain cups and related vessels at Syme Viannou recalls the predominance of such pottery in sanctuaries across the Greek world.[43] The sanctuary on the acropolis of Gortyn, which yielded abundant pieces with pattern painted decoration,[44] presents the most notable Cretan exception to this pattern.

The surface treatment of some of the pottery from Syme Viannou includes potter's marks. Such marks are rendered on the underfoot of five PG bell skyphoi which are made mostly in MFG E and come from the Terraces and the Water Channel (P368, P413, P461,

P485; MFG F: P149, P387, P411, P854; MFG I: P239, P388, P400, P410, P714; MFG J: P47, P53, P147, P148, P162, P233, P245, P265, P298, P301, P305, P354, P355, P395, P449, P476, P527, P617 (?), P797, P847, P848, P849, P852, P855, P856.

41. This also applies to the Material of Unknown or Uncertain Find Context.
42. P90, P110, P141, P142, P143, P172, P175, P186, P187, P206, P207, P244, P250, P274, P275, P291, P313, P357, P368, P387, P410, P488, P496, P499, P515, P550, P551, P552, P553, P554, P555, P556, P557, P558, P613, P651, P702, P841; perhaps also: P13, P34, P156, P258, P324, P433, P473, P501, P678, P702.
43. Stissi 2002, 245–246; 2003, 78.
44. Johannowsky 2002.

P480, P487).⁴⁵ The types of marks include an incised line (P413, P461, P480), an incised X (P368), or a painted band (P487). The stamped rosette on the handle of the AR-CLAS cup/jug P609 may also be a potter's mark. This range of potter's marks is much smaller and much less varied than the range of such marks identified on Minoan pottery from Syme Viannou.⁴⁶ The Minoan potter's marks from the site – and from other Cretan sites – include individual incised lines and incised Xs⁴⁷ like those seen on the PG bell skyphoi mentioned above. Similar incised marks as well as single painted bands are attested among the EIA potter's marks from Eleutherna.⁴⁸

The attestation of cups and related vessels at Syme Viannou displays interesting chronological patterning. In general, numbers seem fairly stable from the PG to the LHEL period except for a major spike in AR times. The nearly 50 specimens assigned to the PG period – which are basically bell skyphoi – represent a second, considerably lower spike in the representation of small, deep open vessels.⁴⁹ At Syme Viannou, bell skyphoi succeed the kylikes and the deep bowls of the LM IIIC period,⁵⁰ dominating the pottery record of the PG period. In turn, bell skyphoi give way to shallow skyphoi and especially cups during the G period (see below). Cups, however, only become numerous in the AR period when their number presents a major spike. Approximately 80 pieces date specifically to this period, and an estimated dozen more specimens may also date to it. The spike begins on the transition from the LPAR to the EAR period, culminates in the LAR, and is manifested at a time during which the ceramic record from Syme Viannou is otherwise rather limited. The spike of the AR period was correctly identified by Erickson,⁵¹ who was not right, however, in assuming that the predominance of the cups persisted into the CLAS period.⁵² Numbers suggest a considerable drop at the time, with 40 pieces dated specifically to the CLAS period (which covers circa 160 years, as opposed to the circa 120 years of the AR period) and an estimated sixteen more specimens dated more loosely to this period and/or another. Half a dozen pieces attributed to cups or other shapes (especially jugs) can be added to the total which remains, however, far lower than the total obtained for the AR period. In absolute numbers, the deposition of cups remains fairly stable from the CLAS to the HEL period, but the overall pottery repertory of the sanctuary grew to be more varied during the latter period. Notwithstanding the popularity of different forms of cups and related vessels for two millennia at Syme Viannou, these vessels disappeared in the ROM period, at which time there is a notable shift in the repertory of shapes represented and a serious decrease in the overall number of vessels deposited (see Section 5.6). Nevertheless, the

45. But note that P487 is made in MFG C2, while the incision on P413 may not be intentional and is rendered by the handle root.
46. On the Minoan potter's marks from Syme Viannou, see Christakis 2014.
47. Christakis 2014, 48 and 50 fig. 21, 128–129 no. A1 fig. 23, 134 no. C24 fig. 24.
48. Kotsonas 2008, 64–65, with references.
49. The gravity of this second spike depends on whether the bell skyphoi from Syme Viannou cover the full chronological range of the Cretan PG period, i.e., the early 10th to late 9th centuries BCE. The better-preserved specimens date only from the 9th century BCE.
50. Kanta 1991, 490, 494; cf. Prent 2005, 347; Lefèvre-Novaro 2014, 105.
51. Erickson 2010a, 260; 2010b, 228–229 fn. 40, 230.
52. Erickson 2010b, 228–229 fn. 40.

disappearance of cups and related vessels is not site-specific and conforms to an island-wide pattern of decline of the cup from all kinds of contexts.[53]

The spatial distribution of cups and related vessels in the different parts of the sanctuary of Syme Viannou shows interesting patterning. In absolute terms, most pieces come from the Terraces and the Water Channel (over 100 pieces), while considerably fewer cups (over 70) were found in the Area of the Altar. Other areas produced far fewer cups and related vessels: the Central and South-Central Part of the Podium yielded over 30 specimens, while a few areas yielded circa 20 specimens (the Area of the Protoarchaic Hearth, the North Part of the Enclosure and the Podium),[54] or between five and a dozen pieces (Building E and its Immediate Surroundings, Building C-D and its Immediate Surroundings, the West Part of the Enclosure). It is also worth considering, on the one hand, the ratio between cups and related vessels from a certain area and, on the other, the total number of inventoried pieces from the same area. In most areas, cups and related vessels make up a half (the Central and South-Central Part of the Podium, the Area of the Protoarchaic Hearth, the West Part of the Enclosure, the North Part of the Enclosure and the Podium) to a third (the Area of the Altar, the Terraces and the Water Channel, Building E and its Immediate Surroundings) of the assemblage.[55] Significantly, the ratio drops to one fifth in the case of Building C-D and its Immediate Surroundings, which has yielded the latest material from the site. This is indicative of broader changes in the ceramic repertory used at the sanctuary in the ROM period, as explained in Section 5.6.

The different shapes of deep open vessels of small size are attested over varied time spans. Indeed, bell skyphoi dominate the record for the PG period but then disappear and are succeeded by cups and skyphoi – especially from the LG period onward. Skyphoi remain few and do not outlast the PAR period, but cups make up the largest assemblage of vessels from Syme Viannou from the AR to the LHEL period. Varied types of cups appear in HEL times (cylindrical, with everted rim, and very rarely carinated or tulip) during which they co-exist with the few kantharoi identified at the site. The following paragraphs elaborate on the general patterns outlined above, and zoom in on the representation of the different vessel shapes.

Forty-eight pieces from Syme Viannou are identified as bell skyphoi. Many of these fragments are conical feet, the form of which is typical for the PG period; their narrow diameter is indicative of vessels of small size. I consider that these fragments belong to bell skyphoi rather than bell cups because the better preserved pieces show horizontal – as opposed to vertical – handles, and also because of the popularity of the former shape and the rarity of the latter in the Cretan repertory.[56] Most of the bell skyphoi from Syme Viannou are made in MFG C2, but some specimens are made in MFGs E (P13, P91, P368, P413, P457, P480, P485) and C1 (P34, P348, P357, P501), while individual specimens are made in B2 (P639) and perhaps D (P125). Lastly, the MFG of P198 is uncertain, while P369 is a fabric loner. Cretan bell skyphoi were typically dipped from the foot which remains reserved along with the lower body.[57] Most of

53. On ROM cups from Crete, see Forster 2001, 143, 151–153.
54. The same applies to the Material of Unknown or Uncertain Find Context.
55. An intermediate ratio is identifiable for the Material of Unknown or Uncertain Find Context.
56. Coldstream 2001, 51, 55.
57. Coldstream 2001, 51; Kotsonas 2008, 187–188.

Figure 4.3: PAR skyphoi (from left to right P1, P2, P3).

the fragments from Syme Viannou preserve slip, but a number of them are plain, which is not surprising given that many are foot fragments and considering that this body part remained reserved. Bell skyphoi are typical for the Cretan PG period and can be dated more precisely when much of the profile is preserved.[58] This is rarely the case at Syme Viannou, but a few of the better-preserved pieces can be dated more closely to the (MPG)-PGB periods (P485, P486, P519, P594, P677). The majority of the bell skyphoi from the sanctuary were found at the Terraces and the Water Channel. A sizeable group came from the Area of the Altar (P12, P13, P14, P34, P90, P91, P125, P192, P198, P204) and one to three pieces from the Central and South-Central Part of the Podium (P573), the Area of the Protoarchaic Hearth (P594, P619), the West Part of the Enclosure and the Podium (P637, P639), and the North Part of the Enclosure and the Podium (P677, P678, P679). The mostly thin but fairly broad distribution of bell skyphoi over most of the sanctuary (excluding its northeast part) indicates that, during the PG period, activity at the site was not centered exclusively on the Altar which was built at the time. The copious attestation of bell skyphoi at Syme Viannou is paralleled at the sanctuary on the Armi hill of Gortyn and also at Kommos.[59] The paucity of such finds from the sanctuary of Demeter at Knossos and the sanctuaries on the acropolis of Gortyn and the west acropolis of Dreros can be explained by the inauguration of cult practice at these sites after the PG period.

The shallow skyphoi of Mainland type are poorly represented at Syme Viannou by only five specimens (Figure 4.3).[60] Four of these vessels (P1, P2, P3, P4) form a very homogeneous group (they are made in MFG D, they are circa 5.5 cm tall, and they are monochrome) and were found together adjacent to the Altar. This patterning, which contrasts with the overall rarity of the shape at the site, indicates that the four vessels represent a single deposition.[61] The fifth piece (P814) has no certain findspot and may be earlier than the other four. Skyphoi were equally rare at the two Gortynian sanctuaries: The very few pieces from the acropolis are imported from elsewhere in the Aegean,[62] while the sanctuary on the Armi hill yielded no

58. Coldstream 2001, 51; Kotsonas 2008, 187–191.

59. Gortyn: Anzalone 2013, 242 nos 7–9, 248 nos 109–113, 245 nos 257–260, 250 nos 169–171, 251 nos 179–181, 254 nos 241–242 (PG). Kommos: Callaghan and Johnston 2000, 213 nos 2–7, 216 nos 21–25, 217 nos 31–33, 225 no. 128, 226 nos 136–137, 232 nos 188–189, 233 nos 208–209 (PG); Johnston 2000, 195 no. 7 (LPG).

60. It is not easy to distinguish fragments of skyphoi from those of cups, but the ceramic record of Syme Viannou shows a paucity of horizontal handles belonging to small (open) vessels, which contrasts with the abundance of diagnostic cup fragments.

61. Stissi (2009, 28) notes that "beautiful decorated cups were placed close to altars in stacks, directly from the shop." Although the four skyphoi from Syme Viannou carry no elaborate decoration, they may represent such a stack. On the standardization of ceramic vessels, see Kotsonas 2014.

62. Johannowsky 2002, 54 nos 347–349 (examples of the 9th and 7th centuries BCE).

Figure 4.4: LG-AR cups: from left to right P676 (EAR-AR), P651 ((LG)-EPAR), P682 (LG-(EPAR)).

certain example.[63] Skyphoi were slightly more common at the sanctuary on the west acropolis of Dreros, whereas the sanctuary of Demeter at Knossos and especially that of Kommos produced more numerous examples, including imported EIA pieces and Attic CLAS ones.[64]

The inventoried cups from Syme Viannou amount to 223 pieces (including miniature pieces, but excluding fragments which may belong to this shape or another) (Figure 4.4). The high quantity of such vessels conforms to a widely attested pattern according to which "cups are the commonest shapes made in clay and therefore the commonest of the pottery offerings" found in Greek sanctuaries.[65] Roughly three quarters of these cups are made in MFG C2. MFGs A1 and J are represented by a fair number of specimens,[66] while other MFGs are attested only thinly; this includes A2 (P142, P274, P382, P553, P557, P558, P850), B3 (P101), C1 (P63, P103, P357, P602, P813), D (P5, P38, P283 ?, P329 ?, P379), E (P472), F (P387, P854), I (P239, P388, P400, P683, P714) and J (P410). A few pieces are of uncertain fabric (P20, P150, P682) or belong to fabric loners (P275, P278, P366, P459, P518, P682, P779, P785).

The shape of the Cretan cups changed considerably from the EIA to the HEL period, but most synchronic variation (i.e., variation within a single period) is identifiable in HEL times.[67] The more diagnostic specimens from Syme Viannou suggest that, among the different HEL types, cups with everted rim are dominant (P147, P148, P149, P150, P151, P152, P153, P154, P155, P156, P275, P387, P388, P395, P410, P411, P472, P476, P779, P782, P785, P786, P788,

63. Anzalone 2013, 251 nos 179–181 (G ? cups/skyphoi).
64. Dreros: Kotsonas forthcoming. Knossos: Coldstream 1973b, 20 nos A7–A20 (LG), 25 nos B12–B13 (MCLAS), 40 no. H31 (LCLAS/EHEL), 45 nos H135–H136 (CLAS-MROM), 52 nos K1–K2 (Attic and Corinthian MG pieces). Kommos: Callaghan and Johnston 2000, 217 no. 34 (Attic/Cycladic MG), 219 nos 46–47 (PG-G), 223 no. 99 (Cycladic EG), 226 no. 139 (Attic MG), 228 no. 158 (Attic/Cycladic MG), 233 no. 212 (PG), 236 no. 236 (East Greek, 7th century BCE), 239 nos 256 and 258 (G), 240 no. 266 (LG), 241 no. 277 (EPAR), 243–244 nos 313–323 and 326–327 (imports of the 7th century BCE), 246 nos 358–360 (mostly imports, largely of the 7th century BCE), 253 no. 422 (Attic LCLAS), 255 no. 440 (Attic LCLAS), 257 no. 454 (Attic LCLAS), 262–263 nos 502–503 and 512–515 (Attic and Atticizing MCLAS-LCLAS); Johnston 2000, 212–214 nos 80–93, 223 no. 126 (MG-LG); 2005, 324 nos 46–48 (PG), 329–331 nos 73–76 (G, including imports), 354–355 nos 163–165 (LG-PAR, including an import), 376–377 nos 250–254 (Attic CLAS).
65. Boardman, Mannack and Wagner 2004, 307.
66. MFG A1: P141, P170, P175, P186, P206, P474, P515, P550, P554, P555, P556, P609, P613, P650, P651. MFG J: P53, P147, P148, P245, P265, P355, P411, P449, P527, P617 (?), P797, P847, P848, P849, P852, P855.
67. Coldstream 2001, 55–57; Coldstream and Eiring 2001, 78–80; Eiring 2001, 92–97; Englezou 2005, 149–165; Kotsonas 2008, 197–215.

P848, P849, P850); cylindrical cups, which represent "the most characteristic shape of Cretan ... Hellenistic table ware,"⁶⁸ are not uncommon (P20, P145, P245, P258, P329, P527, P615, P616, P617, P853), but tulip cups (P110, P801) are very rare. Synchronic variation in morphological traits is much less pronounced in other periods (Figure 4.5); however, the copious specimens of the little known AR period can be distinguished on the basis of the morphology of their base into: a) cups with disc base with slightly raised resting surface, which I assign to the LPAR-LAR period;⁶⁹ b) cups with flat or low disc base with stepped underside, which are here dated to the EAR-AR period;⁷⁰ and c) cups with low conical foot with stepped underside, which I assign to the AR-LAR period.⁷¹ The last type of base has been studied in detail by Erickson, but the dating of the other two types is not well established and relies on comparisons I have identified elsewhere in Crete, as noted in Chapter 2.

Most of the cups from Syme Viannou are coated. Indeed, the coated cup is the most popular vessel type in Crete of the EIA, and perhaps also of the AR and CLAS periods.⁷² In a few cases, coating is combined with incised decoration (P154, P355, P449, P690). Other decoration is very rare. Dipping is limited to the single PG cup from the site (P283), and perhaps a second, MHEL example (P111). Pattern painted (P170, P523, P819) and stamped (P608) decoration is equally rare. Plain cups are more common (P110, P141, P142, P156 ?, P175, P180, P186, P206, P258, P274, P275, P387, P410, P515, P550, P553, P554, P555, P556, P557, P558, P613, P651, P702), although this may be partly due to the effects of preservation (i.e., the wearing of the slip). Most of these vessels are CLAS-HEL in date, are made in MFGs A1, A2 and C2, and were found in the Area of the Altar, and the Terraces and the Water Channel.

The chronological distribution of the cups from Syme Viannou recalls the distribution of the larger assemblage of small, deep open vessels; however, it also presents a single notable departure and some slight variation. The notable departure regards the earliest period covered here (PG-MG), which is represented by only two or three cups (P283, P382 and perhaps P813). Numbers rise slightly during the LG-PAR period, while the AR period sees the major spike identified above with reference to the full range of small, deep open vessels. Numbers drop considerably during CLAS times and remain at this level in the HEL period, by the end of which the cup basically disappears from Syme Viannou and the rest of Crete. The remarkable ebb and flow in the number of cups deposited at the sanctuary across the Greek and Roman period undermines Erickson's hypothesis that these vessels are connected to the maturation rituals which are thought to have been held at the site continuously from the PG to the HEL or the ROM period.⁷³ More specifically, Erickson linked the preponderance of AR cups at Syme

68. Eiring 2001, 92.

69. Cf. Coldstream 1973a, 41 no. H58 (late 7th century BCE); Johnston 2000, 343 nos 1 and 8 (late 7th century BCE); Callaghan and Johnston 2000, 246 no. 345 (late 7th century BCE); Erickson 2002, 58 nos 42–45 (500–475 BCE); 2010a, 94 nos 148–149 (6th century BCE).

70. Cf. Johnston 1993, 343 no. 5 (Kommos); Callaghan and Johnston 2000, 246 no. 353 (Kommos); Erickson 2010a, 125, 127 fig. 4.5.

71. Erickson was the first to document this type in detail on the basis of material from Syme Viannou (Erickson 2002, 53–54 nos 19–27).

72. Kotsonas 2019a, 597.

73. On the maturation rituals held at Syme Viannou, see especially: Lebessi 1985b, 188–198; 1991b, 163–165; 2002b,

Figure 4.5: Drawings and hypothetical reconstructions of cups dating from the EPAR to the LCLAL period, which document the development of the shape before the introduction of diverse HEL types: from left to right and top to bottom P651 ((LG)-EPAR), P655 (LPAR-AR), P676 (EAR-AR), P214 (AR-LAR), P540 (AR-LAR), P328 (ECLAS-MCLAS), P612 (ECLAS-MCLAS), P140 (MCLAS), P187 (LCLAS). The reconstructions are based on Erickson 2002, 62 fig. 14 (for P140 and P187); 2010a, 136 fig. 4.10 nos 293-294 (for P328 and P612); Haggis et al. 2007, 351 fig. 6 (for P214 and P540).

Figure 4.6: Miniature handleless cups: from left to right P10 and P11 (CLAS ?), P62 (ECLAS-MCLAS).

Viannou and the attestation of two G-PAR figurines of men holding cups with the Cretan maturation rituals described by Strabo (10.483), which involved an older lover gifting a cup to his younger lover.[74] Although I concur that maturation rituals were held at Syme Viannou, I find that the direct connection of the clay cups excavated at the site with the time-honored custom of cup-giving mentioned by Strabo in the context of maturation rituals must remain tenuous. This is partly because the deposition of cups at the site fluctuated markedly over time, and partly because the spike in their deposition in the AR period is associated with a spike in the deposition of fast-pouring vessels, which indicates the combined use of these containers in ritual practice.

Cups make up roughly 75% to 85% of the small deep open vessels in the different areas of the sanctuary. There are two notable exceptions to this pattern. On the one hand, all thirteen small, deep open vessels from Building E were cups (100%). On the other hand, cups amounted to circa 65% of the small, deep open vessels from the Terraces and the Water Channel, which yielded by far the largest number of these vessels.

Special reference should be made to a group of three cups with bell-shaped, handleless body (Figure 4.6), which are too small to fulfill the formal function of the shape.[75] The miniature cups from Syme Viannou are either coated in slip (P10, P11) or carry grooving (P62), and originate from the Area of the Altar. Miniature pottery is commonly attested at Greek sanctuaries from the PAR to the HEL period,[76] but at Syme Viannou this material is limited to the three CLAS cups in question in addition to a hydria of CLAS-HEL date (P19, see Section

269–282; 2009, 533–538; 2021, 135–138, 143, 145, 148–151, 191, 202; Lebessi and Stefanakis 2004, 186–187. On the introduction of these rituals in the 11th to 10th century BCE see: Lebessi 2002b, 278, 280–281; 2009, 533; 2021, 136. Lefèvre-Novaro (2014, 118) follows Lebessi, but Koehl (1986) traces these rituals back to the Minoan period (*contra* Lebessi 2000b, 175; Prent 2005, 579–580). Coversely, Prent (2005, 578–582) is skeptical and considers that these rituals were perhaps introduced in the 8th century BCE. The discussion is centered on the male maturation rituals, and has largely overlooked those for young females, the introduction of which is placed in the early 7th century BCE (Lebessi 2021, 143, 145). Lebessi (1985b, 197; 2018–2019; Lebessi and Stefanakis 2004, 186, 187) once hypothesized that these rituals continued into the ROM period, but more recently she accepted the possibility that the Roman conquest interrupted them (Lebessi 2021, 191, 202), as argued previously by Chaniotis (2009, 65).

74. Erickson 2010a, 261. The two figurines include one published bronze specimen of the MG period (Lebessi 2002b, 81–86, 219–222 no. 17) and a then unpublished terracotta piece (mentioned in Erickson 2010a, 261 fn. 122, and now published in Lebessi 2021, 19–20, 39–40 no. 91; see Section 4.1).

75. Cf. Morgan 1999, 325.

76. Recent studies include Barfoed 2018; Pemberton 2020.

4.8) and three G-PAR aryballoi (P92, P649, P792, see Section 4.7). In Cretan EIA sanctuaries, "there are ... only few recorded instances of miniature vessels."[77] Miniature vessels, especially drinking vessels, like the three specimens from Syme Viannou, appear more commonly in Cretan sanctuaries during the CLAS-HEL periods. At the Knossian sanctuary of Demeter, "the number of miniature vessels is legion" during the MCLAS-MHEL period,[78] and it includes krateriskoi, hydriiskai, cups, and skyphoi.[79] Coldstream assumed that "as offerings to Demeter, they [these miniature vessels] are more likely to have contained grain or other solid fruits of the earth."[80] CLAS-HEL miniatures are also known from other Knossian cult sites: two dozen miniature open vessels were found at the sanctuary of Rhea,[81] and a broader range of miniature forms was represented at the sanctuary of Glaukos.[82] Elsewhere in Crete, finds are less numerous. A thin scatter of PG to HEL miniature open vessels was identified at Kommos,[83] CLAS-HEL miniatures were found at Vryses and Roussa Ekklesia,[84] while a few specimens are known from an ECLAS deposit at Priniatikos Pyrgos.[85]

The single kotyle from Syme Viannou (P537) comes from the Central and South-Central Part of the Podium, is made in MFG B3, and dates to the AR period.[86] A few earlier LG-PAR kotylai are known from the sanctuary of Demeter at Knossos and from Kommos.[87] Kotylai were not attested at the two Gortynian sanctuaries. The single kylix from Syme Viannou (P459) is an Attic specimen from the Terraces and the Water Channel. Attic kylikes are generally missing from Cretan sanctuaries with the notable exception of Olous.[88]

The analysis of deep open vessels of small size closes with the kantharoi, which are few in number and HEL in date. Most pieces are Cretan and are made in MFGs J (P47, P233, P298, P301, P354) and C2 (P843); however, P314 is an import, probably from the Greek Mainland. Kantharoi were found in the Area of the Altar (P47), and especially at the Terraces and the Water Channel (P233, P298, P301, P314, P354), while P843 is among the Material of Unknown or Uncertain Find Context. Kantharoi are rare in Cretan sanctuaries. A single possible example comes from the Armi hill and two from the acropolis of Gortyn,[89] a few vases

77. Prent 2005, 419. Prent identified groups of miniature vessels only at Aimonas near Axos (Prent 2005, 251, 504) and at Praisos Vavelloi (Prent 2005, 308). Nevertheless, she also noted that "many assemblages" from suburban sanctuaries contained "miniature vessels" in addition to terracotta animal figurines and kernoi (Prent 2005, 499).
78. Coldstream and Higgins 1973, 183.
79. Coldstream 1973b, 25 nos B12–B15 (MCLAS), 27 nos C19–C21 (MCLAS/LCLAS), 29–31 nos D16–D20 (LCLAS-EHEL), 37 (EHEL-MHEL), 39, 45 nos H120–H137 (CLAS-MROM).
80. Coldstream and Higgins 1973, 183.
81. Popham 1978, 186; Coldstream 2000, 286–288 nos J1–J11 (CLAS-HEL).
82. Callaghan 1978, 20–23, 27–28.
83. Callaghan and Johnston 2000, 301.
84. Vryses: Zois 1976, 61–62 (CLAS miniature hydriai). Roussa Ekklesia: Erickson 2010b, 229–230 (ample CLAS-HEL miniature cups, bowls and juglets).
85. Erickson 2010c, 332 fn. 63 (two Corinthian kotyliskoi and three local miniatures).
86. The piece is published in Erickson 2002, 51–52 no. 9 (575–550 BCE).
87. Knossos: Coldstream 1973b, 20 nos 13–14 (LG-EPAR). Kommos: Callaghan and Johnston 2000, 240 no. 269 (Corinthian, 7th century BCE), 241 nos 284–285 (PAR), 243 nos 306–312 (Corinthian, late 8th and 7th centuries BCE), 246 nos 361–362 (Corinthian, late 8th and 7th centuries BCE); Johnston 2000, 223.
88. Apostolakou and Zografaki 2006, 98, 100–104.
89. Armi: Anzalone 2013, 250 no. 153 (EHEL). Acropolis: Johannowsky 2002, 105 nos 612–613 (EHEL-MHEL).

come the west acropolis of Dreros[90] and from Kommos,[91] while a sizeable group is only known from the sanctuary of Demeter at Knossos.[92] The Knossian sanctuary of Glaukos also yielded a number of kantharoi.[93]

4.3. Deep Open Vessels of Large to Medium Size (Cauldrons, Dinoi, and Kraters)

Cauldrons: P456, P478, P620

Dinoi/Stamnoi: P100, P196

Kraters: P65, P66, P67, P77, P83, P84, P94, P95, P106, P113, P115, P116, P124, P128, P136, P185, P221, P222, P264, P272, P289, P352, P370, P398, P466, P493, P494, P532, P563, P572, P652, P658, P680, P811

Krater/Dinos: P138

Krater/Jar: P846

Deep open vessels of large to medium size are typically considered to have served the mixing of wine and water.[94] The specimens identified at Syme Viannou are mostly kraters and – to a much lesser extent – cauldrons and dinoi.[95] None of these pieces could be associated with the few griffin and ram protomes from the site which were published as probable attachments to dinoi.[96]

The vast majority of the kraters, cauldrons, and dinoi from Syme Viannou are made in MFG C and are divided almost evenly between C1 and C2. Only a few vessels are ascribed to MFGs A1 (P100, P196, P398, P563), A1a (P478), D (P116, P456), and F (P466), and there is also a fabric loner (P138). The kraters and related vessels are typically pattern painted or coated (fully or partly). Plain examples are uncommon and include a few PAR to CLAS dinoi (P100,

90. Kotsonas forthcoming.
91. The material from Kommos includes some G-PAR specimens that are not closely connected to the CLAS and HEL shape, which is represented thinly: Callaghan and Johnston 2000, 264 no. 528 (LCLAS), 270 no. 592 (LHEL ?); Johnston 2000, 214 nos 94–96, 220–222 nos 122 and 132 (MG-LG pieces, two of which imported); 2005, 331 no. 78, 354 no. 161 (LG-PAR), 379 no. 264 (Attic LCLAS).
92. Coldstream 1973b, 26 no. C11 (MCLAS), 29 nos D6 and D9–11 and D13 (EHEL), 32 nos E4 and E6–E7 and E10–E11 (MHEL), 35 nos F1–F8 (MHEL), 36 no. F11 (MHEL), 38 no. G5 (MHEL), 40 nos H19–H25 (LCLAS), 42 no. H60 (HEL), 43 nos H84–H90 (HEL), 46 nos H138–H140 (HEL), 53 no. K12 (HEL), 54 nos K15–K16 (HEL).
93. Callaghan 1978, 10–11 nos 24–26 (CLAS), 19–20 nos 72 and 75–78 (HEL).
94. Coldstream 2001, 46–47; Kotsonas 2008, 183; 2011a, 944.
95. For bronze stands from Syme Viannou, which must have supported cauldrons, see Papasavvas 2001, 247 no. 38, 249 no. 47, 254–255 nos 54 and 56 (on their date see pages 178, 192).
96. Muhly 2008, 94–98, 105–107 nos 281, 285, 289–290.

P138, P196) and PAR to MHEL kraters (P398, P563, P652). One small krater (P466) and two cauldrons (P456, P478) carry simple decoration in relief.

The kraters, dinoi, and cauldrons from Syme Viannou largely date from the PG to the LCLAS period. Only two pieces are later and date to the HEL period (P398, P466). A spike in numbers is clearly identifiable in the PAR and AR periods, at which time there is also a spike in the number of cups and related vessels (Section 4.2). The Area of the Altar produced half of the deep open vessels of large to medium size, mostly of the EIA to the AR period, while other areas yielded fewer specimens and of more varied date. These areas include the Terraces and the Water Channel which yielded only slightly fewer pieces than the Area of the Altar, as well as the Central and South-Central Part of the Podium, the Area of the Protoarchaic Hearth, and the North Part of the Enclosure and the Podium, which produced fewer than five examples each.[97] Kraters, dinoi, and cauldrons were missing from the West Part of the Enclosure and the Podium, as well as from the buildings on the northeast part of the site (Building E and its Immediate Surroundings, Building C-D and its Immediate Surroundings).

Kraters and related vessels are represented unevenly in different Cretan sanctuaries. In the two sanctuaries of Gortyn, kraters are basically limited to the EIA. However, while the pieces from the Armi hill are PG and – to a lesser extent – G,[98] the more numerous pieces from the acropolis hill date to the PAR period.[99] The west acropolis sanctuary at Dreros yielded a limited number of EIA to ECLAS – but mostly PAR – kraters.[100] At the sanctuary of Demeter at Knossos, kraters are attested from the EIA to the MHEL period, with most specimens dating from the LG-EPAR and the MHEL periods.[101] Lastly, a "large number of kraters" of the EIA was found at Kommos, where the shape fell in "demise" during the PAR period.[102] This demise has raised the possibility that bronze mixing bowls were used at the site at the time.[103] Kraters reappear in "fair numbers" at Kommos during the CLAS period,[104] while later (HEL-ROM) examples are extremely few.[105]

The representation of kraters at Syme Viannou and other Cretan sanctuaries relates to the broader discussion over the ebb and flow of the krater in the archaeology of Greece in general and Crete in particular, which has received considerable attention in the last quarter century. With respect to the archaeology of Crete, Coldstream was the first to observe that

97. This also applies to the Material of Unknown or Uncertain Find Context.

98. Anzalone 2013, 232, 242 nos 1–6 (PG kraters), 245 nos 52–56 (several PG kraters and one G), 247 nos 103–108 (several PG kraters and one G), 250 nos 167–168 (PG kraters).

99. Johannowsky 2002, 47–49 nos 305f–318 (PAR dinoi), 56–57 nos 359–373 (PAR kraters), 107 no. 639 (Attic AR).

100. Kotsonas forthcoming.

101. Coldstream 1973b, 18–20 nos A1–A7 (LG-EPAR kraters), 21 no. A32 (EIA krater), 26 no. C6 (MCLAS/LCLAS krater), 32 nos E5 and E12 (MHEL kraters), 38 nos G2, G4, G10–G12 (MHEL kraters), 53 no. K9 (MCLAS krater).

102. Callaghan and Johnston 2000, 300. I have quantified the EIA kraters from Kommos in Kotsonas 2011a, 945. A less comprehensive quantification appears in Whitley 2005, 48, 52; 2015, 294–295. For a related brief note see Rabinowitz 2014, 103–104.

103. Callaghan and Johnston 2000, 301.

104. Callaghan and Johnston 2000, 301. But note that the inventoried pieces are few: Callaghan and Johnston 2000, 265 no. 553; Johnston 2005, 373–374 nos 238–242.

105. Callaghan and Johnston 2000, 281 no. 688 (HEL); Hayes 2000a, 318 no. 40 (ROM).

kraters were popular in Knossian burials during the PG period, but became rare in the G-PAR periods.[106] Likewise, Whitley documented the demise of the krater in EIA domestic contexts at Knossos and in the temple deposits at Kommos.[107] My own survey of the attestation of kraters in EIA Crete produced varied results:[108] kraters were found to be common in Cretan settlements throughout the EIA; cemeteries in central to east Crete were shown to yield abundant PG finds but only a few G-PAR examples; and the evidence from sanctuaries was considered limited and inconclusive. On this basis, I argued that Cretan cups, which were much enlarged in size during the G and PAR periods, may have replaced the kraters in their use as mixing bowls in extra-urban contexts.[109] More recently, the discussion of the topic has focused on the persistence of Cretan kraters into the AR period, with emphasis on the evidence from Azoria.[110]

The attestation of the krater in later periods of Cretan antiquity has not been addressed by scholarship. Indeed, this scholarship has overlooked the paucity of kraters in Cretan sanctuaries during the AR to ROM periods, which was sketched above. Knossos presents a notable exception to this pattern, since the sanctuaries (and settlement contexts) of the site have yielded ample kraters, which have hitherto nearly monopolized the largely typological discussions of Cretan kraters in the HEL period.[111] The shape is poorly attested elsewhere in Crete of the HEL period, excluding a small assemblage from the urban area of Gortyn in which HEL kraters are adequately represented.[112] Beyond central Crete, Laftsidis identified a small number of finds from settlement sites,[113] but these include pieces, the size of which suggests "small scale drinking or individual service."[114]

The paucity of the krater in HEL (and earlier) Crete may partly depend on problems of identification and issues of classification. Indeed, I wonder whether the large shallow bowls classified here as lekanai, which present a spike at Syme Viannou in the EHEL-MHEL period (see Section 4.5), could have functioned as kraters (thus recalling modern punch bowls). This is worth considering especially since some of these lekanai are no shallower than some types

106. Coldstream and Macdonald 1997, 238; Coldstream 2001, 51. Some scholars assume continuous popularity of the krater in Knossian EIA tombs (Whitley 2004, 438; Rabinowitz 2014, 101–103, 105), but I am not convinced, as explained below.

107. Whitley 2005, 47–50; 2015, 294–295; 2018, 238–239. Whitley, however, did not cover the entire assemblage of kraters from EIA Kommos, on which, see Kotsonas 2011a, 945.

108. Kotsonas 2011a, 944–946.

109. Kotsonas 2011a, 946–950. Also Wecowski 2014, 299–300.

110. Haggis 2014, 133, 135–138, 148–151; 2018, 110–111; Rabinowitz 2014, 106; Whitley 2014, 156–157; Kotsonas 2016b, 269.

111. On kraters from the sanctuary of Demeter see fn. 101 above. Eiring (2001, 98) and Englezou (2005, 218–221) discuss a fair number of pieces from Knossian sanctuaries and settlement contexts, but hardly any example from elsewhere in Crete. Laftsidis (2018, 609, 628, 639–640, 674–677, 691) also focuses on Knossos but offers a broader perspective. Laftsidis (pers. comm.) informs me that, leaving Knossos aside, all Cretan kraters in his database of HEL pottery come from settlement contexts (with the exception of a single burial find from Gortyn).

112. Laftsidis 2018, 639, with reference to De Tommaso 2011, 80 crateri nos 1–4, 81 crateri no. 1.

113. Laftsidis 2018, 609, 628, 639. The publication of two kraters from Lato includes a reference to sherds from vessels of comparable style, but it does not specify if this regards specifically kraters (Ducrey, Hadjimichali and Picard 1971, 253–260).

114. Laftsidis 2018, 639.

of Attic and Corinthian kraters of the HEL period.¹¹⁵ In any case, the demise of the krater in HEL Crete can be taken to conform to the broader phenomenon of the "missing krater," which Susan Rotroff identified in HEL Athens and elsewhere in the Greek world, especially after 175 BCE.¹¹⁶ Rotroff considered that this phenomenon may be due to a shift from clay to metal kraters, but concluded that it probably represents the habit of mixing wine and water in smaller vessels, for individual use, which reshaped the practice of communal drinking in the HEL period. The Athenian pattern does not apply to some Aegean regions.¹¹⁷ At Corinth, kraters remained popular until the destruction of the city in 146 BCE, but Sarah James has observed a notable shift in the attestation of the vessel, from public and ritual contexts in the LCLAS period, to HEL domestic contexts.¹¹⁸

The question of the role of the krater in HEL Crete can be illuminated by a passage of the EHEL historian Dosiadas, which describes the syssitia held on the island, specifically at Lyktos/Lyttos (apud Athenaeus 4.143; *FGrH* 458 F2). Dosiadas explains that, at the Cretan syssition, "on each table is placed a cup filled with wine much diluted (ποτήριον κεκραμένον ὑδαρῶς); this is shared by all who are at the same table, and a second cup is served after they have finished the meal. For the boys (τοῖς παισὶ) a mixing-bowl ("krater") is prepared which they share in common (κοινὸς κέκραται κρατήρ), but permission is given the older men to drink more if they desire" (translation by C.B. Gullick, London, 1928).

Scholars have developed different ideas on the vessels mentioned by Dosiadas. Aikaterini Mandalaki has taken the ποτήριον to designate a jug.¹¹⁹ Adam Rabinowitz has observed that "Dosiadas seems to describe adult drinking without kraters,"¹²⁰ while Erickson has noted that the ancient author "states that the adult banqueters from each table drank from a single cup, while the boys collectively shared a wine mixer."¹²¹ I am skeptical over these interpretations. Indeed, I find that the identification of the vessel form assumed by Mandalaki has no obvious basis, while the identifications proposed by Rabinowitz and Erickson rely on the questionable assumption that the ancient vessel shapes mentioned by Dosiadas (ποτήριον and κρατήρ) match the forms that we – modern scholars – call cup and krater respectively. My skepticism further extends to the identification of the ποτήριον of Dosiadas with a small vessel and his κρατήρ with a large vessel. This skepticism is grounded on the impression that the spirit of the Cretan syssition, as conveyed in this passage and in other textual sources,

115. Rotroff 1997, 135-139, with reference to mostly bolster kraters and lug-handled kraters; James 2018, 125-126, with reference to bolster kraters.

116. Rotroff 1996; 1997, 14-15. Although the quantitative data used by Rotroff regard the Athenian Agora specifically, she seems confident that the pattern also extends elsewhere in Athens and the Greek world (cf. Lynch 2015, 261; 2018, especially 246-247). At Corinth, ample specimens are attested until the early 2nd century BCE (James 2018, 121-122; 2019). Laftsidis (2018, 435-436, 572) has found that kraters are adequately represented in Boeotia, Rhodes, and Naxos in the HEL period.

117. Laftsidis 2018, 435-436, 572.

118. James 2018, 121-122; 2019.

119. Mandalaki 2004, 217.

120. Rabinowitz 2014, 92 (also page 95).

121. Erickson 2010a, 326 fn. 77; 2011, 388 fn. 28 (cf. Wecowski 2014, 109). Erickson pays more attention to the architectural correlates of the syssition, as deduced from the text of Dosiadas (see, e.g., Erickson 2010a, 309-311, 316-317; 2011, esp. 381-383, 386).

cannot have the boys, who drink together from a κρατήρ, consume more than the adult men, who drink together from two ποτήρια.¹²² To avoid this paradox, we have to accept that the ποτήριον κεκραμένον and the κρατήρ of Dosiadas do not correspond to what we call a cup and a krater. Indeed, I am inclined to think that the two different names may not stand for two different forms, as indicated by their shared etymological connection to the verb κεράννυμι (to mix). Perhaps the former term is the original one used in Crete and cited by Dosiadas, while the latter is Athenaios' "translation."¹²³ If we take the ποτήριον κεκραμένον and the κρατήρ as alternative names for the same vessel shape, we would read in this passage that the adult men consumed twice the amount of wine consumed by the boys, which makes sense. This reading would correspond very well to the reference of Dosiadas (in this same passage) to the mode of dividing the food in the Cretan syssitia: "An equal portion of the food on hand is served to each person, but only a half-portion of meat is given to the younger men (τοῖς νεωτέροις)."¹²⁴

What kind of vessel form is the ποτήριον/κρατήρ likely to be? I think we can take that the sharing of the content of a ποτήριον by an unspecified – but clearly considerable – number of adult men seated around a table implies that this vessel was closer to the size of what we call kraters than what we call cups. My conclusion that Dosiadas actually refers to the use of large mixing bowls (i.e., krater-like vessels) in the Cretan syssitia may relate to the – admittedly patchy – attestation of kraters in HEL settlements (as opposed to the paucity of these vessels in other contexts).¹²⁵ Notwithstanding the uncertainties of the Cretan archaeological and textual record over the use of the krater in HEL times, I think that the demise of the shape on the island should be approached in light of earlier developments, starting from the demise of the krater in Cretan extra-urban contexts already in the G and PAR periods.

4.4. Shallow Open Vessels of Small Size (Bowls, Dishes, Plates, and Trays)

Bowls: P80 (moldmade ?), P146, P160 (one-handler), P161 (echinus bowl), P238 (omphalos bowl), P266 (bowl with flaring lip), P285 (bowl with flaring lip), P337, P418, P513, P539, P775 (echinus bowl), P793 (one-handler)

122. On wine drinking in textual sources for ancient Crete, see Mandalaki 2004, 216–218.
123. I owe this observation to David Sider (pers. comm.), and I thank both him and Donald Haggis for their feedback on my reading of this passage.
124. This division of the food in Cretan syssitia is also reported by the Hellenistic author Pyrgion (apud Athenaeus 4.22; *FGrH* 467 F1) in a passage which presents notable similarities to the text of Dosiadas. The term νεώτεροι, which is used in the phrase of Dosiadas cited above, is usually taken to match the παῖδες mentioned by him in the same passage, and the two are considered to refer to the same age group (Mandalaki 2004, 215; Wecowski 2014, 109. Pyrgion uses the term νεώτατοι and seems to refer to minors). My argument holds even if the παῖδες are considered as a sub-group of the νεώτεροι.
125. The contrast is more pronounced in HEL Corinth (James 2019, 514–515).

Bowls/Plates: P177, P257, P288, P294, P303, P307

Dish: P777

Plates: P647, P771, P857

Trays: P243, P342, P595, P741

The considerable number of cooking vessels (see Section 4.11), the large amount of animal bone, and the small quantity of marine remains recovered from the sanctuary of Syme Viannou indicates that food was cooked and consumed at the site.[126] Small shallow open vessels, however, which are usually related to food consumption, are not numerous. The rarity of such vessels – especially plates – in Greek sanctuaries and other contexts is well-known,[127] and also encompasses Cretan cult sites, as explained below. Stissi observed that "pottery for ordinary meals and in any way associated with food consumption is virtually absent at shrines" of the PAR and AR periods.[128] This absence has invited different interpretations. Stissi speculated that small shallow open vessels may have been "the victims of selective publication" of sanctuary assemblages,[129] but Morgan argued that their paucity could be better explained by the hypothesis that food consumption mostly involved deeper clay vessels such as cups and skyphoi, or vessels made in perishable materials (such as wood).[130]

The bowls, dishes, plates, and trays found at the sanctuary of Syme Viannou show some patterning with reference to fabric, decoration, and date. Most of the vessels are made in MFGs C1 and C2, while a range of other MFGs are represented by a few pieces. This includes A1 (P266, P539), E (P303, P775), and J (P161, P793). There is a relatively high number of fabric loners (P160, P307, P342, P771, P777), a single piece of uncertain fabric (P288), and a Knossian specimen (P418).

The vessels in question are typically monochrome, with two vases combining monochrome and relief decoration (P80, P418). Plain specimens (P160, P266, P307, P337, P539) and pieces with patterned decoration (P342, P595) are uncommon, while a single vessel (P777) is glazed.

Most of these vessels date to the HEL period during which bowls, dishes, plates, and trays first became common in the ceramic repertory of Crete and beyond.[131] Earlier (P238,

126. See fn. 36 above.

127. Morgan 1999, 261, 322–323; Stissi 2009, 249.

128. Stissi 2009, 249. Elsewhere, Stissi (2002, 249) notes that "the few relatively fully published assemblages indicate that pottery related to ... consumption of food definitely played a small part at some sanctuaries."

129. Stissi 2009, 249.

130. Morgan 1999, 322–323. For the hypothesis that clay "drinking" vessels were used for eating see also Risser 2015, 94.

131. On Cretan bowls (which encompass specific types of shallow open vessels rather than a full range of small open vessels), see: Coldstream and Eiring 2001, 85; Eiring 2001, 98–104; Forster 2001, *passim*; Englezou 2005, 256–268; Laftsidis 2018, 619–620, 641, 681–682, 698–699, 700–701. On Cretan plates, see: Coldstream 2001, 59; Coldstream and Eiring 2001, 82; Eiring 2001, 104–106; Forster 2001, 141, 151; Englezou 2005, 249–255; Laftsidis 2018, 618–619, 642–643, 683, 699–700. On Cretan trays, see: Coldstream 2001, 59–60; Englezou 2005, 255–256; Kotsonas 2008, 230. On the introduction and the marked increase in the popularity of small shallow open vessels in Athenian contexts ca. 300 BCE, see Lynch 2015, 258.

P243, P342, P513, P539, P595, P741) specimens are few and largely date to the PAR-AR period. Later specimens are even fewer and include a MROM (P337) and a MBYZ (P777) piece. The chronological distribution of these vessels does not correspond to that of the cooking vessels, which peaks in the EIA and shows a lower spike in the LHEL period (see below), thus complicating our understanding of food consumption at the site.

Half of the bowls, plates, trays and dishes from Syme Viannou were found at the Terraces and the Water Channel. One to five pieces originate from the Area of the Altar, the Central and South-Central Part of the Podium, the Area of the Protoarchaic Hearth, Building E and its Immediate Surroundings, and Building C-D and its Immediate Surroundings, while one piece is among the Material of Unknown or Uncertain Find Context. Interestingly, all five pieces from the Area of the Altar date to the HEL period.

Other Cretan sanctuaries with large ceramic assemblages confirm the rarity of bowls, plates, and trays. The sanctuary on the acropolis of Gortyn yielded a few plates of mostly PAR date,[132] while the sanctuary on the Armi hill produced a single HEL piece.[133] The plate and the tray are not represented at the sanctuary on the west acropolis of Dreros, while bowls remain few and date from the PAR to the HEL period.[134] A fair number of fragments from such vessels, especially of LCLAS to HEL date, were discovered at the sanctuary of Demeter at Knossos.[135] At Kommos "the standard-sized plate is a rarity,"[136] and the same applies to trays; however, bowls are better represented.[137] At Kommos, as at Syme Viannou, the number of these vessels increases sharply in the HEL period, with a much lower spike in PAR times.

132. Johannowsky 2002, 55–56 nos 356–358j (PAR plates), 105 no. 617 (CLAS plate).
133. Anzalone 2013, 250 no. 151 (HEL plate).
134. Kotsonas forthcoming.
135. Coldstream 1973b, 20 no. A15 (LG plate), 22 no. B4 (MCLAS plate), 27 no. C14 (MCLAS/LCLAS plate), 29 nos D1–D5 (four bowls and one one-handler of the LCLAS-EHEL period), 32 no. H13 (HEL tray), 36 nos F12–F14 (MHEL bowls), 39 no. G15 (MHEL bowl), 41–42 nos H40–H52 and H66 (LCLAS-EHEL bowls), 42–43 nos H68–H78 (CLAS-HEL trays), 45 nos H135–H136 (HEL trays), 47 nos J8–J9 and J11 (EROM bowls), 48 no. J19 (EROM tray), 52–53 nos K10–K11 (MCLAS bowls), 54 nos K22 and K24 (HEL bowl and tray).
136. Callaghan and Johnston 2000, 301.
137. Johnston 1993, 349 nos 39 and 41 (PAR bowls); Callaghan and Johnston 2000, 213 nos 8–9 (SMIN bowls), 237 no. 242 (PAR bowl), 241 nos 282–283 (PAR tray/plate and bowl), 247, nos 364–366 (PAR bowls), 252 no. 411 (LPAR bowl), 254 no. 431 (LCLAS bowl), 257 no. 455 (LCLAS bowl), 272 nos 607–609 (LHEL bowl and saucers), 280 nos 669–672 and 674 (HEL bowls and saucers), 282 nos 706–707 and 709 (HEL bowls), 283–284 nos 720–727 (HEL saucers and bowls), 288 nos 805 and 810 (HEL saucer and plate), 289 nos 815–821 and 823–826 (LHEL-EROM bowls and saucers), 290 nos 832–835 (LHEL/EROM-EROM), 292–293 nos 857–866 (LHEL bowls and saucers), 296 no. 834 (EROM bowl), 296–297 nos 904–910 (LHEL/EROM saucers and bowls); Hayes 2000a, 315 nos 5–6 and 10–13 (EROM bowls and plates), 316 nos 16 and 22 (EROM bowls); Johnston 2005, 325 nos 52–54 (PG tray and bowls), 355 nos 166–169 (PAR bowls), 357–358 nos 173–175 (LG-PAR), 377 nos 255–256 (CLAS bowls), 379 nos 261–262 (CLAS-HEL plate and bowl).

4.5. Shallow Open Vessels of Large to Medium Size (Basins, Kalathoi, Lekanai, and Other)

Basins: P212, P224, P295, P300, P306, P412

Kalathoi: P51, P52, P68, P262, P420, P624, P752, P799

Lekanai (and lekanides): P21, P26, P36, P45, P75, P78, P107, P108, P109, P119, P121, P130, P144, P159, P190, P193, P217, P225, P237, P242, P249, P261, P269, P277, P279, P280, P281, P297, P318, P330, P334, P344, P345, P346, P353, P394, P401, P402, P409, P419, P424, P452, P465, P500, P514, P533, P545, P546, P565, P566, P591, P600, P614, P636, P694, P698, P751, P810, P842, P844, P845

Other: P282 (mortarium), P440 (platter)

Scholarship on the archaeology of Crete refers to both basins and lekanai, but does not acknowledge – let alone address – the terminological complexities embedded in the use of these two terms. Some scholars treat them as synonymous,[138] while others use them without explaining the morphological traits which distinguish a basin from a lekane.[139] At Knossos, the distinction often depends on chronology. This is clear in two articles published by Coldstream in subsequent years, which treat – respectively – PG-G and PAR-AR pottery from settlement contexts; the term basin is used with reference to the earlier material published in the first article, while the term lekane (and lekanis) is applied to the later material discussed in the second article.[140] The inconsistency becomes more pronounced in the various chapters of the *Knossos Pottery Handbook: Greek and Roman*; the EIA chapter refers to both basins and lekanai,[141] the latter term is also used in the two chapters that treat the AR to HEL material,[142] while the former term is used in the ROM chapter.[143] The problem of inconsistency cannot be fully resolved in this study, but following a certain trend in the literature, I retain the term lekane for vessels dating from the EIA to the HEL period,[144] and the term basin for their ROM counterparts.[145] My reference to comparative material from other sites retains the terms used in the original publications.

The nomenclature of the remaining three vessel shapes discussed in this section is more straightforward. The mortarium, which is the Latin term for grinding bowl (the Greek term was *thyeia*),[146] designates "an open bowl (usually between 20 and 40 cm in diameter),

138. Moignard 1996, 452; Coldstream 2001, 59, 63.
139. Callaghan and Johnston 2000.
140. Coldstream 1972, 73 no. B46, 87 nos F31-F32 and F34, 98 nos G136-G137; 1973a, 39 nos H37-H42, 43 nos J25-J28, 45 nos K16-K18, 53-54 nos L34-L43 (but L113, on page 60, is called a basin).
141. Coldstream 2001, 59, 63.
142. Coldstream and Eiring 2001, 80-82; Eiring 2001, 98, 106.
143. Forster 2001, 145, 164, 166.
144. Cf. Anzalone 2013 (Gortyn, Armi hill).
145. Cf. Hayes 2000a, 314 nos 1-2, 318 nos 38-40 (Kommos).
146. Villing and Pemberton 2010, 557.

conical to hemispherical in shape, with a flat base or a low foot."[147] The kalathos is a conical open vessel of large or medium size, generally considered as a bowl for food,[148] whereas the platter is identified as a large plate.[149]

Basins, kalathoi, and especially lekanai are amply attested at Syme Viannou, but the mortarium (P282) and the platter (P440) are represented by single pieces. Most of the basins and the lekanai are made in a few MFGs (A1, B1, C1 and C2), but a much broader range of MFGs is represented by the remaining pieces. This includes A1a (P130, P280, P419), A2 (P300, P500), B2 (P545), E (P217), F (P144, P249, P269), I (P225 ?, P452), and J (P533), as well as a few loners (P190, P224, P412, P514, P751, P842) and an uncertain case (P600). The kalathoi are made in the MFGs seen on the majority of the basins and the lekanai (A1 and A1a, B1, C1 and C2), but there is also a loner (P420). Lastly, the single mortarium (P282) is made in MFG C1 and the single platter in MFG I (P440).

The majority of the basins and the lekanai from Syme Viannou are plain. Some vessels, however, carry slip on the lip and, occasionally, on the body (P26, P75, P108, P159, P193, P249, P261, P297, P346, P394, P533), while others show painted (P78, P190, P409) and especially relief (P107, P130, P242, P277, P279, P280, P281, P334, P344, P401, P424, P546) decoration. Also, P224 carries incised decoration, P842 combines incision and coating, and P269 bears painted and relief decoration. The kalathoi are typically plain and three of them carry attachments (P262, P420, P799).

Basins and lekanai are attested at Syme Viannou from the EIA to the MROM period, albeit mostly in low numbers. The number of pieces grows exponentially in two periods: the AR-ECLAS and the EHEL-MHEL. Kalathoi are attested from the EIA to the HEL period, but the dating of several pieces involves some uncertainty.

Over one dozen basins and lekanai were found in the Area of the Altar, and more than double came from the Terraces and the Water Channel. One to six specimens were discovered in the Central and South-Central Part of the Podium (P533, P545, P546, P565, P566, P591), the Area of the Protoarchaic Hearth (P600, P614, P636), and Building E and its Immediate Surroundings (P694, P698, P751), while three pieces are among the Material of Unknown or Uncertain Find Context (P842, P844, P845). Most of the kalathoi were found in the Area of the Altar, and the Terraces and the Water Channel, while individual pieces came from the Area of the Protoarchaic Hearth (P624), Building E and its Immediate Surroundings (P752), and Building C-D and its Immediate Surroundings (P799).

In the archaeology of Greek sanctuaries, scholars have considered that vessels for food processing and other basic household activities such as basins, lekanai, mortaria, and kalathoi have been "victims of selective publication,"[150] and perhaps also retension. The varied representation of such vessels in different Cretan sanctuaries, however, does not lend support to this idea. Although these shapes are very thinly attested in the ceramic assemblages from the

147. Villing and Pemberton 2010, 559.
148. Brock 1957, 162; Coldstream 2001, 57; Kotsonas 2008, 216. Cretan kalathoi were commonly used as lids for urns during the LPG-PGB period.
149. Coldstream and Eiring 2001, 81.
150. Stissi 2002, 249.

acropolis of Gortyn,[151] and the sanctuary of Demeter at Knossos,[152] they are amply represented, from the EIA to the HEL period, at the sanctuaries of the Armi hill at Gortyn,[153] and the west acropolis of Dreros,[154] and, from the EIA to the ROM period, at the sanctuary of Kommos.[155] At Kommos, the repertory in question presents a spike in the LCLAS and – to a lesser extent – the LHEL periods. The high number of LG-EPAR kalathoi found at the sanctuary on the west acropolis of Dreros suggests that these vessels were central to the rituals held there at the time.[156]

4.6. Open Vessels of Uncertain Shape and Function

Medium-sized: P506, P507, P508, P509, P716

Small: P367, P505, P767

A handful of pieces – mostly fragments of base, handle, and lip – belong to open vessels of uncertain shape and function. These pieces are divided above according to size classes, with large specimens missing.

The group is dominated by vessels made in MFG C2. Other MFGs represented include C1 (P506), E (?) (P367), and J (P767). All the vessels are coated except for P367 which carries painted and relief decoration. Most of the pieces come from the Terraces and the Water Channel, while individual specimens were identified at Building E and its Immediate Surroundings (P716), and Building C-D and its Immediate Surroundings (P767).

151. Johannowsky 2002, 44 nos 294-298 (kalathoi), 54-55 nos 350-355 (basins).
152. Coldstream 1973b, 22-24 nos B6 and B7 (MCLAS lekanides), 26 no. C4 (MCLAS/LCLAS lekanis), 29 no. D14 (EHEL kalathos), 32 nos E15-E16 (MHEL kalathoi), 39 no. H27 (Attic LCLAS lekanis), 48 no. J20 (LHEL/EROM-MROM basin).
153. Basins/lekanai: Anzalone 2013, 233-234, 243 nos 18-25 (PAR-CLAS), 246 nos 75-82 (G-HEL), 248-249 nos 128-131 (G-HEL), 252 no. 215. Kalathoi: Anzalone 2013, 231, 233, 239, 244 no. 35, 249 nos 134-140, 251 nos 188-189, 252 no. 214, 253-254 nos 226-228 and 234-240 (mostly LM IIIC specimens, with fewer PG and G examples).
154. Kotsonas forthcoming.
155. Johnston 1993, 349 nos 43 and 45 (PAR lekanis and basin); 2000, 219 no. 114 (G kalathos); 2005, 324 no. 51, 357 no. 172 (EIA kalathoi), 359-361 nos 182-184 (PAR mortaria), 374 no. 242 (LCLAS ? lekane), 378 no. 259 (LCLAS-EHEL lekanis), 379 nos 260 and 263 (LCLAS lekanides), 382-383 no. 275 (LHEL basin); Callaghan and Johnston 2000, 218 no. 43 (PG basin), 229 no. 168 (PG basin), 232 nos 190 and 197 (EIA kalathoi), 237 no. 251 (PAR basin), 242 no. 297 (LPAR lekane), 247 no. 369 (PAR basin/mortarium), 251 nos 403-404 (LAR lekane and mortarium), 255 no. 438 (Attic LCLAS lekane), 258 no. 468 (LCLAS basin), 260 no. 480 (LCLAS lekane), 261 no. 496 (LCLAS lekane), 263 no. 524 (LCLAS lekane), 264-265 nos 534-541 (LCLAS basins, lekanai, mortaria), 267 no. 571 (LCLAS lekane), 269 no. 584 (LCLAS lekane), 270-271 nos 596 (LHEL kalathos), 273 nos 617-618 (LHEL basins), 275 no. 627 (LHEL basin), 278 nos 650-651 (MHEL basins), 280-282 nos 676-682 and 696-700 (HEL basins, lekanai and mortaria), 285 nos 749-750 (LHEL basin and lekane), 287 nos 780-781 and 793 (LHEL-EROM basins), 293 nos 873-874 (LHEL lekane and mortarium), 296 no. 897 (LHEL/EROM lekane); Csapo, Johnston and Geagan 2000, 128-129 nos 81 and 83 (LCLAS and HEL basins); Hayes 2000a, 314 nos 1-2, 318 nos 38-40 (ROM basins).
156. Kotsonas forthcoming. See also the preliminary reports in Zographaki and Farnoux 2011, 633; Farnoux, Kyriakidis and Zographaki 2012, 183; Zographaki and Farnoux 2014, 106.

4.7 Slow-Pouring Vessels (Aryballoi, Unguentaria, and Other)

Aryballoi: P69, P92, P93, P182, P430, P454, P517, P530, P597, P649, P656, P754, P792, P820, P821

Aryballoi/Lekythia: P319, P425, P426, P438

Unguentaria: P57, P86, P87, P88, P89, P234, P241, P247, P248, P299, P311, P339, P356, P421, P422, P428, P769, P776, P790, P791, P858, P859, P860, P861, P862

Other: P114 (lekythion), P441 (uncertain shape), P675 (lekythos)

A fairly narrow repertory of slow-pouring vessels is attested at the sanctuary of Syme Viannou; these are generally considered as unguent vessels.[157] Stissi has argued that "it is indeed possible, in my opinion even likely, that many oil containers were offered [to Greek sanctuaries] as empties,"[158] but this argument is largely based on an analysis of Corinthian and Attic material of the 7th to early 5th centuries BCE, the morphology and especially the decoration of which is much more elaborate than the morphology of the unguent vessels from Syme Viannou. Below, the unguent vessels from the site are discussed in chronological groupings.

The sanctuary of Syme Viannou yielded a considerable number of EIA slow-pouring vessels of small size. These are largely aryballoi of the G-PAR period (P69, P92, P93, P319, P425, P426, P438, P454, P530, P597, P649, P754, P792, P820, P821); however, there is also the PGB aryballos P430, the G-PAR lekythion P114, and P441 which is of uncertain shape and date but must belong to the EIA. The vessels are made in varied MFGs which are represented by a few specimens (B3, C2, E, I, and uncertain), while group C2 is the only one that is commonly attested. Cretan unguent vessels are typically small in size, but there are at least a few true miniatures from Syme Viannou (P92, P649, P792) which are explained by the cultic function of the site.[159] The EIA unguent vessels from Syme Viannou typically carry painted decoration except for P92 – and perhaps P93 and P441 – which is undecorated. Several vases were found in the Area of the Altar (P69, P92, P93, P114) and the Terraces and the Water Channel (P319, P425, P426, P430, P438, P441, P454), while individual pieces come from nearly all other areas (P530, P597, P649, P754, P792).

Given our poor understanding of Cretan AR unguent vessels, one cannot exclude the possibility that some of the pieces I have assigned to the PAR period may be slightly later in date, thus overlapping with the three Corinthian aryballoi of the early 6th century BCE which were found at Syme Viannou (P182, P517, P656). Unguent vessels largely disappear from the site for the next four centuries, with the exception of the CLAS lekythos P675.

157. For the EIA shapes, see Coldstream 1996, 351, 356; 2001, 42–44; Kotsonas 2008, 168, 174. For the HEL unguentaria see Englezou 2005, 232.

158. Stissi 2009, 28; cf. 2003, 78. But see also Stissi 2002, 243: "Small oil containers (alabastra, aryballoi, lekythoi, etc., including statuette bottles) seem the only vessels which would readily make sense as votives with contents, as these contents must have been obvious without showing, and well protected too, although it is a mystery what happened to all that oil in the long term."

159. For the few miniature vessels from Syme Viannou, which are of G-HEL date, see Sections 4.1 and 4.2.

At Syme Viannou, unguent vessels – specifically unguentaria – return with force in the LHEL period when their number surpasses the number of aryballoi of the G-PAR period. Earlier unguentaria include the EHEL P769 and possibly two pieces in black gloss (P791, P858) which are too fragmentary to be dated with any precision. The vast majority of these vessels present a fusiform body with tall, solid cylindrical foot which is typical for the LHEL period.[160] The unguentaria are always small in size and undecorated (except for the two black gloss pieces mentioned above); they are made in various MFGs (A2, C2, perhaps D, F, G, I, J and loner) but especially in group G, which encompasses more than half of the specimens. Unguentaria were found in the Area of the Altar (P57, P86, P87, P88, P89), the Terraces and the Water Channel (P234, P241, P247, P248, P299, P311, P339, P356, P421, P422, P428), and Building C-D and its Immediate Surroundings (P769, P776, P790, P791), but several specimens are among the Material of Unknown or Uncertain Find Context (P858, P859, P860, P861, P862). This spatial distribution is considerably narrower than that of the earlier, G-PAR unguent vessels.

The ebb and flow of unguent vessels at Syme Viannou from the EIA to the CLAS period finds comparisons in other Cretan sanctuaries. Indeed, a considerable number of G and especially PAR aryballoi, lekythoi, and alabastra were found at the acropolis sanctuary of Gortyn as well as at Kommos.[161] There were only a few G-PAR aryballoi and lekythoi at the sanctuary of Demeter at Knossos,[162] and one or two specimens at the west acropolis sanctuary of Dreros,[163] while no such pieces were discovered at the sanctuary of the Gortyn Armi hill. A few AR-CLAS black- and red-figure lekythoi were found at the sanctuary on the acropolis of Gortyn,[164] while some – mostly Attic – CLAS lekythoi came from the sanctuary of Demeter at Knossos and from Kommos.[165] This poor record contrasts with the pattern identified in sanctuaries elsewhere in the Greek world, where unguent vessels often make up 30% of the ceramic assemblage of the 7th to early 5th centuries BCE.[166] Back to Crete, HEL unguentaria are commonly attested in burial contexts especially, but are largely missing from sanctuaries.[167] Indeed, no HEL unguentaria were found in the Gortynian sanctuaries on the acropolis and Armi hills and the west acropolis sanctuary of Dreros, while a single piece was identified at the sanctuary of Demeter at Knossos.[168] At Kommos, unguentaria are "scarcely frequent,"[169] and largely date from the LHEL period.[170] This chronological pattern recalls the rich series

160. P57, P86, P87, P88, P89, P234, P241, P247, P248, P299, P311, P339, P356, P421, P422, P428, P776, P790, P859, P860, P861, P862. Kanta (1991, 500 fig. 45) proposed a 2nd century BCE date for three of these vessels.

161. Gortyn: Johannowsky 2002, 62–69 nos 401a–441a. Kommos: Johnston 1993, 348 nos 32–34, 350–351 nos 50–51; 2000, 206 no. 52, 223 no. 124; 2005, 318 no. 23, 341–344 nos 111–127; Callaghan and Johnston 2000, 235–237 nos 224–225, 227, 230–231, 245–246 and 249, 240 no. 268, 242–243 nos 290–293 and 302–305, 247–249 nos 374–376 and 390–391, 252 no. 407.

162. Coldstream 1973b, 21 nos A28–A31.

163. Kotsonas forthcoming.

164. Johannowsky 2002, 105–106 nos 620–620a, 624–625.

165. Knossos: Coldstream 1973b, 26 no. C7, 39–40 nos H1–H12 and H14–H15. Kommos: Callaghan and Johnston 2000, 333 fn. 17; Johnston 2005, 373 nos 235–236.

166. Stissi 2002, 249.

167. Englezou 2005, 232.

168. Coldstream 1973b, 48 no. J18 (ROM unguentarium).

169. Callaghan and Johnston 2000, 301.

170. Callaghan and Johnston 2000, 280 no. 679, 287–288 nos 782–785 and 806–809; Johnston 2005, 383 no. 277.

Figure 4.7: Elaborate handles of HEL fast-pouring vessels (upper line, from left to right: P230, P246, P240; lower line, from left to right: P293, P292, P304).

of LHEL unguentaria from Syme Viannou, which seems fairly exceptional and invites for a local explanation. It is tempting – but admittedly speculative – to consider that the unguents contained in these vessels could be offerings to a cult statue kept inside Building C-D, the existence of which has previously been hypothesized – with due caution – by Sporn on the basis of terracotta statuettes from the site.[171]

4.8. Fast-Pouring Vessels (Hydriai, Jugs/Juglets, Lagynoi, Oinochoai, and Other)

Hydriai: P19, P135, P268, P284, P516

Jugs/Juglets: P23, P48, P49, P50, P55, P56, P137, P163, P166, P167, P173, P218, P226, P230, P240, P246, P260, P286, P287, P292, P293, P296, P304, P308, P312, P338, P378, P390, P391, P397, P403, P404, P408, P429, P464, P475, P547, P570, P578, P593, P607, P645, P686, P699, P705, P715, P759, P768, P781, P796, P806

Jugs, cylindrical: P54, P120, P455, P787

171. Sporn 2018, 132.

Lagynoi: P396, P405

Oinochoai: P31, P188, P389, P571, P766, P822 (lekythos/oinochoe)

The repertory of fast-pouring vessels from Syme Viannou includes a few hydriai which are characterized by two horizontal handles and a vertical one;[172] a few oinochoai which are distinguished by their trefoil lip;[173] and very few cylindrical jugs and lagynoi.[174] The majority of the remaining pieces are too fragmentary to be ascribed to specific vessel shapes and are labelled conventionally as jugs (Figure 4.7).[175]

The vessels are made in various MFGs which are represented by one to eight specimens (A1a, A2, B1, B2, B3, C1, E, F, H, I, J), but groups A1 and C2 are represented more widely. Most specimens are plain or coated (including dipped, partly coated and banded), while pattern painted vessels are uncommon (P54, P268, P578, P715, P822) and largely date to the PAR period.

Fast-pouring vessels are attested at Syme Viannou from the PG (P188, P464) to the MROM and LROM periods (P260, P781, P796). A spike in numbers is evident in the HEL period. A lower spike emerges in the PAR period if the closed vessels of uncertain shape and function (Section 4.10) are considered. Erickson's impression that jugs are "amongst the most conspicuous finds" at Syme Viannou during the AR period cannot be confirmed.[176]

Fast-pouring vessels were recovered from most areas of the sanctuary, but only one piece came from the North Part of the Enclosure and the Podium (P686), and none from the West Part of the Enclosure. Four areas (the Central and South-Central Part of the Podium, the Area of the Protoarchaic Hearth, Building E and its Immediate Surroundings, Building C-D and its Immediate Surroundings) yielded circa five pieces each. The finds from the Area of the Altar, and the Terraces and the Water Channel were much more numerous: one and a half dozen pieces come from the former area, and two and a half dozen pieces from the latter.

Zooming in on the three main shapes of the fast-pouring vessels represented at Syme Viannou, one finds that the few hydriai make up a fairly homogeneous group, while the few oinochoai and cylindrical jugs are more varied. More specifically, the hydriai are made in MFGs A or C2, are mostly plain (but P268 carries painted decoration), date from the PAR to the HEL period, and come only from the Area of the Altar, and the Terraces and the Water Channel.[177] In contrast, the oinochoai are made in a range of MFGs, are variously decorated,

172. On hydriai and their attestation in sanctuaries, see Trinkl 2009 with references. On Cretan hydriai, see Coldstream 2001, 37–38; Englezou 2005, 295–313; Kotsonas 2008, 153.

173. On Cretan oinochoai, see Coldstream 1996, 342; 2001, 39; Englezou 2005, 204–218; Kotsonas 2008, 158; Laftsidis 2018, 612–613, 636–638, 665–672.

174. On Cretan cylindrical jugs and lagynoi, see Eiring 2001, 109, 125; Englezou 2005, 195–199, 221-223.

175. A number of cups/jugs (P143, P207, P244, P291, P313, P400, P499, P551, P552, P609, P841) are discussed with the deep open vessels of small size in Section 4.2. It is worth noting that most of these pieces are made in MFG A1 and all but P400 and P609 are plain. Their date range is LAR to EHEL, but most are LCLAS. Lastly, half of the pieces come from the Terraces and the Water Channel, while the rest are from varied areas.

176. Erickson 2010b, 235 (cf. 229 fn. 40).

177. Note that hydria P19 is a miniature; for the few miniature vessels from Syme Viannou, which are of G-HEL date, see Sections 4.1–4.2.

show a notable chronological range (PG to HEL), and come from the Area of the Altar, and the Terraces and the Water Channel. Lastly, cylindrical jugs are made in varied MFGs but all carry painted decoration, are HEL in date, and originate from the Area of the Altar, the Terraces and the Water Channel, and Building C-D and its Immediate Surroundings.

The fairly high number of fast-pouring vessels at Syme Viannou is notable, since such vessels are represented in fairly limited numbers at the sanctuary of Demeter at Knossos,[178] the sanctuary on the west acropolis of Dreros,[179] and the sanctuaries on the acropolis and the Armi hills of Gortyn.[180] The chronological range of the material in these different sites is broad, but fast-pouring vessels from the acropolis sanctuary of Gortyn date mostly from the PAR period. The evidence for fast-pouring vessels at Kommos is more abundant. At this site, fast-pouring vessels are reportedly represented in modest numbers,[181] and they seem to be more common in the PAR and the LHEL periods.[182] This chronological patterning broadly matches the chronological patterning of the fast-pouring vessels from Syme Viannou. However, at Syme Viannou, the HEL spike in the representation of these vessels comes before the LHEL period.

4.9. Storage Vessels (Amphoras and Amphoriskoi, Pithoi, and Other)

Amphoras and amphoriskoi: P15, P33, P169, P216, P223, P231, P267, P351, P372, P445, P447, P761, P763, P764, P770, P780, P794, P803, P804, P805, P807, P808, P865

Pithoi: P681, P688, P704, P832

Other: P371 (necked jar), P381 (jar), P399 (straight-sided jar), P490 (jar), P564 and P567 (stamnoi), P795 (jar), P818 (necked jar)

Studies of pottery assemblages from Greek sanctuaries suggest that storage vessels "played a

178. Coldstream 1973b, 21 nos A28–A30 (G-PAR), 27 no. C15 (CLAS), 29 nos D12 and D15 (HEL), 39 no. H13 (LCLAS hydria), 43 nos H79–H83 (LCLAS-MROM), 43 no. H99 (EROM ?), 49 no. J21 (ROM oinochoai).

179. Kotsonas forthcoming.

180. Acropolis: Johannowsky 2002, 60–61 nos 389–396 (PAR hydriai), 61–62 nos 397–401 (PAR oinochoai), 105 nos 618 and 621 (AR jugs). Armi: Anzalone 2013, 233 nos 32, 195–196, 231 (PG and HEL hydriai), 233 nos 132 and 252, 246 no. 83, 249 no. 133 (EIA fast-pouring vessels), 246–247 nos 88 and 91 (HEL hydriai).

181. Callaghan and Johnston 2000, 300–301.

182. Johnston 1993, 344–346 nos 12–19 (PAR hydriai), 347–348 nos 28–31 and 35 (PAR jugs), 351–352 nos 54–57 (PAR oinochoai); 2000, 198–202 nos 13, 18 and 20, 22–27, 32–34 (G hydriai), 205–206 nos 40–56 (G jugs and oinochoai), 218 no. 110 (G hydria), 219–220 nos 116 and 121 (G jugs), 222 nos 124–125, 223 nos 82B/45 and 82A/19 (G jugs); 2005, 311–313 no. 3, 315 no. 14 (PG hydriai ?), 332–334 no. 82, 335 no. 88 (LG-PAR hydriai ?), 337–341 nos 95–110 (PAR hydriai, jugs, oinochoai), 345 nos 129 and 131 (PAR hydriai), 379–380 (LCLAS mugs); Bikai 2000, 312 nos 16–19 (Phoenician EIA juglets); Callaghan and Johnston 2000, *passim* (the inventoried pieces, which are EIA–HEL, are too many to cite); Hayes 2000a, 317–318 nos 32, 35–37, 43 (ROM).

small part" in the activities held at these sites during the 7th to early 5th centuries BCE.[183] And yet, the number of storage vessels from Syme Viannou is considerable and dates both from this and other periods. This number may actually be considerably higher judging by the ample attestation of sizeable closed vessels of uncertain shape and function which are discussed in Section 4.10.

Most of the storage vessels from Syme Viannou are made in MFGs C and H, with the former being most common among the EIA specimens and the latter dominating the ROM material. A few vessels are made in MFGs A (A1: P399, P681, P688; A1a: P567; A2: P490) and B (B1: P445, P564, P704) and largely date to the EIA. Individual specimens represent MFGs C2 (P763), F (P223) and H (P372, P808, P865 ?), but loners are fairly numerous (P33, P169, P267, P351, P832).

Amphoras predominate among the storage vessels from Syme Viannou, while pithoi,[184] stamnoi,[185] necked jars, and other shapes are represented by a few pieces. The assemblage is missing neckless vases or pyxides, which are often supplied with a lid.[186] Indeed, the relatively few storage vessels which preserve their lip show that this was not designed to carry a lid. This observation has obvious implications for the function of the numerous lids found at Syme Viannou (see Section 4.12). It also relates, however, to Muhly's hypothesis for the deposition of horse pyxides at the site, which she deduced from the study of terracotta animal figurines that were perhaps attached to pyxis lids.[187] The material published here cannot confirm Muhly's hypothesis, although this may be because of accidents of survival. Alternatively, any lids with horse attachments may have reached the site independently of any containers.

The range of decorative schemes which are attested on the storage vessels from Syme Viannou is quite broad. Pattern painting is common on the EIA examples, and ribbing is typical for MROM-LROM amphoras. Smaller groups of vases show coating/banding (P33, P169, P223: PAR-HEL), incised decoration (P381, P681, P761, P795: mostly ROM) or relief decoration (P688 and P832: PAR-AR), while others are plain (P399, P445, P490, P564, P567, P704, P804, P805: varied date).

Most of the storage vessels date to either the G-PAR or the MROM-LROM period, and there are only a few specimens which can be assigned from the AR to the HEL period.[188] This relates to the limited attestation of storage vessels of the AR-HEL period in published assemblages from Crete,[189] and probably also to our unsatisfactory understanding of the morphological development of Cretan storage vessels after the EIA.

183. Stissi 2002, 249.
184. I reserve the term pithos for coarse, very large storage vessels and do not apply it to smaller, finer and often painted storage vessels, which I call jars instead. The problem is treated in detail in Kotsonas 2008, 80, 100–101, 133, 136–137. Also Ximeri 2021.
185. The dinoi/stamnoi P100 and P196 are discussed with the deep open vessels of large to medium size in Section 4.3.
186. See, for example, Coldstream 2001, 27–37.
187. Muhly 2008, 16–17 nos 7–8 (780–760 BCE), 92–93 no. 263 (840–820 BCE), 141–142; 2013, 298, 300.
188. In rough chronological sequence, these pieces are: P832 (PAR), P399 (PAR-AR), P169 (LPAR-AR), P704 (EIA-HEL), P33 (AR-HEL), P567 (EHEL-MHEL), P223 (MHEL), P770 and P805 (HEL-ROM), P804 (MROM-LROM).
189. See, for example, Coldstream and Eiring 2001; Eiring 2001.

Figure 4.8: **Body fragments of Roman amphoras with ribbing, from Building C-D and its Immediate Surroundings** (P216 at top left, P267 at top right, P231 below).

Storage vessels are attested in all areas of the sanctuary of Syme Viannou, but most areas yielded one to five pieces. Roughly a dozen pieces come from the Terraces and the Water Channel, and Building C-D and its Immediate Surroundings. In most areas, the storage vessels are largely G-PAR. However, the specimens from Building C-D and its Immediate Surroundings are largely MROM-LROM, and the specimens from the Terraces and the Water Channel present a broad date range – from SMIN-PG to LROM. The bulkiest storage vessels show two notable concentrations: the few PAR-AR pithos fragments were found inside and around Building E, while most of the MROM-LROM amphoras were discovered inside Building C-D. This pattern indicates a strong association between bulk storage and roofed structures.

Elaborating on the general patterns outlined above, the next paragraphs focus on specific shapes, starting with the pithoi. The fragments of pithoi from Syme Viannou are very few in number (P681, P688, P704, P832),[190] but represent at least three different vessels, as indicated by the variety of MFGs: P681 and P688 belong to group A1, P704 to group B1, while P832 looks like a loner but its micaceous fabric recalls MFG A1. The pithoi from Syme Viannou basically date to the G-AR period and come from Building E and its Immediate Surroundings (trenches K47, Λ47, M47).[191]

Thomas Brisart has noted that "les pithoi retrouvés dans les sanctuaires sont probablement des offrandes mais ont sans doute conservé leur fonction de conteneur alimentaire;" however, he could only identify a few pithoi in Cretan sanctuaries.[192] Indeed, only a single sherd is published from the sanctuary of Demeter at Knossos,[193] very few pieces were found at the sanctuary on the west acropolis of Dreros and on the acropolis sanctuary of

190. I could not locate and study the pithos rim sherd published in Kanta 1991, 498 fig. 37.
191. But note that P704 cannot be dated with any precision, while P832 is without context.
192. Brisart 2009, 152 fn. 28. See also Ximeri 2021.
193. Coldstream 1973b, 21–22 no. A34.

Figure 4.9: **Body fragments of Roman amphoras with ribbing, from the Terraces and the Water Channel**
(from left to right P780, P807, P803).

Gortyn,[194] while none are known from the sanctuary on the Gortyn Armi hill. More specimens were probably found at Kommos, but pithoi are said to be poorly attested at the site and very few pieces are actually published.[195]

Most of the amphoras and the amphoriskoi from Syme Viannou are made in MFG H. Individual specimens are assigned to MFGs C1 (P447), (P15, P446), F (P223), H (P372, P808, P865 ?). Although most specimens are very fragmentary, it is possible that the earlier material represents a range of amphora types,[196] while neck-handled specimens probably predominate in the HEL-ROM period. Imported transport amphoras are limited to the Laconian (?) LPAR-AR P169. Half of the amphoras show ribbing on the body (and these are MROM-LROM), while the other half preserves varied decoration – pattern painted (P15, P351, P447), coated/banded (P33, P169, P223), incised (P761, P795) – or is plain (P445, P804, P805). Most of the amphoras are MROM-LROM, some date to the EIA, and only very few can be assigned to the AR, CLAS or HEL periods. The fragments of these vessels derive from the three areas of the sanctuary which yielded ample pieces from storage vessels, namely the Area of the Altar, and mostly from the Terraces and the Water Channel and Building C-D and its Immediate Surroundings. MROM-LROM pieces predominate in the last two areas, but they are missing from the Area of the Altar. The Terraces and the Water Channel yielded a few EIA pieces.

A fairly uniform assemblage of MROM-LROM neck-handled vessels with ribbing made in MFG H was discovered in Building C-D and its Immediate Surroundings. Several pieces came from within the building (trenches Λ48 and M48: P763, P764, P770, P780, P794, P795),[197] and from the neighboring trench M47 (P803, P804, P807, P808) (Figure 4.8).[198] A

194. Dreros: Kotsonas forthcoming. Gortyn acropolis: Johannowsky 2002, 74–75 nos 503–506.
195. Johnston 1993, 340; 2000, 218, 223, 225 (EIA); 2005, 380 no. 269 (LCLAS ?); Callaghan and Johnston 2000, 268, 271 no. 597 (LHEL), 296 no. 900 (LHEL/EROM), 298.
196. For the range of amphora types which is attested in EIA Crete, see Coldstream 2001, 23–24; Kotsonas 2008, 81–100.
197. Note that P763 is assigned to MFG C2. The jar P761 could be added to this list.
198. One could add to these vessels P805 which belongs to a HEL-ROM amphora.

thinner scatter of fragments was found south and southeast of Building C-D, at the relevant part of the Terraces and the Water Channel (trenches Λ49, N49, Ξ49, O49: P216, P231, P267, P372) (Figure 4.9).[199] The best-preserved amphora is a fabric loner of uncertain context (P865).

Amphoras are very rarely attested in most Cretan sanctuaries. Very few pieces (none of which are transport amphoras) are published from the cult site on the Armi hill and none from the acropolis hill at Gortyn.[200] The sanctuary of Demeter at Knossos yielded a number of mostly G-EPAR pieces, including a few imported examples, but no transport amphoras.[201] A few transport amphoras were identified among the material from the sanctuary on the west acropolis of Dreros.[202] In contrast, amphoras – especially transport amphoras – were copiously represented at Kommos in the EIA (especially the PAR period).[203] Likewise, "amphoras make up the great bulk of finds from the Roman layers" at Kommos,[204] even though this material may derive from a production facility located in the vicinity of the sanctuary which was partly or completely abandoned at that time.[205] The ROM amphoras from Kommos are slightly earlier than those from Syme Viannou as they present no ribbing on the body, but the amphoras from both sites are largely Cretan, which is unlike the more diverse assemblages of ROM amphoras recovered from different cities of the island.[206] In any case, the copious representation of ROM amphoras at Kommos, Syme Viannou, and different Cretan sites is indicative of the considerable increase in amphora production which is attested on the island after the Roman conquest.[207]

At Syme Viannou, storage vessels other than pithoi and amphoras show remarkable variation in terms of fabric, shape, decoration, and dating. Most of the pieces were found at the Terraces and the Water Channel.[208] Storage vessels other than pithoi and amphoras seem poorly represented in Cretan sanctuaries, including those of Demeter at Knossos, those on the acropolis and Armi hills of Gortyn, and the west acropolis of Dreros.[209] Even Kommos yielded only a few examples.[210]

199. These vases represent different MFGs. One could add to these vessels the stamnos P381 (MFG H).

200. Armi: Anzalone 2013, 233 nos 146, 158 and 194.

201. Coldstream 1973b, 21 no. A22 (MG-LG) and no. A33 (Attic MG II), 38 no. G3 (MHEL), 52 no. K2 (Attic/Cycladic G).

202. Kotsonas forthcoming.

203. For imported transport amphoras at Kommos, see especially Johnston 1993; Bikai 2000; de Domingo and Johnston 2003; Gilboa, Waiman-Barak and Jones 2015. More detailed information is provided in Section 3.5. For other types of amphoras see: Callaghan and Johnston 2000, 221 nos 65 and 71-74, 231 nos 178-179, 248 no. 377 (PG-PAR); Hayes 2000a, 318-320 nos 44-56 (ROM); Johnston 2000, 197-204 nos 12-39 (EIA, some of these pieces are amphoras/hydriai); 2005, 332-336 nos 79-94 (LG-PAR).

204. Hayes 2000a, 318.

205. Hayes 2000a, 318.

206. Hayes 2000a, 319.

207. Gallimore 2019, 608. On amphora production in Roman Crete, see Empereur, Kritzas and Marangou 1991; Marangou-Lerat 1995; Gallimore 2015, 208-222.

208. This excludes P567 which comes from the Central and South-Central Part of the Podium and P818, which is from the Material of Unknown or Uncertain Find Context.

209. Knossos, Demeter: Coldstream 1973b, 20-21 nos A16-A21 (LG-EPAR necked and neckless jars) and no. A31 (East Greek LG closed vessel). Gortyn acropolis: Johannowsky 2002, 57-58 nos 374-377b (straight-sided jars). Gortyn Armi: Anzalone 2013, 233 nos 29-31 and 193 (necked jars). Dreros, west acropolis: Kotsonas forthcoming.

210. Callaghan and Johnston 2000, 214 no. 12 (PG), 228 no. 156 (PGB), 230 no. 176 (PGB), 232 no. 187 (PG), 240 no. 271 (LPAR), 242 no. 296 (PAR), 252 no. 408 (LPAR), 297 no. 914 (LHEL), 300 (G); Johnston 2005, 350-351 nos

4.10. Closed Vessels of Uncertain Shape and Function

Large: P35, P58, P81, P112, P189, P340, P423, P432, P529, P579, P596, P621, P783

Medium-sized: P37, P165, P263, P271, P504, P510, P522, P531, P575, P640, P689

Small: P164, P178, P359, P460, P574, P638, P784

Closed/Open: P219 (medium-sized), P492 (small), P812 (large)

Over 25 pieces which are mostly body fragments can be ascribed to closed vessels of uncertain shape and function, while three pieces belong to either closed or open vessels. The material represents different size classes, as indicated above. The large specimens probably belong to storage vessels, while P189 belongs to an amphora or hydria. Small examples (probably pyxides or fast-pouring vessels) are apparently rare.

The material in question is dominated by vessels made in MFGs C1 and C2. Other MFGs – including A1 (P263), B2 (P529, P531), B3 (P575), E (P164 and perhaps P359 and P784), F (P423) – as well as loners (P165, P219) are only thinly attested. Most of the vessels carry painted decoration, especially pattern painted or banded, while coating (P35, P271 and perhaps P574) or dipping (P460 ?) is rare. Two pieces carry ornaments in relief (P783, P784), while nearly one third of the vessels are plain (P164, P165, P219, P263, P359, P423, P504, P638). Most of these vessels date to the EIA. AR or CLAS specimens are largely missing (P510 may date to this period), but HEL ones are more common (P263, and perhaps P164, P165 and P784). One piece is AR-CLAS (P219), while one or two pieces are ROM (P783 and perhaps P423). The vases in question come from nearly all areas of the sanctuary except for the North Part of the Enclosure and the Podium. In most areas there were only one to five pieces, but the Area of the Altar, and the Terraces and the Water Channel yielded two thirds of the material.

4.11. Cooking Vessels (Baking Trays, Chytrai, Cooking Jugs, Lopades, and Other)

Baking trays: P497, P498

Chytrai: P32, P229, P697

Cooking jugs: P64, P133, P134, P453, P491, P528, P625, P626, P633, P749, P753, P765

Lopades: P157, P158, P347, P569, P789

Cooking vessels of uncertain shape: P168, P174, P259, P315, P341, P376, P377, P380, P477

148–151 (G-PAR), 358–359 nos 176–181 (PAR jars), 360 nos 267–268 (CLAS).

According to Lebessi and Muhly, "large numbers of fragmentary cooking pots" were found at Syme Viannou.[211] The excavators took these vessels and the quantities of animal bone recovered from the site as evidence that animals were sacrificed, cooked, and consumed there.[212] My study identified a considerable number of Greek and Roman cooking vessels at the site, but these are noticeably fewer than the unpublished Minoan specimens.

Most of the Greek and Roman cooking vessels from Syme Viannou are made in MFGs A (A1 is most common, but some examples are made in A2: P32, P134, P259, P380, P477, P765) and a few specimens are made in MFGs B1 (P341, P491, P626, P633) and B2 (P497, P498) but no other MFG is represented. The shape repertory includes cooking jugs which date from the EIA to the AR period; chytrai which date from the CLAS period; lopades which date from the HEL period; baking trays of the EIA; and vessels of uncertain shape which are of HEL-ROM or indeterminate date. This ceramic repertory suggests that the main mode of cooking at the site was boiling (rather than grilling or baking), as was probably the case for most Greek sanctuaries.[213] The cooking vessels from Syme Viannou are typically of modest size, which is indicative of the size of the groups of people who used these pots at the site. This contrasts with the EIA-HEL evidence from Kommos where "many of the cooking pots were on a very large scale."[214]

The EIA cooking jugs from Syme Viannou are characterized by a grooved neck. This vessel type is widely found in central and east Crete during the EIA,[215] and is considered particularly common in east Crete during the LG and PAR periods.[216] Single specimens from a LAR context at Knossos and an ECLAS context at Priniatikos Pyrgos suggest that the type survived longer.[217] The very tall grooved neck of these two pieces indicates that they are not residual but represent a late stage in the morphological development of these jugs which are known to have grown a taller neck over time.[218] On this basis, I assign the cooking jugs from Syme Viannou which show a short, grooved neck to the EIA, while examples with necks of uncertain height are dated to the EIA-(AR) period.

Cooking vessels post-dating the EIA-(AR) period are rarely attested at the sanctuary of Syme Viannou, but the LHEL period presents a notable exception. The decrease in the number of cooking vessels after the EIA is reflected in their spatial patterning. EIA cooking jugs are found in most areas of the sanctuary, but CLAS to ROM lopades and other cooking vessels are found almost exclusively in the Area of the Altar, and the Terraces and the Water Channel (exceptions are limited to P569, P697 and P789).

211. Lebessi and Muhly 1990, 327; cf. Kanta 1991, 482.
212. See fn. 36 above.
213. Ekroth 2017a, 45–46.
214. Callaghan and Johnston 2000, 290. On the cooking pots from Kommos, see fn. 229 below.
215. For EIA examples from Knossos, see Coldstream 1996, 347, type Eii; 2001, 63. For other sites in central Crete, see Kotsonas 2005, 233–234; 2008, 158–160; Wallace 2012, 58; 2020, 87, 157; Nodarou 2020, 199. For east Crete, see Mook 1993, 208.
216. Haggis 2012, 159, with reference to fig. 43:C109.
217. Knossos: Callaghan 1992, 91 no. H3:8. Priniatikos Pyrgos: Erickson 2010c, 323–324 fig. 15:8.
218. Coldstream 1992, 86 with reference to Knossos. The opposite trend is identifiable for the cooking jugs from Eleutherna, see Kotsonas 2005, 232; 2008, 160.

The temporal and spatial distribution of cooking vessels does not lend support to the hypothesis of Birgitta Bergquist that, during the first millennium BCE, "the whole of the theatre-like inclining plateau at Kato Syme" may have been "dotted with individual cooking pits and barbecue-sites of various family, village, guild, thiasos or some such groups and those of cult personnel, which prepared their sacral meal equipped with the relevant, cultic utensils and objects celebrating the deity (deities) in whose honour they feasted."[219] Cooking may also have been practiced, however, outside the excavated area, which occupies only a fraction (over 3,000 sq.m.) of the area which yielded surface evidence for ancient remains (over 17,000 sq.m.).[220] Furthermore, the unexplored plateau which lies east of the sanctuary and covers 3200 sq.m. could have accommodated the overnight stay of as many as 400 visitors,[221] and could have also hosted cooking and feasting activities. This hypothesis recalls the argument of Ulrich Sinn for the identification of an extensive "Festwiese" (or festival meadow) at different Greek sanctuaries, including those of Aphaia on Aegina, Poseidon at Kalaureia, Athena at Sounion, and the Argive Heraion.[222] More recently, Sinn has added more sanctuaries to this list, including Delphi, Nemea, Olympia, the Amphiareion at Oropos, and Perachora;[223] and Ekroth has explored the issue further.[224] Additionally, it is worth noting that at the sanctuary of Poseidon at Isthmia, the study of the faunal and ceramic evidence suggested that while sacrificial and feasting activities were centered on the same area in the EIA, these activities were separated in the AR period when the feasting was moved to a different location.[225]

Stissi has noted the apparent rarity of cooking ware in Greek sanctuaries, including those where feasting is thought to have taken place, and has pondered on the possibility that these vessels "might have been the victims of selective publication."[226] This concern may be relevant to a number of publications of Cretan cult sites which report very little – if any – evidence for cooking vessels. For example, no piece is published from the sanctuaries on the acropolis and Armi hills at Gortyn,[227] while the few pieces known from the sanctuary of Demeter at Knossos are probably only a fraction of the EROM/MROM cooking vessels which were found in an area with open-air clay ovens.[228] Many more cooking vessels appear in the final publication of Kommos, which also mentions non-inventoried pieces.[229] Nevertheless,

219. Bergquist 1988, 30–31.
220. Lebessi 2002b, 3; Zarifis 2007, 64.
221. Zarifis 2007, 307–308, see also pages 182, 218–219, 247, 304, 312.
222. Sinn 1988, 154–157; 1992, 183.
223. Sinn 2005, 5, 6, 9, 10, 12. On Olympia, see especially Kyrieleis 2006, 27–55, which includes comparative references to Syme Viannou on pages 36–37, 40, 43.
224. Ekroth (2017b, especially 43–45) has revisited the issue on the basis of evidence from more Greek sanctuaries. I am grateful to Gunnel Ekroth for her advice on the Festwiesen.
225. Gebhard and Reese 2005, 126–127, 130–132; cf. Morgan 1999, 316–321.
226. Stissi 2009, 249.
227. Anzalone (2013, 234) notes the absence of such material at the sanctuary on the Armi hill.
228. Coldstream 1973b, 49 nos J24–J31.
229. Johnston 2000, 195 no. 9, 216–218 nos 105–107, 220 no. 120, 225 (EIA); 2005, 347 no. 136, 361–362 nos 185–190, 383 no. 276 (EIA, except for the last piece which is a HEL waster); Callaghan and Johnston, 222 no. 90, 229 no. 169 (PG), 237 no. 252, 248 nos 379–381 (PAR), 270 no. 593 (LHEL), 275 nos 625–626 (LHEL/EROM), 281–282 nos 696, 698 and 712 (MHEL), 284–285 nos 741–748 and 760–761, 287–288 nos 786–789 and 811, 293–295 nos 875–878 and 890–891, 296–297 nos 903 and 913 (LHEL and LHEL/EROM); Csapo, Johnston and Geagan 2000, 118 no. 29

these vessels seem rare at Kommos in all periods except for the LHEL.[230] Lastly, my own work on the material from the west acropolis sanctuary at Dreros identified extremely few cooking vessels.[231]

4.12. Domed Lids/Shields and Related Vessels (Conical Lids, Discs)

Conical lids: P201, P646, P823

Discs: P73, P74, P559, P560, P561, P562

Domed lids/Shields: P6, P7, P16, P17, P18, P22, P25, P39, P40, P41, P42, P59, P70, P71, P72, P96, P97, P98, P99, P117, P122, P123, P127, P179, P195, P199, P200, P208, P232, P235, P320, P321, P322, P323, P326, P331, P332, P349, P350, P383, P384, P385, P386, P393, P406, P414, P431, P434, P435, P437, P439, P443, P444, P448, P451, P467, P521, P525, P576, P577, P580, P581, P592, P598, P599, P622, P623, P648, P671, P684, P685, P700, P706, P772, P773, P774, P800, P815, P816, P817, P824, P825, P826, P827, P828, P829, P830, P831

The lids and related vessels make up the second largest functional class represented at Syme Viannou after that of deep open vessels of small size (but the fast-pouring vessels are basically as numerous as the lids). Domed lids/shields and conical lids, which form the vast majority of the pieces treated here, are discussed first. The few discs, which are of uncertain function, receive a separate and much shorter treatment in the end of the section.

A few lids from Syme Viannou appeared in preliminary reports where Lebessi called them "small shields" and "lids."[232] The two terms also appear in Kanta's overview of the BA to ROM pottery from Syme Viannou, which includes a general reference to "small clay votive 'shields,'" followed by a discussion of specific pieces called "lids."[233] Lastly, Muhly used the term "lids" in her study of vessels with animal attachments from Syme Viannou.[234] Secondary literature on the finds from the sanctuary calls these vessels "lids" and "lids/shields."[235] These terminological complexities are also identifiable in discussions of such vessels from other sites (as noted below) and relate to the uncertainties over their function.

The complexities over the terminology and the function of the Cretan lids derive from the morphological similarity of these vessels to bronze shields, as first observed by Humfry

(PAR), 132 no. 102 (ROM); Hayes 2000a, 317–318 nos 24–29 and 34 (ROM).
 230. The appearance of cooking ware at Kommos is characterized as "sporadic" in Callaghan and Johnston 2000, 300; Johnston 2005, 361.
 231. Kotsonas forthcoming.
 232. Lebessi 1984, 445–446 fig. 3; 1988, 261 pl. 173d; 1992a, 217 pl. 93b.
 233. See Kanta 1991, 483 and 498 respectively.
 234. Muhly 2008, 16–17, 88–89, 93, 94–95, 97, 141–142.
 235. Lids: Watrous 1996, 67; Prent 2005, 347. Lids/shields: Lefèvre-Novaro 2014, 106.

Figure 4.10: The domed lids/shields P40, P39, and P98 (above, from left to right), P127, P7, and P99 (below, from left to right).

Payne nearly a century ago.[236] Following Payne, Richard Hutchinson used the term "shield lids," hypothesized that the vessels were provided with suspension holes because they were hung up against walls, and compared the lids to the bronze shields of the Idaean Cave type.[237] James Brock embraced these ideas and hypothesized that these vessels "served some religious purpose."[238] These ideas remain current to the present,[239] but recent scholarship distinguishes between lids with knob, which are typically called conical, and lids without knob, which are called domed.[240]

The primary function of conical lids was to cover cremation urns, especially neckless jars, from the mid-9th (when inurned cremation started becoming widespread in Crete) to the 7th century BCE.[241] Such vessels are well attested in the cemeteries of Knossos and the rest of central Crete, but they seem considerably rarer in the west half and the east end of the island.[242] Conical lids and associated urns can bear matching decoration, as documented

236. Payne 1927–1928, 263. Francis Welch (1899–1900, 92) had earlier argued more vaguely for the similarity of the clay "flattish bowls" from EIA Knossos to "the [metal] bowls and other metallic objects found in the Idaean cave."

237. Hutchinson and Boardman 1954, 222 (see also page 225 nos 39–48).

238. Brock 1957, 164–165 (the quote is from page 165).

239. Coldstream 1994, 119, 121; 1996, 327; 2001, 31, 33; Moignard 1996, 431; Prent 2005, 419–420.

240. Coldstream 1994, 119; 1996, 325; 2001, 31.

241. Coldstream 1996, 325; 2001, 31.

242. For Knossos, see, e.g., Brock 1957, 162–165; Coldstream 1996, 325–335; 2001, 31–35; Moignard 1996, 427–432. For the rest of central Crete, see, e.g., Pernier 1914, 64–70 (Prinias); Levi 1927–1929, 493 fig. 592-D (Aphrati); Johannowsky 2002, 4–22 (Gortyn); Rethemiotakis and Englezou 2010, 115–119 (Eltyna); Englezou 2011, 285–290, 300–304 nos 8–41 (Ligortynos); Sakellarakis and Sapouna-Sakellaraki 2013:B, 19–20 (Idaean Cave). For west Crete, see Kotsonas 2008, 146–152 (Eleutherna). For east Crete, see Tsipopoulou 2005, 432–437.

at the cemeteries of Knossos and Eltyna.[243] It has been observed that conical lids are largely missing from EIA domestic contexts at Knossos, but this is not the case at the EIA settlement of Chania.[244]

The function of the domed lid (Figure 4.10) is less obvious. Scholars have observed that although domed lids were occasionally used to cover urns, they do not fit them perfectly, which is why these vessels are taken to have served primarily other, ritual purposes.[245] This idea is based on the occurrence of large and homogeneous sets of domed lids in Knossian tombs which yielded considerably fewer urns, as well as on the attestation of such vessels in sanctuaries.[246] The recent publication of a large number of "patere e coperchi a forma di scudo e scudi votivi" from the sanctuary on the acropolis of Gortyn has shed new light on the question of the function of these vessels.[247] This sanctuary did not yield the storage vessels that typically carry such lids in burial contexts;[248] instead, it produced a number of miniature bronze shields (among other miniature armor and weapons).[249] This contextual association, as well as the rendering of the strap of a shield on the interior of a few of the clay lids, suggests that these vessels reproduce the form of miniature bronze shields.[250] At Syme Viannou, as at the sanctuary on the acropolis of Gortyn, the prolific attestation of domed lids contrasts with the paucity of jars designed to receive a lid (Section 4.9). Additionally, at Syme Viannou, these lids were found together with circa 500 bronze miniature shields, which lends support to the association between the two classes of finds.[251] In light of these considerations, I use the term domed lids/shields for the vessels from Syme Viannou which have no knob, and the term conical lids for the vessels with a knob, of which there are merely three. Given that all complete or well-preserved specimens from Syme Viannou are without a knob and that knob fragments are largely missing, I identify the majority of the fragmentary lids as domed lids/shields (rather than as conical lids), acknowledging, however, that this identification involves some uncertainty.

The bulk of the vessels treated in this section are made in MFG C2. Other MFGs are represented by a handful of specimens each; this includes A2 (P773, P774), B1 (P39), B3 (P386), C1 (P25, P576, P685, P827), D (P41, P70, P443, P592), E (P326, P406), I (P235, P393, P439, P444), and J (P414). There are also a few pieces which cannot be assigned to any MFG (P72, P577, P598), as well as a few loners (P18, P71, P117, P383, P384, P521).

The current state of the research suggests that Cretan lids basically date to the EIA. Exceptions are limited to a HEL piece with relief decoration which was found at the sanctuary

243. Knossos: Coldstream 1994, 106, 108; 1996, 325. Eltyna: Englezou 2004, 424–425.
244. Knossos: Coldstream 2001, 31. Chania: Andreadaki-Vlasaki 1997, 234.
245. Hutchinson and Boardman 1954, 221–222; Brock 1957, 164–165; Coldstream 1994, 119; 1996, 327; 2001, 31, 33.
246. For Knossian domestic contexts, see the references in Coldstream 1996, 357. For sanctuaries see below.
247. Johannowsky 2002, 4–22.
248. Johannowsky 2002, 4.
249. Johannowsky 2002, 78–80 (the shields are nos 590–600).
250. Johannowsky 2002, 4.
251. Muhly and Muhly 2018, 546; Papasavvas 2019, 247. See also Lebessi 1974, 226; 1976b, 9; 1977, 410; 1988, 262; 1991a, 324 pl. 207b; 2021, 185; Lebessi and Muhly 1987, 107. Also, Watrous 1996, 67; Prent 2005, 346; Lefèvre-Novaro 2014, 112.

at Krousonas-Kinigotafkos and was compared to the bronze shields of the Idaean Cave type.[252] The development of the form and the chronology of the Cretan EIA lids is well-studied at Knossos and a few central Cretan sites which have yielded pottery that follows Knossian prototypes.[253] In contrast, the development of the large assemblage from the sanctuary on the acropolis of Gortyn, which is quite different in style and largely PAR in date, is not well understood.[254] This is why my own study of the form of the pieces from Syme Viannou relies more on the Knossian sequence to the extent that this is useful. In Knossos, the development of the conical lids can be followed on the basis of changes in the morphology of the knob,[255] but the three conical lids from Syme Viannou have knobs which find no close match in the Knossian sequence. Knossian domed lids/shields "follow a consistent development from EG to EO [=Early Orientalizing] in which the ratio of height to diameter decreases fairly steadily, while the breadth of the central dome expands at the expense of the offset lip."[256] Furthermore, "during MG the rim handle is replaced by pairs of holes for suspension, and from now onwards the inside is unpainted."[257] None of the examples from Syme Viannou preserve the narrow central dome or the handle which is typical for the earlier Knossian pieces, which suggests a LG-PAR date for the assemblage from the sanctuary. The single MG specimen from the site (P451, dated on the basis of its decoration) shows a broad dome, but is too fragmentary to preserve a handle or any suspension holes. One or more suspension holes occur on almost two dozen pieces from Syme Viannou (P7, P18, P71, P99, P117, P208, P320, P323, P349, P434, P580, P598, P599, P622, P700, P825, P826, P827, P828, P829).[258] Nearly all other specimens are too fragmentary to allow for any conclusions over the attestation of suspension holes. At Syme Viannou, these holes would have served the suspension of these vessels from trees rather than from the walls of buildings. Indeed, Lebessi has made a similar argument for a range of votive offerings found at the site on the basis of: a) a HEL graffito which reads ἵδρυσα κέδροις and is taken to refer to the suspension of votive offerings from trees located at the site, and b) the suspension rings identified on some of the bronze cut-out plaques.[259] The perforated domed lids/shields of Syme Viannou could have been suspended in bundles by means of a string.[260]

The lids, and especially the domed lids/shields from Syme Viannou form the most decorated vessel class in a ceramic assemblage which is dominated by coated and plain vessels. Lids with pattern painted decoration predominate, banded specimens are common, while coated and plain pieces are rarer. The same pattern is identifiable at the sanctuary on the acropolis of Gortyn.[261] At Syme Viannou, coated (P97, P122, P320, P393, P414, P439,

252. Rethemiotakis 2001-2004.
253. Knossos: Coldstream 2001, 31-35. Eltyna: Rethemiotakis and Englezou 2010, 115-119. Ligortynos: Englezou 2011, 285-290, 300-304 nos 8-41.
254. Johannowsky (2002, 5-6) offers only limited observations on the shape of these vessels.
255. Coldstream 2001, 31, 33.
256. Coldstream 2001, 33.
257. Coldstream 2001, 35.
258. The holes on P25 probably represent a repair.
259. Lebessi 1981b, 5 (inscription); 1985b, 69-70, 73 nos A61, B7, B8 (plaques); 2009, 535-536 (plaques and inscription).
260. Cf. Ekroth 2003, 36.
261. Johannowsky 2002, 5.

P521, P648, P671, P772, P816, P826, P827) and plain (P39, P384, P431, P773) specimens are conventionally assigned to the LG-(AR) period. The more numerous banded specimens are also assigned to the LG-(AR) period (P18, P25, P42, P59, P71, P96, P123, P127, P326, P383, P443, P576, P580, P581, P599, P623, P646, P817, P823, P825, P828). The majority of the domed lids/shields, which are pattern painted, can be dated more precisely. Most of the patterns they carry are simple (such as zigzags, rows of Ss, double or triple concentric circles, and groups of strokes), but in a few cases the vessels carry ornaments which are typical for the Geometric (P451, P815) or the Orientalizing (P17, P179, P323, P331, P598, P684, P706, P800) style. White-on-dark decoration is attested on a number of pieces (P6, P98, P201, P208, P321, P322, P349, P576, P577, P622, P817) and it is occasionally combined with the more widespread dark-on-white decoration (P7, P16, P127). Although white-on-dark decoration becomes common on Knossian and Gortynian lids in the late 8th to early 7th century BCE (and persists for the rest of the 7th century BCE),[262] I assign the comparable specimens from Syme Viannou to the (LG)-PAR period (if finer dating is not possible) since I doubt they belong to the vanguard of this stylistic development. The interior of the body of the domed lids/shields and the conical lids from the site is usually plain and smoothed, while coating is uncommon (P97, P122, P332, P393, P521, P577, P622, P772, and perhaps P825) and banding is rare (P70, P434, P800, P830). Interior decoration is attested on some of the earlier PGB-MG examples from Knossos,[263] and on a few pieces from the acropolis sanctuary at Gortyn.[264]

The majority of the domed lids/shields and one of the two conical lids (P201) were found in the Area of the Altar, and the Terraces and the Water Channel. More specifically, two dozen domed lids/shields came from the latter area and a few more pieces from the former. The other areas of the sanctuary collectively yielded nearly three dozen pieces, but each of these areas produced no more than a dozen pieces, with only two specimens coming from Building E and its Immediate Surroundings (P700, P706).

Because of their shape and decoration, the domed lids/shields and the conical lids from Syme Viannou are generally assigned to the LG-PAR period or to parts of this timespan, with most specimens identified as PAR. P451 is the only piece which is demonstrably earlier, specifically MG. The possibility that some examples persisted into the AR period could be dismissed on account of the latest pieces from Knossos and Gortyn, which are identified as Late Orientalizing in style and are dated to the late 7th century BCE.[265] However, I prefer to keep this possibility open since the absolute chronology of the Knossian Orientalizing style, and especially its lower end, needs to be revisited,[266] while the Orientalizing pottery from the acropolis sanctuary at Gortyn can be shown to include pieces which date to the early 6th –

262. Knossos: Brock 1957, 163–164, type Eii; Coldstream 1996, 329–331, type B; 2001, 31, 35; Moignard 1996, 427, type A; Coldstream 2001, 35. Gortyn: Johannowsky 2002, 6.
263. Coldstream 2001, 35.
264. Johannowsky 2002, 4.
265. Knossos: Moignard 1996, 427–432; Coldstream 2001, 35. Gortyn: Johannowsky 2002, 7.
266. I have developed a more critical approach toward the chronology of the Knossian Orientalizing style since my review of it in Kotsonas 2008, 34–35. For a new find which includes a cross-reference with the Corinthian sequence, see Lebessi 2010b.

rather than the 7th – century BCE.²⁶⁷ Besides, I find it unlikely that domed lids/shields, which were so common through the 7th century BCE, disappeared abruptly and completely by the end of it. In light of these considerations, I assign some of the domed lids/shields from Syme Viannou to the G-(AR), (LG)-AR, or PAR-(AR) periods.

The large assemblage of lids – especially domed lids/shields – from Syme Viannou amounts to just over half the size of the published assemblage from the acropolis sanctuary at Gortyn (which includes over 150 pieces).²⁶⁸ Conversely, there was only a single PAR domed lid/shield at the sanctuary on the Armi hill of Gortyn,²⁶⁹ a few PAR pieces at Kommos,²⁷⁰ and a few LG-EPAR specimens at the sanctuary of Demeter at Knossos.²⁷¹ Considerable numbers of these vessels are reported from a few other central Cretan sanctuaries. Indeed, a preliminary overview of the pottery from the Idaean Cave indicates that domed lids/shields and conical lids were abundant at the site, with the earliest pieces dating from the PGB-EG period and most specimens dating from the LG-PAR.²⁷² Such vessels were also amply represented at Prinias Temple A,²⁷³ and perhaps at Kophinas.²⁷⁴ This survey confirms Prent's impression that domed lids/shields were particularly popular in the 7th century BCE, which she connected to "the general increase in terracotta votives in [the] 7th century BC." ²⁷⁵ Remarkably, Cretan LG-PAR domed lids/shields were exported over long distances, from Al Mina in the east to Megara Hyblaia in the west,²⁷⁶ despite the general paucity of Cretan ceramic exports in the Mediterranean in this period.²⁷⁷

The present section closes with a brief commentary on the six "discs" from Syme Viannou which are basically discoid, flat objects (excluding the tubular projection of P561), and range from 5 cm to 12 cm in diameter (Figure 4.11). The function of these objects is unclear but they could have served as vessel covers. The discs can be subdivided in two groups: a) fine-ware, pattern painted examples (P73 and P74, made in MFGs C2 and B3 respectively); and b) coarse ware examples with relief decoration of grooves and ridges (P559, P560, P561, P562), all made in MFG A1a, which is not represented among the dozens of lids. Interestingly, the two groups reflect contextual associations: P73 and P74 come from a specific level in the Area of the Altar, while P559, P560, P561, and P562 come from the Central and South-Central Part of

267. Kotsonas 2019a, 598.
268. Johannowsky 2002, 4–22.
269. Anzalone 2013, 233, 244 no. 36.
270. Callaghan and Johnston 2000, 215 no. 15, 233 no. 200, 234 no. 219, 236 no. 235; Johnston 2005, 347–348 nos 137–140.
271. Coldstream 1973b, 21 nos A23–A27.
272. Sakellarakis and Sapouna-Sakellaraki 2013:B, 19–20. Lids are by far the most numerous pieces discussed in this brief report.
273. Pernier 1914, 64–70.
274. Spiliotopoulou 2015, 285–286 figs 4η–θ.
275. Prent 2005, 420.
276. Schaus and Benson 1995, 3–4 pl. 1.4 (Al Mina); de Barbarin 2020, 443, 445; 2021, 501 (Megara Hyblaia). Although domed lids/shields are not among the Cretan LG storage jars identified on the Acropolis of Athens (Gauss and Ruppenstein 1998, 34), they could have accompanied them. It is tempting to consider the possibility that imported Cretan domed lids/shields inspired their Attic counterparts (on Attic and other Greek specimens see Stillwell 1952, 216–231; on the Attic specimens see also Laughy 2018).
277. I have often argued that the impression of a general paucity is exaggerated and relies on outdated evidence: see Kotsonas 2008, 286, 288; 2012b, 156–157; 2017a, 20–22; 2022.

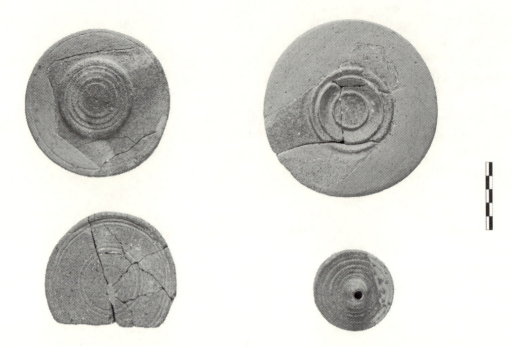

Figure 4.11: LCLAS discs (?): P559 and P562 above, P560 and P561 below, from left to right.

the Podium (specifically from a stratigraphic unit which cuts across trenches K48 and K49 and baulk K48/K49). Lastly, the former group includes PAR vessels, while the latter includes CLAS (?) pieces. Comparisons for these vessels are extremely rare, and the few parallels identified for the coarse discs date from either the LM IIIC or the HEL period (with the HEL comparisons being much larger in size).[278]

4.13. Kernoi and Ring Kernoi

Kernoi: P8, P9, P76, P118, P181, P202, P203, P210, P213, P362, P417, P436, P458, P524, P534, P627, P628, P629, P630, P631, P632, P653, P654, P659, P661, P667, P668, P669, P670, P701, P710, P711, P712, P713, P717, P718, P719, P720, P721, P722, P723, P724, P725, P726, P727, P728, P729, P730, P731, P732, P733, P734, P735, P736, P737, P738, P739, P740, P742, P743, P744, P745, P746, P747, P748, P750, P755, P756, P798, P802, P809

278. For LM IIIC comparisons ("cooking lids"), see Day 2011, 283–285; 2016, 85–86. Also cf. a pithos lid from a LHEL kiln at Loutra, near Eleutherna (Tsatsaki and Nodarou 2014, 296–297 no. P13), and a HEL lid for a beehive from Prinias (Biondi and Oikonomaki 2020, 98–99, 107 fig. 4.7). For P561 in particular cf. a few HEL pieces from Chania (Tsigkou 2010, 1689–1690 fig. 60).

Figure 4.12. Hypothetical reconstruction of a kernos from different fragments which belong to more than one vessel: base (P738), body (P739), lip (P720), kotyle and knob attachments (P725 and P736 respectively).

Ring kernoi: P836, P837, P838, P839

Fragments of kernoi were particularly abundant at the sanctuary of Syme Viannou, but may represent only a small number of vessels (a minimum of nine is estimated on the basis of variations in the morphology of the lip). The fragments of ring kernoi are less numerous but represent a minimum of four vessels judging by their morphology and fabric. Taken together, these kernoi and ring kernoi undermine the impression that "ritual vessels disappear" from Syme Viannou after the BA.[279]

The vast majority of the fragments of kernoi from Syme Viannou are made in MFG C, and any exceptions are limited to a few pieces made in MFG D (P8, P9, P202, P203). The fabric and the firing of the kernoi in question distinguishes them from comparable Minoan vessels from the site. The ring kernoi are made in MFG A (P836, P837, P838, P839).

279. Lebessi 1991b, 162. A more recent publication reports that "the number of ritual vessels made of clay is negligible" (Lebessi 2009, 523).

Figure 4.13. Hypothetical reconstruction of a kernos from Syme Viannou based on the form of surviving fragments.

The kernoi from Syme Viannou are highly fragmentary and the form of their body is unclear. Drawing together the morphological evidence from different pieces (especially the better preserved P436, P627, P632, P654, P718, P719, and P720), one can reconstruct a deep kalathos-like form with a broad lip (Figures 4.12 and 4.13). The body can show fenestrations (P417, P628, P718, P723, P740),[280] which can also appear on the resting surface that is flat and fairly thin (P737, P738) and is typically reinforced on the exterior (P629, P701, P737, P738). A possibly different form is represented by P436, which shows a shallow bowl with flat base standing on a cylindrical pedestal/stand.[281] Attachments are affixed to the upper surface of the lip and can have the form of: a) kotylai (i.e., miniature conical bowls), which are plain or – rarely – coated, and make up the bulk of the examples preserved; and b) cylindrical knobs in the form of pine-cones, which are uncommon and are typically adorned by horizontal grooves.[282] The miniature pyxis P707 may or may not belong to a kernos (Section 4.14). Kotylai were stacked on top of each other (e.g., P362) and could be combined with knobs, as exemplified by P76. Occasionally, traces of kotylai or other attachments survive on the exterior (P701) or the

280. For the fenestrations cf. Johannowsky 2002, 27–28 nos 164, 170 and 172, 30 no. 193 (kernoi), 42 nos 285–287 (stands); Haggis et al. 2007, 256 fig. 9, 289–290 fig. 34.3 (stands).
281. Cf. a coarse specimen from Itanos which is dated to LM IIIB or IIIC (Kanta and Kontopodi 2011a, 67 no. 49).
282. A knob-shaped kernos attachment is illustrated in Kanta 1991, 498 fig. 36e (where the reference is misprinted as fig. 36d, and the piece is identified as a lid knob).

Figure 4.14: Fragments of CLAS ring kernoi (from left to right, P836, P837, P838, P839).

interior (P740) of the body of the kernoi, which rarely carries incisions (P458, P722, P739) or grooves (P745, P746). Despite this variation, the similarities in the fabric and the morphology of the vast majority of the kernoi indicate that these vessels originate from very few workshops.

Erickson observed that the kernoi from Syme Viannou are "similar" in form to the CLAS-MHEL kernoi from Roussa Ekklesia.[283] However, he described the kernoi from the latter site as follows: "The usual form is a deep, cylindrical container similar to a basket ... with molded attachments on the rim in the form of miniature cups, jugs, and bowls."[284] This description suggests that there are undeniable similarities but also differences between the vessels from the two sites.

The form of the ring kernoi from Syme Viannou is not fully understood (Figure 4.14). The body of these vessels is hollow, has a fairly short diameter (13-14 cm), and is square (P836, P837), rectangular (P838), or elliptical (P839) in section. The upper part of the body carries attachments (cups ?) with perforated bottom, which suggests that liquids poured in each attachment penetrated the ring body, as is common with ring kernoi.[285] The ring kernoi from Syme Viannou are typically plain, but there is grooving on one side of P838 and P839.

Preliminary reports on the excavation of Syme Viannou mention the discovery of fragments of kernoi on the eastern side of the rim of the Altar.[286] However, the spatial distribution of these vessels is considerably wider. Nearly forty fragments, which make up over half of the inventoried material, come from Building E and its Immediate Surroundings. Ten or slightly more fragments were found in the Area of the Altar, and the North Part of the Enclosure and the Podium. Small groups were found in the Area of the Protoarchaic Hearth, and the Terraces and the Water Channel (this relative dearth is notable since the latter area yielded the most numerous specimens from most other shapes). Lastly, very few examples of kernoi are among the Material of Unknown or Uncertain Find Context, which, however, includes all the fragments of the ring kernoi.

283. Erickson 2002, 230.
284. Erickson 2002, 230.
285. Bignasca 2000, 97-100.
286. Lebessi 1972, 196. The attestation of kernoi at Syme Viannou is also reported in Kanta 1991, 482, 483; cf. Prent 2005, 705 table 6; Erickson 2010b, 230.

The kernoi found at Syme Viannou largely come from disturbed find contexts. Nevertheless, the discovery of ample fragments of kernoi underneath the Protoarchaic Hearth and the fine ash layer which was associated with it presents a *terminus ante quem* for the attestation of these vessels at Syme Viannou and indicates that their deposition commenced before the end of the PAR period.

A review of the attestation of the kernos in Crete can inform the dating of the specimens from Syme Viannou. Kernoi of varied form were introduced in the Cretan ceramic repertory in the MM III period and became quite common in the LM period.[287] The persistence of such vessels in the EIA is evidenced by PG open vessels with individual miniature attachments on the rim or just below, which have been found in tombs at Knossos, Eltyna, and Eleutherna,[288] and by PG or later examples from a settlement context at Kavousi Kastro.[289] Notwithstanding these PG vessels, it is unclear if the more elaborate kernoi found in Cretan sanctuaries of the 1st millennium BCE represent a survival or a revival of Minoan vessel forms which people of this period must have encountered in the ancient sanctuaries of the island. The possibility of revival is promoted by contexts like Syme Viannou, which has produced numerous Minoan Neopalatial communion cups with miniature cups attached around their body and rim, together with kernoi of the 1st millennium BCE which show comparable morphology.[290] Lebessi has noted that "the contextual association of communion cups with votive offerings of the 1st millennium BCE in the disturbed layers of hypaethral cult practice at the sanctuary gave visitors the possibility of coming into direct contact with vessels of the past and of appreciating valuable Minoan offerings as consecrated antiques;"[291] this contact could have inspired the dedication of kernoi to the site during the 1st millennium BCE.

The attestation of kernoi at Cretan sanctuaries of the 1st millennium BCE varies. Turning first to published assemblages, a "total absence of kernoi" was observed at the sanctuary of Demeter at Knossos, which is rather surprising given the close association of the goddess with the vessel shape.[292] At Kommos, "the kernos is very sporadic,"[293] and the inventoried pieces are only one or two and date from the second half of the 1st millennium BCE.[294] Likewise, a single PAR piece comes from the Gortynian sanctuary on the Armi hill.[295] Nevertheless, abundant PAR kernoi were found at the acropolis sanctuary of Gortyn.[296] Various dates, from LM IIIC

287. Xanthoudidis 1905–1906, 9–15; Girella 2003, 168–180. Recently published examples come from Vrysinas (Flevari 2016, 178–180 pl. 57; Tzachili 2016, fig. 4) and Sissi (Driessen 2019, 6: the pieces were found in a layer overlying the court of the Minoan building complex, which is why a Neopalatial – rather than a PAR – date is tentatively favored).
288. Girella 2003, 170; Kotsonas 2005, 191–192.
289. Mook 1993, 241 nos P2.143 and P2.187.
290. Lebessi 1983, 354 pl. 237a; Lebessi and Muhly 1987, 110; Archontaki 2012, 21 pl. 6a–b, 24, 26, 28. Also, Girella 2003, 171, 172 nos 35–44, 176.
291. Lebessi 2002b, 221. For comparable ideas on the stone kernoi see Lefèvre-Novaro 2018.
292. Coldstream and Higgins 1973, 183.
293. Callaghan and Johnston 2000, 301.
294. Johnston 2000, 377 no. 255 (miniature bowl possibly from a CLAS ? kernos), 382 no. 274 (rim fragment with attached cup, 1st century BCE).
295. Anzalone 2013, 252 no. 197 (cup attachment).
296. Johannowsky 2002, 22–42. See also Palermo 2002; 2004.

to PAR, have been proposed for the specimens from this sanctuary on the basis of preliminary reports.²⁹⁷ Johannowsky who published the material argued that the earliest of these vessels are PGB but most are PAR,²⁹⁸ while Dario Palermo favored an even earlier, LM IIIC date for a few pieces.²⁹⁹ While I acknowledge the uncertainties involved in the dating of the kernoi from Gortyn, I remain unconvinced by the arguments for the early (LM IIIC-MG) date of some pieces, and favor a (G)-PAR date for the most diagnostic pieces based on their decoration and also based on the preponderance of PAR material among the entire ceramic assemblage from the site.³⁰⁰

Kernoi of later date are known from east Crete. A few CLAS-MHEL specimens have been published from Roussa Ekklesia.³⁰¹ Copious specimens are known from the AR sanctuary deposits at Siteia and a sample of them is on display at the Archaeological Museum of Siteia.³⁰² These are typically unpainted, but can carry other decorative elaboration not seen on the finds from Syme Viannou. This pattern could be taken to support a PAR-(AR) date for the kernoi from Syme Viannou. EIA-AR kernoi have also been reported from several Cretan sanctuaries, the material of which is, however, largely unpublished. This includes Pachlitzani Agriada and Praisos Vavelloi in east Crete,³⁰³ as well as Haghia Triada, the Kouroupito cave, and Aphrati in central Crete.³⁰⁴ Kernoi may also be represented among the G-PAR fragments "from peculiar vessels, either naiskoi or ritual vessels," which were found in the Idaean Cave.³⁰⁵

The function of the Cretan kernoi has attracted various interpretations. Johannowsky considered that the vessels from Gortyn were intended for the offering of liquid and solid offerings, but he also noted that some fenestrated examples could have served as thymiateria or braziers.³⁰⁶ Palermo observed, however, that these vessels preserve no traces of burning and thus they are unlikely to have been used in association with fire.³⁰⁷ Prent has also noted that "the numerous multiple vases or kernoi [from the acropolis of Gortyn] may have been votives

297. Palermo's review of relevant literature showed that most scholars dated this material from the PG to the PAR period, with a LG-PAR date being the most popular; however, he argued for a LM IIIC date (Palermo 2002, 257–260). More recently, Palermo revisited the chronology of these vessels (Palermo 2004), as noted below.

298. Johannowsky 2002, 25–26.

299. Palermo 2004, which revises Palermo 2002, 257–260.

300. Likewise, Erickson (2010b, 232) favors a late 8th – early 7th century BCE date for the kernoi from Gortyn. It may be relevant that stone kernoi (which are of different form) also seem more common in the G-PAR period (Lefèvre-Novaro 2018, 164).

301. Erickson 2010b, 230–234, 248. Based on preliminary reports, Prent took these vessels to be earlier in date (Prent 2005, 301 fn. 480).

302. The finds from Siteia are mentioned briefly in Prent 2005, 301; Tsipopoulou 2005, 444.

303. Prent 2005, 705 table 6. The kernoi from the sanctuary on Mt. Thylakas near Lato are considered Minoan rather than Greek, in Prent 2005, 293. Individual EIA-HEL kernoi originate from burial contexts in east Crete (Xanthoudidis 1905–1906, 18–20; Tsipopoulou 2005, 444–445).

304. Haghia Triada: D'Agata 1998, 19, 22, 23; 1999b, 165–166 nos D5.11-12; Prent 2005, 321. Kouroupitos cave: Efstathiou, Kanta and Kontopodi 2021, 64–65, figs 51 and 61α. Aphrati: personal observation of at least one unpublished cylindrical kernos attachment among the material from the sanctuary excavated by Lebessi (1970, 455–458).

305. Marinatos 1956, 224.

306. Johannowsky 2002, 22–23.

307. Palermo 2004, 280.

rather than cult equipment, as the constituting vessels were closed or solid."[308] The ideas of Johannowsky were taken up by Erickson in his publication of the kernoi from Roussa Ekklesia. Indeed, Erickson concluded that the primary use of the kernoi from this site was to hold foodstuffs, and he also added that, as large open containers, the kernoi were "more suitable for dry goods than for oil or wine offerings."[309] Erickson further hypothesized that the kernoi from Roussa Ekklesia could have held lamps and thus they "may have contributed to atmospheric lighting effects."[310] Actual traces of burning are not reported from the fragments of kernoi from this site, but these fragments are too few in number and too small in size to allow for firm conclusions on the matter. No traces of fire are observable on the kernoi from Syme Viannou, which is why I think they should be associated with liquid and solid offerings. It is possible that the liquid used with these kernoi was water from the nearby spring, especially given Prent's observation that Cretan kernoi are often attested in sanctuaries associated with springs.[311] Additionally, Prent speculated that the kernoi served "the offering of grains and other vegetable food," a ritual practice which "had distinct female connotations."[312] In her view, kernoi are mostly found in sub-urban sanctuaries where "worship may have been a pre-dominantly or exclusively female affair." However, Syme Viannou is not a sub-urban sanctuary, and the association of kernoi with female worshippers has been criticized as "simplistic."[313]

Ring kernoi are the subject of a recent monograph which covers their attestation in the Mediterranean and the Near East.[314] This monograph shows that the ring kernos is very thinly attested in Minoan Crete and is hitherto unknown in Minoan sanctuaries.[315] Individual pieces have been found in PG tombs at Knossos and Kourtes and they are indicative of Cypriot inspiration.[316] The type is attested in Greek sanctuaries from the late 8th century BCE onward,[317] but remains unknown in Cretan sanctuaries during the 1st millennium BCE with the notable exception of some MCLAS-LCLAS examples from the sanctuary of Demeter at Vryses, in west Crete.[318] The ring bodies of the ring kernoi from Vryses are very similar to those from Syme Viannou, hence the CLAS date I propose for the specimens from the latter site. The kernoi from Vryses carried attachments in the form of miniature hydriai, but the form of the attachments on the vessels from Syme Viannou remains unknown.[319] The discovery of

308. Prent 2005, 268–269.
309. Erickson 2010b, 232.
310. Erickson 2010b, 222 (also see pages 233–234).
311. For this association, Prent (2005, 417) cites the example of the sanctuaries of Pachlitzani Agriada and Mesavrysis at Praisos (however, kernoi do not occur at Mesavrysis, but at the other Praisian sanctuary of Vavelloi, which is located by a spring; see Prent 2005, 308, 705 table 6). On Minoan kernoi at prehistoric sanctuaries located near springs, see Girella 2003, 172.
312. Prent 2005, 417 (see also pages 499 and 507).
313. Erickson 2010b, 220.
314. Bignasca 2000. See also Ilan 2021, 175–176.
315. Bignasca 2000, 60 no. E6 (MM piece from Pyrgos), 63 no. E14 (LM IIIB ? piece from Kommos).
316. Kourtes: Xanthoudidis 1905–1906, 15–18. Knossos: Coldstream 1996, 365; 2001, 46. Also, Bignasca 2000, 65–67 nos E24 and E27, maps 3 and 4.
317. Bignasca 2000, 66–78, 164–165.
318. Mortzos 1985, 30–31 (especially nos K1, K140, and K68), 102 pl. 19–20. See also Zois 1976, 61, 68, pls 27b–28; Bignasca 2000, 88.
319. For miniature vessels attached to Aegean kernoi, see Bignasca 2000, 102–103; for zoomorphic,

ring kernoi at Syme Viannou conforms to the broader attestation of such vessels at Cretan sanctuaries associated with springs and water facilities.[320] The different attachments on the ring kernoi from Syme Viannou and elsewhere could have been filled with different liquids (e.g., some with water and others with wine), which were then mixed in the ring body of the vessel.[321] An alternative hypothesis, which was proposed recently, takes the ring kernoi to have held psychotropic substances.[322]

4.14. Miscellaneous Vessels

Attachments: P276, P707

Incense burners/Ladles: P360, P427, P482, P568, P618, P762, P863, P864

Plastic vases: P361 (?)

Ring vases: P43, P129, P327, P484

Stands: P82, P126

Thymiateria: P316 (?)

Tripod cauldrons: P194, P442

This section discusses a range of vessel shapes which are usually (even if tentatively) associated with ritual practice because of their peculiar form,[323] and are thinly attested at Syme Viannou. Incense burners/ladles are represented by eight specimens, while attachments, plastic vases, ring vases, stands, thymiateria, and tripod cauldrons are represented by one to four examples. The different shapes are discussed separately, in alphabetical order, in the paragraphs that follow.

The role of attachments P276 and P707 is unclear. Although P276 looks like the conical knobs attached to kernoi (cf. P118, P181, P213), it is larger and hollow and is made in a fabric (MFG A1) which is not attested for kernoi. The piece also recalls the knobs attached to the lip of kalathoi like P262 and P799, which are, however, much smaller and solid. A third possibility is that P276 is the knob of a large conical lid. The miniature pyxis P797 may also belong to a kernos or be the knob of a conical lid.[324]

anthropomorphic, and other attachments on Aegean kernoi, see Bignasca 2000, 104, 113, 118, 124, 127, 130–133, 136–137, 138, 145.
 320. Bignasca 2000, 165.
 321. Cf. Bignasca 2000, 171.
 322. Ilan 2021.
 323. On ritual vessels, see Simon 1986, 317.
 324. For miniature vessel attachments serving as lid knobs, see Coldstream 1996, 325–326; 2001, 31–32, cf.

Eight pieces are identified as incense burners/ladles. Their shape, which is characterized by a shallow bowl supplied with a long horizontal handle, proved multifunctional in antiquity. Accordingly, experts in Cretan archaeology call this shape by different names related to (assumed) function: ladles, braziers, scuttles, and even kalathoi and lekanai in English;[325] αρύταινες, πυριατήρια, πύραυνα in Greek.[326] Most of these names suggest the use of these vessels in connection with fire, especially the transport of coals. Vessels of this shape are also occasionally identified as lamps or are thought to have functioned as lamps.[327] Traces of burning are often seen on Cretan examples of this shape, including on sets found together in specific HEL domestic,[328] and especially ritual contexts, like the Thesmophorion of Gortyn,[329] the sanctuary of Cybele (?) at Praisos,[330] and a room by the theatre of Aptera.[331] In contrast, traces of burning are missing from vessels of similar form which were found in other sites and were published as ladles. This includes the nearly two hundred HEL and EROM ladles from the sanctuary of Agiasmatsi at Sphakia,[332] the HEL ladles that dominate the ceramic assemblage from the sanctuary of Tsiskiana,[333] the vast majority of the HEL ladles from Kommos, and the (G)-MHEL ladles from the sanctuary on the west acropolis of Dreros.[334] The pieces from these cult sites are thought to have been used for serving food in ritual meals or for transferring and pouring liquid offerings.[335]

Only one of the eight pieces from Syme Viannou preserves traces of burning (P762), but the others are preserved much more poorly. There is no contextual information on the function of the vessels at Syme Viannou,[336] but most are probably small in size (excluding

especially fig. 1.5h = Moignard 1996, 430 no. 292.38 (7th century BCE).

325. Mercando 1974–1975, 119–121 (bracieri); Mook 1993, 190–191, 229–230 (scuttles); Francis et al. 2000, 449–450 (ladles or braziers); Haggis et al. 2007, 260 fig. 14:8 (scuttle), 288 fig. 34:1 (lekane); Allegro et al. 2008, 117 (braziers or ladles); Day 2011, 275–276 (scuttles); Haggis et al. 2011, 60 fn. 145 (lekanai, kalathoi); Anzalone 2013, 231, 234 (bracieri). On the term incense burners, which was been used in the past but has long been abandoned, see Day 2011, 276. For the use of the term ladles in the publication of the Cretan sanctuaries of Agiasmatsi and Kommos, see below.

326. Πυριατήρια: Andreadaki-Vlasaki 1985, 16, 18, 24; Niniou-Kindeli 1995, 682; 2002, 263, 266; Karamaliki 2010, 514. Πύραυνα: Tsipopoulou 2005, 259 no. H4532; Sofianou 2006; 2010, 180. Αρύταινες: Francis et al. 2000 (Greek abstract).

327. Seiradaki 1960, 12; Mook, 1993, 190; Callaghan and Johnston 2000, 232–233 nos 196 and 203–206; Hayden 2003, 54 no. 125; Haggis et al. 2011, 60 fn. 145.

328. Karamaliki 2010, 514 (settlement of Agia Irini, Rethymno).

329. Allegro et al. 2008, 117.

330. Sofianou 2010, 180. Several pieces are on display at the Archaeological Museum of Siteia.

331. Vanna Niniou-Kindeli, pers. comm.

332. Francis et al. 2000, 450.

333. Niniou-Kindeli 1995, 682; 2002, 263, 266. Most of the ladles from Tsiskiana are made in fine or semi-fine fabrics and preserve no traces of burning. The few coarse examples are very fragmentary (Vanna Niniou-Kindeli, pers. comm.).

334. For an exception to the general pattern, see Callaghan and Johnston 2000, 281 no. 690. Peter Callaghan (pers. comm.) kindly informed me that, before cleaning, some of the ladles from Kommos preserved a line of soot opposite the handle, perhaps indicating the presence of a wick. On the finds from Dreros, see Kotsonas forthcoming.

335. Callaghan and Johnston 2000, 291, 297 no. 915 (Kommos); Francis et al. 2000, 450–451 (Agiasmatsi); Portale 2000, 81 (Phaistos); Niniou-Kindeli, pers. comm.

336. The same applies to the pieces from the sanctuaries on the Armi hill of Gortyn (Anzalone 2013, 231, 234) and the west acropolis of Dreros (Kotsonas forthcoming). There is, however, contextual information on the pieces from

P618). Given this size, the bowl of the vessels could not hold enough coal to heat even a small space, which makes it unlikely that they served as braziers/scuttles.[337] Accordingly, I identify most of these pieces as incense burners/ladles. However, I consider that the better preserved P427 is a ladle, while P762, with its peculiar form and traces of burning, is an incense burner.

Several of the incense burners/ladles from Syme Viannou are made in MFG A1 (P618, P863, P864 ?), but MFGs A1a (P762), B1 (P427), and B2 (P482) are also represented, while P360 is a fabric loner. This variety of fabrics contrasts with the near monopoly of a single fabric on the ladles from the cave sanctuary at Agiasmatsi,[338] and the sanctuary on the west acropolis of Dreros.[339] Notwithstanding the variety of fabrics seen on the incense burners/ladles from Syme Viannou, these are typically made in coarse ware (except P482, which is semi-coarse to semi-fine). EIA to CLAS ladles from Kommos are made in semi-coarse fabrics, with semi-fine to fine ware examples taking over in the HEL period.[340] Also, the HEL and EROM finds from Agiasmatsi are typically made in semi-fine fabric.[341] Nevertheless, the ladles from the sanctuary on the west acropolis of Dreros remain coarse throughout the (G)-MHEL period.[342]

The shape of the incense burners/ladles from Syme Viannou is characterized by a shallow bowl equipped with a long and curving handle. P762 is exceptional in having the form of an oyster open at 90°, which is matched by numerous unpublished specimens from the Inatos Cave sanctuary.[343] The surface of the vessels in question is plain. Any elaboration is limited to the incised herringbone pattern on the handle of P360, the incised X on the handle of P482, the twisted handle of P618, and the grooved lip of P427. Three pieces were found at the Terraces and the Water Channel (P360, P427, P482), individual pieces come from the Area of the Protoarchaic Hearth (P618) and Building C-D and its Immediate Surroundings (P762), while two pieces are among the Material of Unknown or Uncertain Find Context (P863, P864).

Typological dating of the Cretan ladles is difficult because of their simple form and the insufficient study of the shape. Jane Francis and her collaborators, who studied the material from Agiasmatsi, have produced the only study of ladles from Crete of the historical period.[344] They discussed the morphological similarities and differences between the shape

the sanctuaries of Karphi (Day 2011, 276, with reference to the forthcoming publication of related material from the sanctuary at Kavousi Vronda) and Praisos (Sofianou 2006; 2010, 180). For relevant evidence from settlements, see Karamaliki 2010, 514 (Agia Irini, Rethymno).

337. Cf. Georgiou 1986, 29.
338. Francis et al. 2000, 441, 446.
339. Kotsonas forthcoming.
340. Callaghan argues that the change from coarse to fine fabric at both Kommos and Knossos occured in the CLAS period (Callaghan forthcoming, with reference to no. C6.10). For the pieces from Kommos, see the longer discussion which follows.
341. Francis et al. 2000, 441, 446.
342. Kotsonas forthcoming.
343. I thank Danae Kontopodi and Athanasia Kanta for sharing information on the material from Inatos. One piece was illustrated on a poster by Athanasia Kanta, Danae Z. Kontopodi, and Eirini Krasagaki, which was entitled "Conservation and interpretation: Two entwined aspects of archaeological material. The case of the cave of Eileithyia at Inatos Tsoutsouros," and was presented at the 11th International Cretological Congress, Rethymno, 2011.
344. Francis et al. 2000, esp. 440–441, 449–451 (with references). Also, Portale 2000, 81. For examples from the Aegean BA, see Georgiou 1986, 28–29.

of the historical period and the Minoan brazier, contrasted the popularity of the latter with the rarity of the former, and assumed a break in production from the end of the BA until the HEL period. Old and new evidence suggests, however, that bowls with long horizontal handle occur in Cretan domestic, burial, and especially sanctuary contexts throughout the historical period,[345] even if they only become common in the HEL period.

Contextual evidence for the chronology of these vessels can only be found at the sanctuary of Kommos – the single Cretan site which has produced abundant evidence for ladles in securely dated contexts of different periods. The ladle is attested at Kommos from the PG, and especially the G period, to the end of the HEL period,[346] with inventoried pieces being only a fraction of the total of ladles recovered at the site.[347] The PG to EPAR examples from Kommos are characterized by a very low lip and straight wall.[348] By the CLAS period, when the shape reappears at Kommos, a hemispherical body form is established.[349] In the LCLAS period (especially the first half of the 4th century BCE) the ladles from the site develop a broad lip which is mostly horizontal.[350] A shallow hemispherical body and broad lip is typical for examples of the 2nd century BCE,[351] which can also show a distinct base, whereas the latest examples of the 1st century BCE grow considerably deeper. The former (shallow) form also prevails among the HEL braziers from the Thesmophorion of Gortyn,[352] and among the HEL and EROM ladles from Agiasmatsi.[353] Most of the pieces from Syme Viannou are too fragmentary to be situated within this typological sequence, but P360 recalls the EIA-MCLAS comparisons, and P427 the LCLAS-HEL ones.

Four ring vases were identified at Syme Viannou. Kanta took the one piece – which is well-preserved (P129) and is made in MFG C1 – to originate from Aphrati, which has produced most known Cretan examples of the shape until recently.[354] However, the present study

345. In broad chronological sequence: Mercando 1974–1975, 119–121 nos 33–36 (G settlement at Phaistos); Andreadaki-Vlasaki 1985, 16, 18, 24 (G burials at Gouves and Gavalomouri); Kotsonas forthcoming (G to HEL sanctuary on the west acropolis of Dreros); Haggis et al. 2011, 60 fn. 145 (AR settlement at Azoria); Homann-Wedeking 1950, 183, and Callaghan 1992, 101 no. H12.28, 107 no. H15.15, 121 no. H30.10 (HEL domestic contexts at Knossos); Portale 2000, 81 (EHEL-MHEL domestic context at Phaistos); Karamaliki 2010, 514 (MHEL settlement at Agia Irini in Rethymno); Sofianou 2006; 2010, 180 figs 4–5 (EHEL-MHEL sanctuary at Praisos); Francis et al. 2000 (HEL and EROM sanctuary at Agiasmatsi in Sphakia).

346. Callaghan and Johnston 2000, 232–233 nos 196 and 203–206, 237 no. 244, 254 nos 433–436, 264 no. 533, 266–267 nos 559–563, 567 and 570, 272 no. 611, 281–282 nos 689–690 and 709–710, 284 nos 733–735, 287 nos 775–778, 293 nos 866–868, 297 no. 915; Johnston 2005, 381–382 nos 272–273.

347. As explained in Callaghan and Johnston 2000, 237 no. 244 (many sherds in Temple B, which dates to the G and the PAR period), 271 (many pieces in HEL deposits associated with Temple C). The sequence from Kommos is the basis for the dating of the ladles from 'Edifizio A' at Gortyn (Anzalone 2013, 234).

348. This form also characterizes the ladles of Dreros type III, as explained in Kotsonas forthcoming.

349. This form also characterizes the ladles of Dreros type II (Kotsonas forthcoming). The carinated body form, which is the hallmark of Dreros type I (Kotsonas forthcoming), is attested only on one 4th century BCE ladle from Kommos (Callaghan and Johnston 2000, 254 no. 434), but is more common on the HEL and EROM material from Agiasmatsi (Francis et al. 2000, 440 figs 13:50 and 14:55).

350. This form of the lip resembles the lip of the ladles of Dreros types Ia and IIa (Kotsonas forthcoming).

351. The development of a shallower form in the course of the 2nd century BCE is also attested at Knossos (Callaghan 1992, 121).

352. Allegro et al. 2008, 117.

353. Francis et al. 2000, 440 figs 7 and 13–14.

354. Kanta 1991, 498, 501 fig. 38, with reference to Levi 1927–1929, 276–277 fig. 349, 288 fig. 373, 362 fig. 474.

shows that Syme Viannou has produced more specimens than Aphrati and in different MFGs (E, A2 and F, in addition to C1), which must represent different Cretan workshops. The body of these vessels is ring-shaped, hollow but with a thick wall. The vessels are supplied with a mouth (P43, P484) and a handle (P129) on the upper end and stand on a pedestal foot (P129). P327 is plain, P484 was probably coated, while P43 and especially P129 carry banding. All the ring vases from Syme Viannou are attributed to the (L)PAR period on the basis of the best-preserved specimen (P129) and the comparisons from Aphrati. Two of these vases were found in the Area of the Altar (P43, P129), and the other two at the Terraces and the Water Channel (P327, P484).

A plastic vase in the shape of an owl found at Syme Viannou was published by Muhly.[355] A possible second plastic vase is represented by P361 (from the Area of the Altar), the form of which is unclear. The piece is made in MFG C2 (?) and is decorated with cross-hatched lozenges and outlined tongues with arcading, which suggests a PAR date.[356] Plastic vases are better-known from tombs at Knossos and elsewhere in Crete.[357] However, fragments of them are also attested in Cretan cult sites. The Gortyn acropolis sanctuary produced five specimens,[358] while single PAR pieces come from Kommos and the cave sanctuaries of Psychro and Inatos.[359] A considerable number of CLAS Attic plastic lekythoi were found at the sanctuary of Demeter at Knossos.[360]

The two stands, P82 and P126, were found in the Area of the Altar. The former vase is made in MFG A1, is conical in form and carries relief decoration, while P126 is made in MFG C1 and is undecorated. Kanta noted that "various clay stands – some painted with religious symbols – are characteristic of the pottery of the last Minoan to early Greek phases [at Syme Viannou]. They seem to continue at least into the Geometric period when they become covered in black paint."[361] P82 and P126 are later, LG-AR pieces. P82 is best associated with the numerous stands from the Communal Dining Building at Azoria.[362] This form is little known from elsewhere in Crete.

P316 is the only piece which can be tentatively attributed to a thymiaterion. It is made in MFG C2 and carries pie-crust decoration. This decoration and the vessel profile suggest a MROM date (see Section 2.3). The piece comes from the Terraces and the Water Channel. Thymiateria are rare in Crete, but a few specimens (not very similar to P316) are known from Knossos.[363]

A single piece comes from the cave sanctuary of Inatos (Kanta and Kontopodi 2011a, 74 no. 64: the proposed G-EPAR date is probably too early) and another from Praisos (Tsipopoulou 2005, 248, 442–443 no. H3850: EPAR).

355. Muhly 2008, 100, 108 no. 304.
356. For the row of outlined cross-hatched lozenges see Brock 1957, 181, pattern 5k (LG-EPAR). For the tongues with arcading see Brock 1957, 181, pattern 13a; Tsipopoulou 2005, 489–490, pattern 9δ (largely PAR).
357. Moignard 1996, 449–451; Kotsonas 2005, 751–753.
358. Johannowsky 2002, 69 nos 438–441a.
359. Kommos: Callaghan and Johnston 2000, 242 no. 294; Johnston 2005, 352, 388 nos 153–154 (PAR). Psychro: Boardman 1961, 62–63; Watrous 1996, 45 no. 155. Inatos: Kanta and Kontopodi 2011a, 77 no. 70 (LPAR).
360. Coldstream 1973b, 39 nos 1–12.
361. Kanta 1991, 498, with reference to fig. 34. This material is currently under study by Papasavvas.
362. Haggis et al. 2007, 255–256 fig. 9, 281–282 fig. 29:8.
363. Hayes 1983, 111, 132 no. 193; Sackett 1992, 241 nos D5,1 and D5,2; Forster 2001, 165–166 figs 4.15e and 4.15g (2nd century CE).

Preliminary reports on the sanctuary of Syme Viannou mention the discovery of fragments of pieces of tripod cauldrons,[364] which include two G-PAR pieces represented by ring handles that imitate metal prototypes.[365] One of them is coated and comes from the Area of the Altar (P194), while the other is pattern-painted and was found at the Terraces and the Water Channel (P442). Clay tripods with ring handles dating from the late 9th and early 8th century BCE are known from Knossian tombs,[366] but the shape may have survived into the 7th century BCE, as indicated by miniature cauldrons with ring handles from the Gortyn acropolis sanctuary.[367] Bronze counterparts, if not prototypes, are well-known from other Cretan sanctuaries and mostly date from the 8th century BCE: "In addition to the Idaean cave, tripod-cauldrons have been encountered in the sanctuary at Amnisos, at Syme, the Altar Hill at Praisos, at Palaikastro and possibly on the West Hill at Dreros and at Kommos ... They occur occasionally in miniature form, as in the Idaean cave and at the acropolis of Gortyn."[368]

4.15. Conclusion: Ceramic Form and Function at Syme Viannou and Other Cretan Sanctuaries from the Early Iron Age to the Roman Period

This conclusion draws together the main points of the preceding analysis to generate a diachronic synthesis of ceramic consumption at the sanctuary of Syme Viannou in the Greek and Roman period. The ebb and flow in the representation of the different functional categories of vessels is tracked in Figure 4.15. This figure divides the time-span covered in this study in periods of varying length to reflect established discussions over the archaeology of Syme Viannou and the history and archaeology of Crete, as explained in Chapter 5. Figures 4.15a and 4.15b quantify the individual pieces catalogued in this study according to the methodology which is explained with reference to Figure 4.1.[369] Figure 4.15c zooms into these data by charting only the functional categories which are represented by no more than few dozen fragments (thus excluding deep small open vessels, lids, and kernoi).

Figure 4.15 shows that deep open vessels of small size, specifically bell skyphoi, dominate the ceramic repertory of the sanctuary in the PG period, but limited specimens from

364. The vase is discussed in Lebessi 1984, 445–446 fig. 3; Kanta 1991, 498–499 fig. 35. See also Prent 2005, 347.
365. On bronze rod tripods and tripod cauldrons in Cretan EIA sanctuaries, see Prent 2005, 377–381.
366. Coldstream 1996, 372, type Bi.
367. Johannowsky 2002, 48 nos 305g, 305h, 307.
368. Prent 2005, 379–380 (see also page 703, Table 4). For the pieces from the Idaean Cave, see Matthäus 2011, 110; Sakellarakis and Sapouna-Sakellaraki 2013:B, 79, 84.
369. Additionally, a vessel which is dated broadly to two different periods, e.g., PAR-AR, is here counted as 0.5 for each period. This principle is retained when dating to one of the two periods is more likely (e.g., PAR-(AR)). Vessels of indeterminate date are not included. When a vessel is dated broadly to around the beginning or the end of the period under discussion (e.g., LM IIIC-PG, or LROM-EBYZ), I count 0.5 for either the PG or the ROM period.

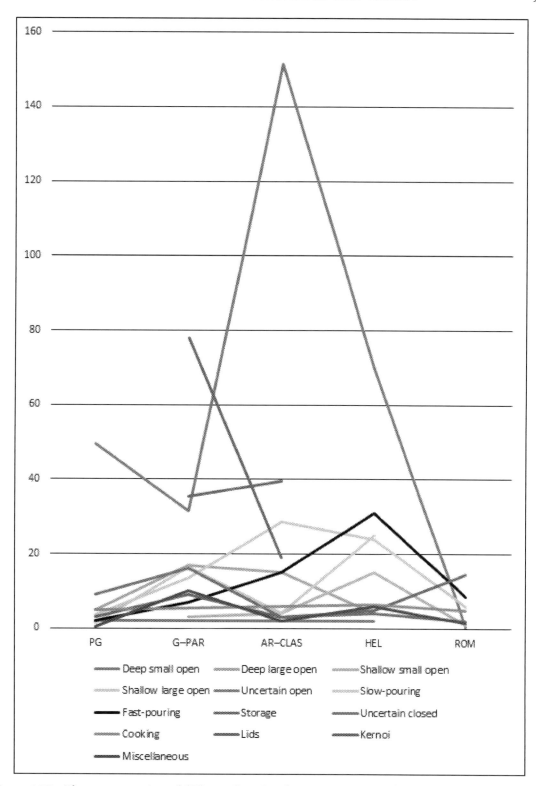

Figure 4.15a: The representation of different functional categories among the Greek and Roman pottery from Syme Viannou, with every piece catalogued counted as one vessel.

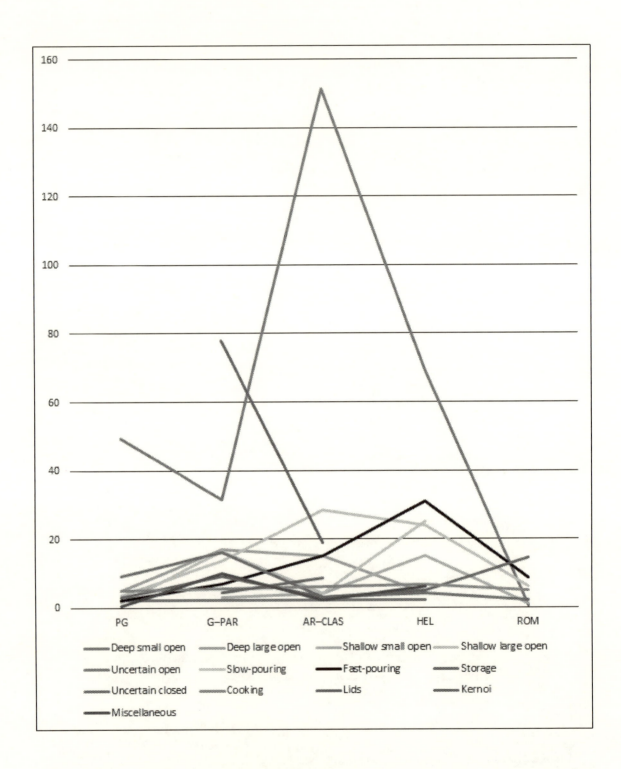

Figure 4.15b: The representation of different functional categories among the Greek and Roman pottery from Syme Viannou, with the kernoi counted according to the minimum number of individual vessels.

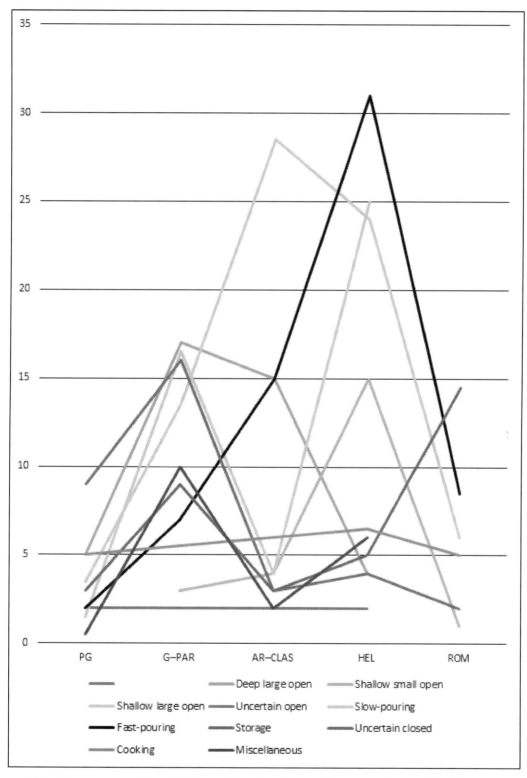

Figure 4.15c: The representation of different functional categories among the Greek and Roman pottery from Syme Viannou, excluding deep small open vessels, lids, and kernoi.

Figure 4.16: Sample of PAR pottery with elaborate – including Orientalizing – decoration (P531 and P578 above, P525 and P579 below, from left to right).

other functional categories (kraters, lekanai, kalathoi, jugs, aryballoi, and cooking jugs) are also attested. This repertory is indicative of activities centered on the preparation and consumption of food and drink, and is not very different (albeit considerably narrower) than domestic assemblages of the same period.[370] Bell skyphoi are apparently the most popular PG vessels in the two other long-lived Cretan sanctuaries which were active in this period, namely Kommos and the sanctuary on the Armi hill of Gortyn.[371] However, the PG pottery from Kommos includes a range of shapes which is considerably broader than that seen from the PG material from Syme Viannou and the Armi hill.

The quantity and variety of vessel shapes represented at Syme Viannou increased considerably during the G (specifically the LG) and PAR periods, as evidenced by Figure 4.15. By this time, bell skyphoi had disappeared and had been replaced by cups, which are attested in considerable numbers, albeit more thinly than the PG bell skyphoi. The deposition of medium-size to large vessels rose considerably. This includes large open vessels (especially kraters and lekanai), fast- and slow-pouring vessels, and storage vessels. Cooking vessels remained stable, while aryballoi and pithoi are largely exclusive to this period, also extending into the earlier part of the AR period. This pattern of increased quantity and variety in the deposition of PAR pottery at Syme Viannou is matched at other Cretan sanctuaries, including

370. Cf. e.g., Coldstream 1992, 67–70; Coldstream and Hatzaki 2003, 288–294.
371. Kommos: Callaghan and Johnston 2000, 212–232. Gortyn: Anzalone 2013, 232–234.

Kommos, the sanctuary of Demeter at Knossos, and the sanctuaries on the acropolis of Gortyn and the west acropolis of Dreros. Furthermore, the 7th century BCE is the only part of the Greek and Roman period during which vessels with elaborate decoration – which are especially but not exclusively domed lids/shields – were deposited at Syme Viannou in considerable numbers (Figure 4.16; see also Figure 4.10 above). In earlier and later parts of the Greek and Roman period, pottery from the site is typically plain or – more commonly – monochrome, as is also the case with many Greek sanctuaries.[372] Decorative elaboration also characterizes the LG-PAR pottery from Kommos, the sanctuary of Demeter at Knossos, and the sanctuary on the acropolis of Gortyn (though the pottery from this last site generally shows considerably more decorative elaboration than that from Syme Viannou).

During the G-PAR period, two shapes of ritual vessels were introduced at Syme Viannou, namely domed lids/shields and kernoi. Ritual vessels were copiously deposited at the site over much of the second millennium BCE, but disappeared in the later part of it. Although the kernoi of the PAR-AR period look back to the Minoan repertory, the domed lids/shields are without precedent. Domed lids/shields form the second largest class of Greek and Roman pottery at the site after that of deep open vessels of small size. Kernoi are rarer at Syme Viannou and are also found in small numbers in other Cretan sanctuaries, most of which are located by springs. The copious attestation of both kernoi and domed lids/shields at Syme Viannou is paralleled only at the Gortyn acropolis sanctuary, and in both cases the deposition peaks in the 7th century BCE. This correspondence is notable and comes in spite of the fact that the two sites show considerable differences in other aspects of their material assemblage. The two sanctuaries also served different audiences: Syme Viannou was an extra-urban cult site which attracted people from different communities in most periods (Chapter 3), while the Gortynian sanctuary was an urban sanctuary which served the local community. The two sites occupy different ends of south-central Crete, but the exclusive combination of domed lids/shields and kernoi cannot be readily considered as a sub-regional phenomenon, since the sub-urban sanctuary on the Armi hill of Gortyn and the extra-urban sanctuary of Kommos produced extremely few specimens of these vessel shapes. Besides, it is possible that the combination of the two vessel shapes also characterizes the assemblage of the Idaean Cave.[373] If this is confirmed, then this combination would be characteristic of – though not exclusive to – the most prominent interregional sanctuaries of Crete during the G and PAR period.

The AR and CLAS material presents inconsistent patterns. On the one hand, deep open vessels – almost exclusively cups – reach unparalleled numbers, fast-pouring vessels show considerable increase, and the combination of the two is perhaps indicative of an emphasis on libations. On the other hand, most other functional categories are represented very thinly. Large deep open vessels and cooking vessels remain more or less stable.[374] Because of the varied trends identified above and the historical problems of AR and CLAS Crete (on which see

372. Stissi 2002, 245–246; 2003, 78.

373. Marinatos 1956, 224 ("peculiar vessels, either naiskoi or ritual vessels"); Sakellarakis and Sapouna-Sakellaraki 2013:B, 19–20 (lids).

374. The kernoi are assigned a PAR-(AR) date (see Section 4.13), which means that their persistence into the AR period is uncertain. Figure 4.15 cannot capture this uncertainty.

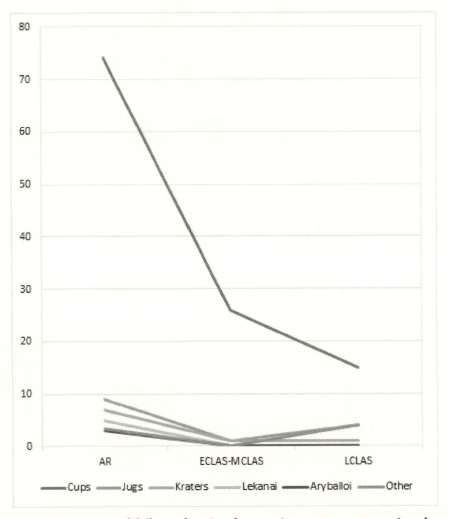

Figure 4.17: The representation of different functional categories among pottery assigned specifically to the AR, the ECLAS-MCLAS, and the LCLAS periods.

especially Chapter 5.4), I have prepared Figure 4.17 which provides an analysis of finer resolution compared to Figure 4.15. This resolution is achieved through: a) the division of time into shorter periods, namely the AR (circa 120 years), the ECLAS-MCLAS (circa 80 years), and the LCLAS (circa 80 years); and b) the inclusion of vessels which can be dated specifically to the three periods in question.[375] This means that vessels which are dated more broadly (e.g., PAR-AR, CLAS, MCLAS/LCLAS) are excluded, and thus the material of the 6th to 4th centuries BCE is underrepresented. However, these methodological choices yield a clearer impression of the limited ceramic repertory of Syme Viannou in both the AR and CLAS periods, and of the marked decrease in the quantity of cups deposited at the site after the AR period.

375. This excludes vessels dated more broadly, e.g., PAR-AR, LAR-ECLAS, or CLAS.

The AR period represents an almost complete gap for most Cretan sanctuaries. Only few vessels from the sanctuary of Demeter at Knossos, Kommos, and the sanctuaries on the acropolis and Armi hills of Gortyn have been assigned to this period.[376] Erickson has argued that Syme Viannou is exceptional for Crete in yielding ample AR pottery, especially cups.[377] The present study – including Figures 4.15 and 4.17 – confirms this impression, but also shows that the high number of cups is exceptional for the Greek and Roman ceramic record from the site. My study, however, has also identified a broader repertory, which is typically represented by fewer specimens than in the PAR period. The study of the pottery from the sanctuary on the west acropolis of Dreros also yielded evidence for considerable activity in the AR period,[378] which indicates that a closer look at the material from other Cretan sanctuaries may temper the notion of a gap in the deposition of ceramics.

At Syme Viannou, the number of cups and lekanai dropped considerably in the CLAS period, but the cup remained the most common vessel form (Figures 4.15 and 4.17). The rest of the repertory shrank further, and storage vessels, slow-pouring vessels, and shallow open vessels of small size nearly disappeared. Cooking vessels remain rare. This pattern is not unparalleled at other Cretan sanctuaries, including those on the acropolis and Armi hills of Gortyn.[379] Kommos and the sanctuary on the west acropolis of Dreros have yielded little ECLAS-MCLAS pottery, but much more LCLAS material.[380] Copious CLAS pottery comes from the sanctuary of Demeter at Knossos, but this largely dates from the end of the MCLAS and the LCLAS periods.[381]

The number and variety of ceramics deposited at Syme Viannou increased considerably in the HEL period,[382] as confirmed by the spikes of different functional categories in Figure 4.15. This conforms to a pattern which is also identifiable at Kommos, the sanctuary of Demeter at Knossos, and the sanctuaries on the Armi hill of Gortyn and the west acropolis of Dreros.[383] The cup remained the most popular vessel shape,[384] but other types of deep open vessels of small size also appeared. Fast-pouring vessels and shallow open vessels of small size are more numerous than in any other period. Lekanai present a second spike during the EHEL-MHEL

376. Knossos, Demeter: Coldstream 1973b, 52–53 nos K4-K6. Kommos: Callaghan and Johnston 2000, 250–253. Gortyn acropolis: Johannowsky 2002, 103, 104, 107; Gortyn Armi: Anzalone 2013, 234.

377. Erickson 2002.

378. Kotsonas forthcoming.

379. Gortyn acropolis: Johannowsky 2002, 103–106; Gortyn Armi: Anzalone 2013, 234; Dreros: Kotsonas forthcoming.

380. Callaghan and Johnston 2000, 253–266.

381. Coldstream 1973b, 22–31, 39–46, 53: Deposits B, C and partly D, H and K.

382. Sporn (2018, 132) reports that there is "only scarce pottery attributable to Hellenistic and Roman times" at Syme Viannou, but this is only true for the ROM material. Her related observation for the lack of "indications for extensive banqueting" in the same time span (Sporn 2018, 132) can be confirmed for the ROM period; however, the ceramic repertory of the HEL period is considerably richer and thus less straightforward on the matter.

383. Kommos: Callaghan and Johnston 2000, 266–297 (the increase at Kommos is identifiable only from the 2nd century BCE). Knossos, Demeter: Coldstream 1973b, 27–46, 53–54: Deposits E, F, G and partly D, H and K. Gortyn, Armi: Anzalone 2013, 234–235; Dreros: Kotsonas forthcoming.

384. The number of HEL cups from Syme Viannou which is published here is comparable to the number of CLAS cups from the site. However, there is a considerable number of HEL cups among the unpublished inscribed material currently under study by Kritzas.

period (after the spike seen in the AR-ECLAS period), but they became much less common thereafter. Notwithstanding this general pattern of increased investment in ceramics, deep large open vessels basically disappeared from the site. I have argued that this phenomenon is paralleled at different Cretan sanctuaries and seems to be symptomatic of the broader trend for the "missing krater" which characterizes HEL Greece.[385]

Although the LHEL ceramic record from Syme Viannou largely conforms to the patterns discussed above, it also presents two exceptional, albeit short-lived developments. First, cooking vessels show a notable rise which remains outstanding for any period after the EIA. Second, unguent vessels, specifically unguentaria, appear in considerable numbers. This second pattern is also identifiable at Kommos,[386] but has no obvious explanation.

The ROM period represents the most dramatic change in the ceramic repertory from Syme Viannou. The number of vessels deposited drops markedly,[387] and the representation of most functional classes diminishes, with further diminution attested after the EROM period. An extreme manifestation of this phenomenon is the disappearance of cups and other deep open vessels which had dominated the pottery record of the site for nearly two millennia. This particular change is not site-specific and conforms to the disappearance of cups and related vessels from the Cretan ceramic repertory. However, the pottery of Roman Crete is rich in shallower open forms,[388] which are not attested at Syme Viannou.

Notwithstanding the general decline in the ceramic record from Syme Viannou, the number of storage vessels peaks in the MROM-LROM period. This contrast is not identifiable in the ROM ceramic assemblage from the two other well-published Cretan sanctuaries which were active from the EIA to the ROM period, namely Kommos and the sanctuary of Demeter at Knossos.[389] This indicates that a local explanation should be sought for the skewed ROM ceramic record from Syme Viannou. The issue is explored in Chapter 5, which offers a more comprehensive overview of the Greek and Roman pottery from Syme Viannou, setting it against the evidence of other classes of material.

385. Rotroff 1996; 1997, 14–15.
386. Callaghan and Johnston 2000, 280 no. 679, 287–288 nos 782–785 and 806–809; Johnston 2005, 383 no. 277.
387. Sporn (2018, 132) is right in identifying this drop, but not in extending it to the HEL period.
388. See e.g., Forster 2001, 137–153.
389. Kommos: Hayes 2000a (on the ROM amphoras from Kommos see also Section 4.9). Knossos, Demeter: Coldstream 1973b, 39–55, Deposits H and J, and partly Deposits H and K.

5
Synthesis:
The Greek and Roman Pottery from Syme Viannou in Context

5.1. Introduction

By the final page of Agatha Christie's *Death in the Clouds*, the fictional archaeologist Armand Dupont has inspired the inquisitive Hercule Poirot to become "interested in archaeology and prehistoric pottery."[1] Much as I envy Dupont's success, I cannot subscribe to his ceramocentric approach to "the whole romance of humanity."[2] Accordingly, in the present chapter I set the results of the preceding analysis of the Greek and Roman pottery from Syme Viannou – including the primarily spatial and chronological focus of Chapter 2, the emphasis on fabrics developed in Chapters 3 and 6, the analysis of the form and the function of the pottery explored in Chapter 4, and the quantitative analyses pursued in Chapters 3 and 4 – in the context of a much broader range of evidence from the site, including building activity and the deposition of materials other than pottery. The approach is enriched by comparative perspectives on similar developments in other sanctuaries in Crete and beyond, and by discussions of the broader historical context. Thus, this chapter offers a diachronic panorama of activities at Syme Viannou, engages broader questions over the history and archaeology of ancient Crete, and promotes a more holistic approach to the study of pottery from Greek sanctuaries.[3]

The body of 865 pieces of pottery published in this volume is very high in absolute terms, but, if taken at face value, represents – roughly speaking – the deposition of only half a vase per year over the circa one and a half millennia of the Greek and Roman period. However, such an approach would be misleading in overlooking several parameters, including that the site is not fully excavated and has been heavily affected by landslides. The following analysis divides the Greek and Roman period into phases of unequal length on the basis of the patterning of the ceramic and other material. The length of the discussion dedicated to each phase depends

1. Christie 1974, 256.
2. Christie 1974, 211.
3. Given the quantity and variety of unpublished finds made in other materials and the extent of the hitherto unexcavated areas of the sanctuary of Syme Viannou, some aspects of the following discussion remain tentative and will have to be revisited in the future.

on the range and the complexity of the evidence which dates to it, and on the extent to which scholarship has previously engaged with this evidence. However, all sections address issues of continuity and change in cult practice at Syme Viannou, explore the shifting patterns of construction and material deposition, and chart the ebb and flow of the interregional role of the sanctuary.

5.2. The Protogeometric Period

The collapse of the Mycenaean palaces circa 1200 BCE is associated with major changes and discontinuities across the Aegean.[4] In Crete, the 12th century BCE is characterized by an extensive reconfiguration of settlement patterns, which included the abandonment of many costal and lowland sites and the establishment of settlements of mostly small size on defensible locations.[5] Some of these defensible sites were abandoned in the 10th century BCE, while others show expansion and nucleation from this time onward.[6] Despite these developments and despite the abandonment of many Mainland sanctuaries and the low visibility of cult practice in the Aegean circa 1000 BCE, Cretan sanctuaries are amply represented at the time and many of them are Minoan sites which outlived the collapse of 1200 BCE.[7]

Syme Viannou has played a key role in discussions of continuity and change in cult practice in the Aegean during the transition from the LBA to the EIA. Indeed, the site was once celebrated as "the first cult center in the Aegean that has provided concrete archaeological evidence for the transitional period between the Bronze and the Iron Ages."[8] According to Papasavvas, Syme Viannou survived the collapse of 1200 BCE because it was previously not attached to any single palatial or other center, and because it was essential for the communities of the surrounding area in providing a venue for social interaction at the sub-regional level in times of instability and change.[9]

Lebessi argued that "there were no drastic changes in sacrificial practice from the Minoan to the Greek phases,"[10] but she also noted that the PG period marks "a sharp division in the relationship between humans and the divine."[11] Cult in the second millennium BCE was characterized by the scarcity and the morphological homogeneity of figurines (which

4. Dickinson 2006; Lemos and Kotsonas 2020.
5. Nowicki 2000; Wallace 2010a, 49–72, 104–126.
6. Wallace 2010a, 231–266. For an overview of recent developments in the study of the period in Crete, see Kotsonas 2022.
7. Kotsonas 2017b, 59–60 figs 1–2; also, Prent 2005, 126; Wallace 2010a, 121–125, 132–149. For the question of continuity of cult in major Mainland sanctuaries see Morgan 1999, 295–298, 369–394; Dickinson 2006, 219–228.
8. Lebessi and Muhly 1987, 102; Lebessi 2021, 181–182 (but see also the cautious remarks on pages 177, 179–180).
9. Papasavvas and Fourrier 2012, 292.
10. Lebessi and Muhly 1990, 328. Also, Lebessi 1981b, 19; 2002b, 4; 2009, 522. Cf. Prent 2005, 170.
11. The division was once dated to the 10th century BCE (Lebessi 2009, 523), but more recently to the 9th (Lebessi 2021, 180, 202).

are all male) and the paucity of evidence for the (male ?) gender of the worshipped deity.[12] Conversely, from the transition from the second to the first millennium BCE, anthropomorphic dedications increased markedly and included male and – to a much lesser extent – female figurines of varied types, while the cult of Hermes and Aphrodite (or, rather, Proto-Hermes and Proto-Aphrodite) was introduced.[13] Additionally, maturation rituals for young males were established at the site in the 11th or 10th century BCE and persisted, despite change and transformation, until the ROM conquest of Crete.[14]

Previous characterizations of the PG period at Syme Viannou vary considerably. On the one hand, Lebessi and Muhly noted that, judging by the different finds, "the Protogeometric period was particularly prosperous;"[15] on the other hand, Lebessi has observed that this was a period of decline for the sanctuary, which was affected by a broader, island-wide pattern of social upheaval and economic decline.[16] In any case, by the beginning of the EIA, the Minoan buildings of Syme Viannou were largely in ruins, which nevertheless remained visible and must have been treated with respect (Figure 5.1).[17] As Papasavvas noted: "The collapsed Minoan buildings at Syme were covered by large amounts of ash and burnt wood, bones, pottery, and other finds, while every re-arrangement of this mass to make room for new activities must have brought relics of the past to the surface. This offered the inhabitants of the surrounding regions and those from even further afield a pilgrimage destination that was clearly connected with a glorious, tangible past, and offered the dispersed communities a means to be integrated into an established cult institution."[18]

Any building activity manifested at the time remains modest. In the 11th century BCE, Building L was erected on the southwest corner of the Neopalatial Enclosure; it was a bipartite roofed structure and remained in use until the PG period.[19] The building may have contained a xoanomorphic cult statue dating to the first half of the 10th century BCE, as deduced from the iconography of a PG clay female figurine which recalls later Greek xoana.[20] In the PG period, "an altar was erected approximately 8 m east of Building L, and a paved area was created between them."[21] There is no stratigraphic evidence on the date of the Altar, but a 9th century BCE date is probable on morphological grounds,[22] and PG pottery was found in the vicinity.[23] Lesser

12. Lebessi 2009, 523; cf. 1991b, 162; 2021, 131.
13. Lebessi 2009, 523–524, with discussion of the two gods on pages 534–537. See also Lebessi 2002b, 4, 269–270; 2021, 95–106, 131, 180–183, 194, 196, 200.
14. On the maturation rituals, see especially: Lebessi 1985b, 188–198; 1991b, 163–165; 2002b, 269–282; 2009, 533–538; 2021, 135–138, 148–151, 191; Lebessi and Stefanakis 2004, 186–187; Papasavvas 2019, 243–244. See also Chapter 4, fn. 73.
15. Lebessi and Muhly 1987, 108. Cf. Muhly and Muhly 2018, 545; Papasavvas 2019, 240.
16. Lebessi 1981b, 1.
17. Lebessi and Muhly 1987, 110; Zarifis 2007, 237; Papasavvas and Fourrier 2012, 293.
18. Papasavvas and Fourrier 2012, 293.
19. Lebessi 1977, 417; 1981b, 14; 1985a, 266–268 pl. 127e; Lebessi and Muhly 1987, 108; Zarifis 2007, 237, 238; Lebessi 2009, 527. Also Prent 2005, 172. The pottery from Building L will appear in a forthcoming volume by Kostis Christakis (on which, see Christakis 2013, 169).
20. Lebessi 2009, 527–528.
21. Lebessi 2009, 527. Lebessi (forthcoming) has revised her ideas on the "paved area."
22. Zarifis 2007, 238; Lebessi 2021, 171, 182.
23. See Section 2.2 and also Lebessi 2021, 171, 180.

Figure 5.1: Architectural remains visible in the PG period at Syme Viannou, including earlier ruins. 1: Building L (LM IIIC-SMIN); 2: Building S (originally LM IB, with the part shown reused in the LM IIIC-SMIN Buildings Q and L); 3: PG platform (created from the backfilling of the LM IIIC-SMIN Building Q); 4 Altar (PG); 5: Altar (EPAR); 6: Building U (MM IIB); 7: PG bench; 8: Neopalatial Podium; 9: Wall J (PG). Drawing by Nikos Zarifis.

foci of cult practice during the PG period include a hearth in the West Part of the Terraces and a bench located east of the Altar.[24] The last feature, together with Wall J, served to delimit the activity around the Altar.

The present work has established that PG pottery is dispersed across most of the excavated portion of the sanctuary of Syme Viannou.[25] Considerable numbers of PG vessels were found in the Area of the Altar (a dozen pieces), and the Terraces and the Water Channel (over 40 pieces) (not counting specimens dated broadly to the EIA). One to four PG vessels were found in nearly all other areas (the Central and South-Central Part of the Podium, the Area of the Protoarchaic Hearth, the West Part of the Enclosure, the North Part of the Enclosure and the Podium, and Building E and its Immediate Surroundings), with the exception of Building C-D and its Immediate Surroundings which yielded no PG pieces.

Preliminary reports on the pottery from Syme Viannou have identified both continuity and change in the deposition of pottery during the transition from the BA to the EIA. Generally, the copious quantities of clay – including ritual – vessels which were deposited at the site during the BA did not persist into the EIA.[26] The quantity of pottery decreased sharply already in the

24. Zarifis 2007, 239; Lebessi 2021, 171–172.
25. Zarifis (2007, 240) has observed that PG activity was not limited to the area of the PG structures, which lie east, west, and south of the Altar, but also extended north of it in the area of the Neopalatial Enclosure.
26. Lebessi 2009, 523; 2021, 131, 183.

Postpalatial period,[27] but the trend culminated around the transition to the first millennium BCE. Indeed, although "considerable amounts of pottery" – especially deep bowls, but also kylikes, kraters, and a range of other shapes – were deposited at the site during the LM IIIB and IIIC periods,[28] "the amount of pottery found is dramatically reduced" from the transition to the EIA,[29] and the representation of PG pottery in particular is considered to be very thin.[30] However, the replacement of the Minoan cups in general and the Postpalatial deep bowls in particular by PG bell skyphoi is taken to demonstrate continuity in the use of ceramics at the site across the transition from the BA to the EIA.[31]

The present study has qualified this picture. I have identified a considerable quantity of PG pottery at Syme Viannou and confirmed the preponderance of bell skyphoi among it. However, my study also identified limited specimens from other shapes and functional categories (kraters, lekanai, kalathoi, jugs, and cooking jugs). This repertory is indicative of activities centered on the preparation and consumption of food and drink. The preponderance of bell skyphoi at Syme Viannou is paralleled on the PG assemblages from the sanctuaries of Kommos and the Armi hill of Gortyn (even if Kommos yielded a broader shape repertory).[32] Although hardly any of the PG vessels from Syme Viannou can be dated specifically to the 10th century BCE, it would be unreasonable to consider that the abundant fragments which are assigned broadly to the PG period date exclusively from the 9th century BCE. Such a consideration is undermined by the fact that votive offerings which date from all sub-phases of the EIA/LBA transition have been identified at Syme Viannou, albeit in types and numbers which fluctuate markedly: The LM IIIC-SMIN offerings are dominated by wheel-made animal figurines, but also include a few clay and bronze pieces of other types, amongst which two bronze and roughly a dozen clay anthropomorphic figurines.[33] In contrast, the PG material includes four bronze anthropomorphic figurines, 167 bronze animal figurines, nine clay solid animal figurines, and 31 clay anthropomorphic figurines.[34] Even the species of sea-shell identified at the site during the PG period are considerably different from those seen in the Minoan period.[35]

27. Lebessi, Muhly and Papasavvas 2004, 2.
28. Lebessi and Muhly 1987, 108. Cf. Kanta 1991, 490, 494.
29. Kanta 1991, 482; cf. Lebessi and Muhly 1990, 324; Lebessi 1991b, 162; 2002b, 298 fn. 1304; 2009, 523; 2021, 183; Archontaki 2012, 18, 29; Muhly and Muhly 2018, 545; Papasavvas 2019, 247.
30. Lebessi 2002b, 298 fn. 1304.
31. Kanta 1991, 482, 494, 497; cf. Prent 2005, 347; Lefèvre-Novaro 2014, 105. On the copious finds of Minoan cups and related vessels at Syme Viannou see Kanta 1991, 482, 490, 494; Archontaki 2012. Cf. Prent 2005, 347.
32. Kommos: Callaghan and Johnston 2000, 212–232. Gortyn: Anzalone 2013, 232–234.
33. The finds are summarized in Prent 2005, 172, 176, 581–582; cf. Lebessi 1981b, 14–15; Papasavvas and Fourrier 2012, 292. On the clay wheelmade animal figurines, see also Nodarou et al. 2008, 4. For the bronze and clay anthropomorphic figurines, see Lebessi 2002b, 50–56 nos 8–9; 2021, 27–28 nos 10–13, 16, 18–19, 84–85 nos 205–209.
34. On bronze anthropomorphic figurines, see Lebessi 2002b, 57–74 nos 10–13. On bronze and solid clay animal figurines, see Muhly 2008, 214 tables B and C. On clay anthropomorphic figurines, see Lebessi 2021, 28–33 nos 20–49, 84 no. 203. On pieces of jewelry and other finds, see Lebessi 1981b, 14; cf. Prent 2005, 342–343; Lefèvre-Novaro 2014, 113. On the bronze figurines, see also the table in Whitley 2010, 176, 182 table 1 (the same table appears in two earlier publications by the same author, where, however, the headings of the columns are confused: Whitley 2005, 49, with table 4 on page 53; 2009b, 281; see the relevant note in Kotsonas 2017a, 20).
35. Lebessi and Reese 1986, 184, 185.

The notable changes in the material record of Syme Viannou from the LM IIIC-SMIN period on the one hand, to the PG (and G-PAR) on the other, are indicative of the re-emergence of the interregional role of the sanctuary; this role is identifiable over much of the 2nd millennium BCE, but must have declined during the transition to the EIA.[36] According to Lebessi, the intensification of activity at Syme Viannou during the PG period was promoted by people from the lowlands which extend south of the site, or from central – rather than east – Crete.[37] The rising appeal of the sanctuary in the PG period is indicated by the considerable range of macroscopic fabric groups (MFGs) identified on the PG pottery from Syme Viannou (A, B, C, D, E). This range is evident in the larger assemblages from the Area of the Altar, and the Terraces and the Water Channel, while the material from the remaining areas is nearly monopolized by MFG C2. The interregional role of the sanctuary in the PG period is also indicated by the style of other finds, including bronze stands and bronze anthropomorphic and animal figurines of the PG (and G) period, the manufacture of which can be traced to different sub-regions of the island, including the area of Knossos.[38]

Indirect support for the interregional role of Syme Viannou in the PG period can be deduced from the deposition of bronzes from the Eastern Mediterranean (see Section 3.5). Eastern Mediterranean imports were extremely rare at the site throughout the Minoan period, and their appearance in the early first millennium BCE is indicative of a type of investment which is paralleled at the interregional sanctuary of the Idaean Cave, but is largely missing from lesser Cretan cult sites.[39] Nevertheless, no overseas imports were identified among the PG pottery from Syme Viannou.

5.3. The Geometric and Protoarchaic Periods

The 8th and 7th centuries BCE are the core period of what Pierre Demargne called the Cretan Renaissance,[40] a concept which relates to – but is also distinct from – the broader concept of

36. Prent 2005, 559–562. Cf. Lefèvre-Novaro 2014, 122; Papasavvas 2019, 240.
37. Lebessi 2021, 181.
38. On stylistic variation, see Schürmann 1996, 192 fn. 493 nos 193–194 and 211 (PG bronze animal figurines); Lebessi 2002b, 59, 63, 65, 67, 68, 70–71, 289 nos 10–12 (PG bronze anthropomorphic figurines); Papasavvas 2001, 247 no. 38, 249 no. 47, 254–255 nos 54 and 56 (PG-G stands, on the dating of which see pages 178 and 192); 2012, 136 (PG-G stands). Papasavvas and Fourrier (2012, 289, 291) discuss the complexities involved in deducing the provenance of the votaries on the basis of bronze artifacts. Muhly and Muhly (2018, 548–550) report that the analysis of a few dozen bronze figurines from Syme Viannou, which date from the BA and the EIA, showed they were made of "the same metal."
39. On the bronze vessels and related equipment from the Idaean Cave, see Matthäus 2000; 2011; Sakellarakis and Sapouna-Sakellaraki 2013:B, 31–88. On the interregional role of the Idaean Cave see Jones D. W. 2000, 109–114; Prent 2005, 559–604; Pappalardo 2012, *passim*.
40. Demargne 1947. Demargne's Cretan Renaissance also included the 9th century BCE, but his discussion focused on the following two centuries. For an overview of recent developments in the study of the period in Crete, see Kotsonas 2022.

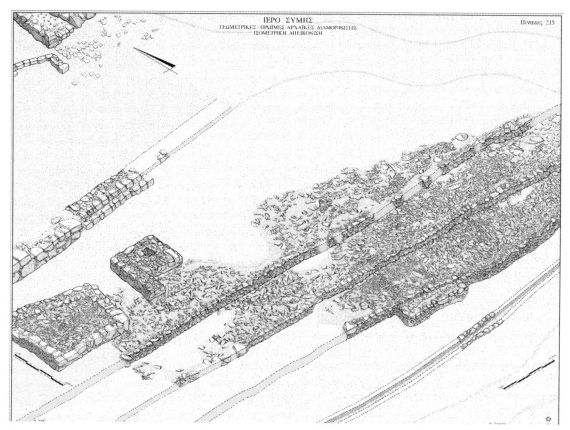

Figure 5.2: Architectural remains of the G-PAR period at Syme Viannou in the Area of the Altar, and the Terraces and the Water Channel. Drawing by Nikos Zarifis.

a Greek Renaissance of the 8th century BCE.[41] The two concepts originally had an artistic and cultural focus, but over time the latter came to encompass social transformations as well. One of the major developments of these times (and especially of the LG and PAR period) is the rise in the number and the distribution of sanctuaries across the Aegean (including Crete), as well as the increase in building activity at these sites and the marked rise in the dedication of votive offerings.[42] Syme Viannou presents no exception to this general phenomenon.

The notable material investment manifested at Syme Viannou in the 8th and 7th centuries BCE has long been noted in the literature. Lebessi once observed that Syme Viannou was especially prosperous from the G to the AR period,[43] but more recently she has specified that the phase of prosperity began only in the LG period,[44] when both the architecture and the pottery suggest considerable increase in material investment. Indeed, major building activity was developed at the site from circa 700 BCE to circa 600 BCE (Figure 5.2). The second phase

41. Kotsonas 2016a, 246–248, with references.
42. Whitley 2001, 140–146, 156–164; Kotsonas 2017b, 59–60 figs 1–2.
43. Lebessi 1985b, 18–19. Cf. Prent 2005, 342; Zarifis 2007, 241; Christakis 2014, 8.
44. Lebessi and Muhly 1987, 106.

of the Altar dates from the early 7th century BCE,⁴⁵ Terraces I and II were constructed in the first half of the 7th century BCE, while Terrace III and the Water Channel were built later in the same century.⁴⁶ At this time, the Protoarchaic Hearth and the substantial structure represented by Wall G were also constructed.⁴⁷ These developments monumentalized the sanctuary after nearly half a millennium of limited building activity, and represent the most extensive landscaping operations of the entire Greek and Roman period. The beginnings of this building activity in the early 7th century BCE largely overlapped with the introduction of maturation rituals for young females,⁴⁸ which complemented those previously established for young males.

G-PAR pottery is amply represented across the sanctuary, even if EG-MG pieces are rare in comparison to later material. Although there is material which is dated more broadly to (parts of) the EIA and may thus be EG-MG, there is only a single vessel from Syme Viannou which is assigned specifically to either the EG or the MG period, namely the MG domed lid/shield P451. This pattern need not represent a break in the deposition of pottery at the sanctuary, but must relate to problems of diagnosticity. Indeed, the highly diagnostic Atticizing style which characterizes the EG-MG pottery of Knossos is rarely attested, if at all, over much of the island.⁴⁹ This is clearly shown by the well-studied sequences of Eleutherna in west-central Crete and Kavousi in east Crete,⁵⁰ where local pottery dating to circa 800-750 BCE perpetuates Protogeometric trends and/or includes a restricted and little diagnostic morphological repertory.

The above-mentioned MG domed lid/shield P451 as well as most of the few vessels which are assigned to the PG-EG or PG-MG period come from the Terraces and the Water Channel.⁵¹ However, EG-MG activity probably extended much more broadly (albeit thinly), as is indicated by the distribution of pottery which *may* be EG-MG but is assigned to a broader date range (e.g., EIA) in nearly all areas of the sanctuary (excluding the West Part of the Enclosure). Up to seven specimens were identified in most areas,⁵² but the Area of the Altar, and the Terraces and the Water Channel yielded many more pieces (16 and 29 respectively).

45. Lebessi 1972, 194 (late 8th century BCE); Lebessi and Muhly 1987, 107 (beginning of the 7th century BCE); Papasavvas 2019, 240, 244 (late 8th - early 7th century BCE); Zarifis 2020, 119 fig. 68 (7th century BCE).

46. See Section 2.3 (a slightly later date is not excluded in Section 2.1.1). Also, Lebessi 1981a, 386 (Water Channel); Lebessi and Muhly 1987, 107 (Terraces). Some of the older literature on the site proposes slightly earlier dates for these structures.

47. See Sections 2.4 and 2.5. Also, Zarifis 2020, 119 fig. 68; Lebessi 2021, 175 pl. A. The AR date which was once assumed for this structure has now been revised.

48. Lebessi 2021, 143, 145.

49. Kotsonas 2008, 36–37, 45.

50. Knossos: Coldstream 2001, 66, 69; Kotsonas 2008, 34. Eleutherna: Kotsonas 2008, 45–46. Kavousi: Mook 2004, 171, 173; cf. Kotsonas 2008, 37. As Mook notes, Kavousi "Kastro Phase VII, immediately preceding LG, has thus been termed 'Geometric,' since little of the material exhibits the strong Atticizing influence that is the essence of Knossian MG" (Mook 2004, 173).

51. This includes the PGB-EG lekane P36, the PGB-MG cup P382, the PG-MG amphoriskos P447, the PGB-(EG) carinated cauldron P456, and the PGB-EG cauldron P620.

52. Central and South-Central Part of the Podium: P528, P529, P575. Area of the Protoarchaic Hearth: P595, P596, P625, P626, P633, P646. North Part of the Enclosure and the Podium: P680, P681. Building E and its Immediate Surroundings: P704, P715, P716, P749, P753. Building C-D and its Immediate Surroundings: P765.

SYNTHESIS: THE GREEK AND ROMAN POTTERY FROM SYME VIANNOU IN CONTEXT 555

The fairly broad range of MFGs (A, B, C, D, E) identified on PG pottery from Syme Viannou persisted into G-PAR times and increased by the introduction of two new groups (I, J) during the PAR period. MFG C (especially C2) predominates across the site, while the other MFGs remain uncommon (A, B, D) to rare (E, I, J). The number of fabric loners also increased in the (G)-PAR period and included a few pieces which may come from Knossos and north central Crete (P342, P351) or may be Gortynian (P18, P521, P690 and perhaps P383).[53] The notable range of fabrics identified on G-PAR pottery from the sanctuary recalls the range of PFGs identified on the solid animal figurines of the G-(PAR) period and – to a much lesser extent – the range of PFGs of G wheelmade animal figurines.[54]

As mentioned above, pottery post-dating the PG period and pre-dating the LG is thinly represented at Syme Viannou. In contrast, there is ample LG and especially PAR pottery, which suggests a notable increase in the deposition of clay vessels. Four very similar, PAR coated shallow skyphoi of Mainland type (P1, P2, P3, P4) made in MFG D were found adjacent to the Altar. This set, which contrasts with the overall rarity of the skyphos at Syme Viannou, indicates that the four vessels represent a single act of deposition.[55] It is not only the quantity, but also the variety of pottery which markedly increases at Syme Viannou in the LG-PAR period. By this time, bell skyphoi have disappeared from the Cretan repertory and have been replaced by cups. However, in this period, cups remain few at Syme Viannou and they are no more numerous than the specimens from a range of other functional categories, including large open vessels (especially kraters and lekanai), fast- and slow-pouring vessels, storage and cooking vessels. Aryballoi and pithoi are largely exclusive to this period, perhaps extending into the AR. The same applies to domed lids/shields and kernoi (kernoi are dated broadly to the PAR-(AR) period, and some lids may be AR). These two shapes represent the first post-Minoan classes of pottery which are not associated with feasting and everyday activities at the sanctuary. The kernoi were ritual vessels and could also have served as votive offerings, while the domed lids/shields must have had a votive role much like their bronze counterparts – the miniature bronze shields which occur in the hundreds at Syme Viannou. Indeed, the clay domed lids/shields are the second largest class of Greek and Roman pottery found at the site after that of deep open vessels of small size. This is despite the poor attestation of domed lids/shields at most other Cretan sanctuaries. Notably, these vessels are found together with kernoi only at the Gortyn acropolis sanctuary,[56] and perhaps at the Idaean Cave.[57]

As at other Cretan sanctuaries (Kommos, the sanctuary of Demeter at Knossos, and the sanctuary on the acropolis of Gortyn), the LG-PAR period at Syme Viannou is the only period during which vessels can show decorative elaboration; in earlier and later times, the pottery is typically plain or monochrome. At Syme Viannou, elaborate – especially Orientalizing –

53. Three of these pieces (P18, P342, P521) are characterized as PAR–AR, which means that they may post-date the 7th century BCE.
54. Solid: Nodarou and Rathossi 2008, 182. Wheelmade: Nodarou et al. 2008, 4.
55. Stissi (2009, 28) has observed that in some Greek sanctuaries "beautiful decorated cups [of the PAR and AR period] were placed close to altars in stacks, directly from the shop" (cf. Stissi 2003, 78). On the standardization of ceramic vessels, see Kotsonas 2014.
56. Johannowsky 2002, 4–42.
57. Marinatos 1956, 224; Sakellarakis and Sapouna-Sakellaraki 2013:B, 19–20.

decoration is attested only on a few pieces of pottery, particularly on domed lids/shields (see Section 4.12 and 4.15). These few pieces represent a departure from the remarkable pattern of deposition of plain and monochrome pottery at the site which cuts across the Greek and Roman period. Symptomatic of the same trend is the above-mentioned paucity of vessels which carry characteristic EG-MG decoration.

The pattern of increased quantity and variety of ceramics which is identifiable at Syme Viannou during the LG-PAR period is paralleled at other Cretan sanctuaries, including Kommos, the sanctuary of Demeter at Knossos, and the sanctuaries on the acropolis of Gortyn and the west acropolis of Dreros. This pattern conforms to the broader rise in the deposition of pottery which is identified in sanctuaries across the Greek world during the 7th century BCE.[58]

Besides pottery, Syme Viannou has produced rich and varied G-PAR finds. This includes 22 bronze anthropomorphic figurines, 360 bronze animal figurines, 52 bronze cut-out plaques, 137 clay anthropomorphic figurines, 165 clay solid animal figurines, and an unspecified number of wheelmade animal figurines (which largely date from the G period).[59] Likewise, bronze and iron weaponry as well as jewelry is amply represented in this period.[60] Indeed, very recent reports suggest that most of the unpublished metal finds from Syme Viannou date from this period. These finds include: circa 40 vessel handles and 35 partially preserved vessels (bowls, cauldrons, ladles, jugs), twelve shields with pictorial decoration, some weapons (such as arrowheads and spearheads), a horse frontlet, circa 350 small elongated blades, circa 35 votive double axes, 80 small models of clothes/textiles, and circa 150 personal items (rings, fibulae, pins, headbands, or belts).[61] The rich and varied offerings deposited at Syme Viannou in the 8th and 7th centuries BCE include a handful of bronzes and other imports from the Eastern Mediterranean (see Section 3.5), whereas other bronzes, particularly bronze cut-out sheets, show notable Orientalizing traits at the time.[62] In contrast, Aegean imports of any kind are missing altogether with the possible exception of the Laconian transport amphora P169 which dates to the LPAR-AR period.

The remarkable increase in the material investment manifested at Syme Viannou during the G and PAR periods conforms to the broader phenomenon of the Cretan and Greek Renaissance discussed above, but has also attracted site-specific interpretations. For example,

58. Stissi 2002, 255, 257.

59. On the bronze anthropomorphic figurines, see Lebessi 2002b, 74–137 nos 14–36. On the clay anthropomorphic figurines, see Lebessi 2021, 33–38 nos 50–84, 84–85 nos 204 and 210 (G period), 38–42 nos 85–113, 56–64 nos 128–177, 83 nos 199–201, 85–88 nos 211–215 and 219–231 (PAR period). On the bronze and solid clay animal figurines, see Muhly 2008, 214 tables B and C. On the clay wheelmade animal figurines, see Nodarou et al. 2008, 4. Cf. Prent 2005, 343–346. On the bronze figurines, see also the table in Whitley 2010, 176, 182 table 1 (on this table, see also the notes in fn. 34 above). On the increased percentage of tin in bronze figurines from Syme Viannou which date to the 7th century BCE, see Muhly and Muhly 2018, 548–550. On clay anthropomorphic figurines, see Lebessi 2009, 524, 540.

60. Weaponry: Lebessi 1974, 226; 1976b, 9; 1977, 410; 1981a, 391; 1984, 450, 456; 1988, 262; 1991a, 324 pl. 207b; Lebessi and Muhly 1987, 107. Jewelry: Lebessi 1974, 226; 1975, 324; 1976a, 403; 1977, 411; 1981a, 394 pl. 259γ; 1984, 450; 1988, 262 fig. 10a. Also, Prent 2005, 346; Lefèvre-Novaro 2014, 112, 113.

61. Muhly and Muhly 2018, 546; Papasavvas 2019, 247.

62. Lebessi 2000b, 178–182; Lebessi and Muhly 2003, 98–100; Karetsou, Andreadaki-Vlazaki and Papadakis 2000, 365–369 nos 400–408. Followed by Jones D. W. 2000, 115.

Lebessi has connected it with broader socio-political developments in Crete at the time,[63] but also took it to be symptomatic of the emerging interregional role of Syme Viannou. As she noted, "care for the sanctuary must have been shouldered by a community official, who would have communicated with his peers, the leaders of the settlements that participated in the cult."[64] A different approach to the developments at Syme Viannou in this period has been promoted by Prent, who took the increased building activity and the introduction circa 700 BCE of new classes of votive offerings – including the series of bronze cut-out plaques which seem to originate largely from a single workshop, and the mouldmade terracottas which are typical for Cretan suburban sanctuaries – to indicate that a specific community took control of the site.[65] As she noted, "a sudden take-over of the sanctuary around 700 BCE at present evidence seems more likely than that of a gradual tightening of control, although by which community remains unclear."[66] This interpretation is compatible with the hypothesis of Viviers that Biannos/Biennos controlled the sanctuary in the 8th to 6th centuries BCE.[67]

Papasavvas has recently challenged Prent's ideas by offering alternative interpretations for the developments which she has highlighted.[68] In his view, the introduction of new classes of votive offerings could depend on economic or technological – rather than political – parameters. Papasavvas has also argued that the scale of investment of energy and resources – which is represented by the construction of the terraces at Syme Viannou – indicates that people from different communities were involved in the cult. Like Papasavvas, I remain unconvinced by the argument which takes the developments of the early 7th century BCE to indicate the takeover of the sanctuary by a single community. This argument cannot be easily reconciled with the above-mentioned increase in the range of MFGs identified on the PAR pottery from Syme Viannou, and by the range of PFGs identified on the animal figurines of the G-(PAR) period. This range recalls the variety of styles identified on G-PAR bronzes – including anthropomorphic and animal figurines, cut-out plaques and stands – found at the site,[69] and does not lend support to the idea that the sanctuary was controlled by a single community. On the contrary, these developments are best explained by the rise of the interregional role of the sanctuary of Syme Viannou especially in the PAR period.

63. Lebessi 2021, 184–185, 202.
64. Lebessi 2009, 537.
65. Prent 2005, 573–576.
66. Prent 2005, 576.
67. Viviers 1994, 256.
68. Papasavvas 2019, 245, 249.
69. On stylistic variation, see Lebessi 1985b, 201–209 (cut-out plaques, largely PAR); 2002b, 90–91 nos 19–20 (G bronze anthropomorphic figurines); Schürmann 1996, 192 fn. 493 nos 237–273 and 337–338 (G animal figurines); Papasavvas 2001, 247 no. 38, 249 no. 47, 254–255 nos 54 and 56 (PG-G stands); 2012, 136 (PG-G stands). See also fn. 38 above.

5.4. The Archaic and Classical Periods

"Crete in the 6th and 5th centuries BCE has been virtually terra incognita," and its study "has lagged behind the study of most other regions of Greece."[70] Our understanding of the archaeology of the island in the AR and (partly) the CLAS periods remains unsatisfactory despite considerable advances in the last two decades.[71] The designation of the 6th century BCE as the period of the "Archaic gap," and the historical interpretations which this gap has attracted, are indicative in this respect.[72] Furthermore, a largely agrarian subsistence economy involving minimal engagement with trade is hypothesized for AR and CLAS Crete,[73] while an import gap is assumed for the island for much of the 5th century BCE.[74] Recent work has challenged these ideas,[75] but problems of archaeological visibility persist and hamper our understanding of AR and CLAS Crete.[76] The effect of these problems on the study of Cretan sanctuaries is remarkable.[77]

Lebessi has observed that the AR period was a phase of decline for the sanctuary of Syme Viannou which culminated in the CLAS period,[78] especially the 4th century BCE.[79] At first, Lebessi did not include the AR period in this phase of decline but treated it together with the PAR, which is a period of prosperity for the site.[80] However, in her final publications of the bronze cut-out plaques and the bronze clay anthropomorphic figurines, Lebessi argued that the AR period was part of the phase of decline which culminated in the early 5th century BCE.[81] As she noted, the serious decline in the quality and quantity of the AR bronzes (and other materials) from Syme Viannou is also identifiable in other Cretan sanctuaries and relates to the conservative character of the sociopolitical system of the island.

70. Erickson 2010a, vii. For an overview of recent developments in the study of the period in Crete, see Kotsonas 2022.

71. These advances are to be found especially in the pottery studies of Brice Erickson (2002; 2005; 2010a; 2010b; 2010c; Gilboa et al. 2017) and the excavations at Azoria by Donald Haggis (2014; Haggis et al. 2007; Haggis et al. 2011).

72. See Section 1.3, particularly fn. 59.

73. Chaniotis 1999.

74. Erickson 2005; 2013, 74–81.

75. On a revised approach to the Cretan economy, see Gagarin and Perlman 2016, 95–120 (especially 111–117). On Cretan pottery exports of the CLAS period to the Eastern Mediterranean, see Gilboa et al. 2017. On AR and CLAS Aegean pottery imports in east Crete, see Brisart 2014. The new fieldwork at Lyktos/Lyttos is yielding copious Attic and – to a considerably lesser extent – Corinthian, Laconian, and Ionian imports of the AR and CLAS periods (Petrakos 2021; forthcoming; Kotsonas, Sythiakaki and Chaniotis 2021; forthcoming).

76. See, e.g., Pilz and Seelentag 2014.

77. Sporn 2002, *passim*; Erickson 2010a, 257–271.

78. Lebessi 1981b, 6–7, 19; Lebessi and Stefanakis 2004, 181, 186–187. Followed by Viviers 1994, 256; Coutsinas 2013, 352.

79. Lebessi 1981b, 6. See also Lebessi 1985b, 197; 2002b, 279, and cf. the comparable but independent impression in Erickson 2002, 84.

80. Lebessi 1981b, 7–9.

81. Lebessi 1985b, 59–60, 100–107, 218–219; 2003, 137–150, 294–296; 2021, 22–25, 50, 53, 185–187. Cf. Papasavvas 2019, 250–251.

The (near) disappearance of bronze and terracotta animal figurines from Syme Viannou after circa 600 BCE has been central to the notion of a phase of decline of the sanctuary.[82] Significantly, no bronze animal figurines date after the PAR period and the same applies to clay animal figurines.[83] The fourteen bronze anthropomorphic figurines of the PAR period are followed by only two AR and two ECLAS ones,[84] while the 100 anthropomorphic figurines of the PAR period are followed by 31 AR and CLAS ones.[85] Likewise, the bronze cut-out plaques of the PAR period, which are over 50, give way to only thirteen pieces of the AR period and two of the ECLAS-MCLAS.[86] The few other bronze and clay offerings of the AR and CLAS periods which are known from preliminary reports do not change this gloomy overall impression.[87]

This pattern has received considerable attention in the secondary literature, which typically connects the decline in the deposition of bronzes (and other offerings) at Syme Viannou during the AR (and the CLAS) period with the broader phenomenon of the "Archaic gap."[88] This literature, however, often overlooks that the (near) disappearance of bronze figurines and terracotta animals during the AR and CLAS periods is not exclusive to Crete but is also identifiable in numerous other Greek sanctuaries, as observed in several volumes of the publication series on Syme Viannou and in other scholarship.[89] Additionally, the scholars who emphasize decline often fail to appreciate that a score of mainly non-figural Greek bronzes from Syme Viannou remains unpublished. These critical remarks are not intended to dismiss the notion of decline, but rather to indicate that there is scope for calibrating it in order to generate a more balanced understanding of the sanctuary in the AR and CLAS periods.

Occasionally, the discussion over the decline at Syme Viannou in the AR and CLAS periods has stressed the paucity of building activity manifested at the site. Indeed, following the major building programs of the PAR period, building activity at the site declined markedly and included only limited construction (of walls rather than buildings) in the central and the southern part of the Podium.[90] Nevertheless, as Erickson has observed, the terraces remained functional and could have accommodated scores of visitors,[91] since they occupied as much

82. Schürmann 1996; Muhly 2008.
83. Bronze animals: Schürmann 1996. Clay animals: Muhly 2008.
84. Lebessi 2002b, 103–137 nos 23–36 (PAR), 137–150 nos 37–40 (AR-ECLAS), 294–296.
85. Lebessi 2021, 38–42 nos 85–113, 56–64 nos 128–177, 83 nos 199–201, 85–88 nos 211–215 and 219–231 (PAR), 42–44 nos 114–127, 64–67 nos 178–194, 88–89 nos 232–238 (AR-CLAS).
86. Lebessi 1985b, 85–100 nos A2–A46 and B1–B4 (PAR), 100–107 nos A47–A59 (AR), 105–107 nos A60–A61 (ECLAS-MCLAS).
87. Lebessi 1981b, 6–7; 2009, 524. Cf. Erickson 2002, 45 fn. 10; 2010a, 260 fn. 114. The circa 500 bronze miniature shields from Syme Viannou can best be evaluated after their date is established; Lebessi (2021, 185) considers them post-G. On these shields see also Lebessi 1974, 226; 1976b, 9; 1977, 410; 1988, 262; 1991a, 324 pl. 207b; Lebessi and Muhly 1987, 107. Also, Watrous 1996, 67; Prent 2005, 346; Lefèvre-Novaro 2014, 112.
88. Viviers 1994, 256; Morris 1998, 62; Erickson 2002, 45, 76, 77–78; 2010a, 260; 2010b, 235; Kotsonas 2002, 46, 47; Whitley 2010, 176, 182 table 1 (on this table see also the notes in fn. 34 above).
89. Schürmann 1996, 216–217 (decline of bronze animal figurines); Lebessi 2002b, 294–295 (near disappearance of bronze anthropomorphic figurines circa 450–350 BCE); Muhly 2008, 147, 164, 214, pl. B and C (decline of terracotta and bronze animal figurines after the mid-7th century BCE). Also, Osborne 1987, 187; Haysom 2011, 98; Papasavvas and Fourrier 2012, 295; Smith 2021, 161.
90. Zarifis 2007, 248–253.
91. Erickson 2010a, 260 fn. 119, 261.

Figure 5.3: The AR and CLAS Building E, reconstruction by Nikos Zarifis.

as 1000 to 2000 sq.m.⁹² The notion of a paucity of building activity in this period needs to be reconsidered in light of the new dating of Building E, which was long treated as a structure of indeterminate date (Figure 5.3).⁹³ Based on the evidence of roof tiles, Zarifis has argued that the structure was built in the LAR/ECLAS period (500–475 BCE) and remained in use until the LCLAS or the EHEL period.⁹⁴ My own study of the pottery from the area of this building (Section 2.8) identified PAR to CLAS material but hardly any earlier or later pieces. On this basis, I believe it is reasonable to infer that Building E was in use during the LAR period (if not earlier) and especially in the CLAS. This inference challenges the notion of a standstill in building activity at the site. Although the function of Building E remains uncertain because of its highly disturbed stratigraphy, its morphological similarity to the later Building C-D raises the possibility that the transfer of cult practice from the open-air to the interior of built structures took place before the construction of the latter building in the HEL period.⁹⁵ An additional

92. Lebessi 2021, 175.
93. Lebessi 2003, 2 pl. B; 2009, 423 fig. 2; Schürmann 1996, X.
94. Zarifis 2020, 3 and fig. 68. Zarifis had earlier proposed a CLAS date for the building on architectural grounds, see Zarifis 2007, 255. See also Christakis 2014, 8 and fig. 2; Lebessi 2021, 175 and pl. A.
95. Preliminary reports note that the transfer of cult practice from the open-air to the interior of built structures

connection between the two buildings is provided by the concentration of fragments from large storage vessels within and around them, which contrasts with the dearth of such vessels in other areas of the sanctuary.

The discussion over the possible decline in cult practice at Syme Viannou during the AR and CLAS periods has often been extended to the pottery. In her review of Minoan to ROM pottery from the sanctuary, Kanta included a single piece from the AR and CLAS periods, thus implicitly corroborating the notion of decline; however, she also commented: "Unfortunately, the sixth and fifth century B.C. pottery from Crete has not been published or studied and is virtually unknown. Obviously, more work is needed on regional styles and coarse pottery before more precise dating can be arrived at."[96] Important work in this direction appeared roughly a decade later, with Erickson's study of pottery and cult practice at Syme Viannou during the AR and CLAS periods.[97] Erickson identified "a mass of broken drinking cups throughout the sanctuary," on the basis of which he inferred "a broad level of participation in religious feasts by worshippers in the 6th century."[98] Following Lebessi, he also noted, however, that "the 4th century marks a period of decline characterized by fewer offerings (bronzes disappear completely at this time) and less utilitarian pottery. Judging from the total volume of pottery left at Kato Syme, visits occurred on a more sporadic basis in the 4th century."[99]

The present study has confirmed and qualified this impression. AR vessels of different shapes (but especially cups and – to a considerably lesser extent – fast pouring vessels, which are perhaps indicative of libations) are amply documented in all areas of the sanctuary. In contrast, contraction is identifiable in CLAS times when both the quantity and the spatial distribution of ceramics shrinks considerably. Concerning quantity, the material which can be dated specifically to the CLAS period amounts to two thirds of the pieces which can be dated specifically to the – somewhat shorter – AR period (72 CLAS pieces versus 100 AR ones).[100] This conforms to a much broader trend identified at sanctuaries across the Greek world, where the AR (and the PAR) period represents a peak in the deposition of ceramics, but the CLAS period sees "the amounts of pottery fall to unprecedented lows."[101] The number of vessels drops further in the course of the CLAS period, as ECLAS-MCLAS pottery is slightly more abundant than LCLAS.[102]

took place during the CLAS period (Lebessi 1981b, 9, 18, 19; 1985a, 276; 2002b, 279; Lebessi and Reese 1986, 183; Lebessi and Muhly 1987, 107; 1990, 336), but more recent publications date this development to HEL times (Lebessi 2002b, 4–5; 2009, 523; Lebessi and Stefanakis 2004, 181), as explained below.

96. Kanta 1991, 500.
97. Erickson 2002.
98. Erickson 2010a, 261.
99. Erickson 2002, 84. The 4th century BCE decline was first observed in Lebessi 1981b, 6; 2002b, 279.
100. Figure 3.5 is indicative in this respect (but because of its nature, it excludes pieces dated broadly to the CLAS period, which are, however, included in the figure provided above (76). The decrease in question seems more notable when vessels dated broadly to either the EIA-AR or the CLAS-HEL period are considered, since the former group is eight times larger than the latter. More generally, the vessels from Syme Viannou which are assigned to the first half of the first millennium BCE (EIA and AR) are two and a half times more numerous than those assigned to the second half of the first millennium BCE (CLAS and HEL). The number of inscribed ceramic vessels – which are largely HEL in date – will smooth this discrepancy but only to a limited extent.
101. Stissi 2002, 255, 257 (the quote is from page 257).
102. This study includes twenty-eight pieces dated specifically to the ECLAS-MCLAS period and twenty-four

Abundant CLAS pottery was found in the Area of the Altar,[103] the Terraces and the Water Channel, the Central and South-Central Part of the Podium, and the Area of the Protoarchaic Hearth, but the remaining areas yielded only two to six pieces which (may) date to the CLAS period, and almost none of them can be dated specifically to the LCLAS period.[104] The LCLAS period is also missing from the Area of the Protoarchaic Hearth, where ECLAS-MCLAS pieces are amply represented. This evidence suggests a contraction in the spatial extent of cultic activity in the course of the CLAS period, which culminated further in HEL times when even fewer vases are attested in the Area of the Protoarchaic Hearth, the West Part of the Enclosure, the North Part of the Enclosure and the Podium, and Building E and its Immediate Surroundings (see below).

The relative frequency and the spatial distribution of the MFGs which are attested on AR-CLAS pottery from Syme Viannou largely conform to the patterns that characterize the previous period: MFG C (specifically C2) is predominant, MFG A is amply represented, and MFGs B, D, E, I, and J are rarely attested if at all. Nevertheless, pieces assigned to MFGs A and B are remarkably numerous in the Central and South-Central Part of the Podium. Most of the fabric loners originate from the Terraces and the Water Channel which yielded the richest body of AR-CLAS material.

The fabrics of the AR and CLAS pottery from Syme Viannou have been involved in discussions over the relations of the sanctuary with specific communities. Erickson observed that the AR-MCLAS pottery from the site was dominated by a fine, soft fabric of very pale brown color (which can be identified with MFG C2 of the present study), whereas the LCLAS material was typically made in a dark reddish-brown fabric with silver mica (which can be identified with MFG A of the present study).[105] According to Erickson, the change in fabric is "abrupt and complete,"[106] since the later fabric is "completely without precedent" at Syme Viannou and "totally replaces" the earlier fabric.[107] Erickson also argued that the earlier fabric represents the output of Aphrati while the later one represents the production of Lyktos/Lyttos, thus concluding that during the 6th and 5th centuries BCE Syme Viannou was frequented by people from Aphrati, whereas from the 4th century BCE the sanctuary was controlled by Lyktos/Lyttos.[108] On this basis, Erickson provisionally proposed that during the AR and CLAS periods Syme Viannou was "a small rural sanctuary under the political control of the principal

which are assigned specifically to the LCLAS period. These figures exclude material which cannot be dated more precisely than CLAS.

103. This includes the CLAS (?) miniature cups P10 and P11 which are similar in fabric and morphology, thus suggesting the possible persistence of the deposition of pairs or sets of vases in the Area of the Altar.

104. West Part of the Enclosure: MCLAS cup P644, (CLAS)-HEL juglet (?) P645. North Part of the Enclosure and the Podium: ECLAS-MCLAS small krater P658, CLAS lekythos P675, AR-CLAS cup P687. Building E and its Immediate Surroundings: LAR-ECLAS lekane P694, ECLAS (?) cup P695, LCLAS cup P696, CLAS chytra P697, AR-CLAS cup P703, EIA-HEL pithos P704. Building C-D and its Immediate Surroundings: CLAS-HEL jug P768, ECLAS cup/kotyle P778, MCLAS/LCLAS tulip cup P801.

105. Erickson 2002, 46 fn. 15, 48.

106. Erickson 2002, 82.

107. Erickson 2002, 83.

108. Erickson 2002, 46–48, 79–85.

nearby polis, attracting visitors from further afield rarely, if at all."[109] These ideas have proven influential,[110] but can be revisited in light of the findings of the present study.

My study has confirmed Erickson's impression that two specific fabrics (here labelled MFGs A and C, specifically C2) dominate the AR and CLAS pottery from the site. It has, however, also established that a range of other fabrics is also represented. More specifically, the range of MFGs represented among the PAR material (A, B, C, D, E, I, and J) largely persists into the AR and CLAS periods,[111] and the number of fabric loners remains stable. Additionally, I have shown that the two fabrics identified by Erickson are attested throughout the EIA-ROM period, which means that the micaceous fabric is not "completely without precedent."[112] Nevertheless, Erickson was largely correct in emphasizing the switch to the micaceous fabric in the LCLAS period.[113] The material which can be dated specifically to the LCLAS period is shown here to include only one piece in MFG C2 (P696) and no specimen in any other MFG (though pieces dated broadly to the CLAS period include specimens from different MFGs). This pattern is very different to that of the AR-MCLAS period, when MFG C2 predominates, MFG A is amply represented, and a range of other MFGs (B, D, E, I, and J) are attested more rarely.

These new insights invite for a reconsideration of the connections between Syme Viannou and the communities of Aphrati and Lyktos in the AR to MCLAS periods and the LCLAS period respectively. I have argued that the association of Erickson's fine pale brown fabric (or MFG C2) with Aphrati is dubious (Chapter 3) since this fabric is not particularly diagnostic of provenance and may represent material from more than one site, including Lyktos/Lyttos. Additionally, this fabric is well-represented over the AR-MCLAS period, but so is a fairly broad range of other MFGs. The notable change seen in the LCLAS period, during which the pottery from Syme Viannou is nearly monopolized by MFG A, could be taken to support Erickson's idea for a closer relationship between the sanctuary and Lyktos/Lyttos. Nevertheless, this assumption is undermined by the observation that this MFG is uncommon in the 2nd century BCE when the involvement of magistrates from Lyktos/Lyttos at Syme Viannou can be deduced on epigraphic grounds.[114]

Erickson has observed that drinking cups (and jugs) are the most conspicuous finds at Syme Viannou during the AR and CLAS periods.[115] In his view, this narrow repertory rendered the site "exceptional even among contemporary Cretan sanctuaries, where a greater variety of ceramic offerings and cult equipment, including terracotta figurines and lamps, commonly

109. Erickson 2002, 81; cf. Erickson 2010a, 270.

110. Lebessi and Stefanakis 2004, 197; Chaniotis 2009, 62; Coutsinas 2013, 353–354; Lefèvre-Novaro 2014, 117–118; Drillat 2022, 10, 18. *Contra* Sjögren 2003, 66 fn. 321.

111. Note, however, that MFGs B2 and B3 disappear after the AR period, and MFG D disappears in the course of the CLAS period. MFG F is well documented from the HEL period but it may have been introduced in LCLAS times.

112. Erickson 2002, 83.

113. Erickson 2002, 82.

114. *SEG* 50 937; Kritzas 2000, 88–96; Chaniotis 2009, 62.

115. Erickson 2010a, 260–261; 2010b, 228–229 fn. 40, 235. These observations are based on the material in Erickson 2002.

occurs."[116] My study has confirmed some of these observations but has also qualified them in some respects. First, I have established that cups predominate at Syme Viannou throughout the AR and CLAS periods, but have also shown that this is a new development which emerged during the transition from the LPAR to the AR period. Second, I have demonstrated that the ceramic repertory of the AR and CLAS periods is considerably broader than previously assumed. In the AR period, lekanai are amply attested while all other functional categories are represented, even if by fewer specimens than in PAR times. The number of cups and lekanai drops considerably in the CLAS period and the rest of the repertory shrinks further, with storage vessels, slow-pouring vessels, and shallow open vessels of small size nearly disappearing. Although this range is not broad, it does not support Erickson's impression that the AR-CLAS ceramic repertory of Syme Viannou remains exceptionally narrow for the standards of Cretan sanctuaries. His impression partly relies on a comparison of the AR-CLAS material from Syme Viannou with assemblages from select Cretan sanctuaries, which were, however, used almost exclusively during the centuries in question.[117] It is probably more appropriate to compare the AR and CLAS ceramic repertory from Syme Viannou with the AR and CLAS repertory of long-lived Cretan sanctuaries, including those at Kommos, on the acropolis and Armi hills of Gortyn, and on the west acropolis of Dreros, as well as of the sanctuary of Demeter at Knossos. Such a comparison reveals that the AR-CLAS ceramic repertory of Syme Viannou is broader and richer than that of most of these sites.[118]

Comparative glances to the pottery from other Cretan sanctuaries are also relevant to the appreciation of the pottery imports of the AR and CLAS periods. Erickson has noted that during the AR and CLAS periods, the sanctuary is characterized by an "extreme paucity of [ceramic] imports."[119] This impression can be qualified on the basis of the findings of my study. First, the AR period has yielded the earliest known clay vessels which were imported to the site from overseas. Second, nearly all off-island pottery imports found at the sanctuary date precisely from this period and include Corinthian (P182, P517, P656), Attic (P459), and Laconian (P169) pieces. Although the absolute number of these imports is unimpressive, it does surpass the number of imported vases of this period which are known from most other long-lived Cretan sanctuaries that are fully or partly published (see Section 3.5). This material confirms that the AR period saw a range of new developments in the deposition of ceramics at Syme Viannou.

In conclusion, the AR and CLAS periods at Syme Viannou did not include the notable material investment which characterizes the earlier G and PAR periods. However, the widespread notion of the sanctuary's demise in the 6th to 4th centuries BCE needs to be qualified given that: a) the (near) disappearance of a range of materials (including figured

116. Erickson 2010a, 261.

117. Erickson 2010a, 261 fn. 118.

118. Kommos: Callaghan and Johnston 2000, 250–266. Gortyn acropolis: Johannowsky 2002, 103–107; Gortyn, Armi: Anzalone 2013, 234. Dreros, west acropolis: Kotsonas forthcoming. Knossos, Demeter: Coldstream 1973b, 22–31, 39–46, 52–53: Deposits B, C and partly D, H, and K (where, however, there is much material dating from the end of the MCLAS and the LCLAS periods). See also Section 4.15.

119. Erickson 2002, 74.

bronzes and terracotta animals) is not a site-specific phenomenon, but conforms to broader patterns identified in Greek sanctuaries of the period; b) the hypothesized paucity of building activity is challenged by the revised dating of the construction of Building E to the LAR (or AR) period; and c) the AR and – to a lesser extent – the CLAS pottery is of a quantity which is considerably larger than previously assumed, especially before the 4th century BCE. All in all, the material deposition and architectural elaboration at the site during the AR and CLAS periods is not much lower – if at all – than in most other phases of the Greek and Roman period, with the notable exception of the LG and PAR. Although the interregional role of the sanctuary may have withered during the AR and CLAS periods, the range of fabrics represented in the 6th and 5th centuries BCE do not favor the hypothesis that a single community controlled the sanctuary at the time. The model of dependency is perhaps more appropriate for the 4th century BCE, when MFG A nearly monopolizes the considerably reduced ceramic repertory from Syme Viannou and other material investment also decreases markedly.

5.5. The Hellenistic Period

To older scholarship, "Hellenistic Crete was a failure; a primitive, pirate-infested, aristocratic, Dorian ghetto with nothing to recommend it beyond its ability to produce very effective mercenaries."[120] A very recent volume challenges this picture and sheds new light on the economy and society of Crete in this neglected phase.[121] This volume also demonstrates that the problems of archaeological visibility which characterize the study of AR and CLAS Crete do not persist in the HEL period, as is also observed in literature focused on the island's sanctuaries.[122]

The HEL period saw considerable but non-abrupt change in cult practice at the sanctuary of Syme Viannou. As Lebessi observed, "while the relationship between mortal and deity remained unchanged during the first millennium, the ritual did change: from the Hellenistic period on, the rites were transferred from the open to the interior of small house shrines."[123] The shrines in question basically refer to the different phases of Building C-D, which was constructed in the EHEL period (3rd century BCE), was repaired twice during the HEL period, and remained in use (with some restorations) until the LROM period (Figure 5.4).[124] Alcock considered that the construction of Building C-D is indicative of a broader

120. De Souza 1998, 112. See also Gallimore 2015, 1.
121. Cantilena and Carbone 2020.
122. On the sanctuaries, see Sporn 2002.
123. Lebessi 2009, 523. Cf. Lebessi 2002b, 4–5; 2021, 169, 188; Lebessi and Stefanakis 2004, 181. Earlier preliminary reports date this transfer to the CLAS period (Lebessi 1981b, 9, 18, 19; 1985a, 276; 2002b, 279; Lebessi and Reese 1986, 183; Lebessi and Muhly 1987, 107; 1990, 336).
124. Previous literature on Syme Viannou dates the end of the temple's use to the 3rd century CE or to circa 300 CE (Lebessi 1973a, 195–198; 2021, 169; Kritzas 2000, 88–96; Lebessi and Stefanakis 2004, 181, 183; Papasavvas 2019, 243; Vogeikoff-Brogan 2020, 101; Zarifis 2020, 8), but my study of the pottery lends support to the tentative proposal

Figure 5.4: **Building C-D in the HEL period**, reconstruction by Nikos Zarifis.

Cretan pattern of "memorial investment in the island's past during the Hellenistic period."[125] Nevertheless, the sanctuary of Syme Viannou has a long history of buildings which are erected on top of – and recycle – older structures and materials. The construction of Building C-D basically conforms to this history and need not depend on broader developments.

Arguably, the most notable development in the material record of Syme Viannou during the HEL period regards the marked increase in inscribed objects. As noted by Lebessi, "the epigraphic evidence from the sanctuary as a whole demonstrates that the custom of writing the names of ordinary mortals and magistrates or of the deities worshiped on fragments of tiles and on vases was not established until the Hellenistic period, while earlier epigraphic testimonia may be counted on the fingers of one hand and are found only on bronze dedications."[126] Although the epigraphic material from the site remains largely unpublished, its discussion in

of Zarifis (2007, 262) for the longer use of the building up to the late 4th century CE.

125. Alcock 2002, 118.

126. Lebessi 2009, 537. For references to HEL epigraphic evidence from Syme Viannou, see also Lebessi 1972, 202; 1973a, 197; 1981b, 4–5; 2021, 188; Kritzas 2000, 88–96; 2015; Lebessi and Stefanakis 2004, 183, 185.

preliminary reports has demonstrated its significance. The HEL epigraphic material from Syme Viannou includes – but is not limited to – a stone inscription, a number of graffiti on pottery which mention Hermes, and a single vase inscribed for Aphrodite.[127] This material establishes that the sanctuary attracted different people from a range of Cretan cities, from mature male magistrates to young maidens.[128] Drawing from this evidence, Lebessi has argued convincingly for the interregional role of the sanctuary in the HEL period.[129] The visitors could have come in crowds, as deduced from an inscribed tile which refers to "those marching together."[130] In light of the above, Chaniotis raised the possibility that in this period the sanctuary was the focus of an amphictyony of different cities located in the wider area, but he also considered that a single city may have administered cult at the site.[131] In any case, the epigraphic evidence for visitors from different cities to Syme Viannou and for the interregional role of the site does not conform to Alcock's argument for an island-wide emphasis on local cults and the local past in HEL Crete. As she admits, the "one clear exception to this emphasis on locality is the remote pilgrimage site of Syme," which she hastened to dismiss as a "somewhat solitary counter-example."[132]

My study of the HEL pottery from Syme Viannou has provided some evidence which relates to these historical discourses. Indeed, it has revealed a peak in the range of MFGs that corroborates the impression of the interregional role of the sanctuary in this period, which was previously deduced on the basis of epigraphic evidence. More specifically, two new MFGs (G, H) were introduced at Syme Viannou in the HEL period, which brings the total of the MFGs represented at the time to nine (A, B, C, E, F, G, H, I, J). This total surpasses the number of city ethnics represented on HEL finds from the sanctuary (which is not to say that the different MFGs can be identified with individual cities, but only to highlight the number of these groups and its relevance to the argument for the interregional importance of the site). The range of MFGs which characterizes the HEL pottery from Syme Viannou is identifiable across the site; HEL fabric loners are also widespread and basically amount to double the number of those dating from the AR and CLAS periods. The range of fabrics does not support any exclusive association of the sanctuary with a specific city in the HEL period. Although epigraphy has been taken to suggest that Lyktos/Lyttos controlled Syme Viannou from the 2nd century BCE onward,[133] this is not reflected on the HEL pottery finds from the sanctuary judging by the relatively low number of vessels ascribed to MFG A, which is associated with the city in question. A different

127. On the inscriptions, see Section 1.2. On the cult of the two deities at Syme Viannou in the HEL period, see Lebessi 1976b, 7, 10–12; 1981b, 4–6; 2009, 533, 536–537; 2021, 188, 194–195, 199; Sporn 2018.

128. Lebessi 2009, 532–533.

129. Lebessi 1981b, 4; Lebessi, Muhly and Olivier 1995, 76. Followed by Chaniotis 1988, 33–34; Erickson 2002, 82 fn. 114.

130. Lebessi 1981b, 4.

131. Chaniotis 1988, 33–34; 1996, 128–130; 2001, 324–325; 2006, 202; 2009, 61. For skepticism, see Sporn 2002, 88–89; Prent 2005, 573; Lebessi 2009, 521; 2021, 189. The cities which are assumed to have controlled the sanctuary for part of the HEL period include Lyktos/Lyttos (Kritzas 2000, 95–96; Chaniotis 2006, 202; 2009, 62) and Biannos/Biennos (Kitchell 1977, 348–349 fn. 133; Viviers 1994, 256).

132. Alcock 2002, 119 (see also page 112).

133. *SEG* 50 937; Kritzas 2000, 88–96; Chaniotis 2009, 62.

community, probably Hierapytna (or Priansos ?), was increasingly connected to the sanctuary during the HEL period, as indicated by MFG F.

The study of the HEL pottery from Syme Viannou confirmed Lebessi's impression that the spatial extent of cult practice was reduced in this period.[134] It also established, however, that the reduction may not have been as dramatic as indicated by other classes of evidence. Indeed, whereas the HEL coins and terracotta figurines from the site were found only inside Building C-D and at the part of the terraces which lies south of it,[135] the HEL pottery shows a broader spatial distribution. Abundant to copious HEL pottery came from Building C-D and its Immediate Surroundings, the Terraces and the Water Channel, and the Area of the Altar. Significantly, most of the HEL material from the Terraces and the Water Channel comes from the section which extends south of Building C-D (trenches M49, M50, M51, N49, N50, N51, and the neighboring baulks) and can probably be associated with it.[136] The same association applies to at least some of the HEL material from the east part of the Area of the Altar. Much less HEL pottery came from the rest of the sanctuary, with hardly any pieces originating from the north part of it. Any closely datable pieces from these areas typically predate the LHEL period.[137] The rarity of HEL material over much of the site adheres to a pattern of reduction in the spatial extent of activity which can be traced back to the CLAS period, as explained above, and which culminated in ROM times, as discussed below.

Notwithstanding the reduction in the spatial extent of HEL cult practice at Syme Viannou, the number and variety of clay vessels deposited at the site increased considerably in this period. Although cups remained the most popular vessel shape, other types of deep open vessels of small size also appeared. Fast-pouring vessels and shallow open vessels of small size are more numerous than in any other phase of the Greek and Roman period. In contrast, mixing vessels basically disappeared from the site as well as from other Cretan sanctuaries and other contexts, with the notable exception of Knossos. This pattern conforms to the broader trend for the "missing krater" which is identifiable in Athens and elsewhere in Greece during the HEL period.[138] Unlike kraters, lekanai present a spike during the EHEL-MHEL period, which raises the possibility that the latter shape assumed the function of the fomer. In any case, lekanai become less common in the LHEL period, during which cooking vessels and unguentaria present a notable, albeit short-lived rise. This rise could perhaps be related to the resurgence in cult practice at Syme Viannou which Lebessi hypothesized for the LHEL period on the basis of numismatic and other evidence.[139] Alternatively, the deposition of the unguentaria could be associated with the tentative hypothesis that a cult statue was kept inside

134. Lebessi and Stefanakis 2004, 181, 185.
135. Coins: Lebessi and Stefanakis 2004, 182 fig. 2, 184 fig. 3. Figurines: Sporn 2018, 126.
136. The West Part of the Terraces yielded a single HEL piece, hydria (?) P516.
137. The Central and West Central Part of the Podium: MHEL cylindrical cup P527, LCLAS/EHEL cup P557, LCLAS-EHEL stamnos (?) P564, LCLAS-EHEL lekane P565, EHEL-MHEL lekane P566, EHEL-MHEL stamnos P567, HEL incense burner/ladle P568, LHEL lopas P569. The Area of the Protoarchaic Hearth: EHEL-MHEL lekane P614, MHEL cylindrical cup P615, HEL cylindrical cups P616 and P617, HEL (?) incense burner/ladle P618, MHEL/LHEL lekane P636. The West Part of the Enclosure: (CLAS)-HEL juglet (?) P645, EHEL plate P647. Building E and its Immediate Surroundings: HEL lekane P698, HEL jug P699, EIA-HEL pithos P704.
138. Rotroff 1996; 1997, 14–15. See also Section 4.3.
139. Lebessi and Muhly 1987, 106; Lebessi and Stefanakis 2004, 179.

Building C-D.¹⁴⁰

Interestingly, pairs or triplets of vases of similar fabric and style which could represent specific acts of deposition were found in the Area of the Altar but probably originate from Building C-D.¹⁴¹ Examples of vessels found together in specific stratigraphic units include: the EHEL jugs P48, P49, and P50 which are made in MFGs A1-A1a; the HEL (?) kalathoi P51 and P52 which are made in MFG A1a; the LHEL unguentaria P86, P87 and P88 which are made in MFG G; the EHEL-MHEL tulip cups P110 and P111 which are made in MFG C2; the MHEL-LHEL cups with everted rim P147 and P148 which are made in MFG J; and the LHEL cups with everted rim P151, P152 and P153 which are made in MFG C2 (and perhaps go together with P154, P155, P156). The deposition of these pairs or sets recalls the deposition of small sets of vases around the Altar during the PAR to CLAS periods (see above).

The range of HEL finds known from Syme Viannou does not allow for a coherent characterization of activity at the site. Coins are first attested at the sanctuary during this period and are central to the hypothesis of a resurgence of cult practice at Syme Viannou in LHEL and ROM times.¹⁴² However, these HEL coins are very few and date largely from the third and fourth quarters of the 1st century BCE,¹⁴³ being only attested sporadically thereafter. Additionally, the idea of a resurgence of cult practice at Syme Viannou does not sit well with the reduction in the spatial distribution of the pottery which characterizes the LHEL period at the site (and culminates in ROM times).

The Cretan HEL coins found at the sanctuary were struck by cities whose citizens are epigraphically known to have visited Syme Viannou (Lyktos/Lyttos, Hierapytna, Knossos, but also Gortyn whose citizens are not attested epigraphically at Syme Viannou). However, overseas polities which otherwise show little – if any – connection to the site are also represented in the numismatic record of Syme Viannou, namely Ptolemaic Egypt and the Roman Republic. Connections with Ptolemaic Egypt are also indicated by five HEL spearheads carrying an incised BE which is taken to refer to the Ptolemaic queen Berenice II.¹⁴⁴ The only clay vessel imported from overseas is the EHEL/MHEL kantharos P314 which probably comes from the Greek Mainland and is the only non-Cretan vessel identified at Syme Viannou in the long period which extends after the MCLAS period.¹⁴⁵

Contrary to coins which make their first appearance at Syme Viannou in the HEL period, bronze and perhaps also terracotta statuettes make their last appearance.¹⁴⁶ A bronze statuette of Hermes dating from just before the mid-2nd century BCE is the latest specimen of an artifact class which was represented at the site since the Minoan period but otherwise

140. Sporn 2018, 132.
141. The Altar itself was probably covered by an episode of landslide by the HEL period (Lebessi, pers. comm.).
142. Lebessi and Muhly 1987, 106; Lebessi and Stefanakis 2004, 179. On the prosperity of LHEL Crete, see De Souza 1998.
143. Lebessi and Stefanakis 2004, 188–189 nos 1–8, 194, 196–199.
144. Karetsou, Andreadaki-Vlazaki and Papadakis 2000, 370 no. 409; Lebessi 2000b, 182.
145. But note that the LHEL plate P771 may well be an off-island import, while two more Attic vessels (a kantharos and a medium-sized piece), which are among the inscribed material to be published by Kritzas, must date from this period.
146. Lebessi 2002b, 150–157 no. 41 (bronze); Sporn 2018, 133 (terracotta).

disappeared after the mid-5th century BCE.[147] Like the HEL anthropomorphic terracottas from the site, the Hermes bronze figurine shows heavy influence from other Greek (i.e., non-Cretan) artistic prototypes.[148]

In conclusion, the evidence from pottery and other materials suggests that the sanctuary of Syme Viannou underwent varied developments in the HEL period. The site attracted visitors and pottery from a remarkable range of sites in central and east Crete but grew smaller in size, with activity being concentrated in Building C-D and its Immediate Surroundings. The quantity and the variety of pottery deposited at Syme Viannou increased considerably in the HEL period, but off-island pottery imports remained extremely rare.

5.6. The Roman Period

Chaniotis has observed that "the coming of Rome was the most significant turning point in the history of Crete since the destruction of the Minoan palaces."[149] Although the immediate impact of this conquest on the archaeological record of the island is largely elusive,[150] Lebessi has argued that this historical development may have brought considerable change in ritual practice at Syme Viannou. In her view, the conquest of the island by the Romans transformed the social fabric of the Cretan communities and had a negative impact on the maturation rituals held at the site; it either deprived them of their civic/communal character and reduced them to private affairs run by select families,[151] or stopped them altogether.[152] In a similar vein, Chaniotis argued that the conquest terminated the interregional role of the sanctuary.[153] To Alcock, the changes at Syme Viannou in the ROM period match a broader Cretan pattern which included diminished emphasis on sites that promoted local traditions in earlier times.[154]

The decline of Syme Viannou in the ROM period is evident in the reduced quantity of the pottery found at the site. In her preliminary overview of the prehistoric and later pottery from Syme Viannou, Kanta dedicated only a single sentence to the ROM material.[155] More recently, Sporn noted that this material remains "scarce" at the site, which she connected to the "shift in ritual" mentioned above.[156] My study has confirmed the scarcity of ROM pottery and has further established that the spatial extent of cult practice diminished. Indeed, the ROM pottery is concentrated in Building C-D and its Immediate Surroundings. This building

147. Lebessi 2002b, 150–157 no. 41.
148. Lebessi 2009, 540; Sporn 2018, 127, 129–132.
149. Chaniotis 2008, 83.
150. Gallimore 2019.
151. Lebessi 1985b, 197; Lebessi and Stefanakis 2004, 186, 187.
152. Lebessi 2021, 191, 202, following Chaniotis 2009, 65.
153. Chaniotis 2009, 65.
154. Alcock 2002, 121.
155. Kanta 1991, 500.
156. Sporn 2018, 132.

Figure 5.5: Building C-D in the ROM period, reconstruction by Nikos Zarifis.

was restored in 40-30 BCE (LHEL/EROM), as deduced on numismatic grounds, and again in the 2nd century CE, as documented by epigraphy (Figure 5.5).[157] The Terraces and the Water Channel also produced a considerable group of ROM vessels, but these largely come from the area which extends south of Building C-D (trenches M49, M50, M51, N49, N50, N51, N52, and neighboring baulks) and can probably be associated with it. The parts of the Terraces which extend west or east of this section yielded very few ROM pieces, and such finds are even fewer in the rest of the sanctuary. The copious assemblage of ceramics from the Area of the Altar included hardly any ROM vessels.[158] Additionally, only two ROM pieces were found in the part of the sanctuary which extends west of Building C-D,[159] while not a single specimen was identified in the northern section of the site. This reduced distribution pattern represents the culmination of a trend which can be traced back to the HEL period if not earlier, and confirms the impression previously formulated on numismatic grounds that the spatial extent

157. Lebessi 1973a, 198 pl. 205; Lebessi and Stefanakis 2004, 183; Zarifis 2007, 260-262.

158. Besides the LHEL/EROM cylindrical cup P63 and jug P167, there is only the EROM-MROM basin P212 and the LROM-EBYZ cooking pot P168.

159. This includes the ROM jug P570 from the Central and South-Central Part of the Podium and the EROM jug P593 from the Area of the Protoarchaic Hearth.

of cult practice basically shrank to Building C-D in ROM times.¹⁶⁰ Abundant ROM lamps also come from Building C-D and its Immediate Surroundings and date to the EROM and MROM periods (1st to 3rd century CE).¹⁶¹

The range of MFGs represented on pottery from Syme Viannou dropped sharply in the ROM period. Nearly half of the MFGs represented in HEL times disappeared (B, E, G, and I), and only A, C, F, H, and J persisted. This is the narrowest range of MFGs seen at Syme Viannou since the PG-G period, and it shrank further by the MROM period during which F and J vanished, and H became predominant. Although the absolute number of fabric loners dropped roughly in half from the HEL to the ROM period, these loners form a larger component of the ROM ceramic assemblage given its reduced size. This fabric range – including the thin attestation of MFG A – does not lend support to the hypothesis that Lyktos/Lyttos controlled the sanctuary in the LHEL and ROM periods, which has been formulated on epigraphic grounds.¹⁶²

At Syme Viannou, the ROM period is characterized not only by the drop in the number of vessels deposited, but also by the diminished representation of most functional classes of pottery (see Chapter 4). One notable loss is the cup, which had dominated the pottery record of the site for two millennia. This loss, however, is not site-specific and conforms to a broader pattern of disappearance of small deep open vessels from the Cretan ceramic repertory (see Section 4.2). From the MROM period there is further diminution in the representation of all functional classes except for storage vessels – especially amphoras – which dominate the ceramic record of the site in MROM-LROM times (see Section 4.9). Although amphora production rose markedly in ROM Crete,¹⁶³ this cannot explain the deposition of these vessels at Syme Viannou. One could speculate that the amphoras found at the sanctuary held the oil that filled the ROM lamps which are copiously represented at the site, or contained water from the spring which was used for ritual purposes. It remains difficult, however, to reconcile these speculations on the rise in the number of storage vessels with the serious drop in the representation of all other functional classes of pottery. The pattern is not identifiable in other well-published Cretan sanctuaries and should thus be considered as a site-specific phenomenon (see Section 4.9). Could it be that sanctuary visitors were expected to take back the vessels they used at the site except for some large ones which were harder to transport or were sanctuary property?¹⁶⁴

The repertory of the shapes and the fabrics of the ROM pottery from Syme Viannou shows strong spatial patterning between Building C-D and its Immediate Surroundings on the one hand, and the Terraces and the Water Channel on the other. The former area yielded largely storage vessels which mostly date to MROM-LROM times and are made in MFG H (with the exception of very few pieces from MFGs A1, perhaps A1a, C2, and fabric loners). Conversely,

160. Lebessi and Stefanakis 2004, 181, 182 fig. 2, 184 fig. 3, 185.
161. Lebessi 1992a, 214 pl. 91. Cf. Lambropoulou 1999, 515; Zarifis 2007, 264; Vogeikoff-Brogan 2020, 103–125.
162. Kritzas 2000, 95–96.
163. Gallimore 2019, 608. On amphora production in Roman Crete, see Empereur, Kritzas and Marangou 1991; Marangou-Lerat 1995; Gallimore 2015, 208–222.
164. Note, for example, that a 5th century BCE inscription from Keos explicitly regulates the removal of the pottery from the area of the cemetery after use (Sokolowski 1969, 188 no. 97, line 10).

the latter area produced a much broader range of shapes which are EROM-MROM in date and represent a wider variety of fabrics (MFGs A1, A2, C2, F, H, J, are represented by two to five specimens), including very few fabric loners.

The deposition of ROM material other than pottery at Syme Viannou presents major peaks and troughs. A case in point is provided by terracotta figurines which disappear completely, or nearly so. Terracotta figurines were deposited at the sanctuary throughout the second and the first millennia BCE,[165] with a number of HEL specimens illustrating Hermes and Aphrodite.[166] However, "none of the figurines can be dated with certainty in the Roman period."[167] Conversely, the number of coins deposited in the sanctuary reached a spike in the beginning of this period,[168] specifically in the third and fourth quarter of the 1st century BCE.[169] To Lebessi and Stefanakis, a group of Knossian coins dating to the 30s BCE indicate that the sanctuary was controlled by Knossos which was the head of the Cretan *koinon* at the time.[170] Pottery neither supports nor challenges this idea. Lebessi and Stefanakis also argue that the rise in the dedication of coins is indicative of the increasing role of private individuals as opposed to communal groups in the life of the sanctuary.[171] This may well be the case, but it is worth noting that the peak in the deposition of coins in the EROM period is a meteoric phenomenon, and later ROM specimens are limited to two pieces which date from the late 1st and early 2nd centuries CE.[172]

Taken together, the evidence from the pottery and other materials suggests that the sanctuary of Syme Viannou was greatly diminished following the Roman conquest of Crete. Cultic activity was largely concentrated on Building C-D and included a smaller amount of pottery made in fewer MFGs. These patterns grew stronger after the EROM period, thus suggesting a gradual process of demise.

5.7. After the Roman Period

The successive construction of two Early Christian chapels on the northwest corner of the excavated area of the sanctuary of Syme Viannou at some point between the 4th and the 7th centuries CE,[173] represents "a sharp division in the relationship between humans and the

165. On Minoan to AR terracotta figurines of animals, see Muhly 2008. On Minoan to CLAS terracotta figurines of humans, see Lebessi 2021. On HEL terracotta figurines, see Sporn 2018. On Minoan to HEL bronze figurines of humans, see Lebessi 2002b, and on PG-PAR bronze figurines of animals, see Schürmann 1996.

166. Sporn 2018, 127–130.

167. Sporn 2018, 133.

168. Lebessi and Stefanakis 2004, 189–193 nos 9–23. The sixteen ROM specimens represent a significant increase in comparison to the seven HEL pieces.

169. Lebessi and Stefanakis 2004, 194.

170. Lebessi and Stefanakis 2004, 199, 200.

171. Lebessi and Stefanakis 2004, 187.

172. Lebessi and Stefanakis 2004, 193–194 nos 21–22.

173. Lebessi 1997, 192–195; Zarifis 2007, 263–265; Vogeikoff-Brogan 2020, 125. I consider that the 4th century CE

divine."[174] This period is also represented by lamps which were found between the northeast corner of Building C-D and the spring, dating from the 6th, 7th, and perhaps 8th centuries CE.[175] It is unclear how long the second chapel remained in use, but a tomb found in its vicinity yielded pottery assigned to the 9th to 11th centuries CE.[176] Other material from the Medieval period and the Renaissance is limited to a single MBYZ dish (P777) which was found above the remains of Building C-D and three Venetian coins which were located further south, in the southeast part of the sanctuary.[177] By the Venetian period, the remains of the sanctuary had largely been covered up, so the three Venetian coins probably belonged to hunters and trekkers attracted to the spring or to farmers who channeled the water of the spring to terraces lower on the mountain slope, which were cultivated until the modern period.[178] Whatever activity took place at the site of the former sanctuary of Syme Viannou during the last fourteen centuries before present, this was hardly "expressed in terms of pottery."

is perhaps too early, especially given that Building C-D was probably still in use at the time.
174. Lebessi 2009, 523.
175. Lebessi 1992a, 214 pl. 91. Cf. Lambropoulou 1999, 515; Zarifis 2007, 264; Vogeikoff-Brogan 2020, 125–130.
176. Lebessi 1997, 193–195; 2021, 202; Zarifis 2007, 264. Vogeikoff-Brogan 2020, 125 pls 8–9 (on the pottery).
177. Lebessi and Stefanakis 2004, 185, 193 nos 24–26, 194–195, 199–200.
178. Lebessi and Stefanakis 2004, 186, 199–200. Cf. Lebessi 1985b, 21; Zarifis 2007, 46–47, 265.

6
Appendix:
Petrographic Analysis of Greek and Roman Pottery from Syme Viannou

Eleni Nodarou

6.1. The Present Study and Previous Analyses

The systematic macroscopic study and characterization of the pottery fabrics from Syme Viannou (Chapter 3) is combined here with petrographic analysis, with the ultimate aim of providing an integrated approach to the pottery assemblage of the sanctuary, including stylistic, macroscopic, and microscopic analyses. The sampling strategy and the petrographic analysis of the ceramic material evolved around four main research axes: a) to determine petrographic variability within the assemblage and compare it to the variability identified macroscopically; b) to define the broadly local components and any imports from more distant areas; c) to examine any association between vessel fabric on the one hand, and vessel form and function on the other; and d) to appreciate the material under study in light of aspects of ceramic consumption at the site and the region.

The selection of samples for thin section petrography was largely based on the macroscopic classification of the pottery (MFGs A-J) and comprised a total of 92 pottery samples out of a total of 865 catalogued pieces (roughly 10.6%). The sampled pieces are listed in Table 6.1, which provides a concordance between PFGs (Petrographic Fabric Groups) and MFGs (Macroscopic Fabric Groups), and records the shape, the date, and the find context of the sampled vessels. As is evident, the sampled material ranges in date from the EIA to the ROM period and derives from various areas of the sanctuary. Additionally, the shape repertory encompasses cooking and storage vessels, transport jars, serving and drinking vessels, and a few shapes of special function, e.g., unguentaria.

The remote location and the ritual character of Syme Viannou, as well as the absence of pottery-making installations and equipment, render on-site or strictly local production highly unlikely for the Greek and Roman period (see Section 3.4). Additionally, the attestation of a broad range of fabrics and their ebb and flow over time suggests that pottery from different areas reached the sanctuary at different times (see Chapter 3). Based on macroscopic examination, Erickson has suggested that the neighboring community of Aphrati and possibly also the community at Myrtos Pyrgos produced the pottery consumed at the sanctuary during

the 6th and 5th centuries BCE. He also argued that this pattern changed radically in the 4th centuries BCE with Lyktos/Lyttos taking control of the site, as deduced from the predominance of pottery that is associated with the latter site and the disappearance of the earlier fabric from Syme Viannou.[1] This macroscopic fabric approach was revisited in Chapter 3, with the petrographic analysis seeking to evaluate it further. The petrographic analyses of the assemblage of animal figurines from Syme Viannou,[2] as well as the pottery from the Pediada survey,[3] provide useful comparisons for the evaluation of this topic, and more broadly, for the provenance of the Greek and Roman pottery from Syme Viannou.

Table 6.1: Concordance of the Greek and Roman pottery from Syme Viannou which was sampled for petrographic analysis, organized by Petrographic Fabric Group.

Petrographic Sample No.	Publication No.	Study No.	PFG	MFG	Shape	Date	Area
SYM 17/3	P41	A74	PFG 1 Coarse/semicoarse meta (a)	D	Domed lid/shield	G-AR	The Area of the Altar
SYM 17/34	P832	A775	PFG 1 Coarse/semicoarse meta (a)	Loner	Pithos	PAR-AR	Material of Unknown or Uncertain Provenance
SYM 17/42	P427	A442	PFG 1 Coarse/semicoarse meta (a)	B1	Ladle	LCLAS-HEL	The Terraces and the Water Channel
SYM 17/71	P565	A2229b	PFG 1 Coarse/semicoarse meta (a)	B1	Lekane	LCLAS-EHEL	The Central and South-Central Part of the Podium
SYM 17/72	P564	A232+A238+A534	PFG 1 Coarse/semicoarse meta (a)	B1	Stamnos	LCLAS-EHEL	The Central and South-Central Part of the Podium
SYM 17/82	P704	A182	PFG 1 Coarse/semicoarse meta (a)	B1	Pithos	EIA-HEL	Building E and its Immediate Surroundings
SYM 17/81	P751	A198	PFG 1 Coarse/semicoarse meta (b)	Loner	Lekane	AR	Building E and its Immediate Surroundings
SYM 17/84	P701	A205	PFG 1 Coarse/semicoarse meta (b)	C1	Kernos bowl	PAR-(AR)	Building E and its Immediate Surroundings

1. Erickson 2002, 46–48.
2. Nodarou and Rathossi 2008 for solid animal figurines and vessel attachments; Nodarou et al. 2008 for wheelmade animal figurines.
3. The Pediada survey was carried out by Nikos Panagiotakis. The petrographic analysis of the pottery is in progress by the author.

APPENDIX: PETROGRAPHIC ANALYSIS OF GREEK AND ROMAN POTTERY 577

Petrographic Sample No.	Publication No.	Study No.	PFG	MFG	Shape	Date	Area
SYM 17/5	P82	A22	PFG 2 Meta w. mica	A1	Stand	PAR-AR	The Area of the Altar
SYM 17/10	P174	A54 +A801	PFG 2 Meta w. mica	A1	Cooking pot	MHEL/LHEL-LHEL	The Area of the Altar
SYM 17/39	P399	A423	PFG 2 Meta w. mica	A1	Straight-sided jar	PAR-AR	The Terraces and the Water Channel
SYM 17/40	P398	A416	PFG 2 Meta w. mica	A1	Krater	MHEL	The Terraces and the Water Channel
SYM 17/68	P591	A750	PFG 2 Meta w. mica	A1	Lekane	LAR	The Central and South-Central Part of the Podium
SYM 17/69	P566	A228	PFG 2 Meta w. mica	A1	Lekane	LCLAS-MHEL	The Central and South-Central Part of the Podium
SYM 17/78	P681	A157	PFG 2 Meta w. mica	A1	Pithos	G-AR	The North Part of the Enclosure and the Podium
SYM 17/79	P694	A186 +A189	PFG 2 Meta w. mica	A1	Lekane	LAR-ECLAS	Building E and its Immediate Surroundings
SYM 17/96	P765	A314	PFG 2 Meta w. mica	A2	Cooking jug	EIA-(AR)	Building C-D and its Immediate Surroundings
SYM 17/7	P130	A78	PFG 3 Meta dark w. quartz + mica	A1a	Lekane	AR-MCLAS	The Area of the Altar
SYM 17/9	P158	A43	PFG 3 Meta dark w. quartz + mica	A1	Lopas	HEL	The Area of the Altar
SYM 17/14	P281	A59	PFG 3 Meta dark w. quartz + mica	A1	Lekane	AR-CLAS	The Terraces and the Water Channel
SYM 17/19	P142	A600	PFG 3 Meta dark w. quartz + mica	A2	Cup	MCLAS/LCLAS	The Area of the Altar
SYM 17/53	P557	A476	PFG 3 Meta dark w. quartz + mica	A2	Cup	LCLAS/EHEL	The Central and South-Central Part of the Podium

Petrographic Sample No.	Publication No.	Study No.	PFG	MFG	Shape	Date	Area
SYM 17/59	P839	A735d	PFG 3 Meta dark w. quartz + mica	A1	Ring kernos	CLAS	Material of Unknown or Uncertain Provenance
SYM 17/60	P838	A735c	PFG 3 Meta dark w. quartz + mica	A1a	Ring kernos	CLAS	Material of Unknown or Uncertain Provenance
SYM 17/63	P626	A256	PFG 3 Meta dark w. quartz + mica	B1 (?)	Cooking jug	EIA-(AR)	The Area of the Protoarchaic Hearth
SYM 17/73	P556	A234	PFG 3 Meta dark w. quartz + mica	A1	Cup	LCLAS	The Central and South-Central Part of the Podium
SYM 17/85	P697	A184	PFG 3 Meta dark w. quartz + mica	A1	Chytra	CLAS	Building E and its Immediate Surroundings
SYM 17/15	P119	A495 +A610	PFG 4 Red ophiolite-related	C1	Lekane	LPAR-AR	The Area of the Altar
SYM 17/17	P531	A528	PFG 4 Red ophiolite-related	B2	Medium-sized closed vessel	PAR	The Central and South-Central Part of the Podium
SYM 17/51	P443	A479	PFG 4 Red ophiolite-related	D	Domed lid/shield	LG-(AR)	The Terraces and the Water Channel
SYM 17/61	P631	A252	PFG 4 Red ophiolite-related	C2	Kernos bowl	PAR-(AR)	The Area of the Protoarchaic Hearth
SYM 17/4	P113	A17	PFG 5 Red fine/v.fine w.pellets	C1	Krater	PAR	The Area of the Altar
SYM 17/16	P33	A71	PFG 5 Red fine/v.fine w.pellets	Loner	Transport amphora	AR-HEL	The Area of the Altar
SYM 17/29	P235	A603	PFG 5 Red fine/v.fine w.pellets	I	Domed lid/shield	PAR	The Terraces and the Water Channel
SYM 17/48	P460	A85	PFG 5 Red fine/v.fine w.pellets	C1	Small closed vessel	PG	The Terraces and the Water Channel
SYM 17/56	P439	A480	PFG 5 Red fine/v.fine w.pellets	I	Domed lid/shield	LG-(AR)	The Terraces and the Water Channel

Petrographic Sample No.	Publication No.	Study No.	PFG	MFG	Shape	Date	Area
SYM 17/58	P811	A146b	PFG 5 Red fine/v.fine w.pellets	C1	Krater	PG	Material of Unknown or Uncertain Provenance
SYM 17/64	P621	A247	PFG 5 Red fine/v.fine w.pellets	C2	Large closed vessel	(LG)-PAR	The Area of the Protoarchaic Hearth
SYM 17/65	P599	A262	PFG 5 Red fine/v.fine w.pellets	C2	Domed lid/ shield	PAR-(AR)	The Area of the Protoarchaic Hearth
SYM 17/80	P746	A840	PFG 5 Red fine/v.fine w.pellets	C1	Kernos bowl	PAR-(AR)	Building E and its Immediate Surroundings
SYM 17/87	P731	A819	PFG 5 Red fine/v.fine w.pellets	C1	Kernos attachment	PAR-(AR)	Building E and its Immediate Surroundings
SYM 17/89	P718	A208 +A829	PFG 5 Red fine/v.fine w.pellets	C1	Kernos bowl	PAR-(AR)	Building E and its Immediate Surroundings
SYM 17/90	P693	A191	PFG 5 Red fine/v.fine w.pellets	C2	Cup	LPAR-AR	Building E and its Immediate Surroundings
SYM 17/20	P575	A544	PFG 6 Red w.small quartz	B3	Medium-sized closed vessel	EIA	The Central and South-Central Part of the Podium
SYM 17/21	P69	A6	PFG 6 Red w.small quartz	B3	Aryballos	G-PAR	The Area of the Altar
SYM 17/22	P101	A583	PFG 6 Red w.small quartz	B3	Cup	LPAR	The Area of the Altar
SYM 17/27	P339	A680	PFG 6 Red w.small quartz	I	Unguentarium	LHEL	The Terraces and the Water Channel
SYM 17/30	P31	A81 +A70	PFG 6 Red w.small quartz	I	Oinochoe	LAR-ECLAS	The Area of the Altar
SYM 17/35	P848	A569	PFG 6 Red w.small quartz	J	Cup	MHEL	Material of Unknown or Uncertain Provenance
SYM 17/36	P849	A656	PFG 6 Red w.small quartz	J	Cup	HEL	Material of Unknown or Uncertain Provenance
SYM 17/37	P847	A618	PFG 6 Red w.small quartz	J	Cup (?)	HEL	Material of Unknown or Uncertain Provenance

Petrographic Sample No.	Publication No.	Study No.	PFG	MFG	Shape	Date	Area
SYM 17/46	P506	A551	PFG 6 Red w.small quartz	C1	Medium-sized open vessel	EIA-AR	The Terraces and the Water Channel
SYM 17/66	P615	A265 +A529	PFG 6 Red w.small quartz	C2 (?)	Cup	MHEL	The Area of the Protoarchaic Hearth
SYM 17/83	P742	A827	PFG 6 Red w.small quartz	C2	Kernos attachment	PAR-(AR)	Building E and its Immediate Surroundings
SYM 17/86	P727	A815	PFG 6 Red w.small quartz	C2	Kernos attachment	PAR-(AR)	Building E and its Immediate Surroundings
SYM 17/93	P379	A321	PFG 6 Red w.small quartz	D	Cup	MCLAS/ LCLAS	The Terraces and the Water Channel
SYM 17/94	P764	A312	PFG 6 Red w.small quartz?	H	Amphora	LROM	Building C-D and its Immediate Surroundings
SYM 17/95	P770	A313	PFG 6 Red w.small quartz	H	Amphora	HEL-ROM	Building C-D and its Immediate Surroundings
SYM 17/100	P763	A311	PFG 6 Red w.small quartz	C2	Amphora	MROM	Building C-D and its Immediate Surroundings
SYM 17/101	P807	A291	PFG 6 Red w.small quartz	H	Amphora	MROM-EBYZ	Building C-D and its Immediate Surroundings
SYM 17/102	P803	A290	PFG 6 Red w.small quartz	H (?)	Amphora	MROM-LROM	Building C-D and its Immediate Surroundings
SYM 17/18	P248	A700	PFG 7 Red w.quartz over-fired	G	Unguentarium	LHEL	The Terraces and the Water Channel
SYM 17/25	P86	A666	PFG 7 Red w.quartz over-fired	G	Unguentarium	LHEL	The Area of the Altar
SYM 17/26	P87	A667	PFG 7 Red w.quartz over-fired	G	Unguentarium	LHEL	The Area of the Altar
SYM 17/52	P311	A406	PFG 7 Red w.quartz over-fired	G	Unguentarium	LHEL	The Terraces and the Water Channel

APPENDIX: PETROGRAPHIC ANALYSIS OF GREEK AND ROMAN POTTERY 581

Petrographic Sample No.	Publication No.	Study No.	PFG	MFG	Shape	Date	Area
SYM 17/91	P790	A306	PFG 7 Red w.quartz over-fired	G	Unguentarium	MHEL/LHEL-LHEL	Building C-D and its Immediate Surroundings
SYM 17/92	P422	A334	PFG 7 Red w.quartz over-fired	G	Unguentarium	LHEL	The Terraces and the Water Channel
SYM 17/8	P149	A724 +A807	PFG 8 Fine calcareous	F	Cup	MHEL-LHEL	The Area of the Altar
SYM 17/12	P368	A63	PFG 8 Fine calcareous	E	Bell skyphos	PG	The Terraces and the Water Channel
SYM 17/13	P359	A67	PFG 8 Fine calcareous	E (?)	Small closed vessel	PG	The Terraces and the Water Channel
SYM 17/23	P338	A681	PFG 8 Fine calcareous	F	Jug	HEL	The Terraces and the Water Channel
SYM 17/24	P144	A687 +A126	PFG 8 Fine calcareous	F	Lekane	LCLAS-EHEL	The Area of the Altar
SYM 17/41	P423	A475	PFG 8 Fine calcareous	F	Large closed vessel	ROM (?)	The Terraces and the Water Channel
SYM 17/45	P461	A117	PFG 8 Fine calcareous	E	Bell skyphos	PG	The Terraces and the Water Channel
SYM 17/54	P457	A86	PFG 8 Fine calcareous	E	Bell skyphos	PG	The Terraces and the Water Channel
SYM 17/55	P249	A549	PFG 8 Fine calcareous	F	Lekane	LHEL/EROM	The Terraces and the Water Channel
SYM 17/57	P645	A128	PFG 8 Fine calcareous	F	Juglet (?)	(CLAS)-HEL	The West Part of the Enclosure
SYM 17/1	P327	A636	Small group 1	A2	Ring vase	PAR	The Terraces and the Water Channel
SYM 17/2	P50	A791	Small group 1	A1	Jug	EHEL	The Area of the Altar
SYM 17/97	P420	A728	Small group 1	Loner	Kalathos	EHEL-MHEL	The Terraces and the Water Channel
SYM 17/98	P773	A318	Small group 1	A2 (?)	Domed lid/shield	(LG)-AR	Building C-D and its Immediate Surroundings

Petrographic Sample No.	Publication No.	Study No.	PFG	MFG	Shape	Date	Area
SYM 17/70	P539	A230	Loner	A1	Bowl	AR	The Central and South-Central Part of the Podium
SYM 17/6	P12	A95	Loner	D	Bell skyphos	PG	The Area of the Altar
SYM 17/32	P169	A598	Loner	Loner	Transport amphora	PAR-AR	The Area of the Altar
SYM 17/28	P234	A80	Loner	I	Unguentarium	LHEL	The Terraces and the Water Channel
SYM 17/77	P680	A162	Loner	Loner	Krater	EIA	The North Part of the Enclosure and the Podium
SYM 17/76	P652	A173	Loner	Loner	Krater	PAR (?)	The North Part of the Enclosure and the Podium
SYM 17/44	P401	A427	Loner	B1	Lekane	AR-CLAS	The Terraces and the Water Channel
SYM 17/62	P624	A250	Loner semi-coarse amphibolite	B1	Kalathos	LM IIIC-PG	The Area of the Protoarchaic Hearth
SYM 17/74	P545	A261	Loner semi-coarse amphibolite	B2	Lekane	LAR	The Central and South-Central Part of the Podium
SYM 17/11	P190	A44	Loner metamorphic	Loner	Lekane (?)	CLAS	The Area of the Altar
SYM 17/67	P567	A231	Loner metamorphic	A1a	Stamnos	EHEL-MHEL	The Central and South-Central Part of the Podium

6.2. Petrographic Fabric Groups

Thin section analysis of the Greek and Roman pottery from Syme Viannou identified two main compositional categories in direct association with the macroscopic classification: petrographic fabric group 1, or PFG 1, which is characterized by metamorphic rocks without mica (cf. MFG B), and PFGs 2 and 3, which are highly micaceous (cf. MFG A) with muscovite (silver) mica being the component that gives the vessels the characteristic sheen under the sunlight.

The question of the provenance of the material is illuminated by the petrographic analysis. The attestation of metamorphic fabrics in a large part of the assemblage (cf. PFG 1)

came as a surprise, since Syme Viannou is not situated in the metamorphic environment of the Phyllite-Quartzite series which is characteristic of the northeast part of the island; instead, it is situated in the marly environment of the broader south coast of Crete, which is characterized by the Ophiolite series and the Flysch mélange. It also came as a surprise that the coarse wares included very little material connected with the so-called south coast fabric(s).[4]

An interesting finding of the petrographic analysis is the attestation of numerous small groups with two or three samples each as well as of copious loners, i.e., samples that were not included in any of the existing groups. This is probably unsurprising for a sanctuary frequented by people who came from both neighboring and distant areas (see Chapter 3), and who occasionally brought with them items that were "foreign" to the local assemblage.

6.2.1. Coarse and Semi-Coarse Fabrics

PFG 1: Coarse to semi-coarse metamorphic

This PFG includes two subgroups characterized by the presence of low-grade metamorphic rocks and the absence of mica.

Subgroup a: SYM 17/3 (P41), SYM 17/34 (P832), SYM 17/42 (P427), SYM 17/71 (P565), SYM 17/72 (P564), SYM 17/82 (P704) (Figure 6.1a)
This is the main metamorphic non-micaceous fabric of the assemblage. It forms a rather homogeneous group characterized by a dark brown firing matrix which is optically inactive.[5] The main non-plastic component is the dark brown elongate fragments of phyllite and there is also some quartzite and sparse small fragments of quartz. In the groundmass there are rare laths of biotite mica. The vessels in this group mostly belong to MFG B1 and are largely intended for domestic non-cooking use. Among them are a domed lid/shield, two pithoi, a ladle, a lekane, and a stamnos, all of which come from different areas of the sanctuary and date from the G to the HEL period.

Subgroup b: SYM 17/81 (P751), SYM 17/84 (P701) (Figure 6.1b)
This small subgroup comprises two samples almost identical to each other. The fabric is characterized by a very fine dark red brown matrix that is optically inactive. The non-plastic inclusions consist of dark brown elongate phyllite fragments, little quartzite, sandstone, quartz, and chert. Despite mineralogical similarity, the fineness of the groundmass and the sparse distribution of the inclusions make this fabric stand out as different from the rest of the metamorphic material. The two samples are from a lekane and a kernos bowl and date to the PAR-AR period.

4. Nodarou 2022.
5. All references to color concern observation under cross polarized light (XP).

Comment on PFG 1: This metamorphic non-micaceous fabric group represents a considerable amount of the Greek and Roman pottery from Syme Viannou. The attestation of the two subgroups cannot be explained in functional or chronological terms; subgroup b could be an AR variant but the number of samples is too small to define a date-specific fabric. PFG 1 is mineralogically associated with an environment of low-grade metamorphic rocks, i.e., the Phyllite-Quartzite series that is not encountered in the immediate geological environment of Syme Viannou. Such outcrops occur west of Ano Syme and near Kephalovrysi,[6] but there is no evidence from this area to suggest exploitation of raw materials for pottery manufacture. This composition is also compatible with the north coast of east Crete, where outcrops of the Phyllite-Quartzite series extend from Kavousi to Sitia.

Comparisons for this fabric, with the characteristic fine brown phyllite as the main non-plastic component, are encountered in sites of the north-eastern part of Crete: on EG to PAR material from Kavousi Vronda,[7] and in Minoan assemblages such as Mochlos and Chalasmenos which range in date from the Neopalatial to the LM IIIC period. Metamorphic fabrics are also attested in the figurine assemblage from Syme Viannou,[8] which shows that materials and people from the north coast reached the sanctuary on a regular basis, at least since the LM IIIC period.

PFG 2: Coarse metamorphic micaceous (Figure 6.1c)
Samples: SYM 17/5 (P82), SYM 17/10 (P174), SYM 17/39 (P399), SYM 17/40 (P398), SYM 17/68 (P591), SYM 17/69 (P566), SYM 17/78 (P681), SYM 17/79 (P694), SYM 17/96 (P765)
This PFG is very homogeneous in terms of composition and texture. It is characterized by a brown firing matrix and non-plastic inclusions which consist of a multitude of metamorphic rock fragments, namely phyllite, quartzite, quartzite-mica schist, some quartz, and very little plagioclase feldspar. In the fine fraction the predominant component is the elongate muscovite and biotite mica laths that give the vessels a shiny appearance. The amount of mica as well as the regular presence of a specific type of weathered metamorphic rock make this group stand out as a distinct recipe. The vessels represented serve cooking, storage, and other domestic functions and come from various areas of the sanctuary. They date from the EIA to the HEL period and they all belong to MFG A1.

PFG 3: Coarse metamorphic micaceous with pellets in a quartz-rich matrix (Figure 6.1d)
Samples: SYM 17/7 (P130), SYM 17/9 (P158), SYM 17/14 (P281), SYM 17/19 (P142), SYM 17/53 (P557), SYM 17/59 (P839), SYM 17/60 (P838), SYM 17/63 (P626), SYM 17/73 (P556), SYM 17/85 (P697)

6. IGME 1993.
7. Nodarou forthcoming.
8. Nodarou et al. 2008, 4; Nodarou and Rathossi 2008, 166.

This is a coarse fabric characterized by a dark brown to gray firing matrix which is optically inactive. The non-plastic components consist of metamorphic rock fragments, mainly fine grained phyllite, quartzite, and quartzite-schist as well as frequent small quartz fragments evenly distributed in the base clay. A characteristic feature of this fabric is the dark brown to black clay pellets that occur regularly in all the samples; they are not indicative of provenance but they reflect a rather standardized way of manufacture. The abundant muscovite and biotite mica laths in the clay matrix give the vessels a characteristic sheen under sunlight. The non-plastic inclusions as well as the micaceous base clay bring this fabric compositionally very close to PFG 2, but PFG 3 is considered as a different recipe for two main reasons: a) the regular presence of the clay pellets, and b) the absence of the weathered metamorphic rock seen in PFG 2. This differentiation could be due to a different source of the raw material. The vessels in this group serve a range of domestic functions (mainly cups, lekanai, and cooking pots) and their great majority belongs to MFGs A1 and A2. The date range is EIA to CLAS, with a single HEL specimen (SYM 17/9 (P158)).

Comment on PFGs 2 and 3: these two groups constitute recipes manufactured with similar raw materials and most likely sharing the same provenance. They are red firing and the presence of metamorphic rocks in a muscovite (white) mica-rich matrix gives the vessels a sheen under the sunlight, which makes them easily identifiable macroscopically. Exact parallels exist among the animal figurines from Syme Viannou.[9] Such micaceous fabrics are not common in east Crete. Indeed, the fabrics from the Mirabello area that contain mica are radically different and contain acid igneous (not metamorphic) rock fragments and biotite (gold), not muscovite (white) mica. The analysis of pottery from the Pediada survey provides close parallels for the material from Syme Viannou (Figures 6.1e-6.1f), whereas clay samples from the area of Thrapsano (Figure 6.1g) show that the alluvial clays of the area are highly micaceous due to the presence of low-grade metamorphic rocks of the Phyllite-Quartzite series rich in mica-schists containing hydromica.[10] This is in accordance with the macroscopic observations which link this fabric with the Pediada and specifically Lyktos/Lyttos.[11] A recent study and analysis of pithoi from Lyktos/Lyttos corroborates the presence of the two recipes identified at Syme Viannou as well as the connection of these recipes with the ancient city.[12] Parallels for both fabrics are encountered in the pottery from sites in the north Lassithi (namely Krasi Siderokephala, Krasi Kastello, and Kera Vigla),[13] which were analyzed in the context of the study of the pottery from the excavation at Karphi.[14] It is significant that these micaceous fabrics are almost absent at Karphi but seem to become rather prominent at the sites of the Lassithi plateau at a later EIA date. A similar fabric has been described in the EIA pottery from Knossos

9. Nodarou et al. 2008, 4; Nodarou and Rathossi 2008, 166. See also Chapter 3.
10. IGME 1989.
11. Erickson 2002, 48; 2010a, 34–35. See also Chapter 3.
12. Ximeri 2021, 75–76.
13. Nodarou 2020, 197.
14. Wallace 2020.

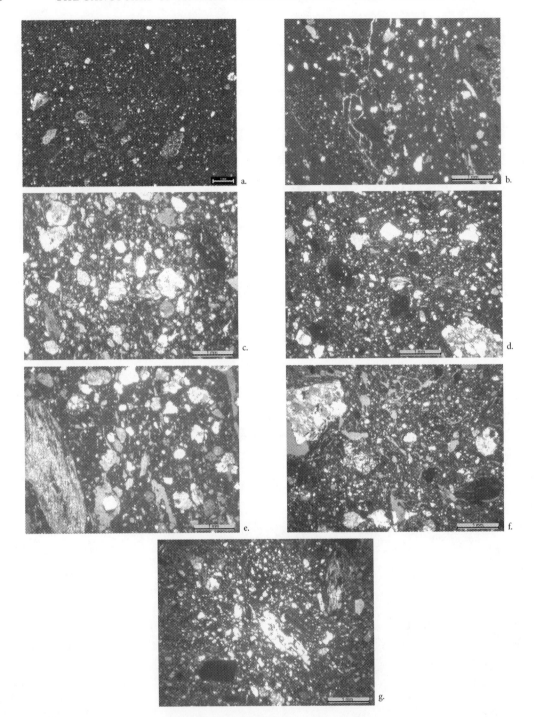

Figure 6.1: Petrography sections. Figure 6.1a: PFG 1, coarse to semi-coarse metamorphic, subgroup (a), sample SYM 17/82 (P704); Figure 6.1b: PFG 1, coarse to semi-coarse metamorphic, subgroup (b), sample SYM 17/84 (P701); Figure 6.1c: PFG 2, coarse metamorphic micaceous, sample SYM 17/78 (P681); Figure 6.1d: PFG 3, coarse metamorphic micaceous with pellets in a quartz-rich matrix, sample SYM 17/7 (P130); Figure 6.1e: Comparative material from the Pediada survey, sample PDS 07/161; Figure 6.1f: Comparative material from the Pediada survey, sample PDS 07/164; Figure 6.1g: Comparative clay sample (CS 16/5b) from Thrapsano. Magnification x25 (except for 6.1a: x12.5).

APPENDIX: PETROGRAPHIC ANALYSIS OF GREEK AND ROMAN POTTERY 587

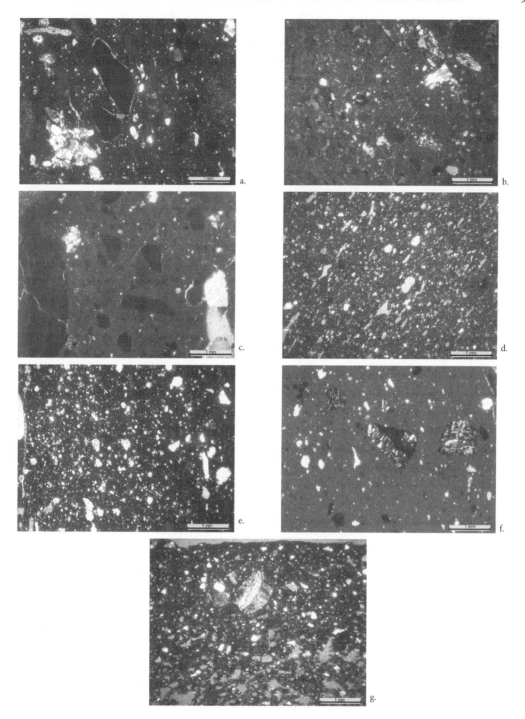

Figure 6.2: Petrography sections. Figure 6.2a: PFG 4, red ophiolite-related, sample SYM 17/15 (P119); Figure 6.2b: clay sample (CS 16/6) from Thrapsano comparable to PFG 4; Figure 6.2c: PFG 5, red fine/very fine with clay pellets, sample SYM 17/16 (P33); Figure 6.2d: PFG 6, fine red with small quartz fragments, sample SYM 17/101 (P807); Figure 6.2e: PFG 7, red with quartz fragments, overfired, sample SYM 17/25 (P86); Figure 6.2f: PFG 8, fine calcareous, sample SYM 17/55 (P249); Figure 6.2g: Small group 1, sample SYM 17/1 (P327). Magnification x25.

and has been assigned to an off-island source, possibly in the Cyclades,[15] but the similarity of the Syme Viannou fabrics with those from the Pediada makes it highly likely that the fabric from Knossos is also from the Pediada, as proposed by Kotsonas on macroscopic grounds.[16] These observations open the way for a more systematic approach to pottery production in the Pediada as well as to the investigation of the possible role of Lyktos/Lyttos in the distribution of ceramics across central and east Crete.

PFG 4: Red ophiolite-related (Figure 6.2a)
Samples: SYM 17/15 (P119), SYM 17/17 (P531), SYM 17/51 (P443), SYM 17/61 (P631)
This is a semi coarse fabric representing a totally different geological environment from the metamorphic one which is represented in PFGs 1-3. It is characterized by a very fine dark red brown firing matrix which is optically inactive. The non-plastic inclusions are rounded to subrounded and rather sparsely distributed; most likely they were added as temper in the clay mix. They consist of red brown fragments of fine-grained siltstone which is almost concordant with the micromass. There are also rare fragments of metamorphic rocks (phyllite, quartzite, and quartzite-schist) and common red brown clay pellets which could be mudstone in some cases. This rock and mineral suite is compatible with the Ophiolite series and the Flysch mélange of either the south coast or the area of south-central Crete. A clay sample taken from a road cut near modern Thrapsano contains metamorphic rocks and clay pellets and is compositionally and texturally very close to the PFG in question (Figure 6.2b). However, a single raw material sample cannot be considered as direct evidence for the provenance of an ancient pottery fabric; rather, it provides an indication and a lead to be followed with further archaeological and geological sampling in the future. PFG 4 includes a variety of vessel forms ranging in date from PAR to AR. The four samples of this PFG (SYM 17/15 (P119), SYM 17/17 (P531), SYM 17/51 (P443), SYM 17/61 (P631)) are assigned to four MFGs (two belong to MFGs C1 and C2), most likely due to variation in surface color.

6.2.2. Fine Fabrics

The petrographic analysis established a series of fine fabrics displaying common textural characteristics (especially PFGs 5-7). Their petrographic characteristics are summarized in Table 6.2.

15. Boileau and Whitley 2010, 233–234.
16. Kotsonas 2011b, 141; 2012b, 162–165; 2013, 243–244; 2019c, 2–3 n. 1; Kotsonas et al. 2018, 64–66; Ximeri 2021, 81–82.

Table 6.2: The petrographic characteristics of the four fine-ware PFGs which are attested on Greek and Roman pottery from Syme Viannou.

PFG	Matrix	Non-Plastic Inclusions	Textural Concentration Features	Geological Association
PFG 5: Red fine/very fine with clay pellets	Very fine, dark red brown, optically inactive	Very few to rare: small quartz fragments; very rare: bright red mineral, micritic limestone, volcanic and metamorphic rock fragments, sandstone	Frequent to rare: clay pellets, equant, sr, in a dark red brown color, almost concordant with the micromass	Ophiolite series/Flysch mélange
PFG 6: Fine red with small quartz fragments	Very fine, dark red brown, optically inactive	Common to few: small quartz fragments; very few: bright red mineral, micritic limestone, polycrystalline quartz/quartzite; very rare: phyllite	Very rare to absent: clay pellets, dark red brown, sr, almost concordant with the micromass	Ophiolite series/Flysch mélange
PFG 7: Red with quartz fragments, overfired	Very fine, dark red, optically inactive; occasionally black margins due to high firing	Common: small quartz fragments; very few: bright red mineral, micritic limestone; very rare: phyllite, quartzite	Very rare to absent: clay pellets, dark red to black, sr, almost concordant with the micromass	Ophiolite series/Flysch mélange
PFG 8: Fine calcareous	Very fine, brown to greenish brown, optically inactive with occasional mottling	Very rare to absent: small quartz fragments, bright red mineral, phyllite/siltstone, volcanics	Few to rare: clay, pellets, red brown mottled	Ophiolite series/Flysch mélange

PFG 5: Red fine/very fine with clay pellets (Figure 6.2c)

Samples: SYM 17/4 (P113), SYM 17/16 (P33), SYM 17/29 (P235), SYM 17/48 (P460), SYM 17/56 (P439), SYM 17/58 (P811), SYM 17/64 (P621), SYM 17/65 (P599), SYM 17/80 (P746), SYM 17/87 (P731), SYM 17/89 (P718), SYM 17/90 (P693)

This is the main fine fabric of the assemblage. It is characterized by a very fine dark red brown firing matrix which is optically inactive. PFG 5 could be considered a finer version of PFG 4, since the matrix is very similar in color and texture. When present, the very few non-plastic inclusions consist of metamorphic (fine grained phyllite and quartzite), and very rarely volcanic (basalt) rocks, which link this fabric to the environment of the Ophiolite series and the Flysch mélange. In most samples there are small quartz fragments sparsely distributed in the base clay as well as red brown to dark brown clay pellets almost concordant with the micromass. The majority of the samples in PFG 5 belong to MFGs C1 and C2, which provides corroborative evidence for the connection between PFGs 4 and 5. The shape repertory comprises all sorts of closed containers and serving vessels, which come from various areas of the sanctuary and date from the PG to the AR period, with single specimens assigned to the CLAS and HEL periods.

PFG 6: Fine red with small quartz fragments (Figure 6.2d)
Samples: SYM 17/20 (P575), SYM 17/21 (P69), SYM 17/22 (P101), SYM 17/27 (P339), SYM 17/30 (P31), SYM 17/35 (P848), SYM 17/36 (P849), SYM 17/37 (P847), SYM 17/46 (P506), SYM 17/66 (P615), SYM 17/83 (P742), SYM 17/86 (P727), SYM 17/93 (P379), SYM 17/94 (?) (P764), SYM 17/95 (P770), SYM 17/100 (P763), SYM 17/101 (P807), SYM 17/102 (P803)
This fabric group bears many similarities to PFG 5: it has the same brown firing and optically inactive matrix and the rare non-plastic inclusions which consist of metamorphic rocks, namely fine grained brown phyllite and quartzite. However, there are two main differences between the two PFGs, which led to the establishment of PFG 6 as a separate group: a) the presence of densely packed small quartz fragments, and b) the absence of the characteristic clay pellets seen in PFG 5. Moreover, the fine fraction contains small fragments of a translucent mineral, yellow in PPL and orange brown to bright red in XP; it could be either serpentinite or some type of optically active clay pellet. Its regular presence is noted because it might be significant in terms of provenance. Clay sampling and comparative material from other sites is necessary for any evaluation of the importance of the presence of this mineral in certain samples. The vessels in this group derive from various areas of the sanctuary and include mostly cups and amphoras. Their date ranges from the EIA to the ROM period.

This rather homogeneous group includes sample SYM 17/94 (P764) (a ROM amphora) which presents certain particularities: it is higher fired than the rest, as indicated by the mottling of the matrix. Also, the non-plastic components consist of quartz fragments which are not as dense as in the other samples, as well as of some dark gray/black almost amorphous inclusions, most likely deformed by the firing temperature. It is not clear whether they are sedimentary rock fragments (fine grained siltstones), clay pellets, or both. There are also a few small fragments of the translucent mineral seen in the other members of this group, which is why this sample is included here.

Comment on PFGs 4-6: these groups are interconnected, the components linking them being the dark red firing clay matrix, the mudstones, and the clay pellets. PFG 4 is coarser, whereas PFGs 5-6 constitute finer variants. When present, the non-plastic components point toward the Ophiolite series and the Flysch mélange, a geological series extending along the south coast of Crete, from Myrtos to the western Mesara. The majority of the samples belong to MFGs C1 and C2, thus corroborating their connection and their probably common provenance. A clay sample from modern Thrapsano points toward the broader Pediada region but provenance cannot be assigned with any certainty. The possible connection of this fabric with Aphrati is reviewed in Chapter 3. Recent analysis of pithoi from Aphrati shows the presence of a red firing fabric with frequent mudstones but it does not seem to be the dominant component of the assemblage,[17] thus leaving open the question of its provenance.

17. Ximeri 2021, 73, sample AF17.

PFG 7: Red with quartz fragments, overfired (Figure 6.2e)
Samples: SYM 17/18 (P248), SYM 17/25 (P86), SYM 17/26 (P87), SYM 17/52 (P311), SYM 17/91 (P790), SYM 17/92 (P422)
This PFG is characterized by a dark red matrix, which in some cases displays almost black margins due to high firing. Leaving aside the color of the matrix and the firing, the mineralogical composition of PFG 7 recalls PFG 6; it is characterized by the same small fragments of quartz and, most importantly, by the yellow/red translucent mineral that could be identified as serpentinite or as a rather particular type of clay pellet. All the vessels assigned to PFG 7 are LHEL unguentaria, and they all belong to MFG G. The composition is not diagnostic of provenance. Although PFG 7 is geologically connected to PFG 6, it shows a different way of manufacture and different surface treatment and firing. Most likely, PFG 7 represents a specialized industry for the production of unguentaria.

PFG 8: Fine calcareous (Figure 6.2f)
Samples: SYM 17/8 (P149), SYM 17/12 (P368), SYM 17/13 (P359), SYM 17/23 (P338), SYM 17/24 (P144), SYM 17/41 (P423), SYM 17/45 (P461), SYM 17/54 (P457), SYM 17/55 (P249), SYM 17/57 (P645)
This PFG is characterized by a brown to greenish brown almost glassy matrix. The color, which displays mottling in parts, and the texture point toward a rather calcareous raw material and a high firing temperature. Most samples are very fine and devoid of any non-plastic inclusions. Some samples contain a little quartz and rare volcanic (basalt) and metamorphic (phyllite, quartzite) rock fragments. This rock and mineral suite as well as the texture of the fabric point toward the Ophiolite series and the Flysch mélange; the attestation of a single fragment of amphibolite in a single sample of this rather fine fabric leads to the association of this PFG with the one used for the East Cretan Cream Ware (ECCW) (on which, see also Section 3.4). The ECCW is characterized by the pale color of the surface (hence its name) and is rather common on amphorae and other domestic shapes (lamps, jugs, plates, bowls). Petrographic analysis of ECCW material from the HEL assemblages of Myrtos Pyrgos and Mochlos identified fragments of amphibolite which led to the tracing of the ware to the south coast of east Crete and the broad area of Myrtos.[18] The presence of amphibolite in PFG 8 as well as the macroscopic classification which assigned nearly all the samples to MFGs E and F leave no doubt that this group can be identified with the ECCW. The shapes represented are mainly small in size (bell skyphoi, juglets) as well as lekanai. Their date is PG to HEL.

6.2.3. Small Petrographic Fabric Group and Loners

The sampled Greek and Roman pottery from Syme Viannou includes several specimens that are not incorporated in any of the main petrographic groups due to compositional and textural

18. Vogeikoff-Brogan et al. 2008.

differences. Most of them represent variants of the main PFGs and some are considered to be off-island imports (for an overview, see Table 6.3).

Table 6.3: The petrographic fabric loners which are attested among the Greek and Roman pottery from Syme Viannou, and their possible provenance.

Petrographic Sample No.	Publication No.	Shape	Possible Provenance
Small group 1 (SYM 17/1, 17/2, 17/97, 17/98)	P327, P50, P420, P773	Ring vase, jug, kalathos, domed lid/shield	Pediada
SYM 17/70	P539	Bowl	Pediada
SYM 17/6	P12	Skyphos	Pediada
SYM 17/32	P169	Transport amphora	Off-island import
SYM 17/28	P234	Unguentarium	Off-island import
SYM 17/77	P680	Krater	Off-island import
SYM 17/76	P652	Krater	South coast
SYM 17/44	P401	Lekane	South coast
SYM 17/62, 74	P624, P545	Kalathos, lekane	South coast
SYM 17/11	P190	Lekane	North coast/Palaikastro
SYM 17/67	P567	Stamnos	North coast/Mochlos

Small group 1: SYM 17/1 (P327), SYM 17/2 (P50), SYM 17/97 (P420), SYM 17/98 (P773) (Figure 6.2g). Semi-coarse fabric characterized by a dark red firing matrix which is optically inactive, and by frequent fragments of monocrystalline quartz densely packed in the base clay. There are also rare fragments of metamorphic rocks (phyllite, quartzite) and sandstone. This composition points toward an alluvial origin of the raw material connected with the Phyllite-Quartzite series. The base clay contains biotite and white mica laths, which link this fabric with PFG 3 and indicate a possible provenance in the Pediada. The vessels represented are a ring kernos, a domed lid/shield, a jug, and a kalathos – most of them of PAR-AR date. Three out of the four vessels belong to MFGs A1 and A2, thus confirming the connection with the Pediada. The kalathos SYM 17/97 (P420) is a macroscopic loner.

SYM 17/70 (P539): Coarse fabric in an orange brown firing matrix which is optically active. The porosity is rather open with long elongate voids oriented parallel to vessel margins. The non-plastic inclusions consist of rounded fragments of metamorphic rocks, namely phyllite and quartzite, and some gneiss. The presence of white and biotite mica laths in the base clay links this fabric to the micaceous deposits of the Pediada. This provenance is also indicated by the attribution of this sample to MFG A1. However, the porosity, the optical activity, and the mineralogy indicate a different recipe and/or production center than those of PFGs 2 and 3. The vessel is a PAR bowl assigned to MFG A1.

SYM 17/6 (P12): Semi-fine fabric with gray brown firing and optically inactive matrix. It is mainly composed of small rounded fragments of siltstone, very little sandstone, and small fragments of quartz which are unevenly distributed in the base clay. The composition is compatible with the Ophiolite series and the Flysch mélange; the presence of frequent dark clay pellets brings the sample close to PFG 4. A compositionally similar fabric has been identified on a pithos from Aphrati,[19] but it is not one of the main components of the sampled assemblage from this site. SYM 17/6 (P12) is from a PG skyphos assigned to MFG D.

SYM 17/32 (P169) (Figure 6.3a): Semi-fine fabric with a brown firing and optically inactive matrix. The non-plastic inclusions consist almost exclusively of frequent small quartz fragments evenly distributed in the base clay with sparse biotite mica laths and rare fragments/aggregates of micritic limestone; there are also sparse microfossils. This composition is not diagnostic of provenance, but this fabric is not comparable to any of the semi-fine/fine fabrics from Syme Viannou. Indeed, the vessel which is a transport amphora of PAR-AR date is a macroscopic and a petrographic loner and it could be an off-island import. The macroscopic study suggested a possible connection either with Laconian transport amphorae or, less likely, with Attic SOS amphorae. The analytical data available for both types is very sparse and fragmentary. Ian Whitbread analyzed "barbarian ware" of the LBA from the Menalaion in Sparta and identified a range of compositionally related fabrics which he considered to be local.[20] In their study of a small group of LPAR transport amphorae from Kommos, Christina de Domingo and Alan Johnston were based on Whitbread's main fabric in order to attribute to Laconia seven amphora specimens (expressing some reservation due to the lack of adequate comparative evidence).[21] The mineralogical composition of the Kommos samples, which is characterized by dense monocrystalline quartz fragments, biotite mica, and sporadic microfossils, matches that of the Syme Viannou sample. In contrast, the description of the SOS amphorae from Incoronata, which show a finer and more micaceous fabric, is not compatible.[22] Therefore, a possible origin from Laconia could be suggested for SYM 17/32 (P619), notwithstanding the absence of good comparative analytical data from Laconia itself.[23]

SYM 17/28 (P234) (Figure 6.3b): Semi-fine fabric with a brown firing and optically inactive matrix containing mainly small and medium sized quartz fragments, some micritic limestone, and biotite mica laths; it also contains frequent microfossils that are not present in any of the other fabrics in the Syme Viannou assemblage (except for loner SYM 17/77 (P680)). This sample is assigned to MFG I, but this is most likely due to similarity in the color of the matrix,

19. Ximeri 2021, 73, sample AF28.
20. Whitbread 1992.
21. De Domingo and Johnston 2003, 37–38, 43.
22. De Domingo and Johnston 2003, 37–38, 44.
23. A small group of black gloss vessels of the 6th-5th centuries BCE from Kolonna in Aegina were assigned to Laconia on macroscopic and analytical grounds, with similar reservations (Pentedeka et al. 2012, 128–131). These vessels are much finer than the transport amphorae, which complicates their comparison with the piece from Syme Viannou.

Figure 6.3: Petrography sections. Samples in Figures 6.3a to 6.3f respectively: SYM 17/32 (P169), 17/28 (P234), 17/77 (680), 17/44 (P401), 17/62 (P624), 17/11 (P190). Magnification x25 (except for Figure 6.3b: x50).

since the inclusions of the specimen in question are too small to be visible by naked eye or hand lens. The vessel is a HEL unguentarium and it could be an off-island import.

SYM 17/77 (P680) (Figure 6.3c): Semi-fine fabric with a brown firing and optically inactive matrix. There are very few quartz fragments, some micritic limestone, and rare fragments of phyllite and quartzite/quartzose as well as some microfossils. The base clay includes frequent muscovite and biotite mica laths. The vessel is an EIA krater assigned to MFG C1, but it could be an off-island import.

SYM 17/76 (P652): Semi-coarse fabric with dark red margins and dark brown/gray core. There are some small fragments of quartz distributed unevenly in the base clay and some rounded non-plastic inclusions, namely fine grained gray phyllite, quartzite/quartzite-schist, and basalt with a black devitrified matrix and plagioclase laths, which were most likely added as temper in the clay mix. This composition is compatible with the Ophiolite series and the Flysch mélange. The piece could originate from the south coast, but other areas of production should also be considered, such as south-central Crete. The vessel is a krater of PAR (?) date assigned to MFG C1.

SYM 17/44 (P401) (Figure 6.3d): Semi-coarse fabric with a dark red brown and optically inactive matrix. The non-plastic inclusions consist of rounded fragments of serpentinite ranging in color from greenish to bright orange. There are also rare fragments of volcanic rocks as well as some polycrystalline quartz ranging into chert. This composition points toward the Ophiolite series and the Flysch mélange. A similar fabric is encountered in a range of Neopalatial domestic vessels from Myrtos Pyrgos,[24] and it must be connected with the production of the south coast. The vessel is a lekane of AR-CLAS date assigned to MFG B1.

SYM 17/62 (P624), SYM 17/74 (P545): The two samples are not identical, but they share certain compositional and textural characteristics. Sample SYM 17/62 (P624) (Figure 6.3e) is coarser, in a red brown and optically inactive matrix; SYM 17/74 (P545) is finer, the color of the matrix is brown and it is also optically inactive. The non-plastic inclusions are common to very few, rounded, and consist of amphibolite and volcanic rocks. The presence of the amphibolite has already been discussed in association with the ECCW (PFG 8) and the broader area of Myrtos on the south coast.[25] Another component common in the two samples is the presence of elongate black features which do not seem to be clay pellets or striations and could be connected to chemical alterations. A similar fabric with the same elongate features is attested among the unpublished hollow animal figurines from Syme Viannou.[26] The two vessels in question are a kalathos and a lekane of LM IIIC-PG and LAR date respectively.

SYM 17/11 (P190) (Figure 6.3f): Coarse fabric with dark red margins and dark brown core, optically inactive. The non-plastic inclusions consist of elongate gray phyllite, some quartzite-schist, and rather dense small quartz fragments. The matrix and the composition are rather commonly attested in Neopalatial and Postpalatial fabrics from Palaikastro, hence the piece in question may originate from the far east of north Crete. It is a lekane (?) of CLAS date and a macroscopic loner.

SYM 17/67 (P567): Coarse fabric with a brown and optically inactive matrix. The non-plastic inclusions consist almost exclusively of elongate brown and very fine grained phyllite

24. Nodarou, work in progress.
25. Vogeikoff-Brogan et al. 2008.
26. Nodarou, work in progress.

with sparse fragments of small quartz. This fabric finds very close parallels on unpublished Neopalatial material from Mochlos,[27] and its provenance should be sought on the north coast of east Crete, near Mochlos. The vessel is a stamnos of EHEL–MHEL date.

6.3. Petrographic Fabric Groups and Pottery Consumption at Syme Viannou

The analysis above has demonstrated that the majority of the coarse and semi-coarse Greek and Roman pottery from Syme Viannou belongs to four PFGs, which represent three different geological environments. The largest group incorporates a broad array of vessels belonging to two compositionally related fabrics: PFGs 2 and 3 represent two recipes manufactured with similar raw materials characterized by red firing and highly micaceous clays with metamorphic rock fragments; the silver mica accounts for the characteristic sheen of the final product. This rock and mineral suite is not compatible with the local geology around Syme Viannou and the geology of east Crete, but points toward the Pediada, as confirmed by clay sampling and analytical work. This conclusion corroborates the point made in Chapter 3 that this range of highly micaceous fabrics represents pottery imported from Lyktos/Lyttos and the Pediada (MFGs A1 and A2).[28]

The second largest group, PFG 1, is also red firing and connected with metamorphic raw materials, but it does not contain the silver mica seen in the fabrics of the Pediada (MFGs B1 and B2). PFG 1 is characterized mainly by fine grained brown phyllite pointing to a source in the Phyllite-Quartzite series of east Crete. Given the improbability of pottery production at the sanctuary and its immediate vicinity in the Greek and Roman periods, the most obvious provenance for this type of pottery should be sought on the north coast of east Crete. The two subgroups indicate a degree of variability which also conforms to the pattern seen on the Minoan pottery from east Crete, the majority of which is connected with metamorphic raw materials.

PFG 4 is encountered in a smaller number of samples and is mostly associated with MFG C1. It is characterized by a very fine matrix in which non-plastic inclusions (mainly siltstone and some metamorphic rocks) were added as temper. This composition and the overall technology of manufacture point to the environment of the Ophiolite series and the Flysch mélange. The closest outcrops are found in the area of Myrtos on the south coast and extend westward to the western Mesara. The small number of samples does not allow for a secure provenance assignment, but both the typology and the macroscopic study suggest it is

27. Nodarou, work in progress.
28. The connection of the Syme Viannou sanctuary with the Pediada is attested already in the Protopalatial period, during which over 50% of the pottery which reached the sanctuary was most likely imported from Kastelli (Christakis 2013, 171–173, 177).

not imported from any distant source. The possible connection of PFG4 with PFG 5, which is the main recipe for the fine wares at Syme Viannou, indicates that this pottery comes from an area which is not far from the sanctuary.

PFGs 5 to 7 encompass the majority of the fine vessels of the assemblage. They represent an array of closely related recipes almost devoid of non-plastic inclusions. They are connected by the color and texture of the matrix, while the rare presence of volcanic rock fragments points to the environment of the Ophiolite series and the Flysch mélange of the south coast, which is also the case with PFG 4. On the basis of their base clay and their rare non-plastics, PFGs 5 to 7 are considered to be finer variants of PFG 4. All groups comprise small and medium sized fine vessels, mainly serving vases and containers for liquids. The higher fired variant represented by PFG 7 (red with quartz overfired) constitutes a recipe used exclusively for unguentaria.

The correlation between the microscopic and the macroscopic classification of the fine wares reveals interesting patterns. PFG 5 (red fine/very fine with pellets) comprises mainly samples from MFGs C1 and C2. The association of MFG C2 with Aphrati was challenged in Chapter 3, and this seems to find corroborative evidence in the petrographic analysis. The amount of pottery assigned to MFGs C1 and C2 and the petrographic connection of the associated PFGs 4 and 5 with the Ophiolite series and the Flysch mélange suggests a provenance from the south coast of east Crete, although other areas, such as the Pediada and the Mesara, cannot be excluded.

PFG 6 (red with small quartz) comprises a multitude of MFGs. This PFG deserves further consideration and invites for additional investigation along the following lines:

a) such a fine red fabric can be associated with different sources which are indistinguishable through petrography. Only chemical analysis would show whether all the samples share a common provenance or derive from different sources;

b) the presence of three samples from MFG C2 among PFG 6 lends support to the argument made above that this fine PFG might not be associated with a single source;

c) there seems to be an exclusive association between PFG 6 on the one hand, and MFGs B3, H, and J on the other. What these three MFGs have in common is the reddish color of the clay and the presence of slip on the specimens from MFGs B3 and J. Perhaps the selection and/or the treatment of the raw material is related to the application of the slip; when levigated, this raw material could have been used for the production of the clay slip. It is only through chemical analysis that one could investigate further whether PFG 6 constitutes a single recipe or a series of similar fabrics.

PFG 7 shows very characteristic attributes (macroscopic and microscopic) and corresponds neatly to MFG G. As noted above, it represents a recipe used for unguentaria.

PFG 8 differs from the other fine fabrics in the greenish brown and glassy texture of the matrix, which is characteristic of a calcareous raw material fired at a rather high temperature. The rare attestation of amphibolites links this fabric to the broader area of Myrtos. This link is corroborated by the macroscopic study, which connects MFGs E and especially F (both associated with PFG 8) with the ECCW ware.

Besides the main coarse and fine PFGs, there is a considerable number of small PFGs and loners, i.e., samples that were not included in any of the main groups due to compositional and textural differences. This does not come as a surprise considering the ritual character of the site and its visitation by people coming from different areas, which is attested by HEL inscriptions (Section 3.4). The samples which were not assigned to any of the eight fabric groups can be divided into four broad classes according to their possible origin (Table 6.3). The majority of the unclassified samples is connected with the Pediada, though with sources other than those of PFGs 2 and 3. Some other pieces are compositionally connected to the Ophiolite series and the Flysch mélange, which suggests a provenance from the south coast. Both the production of the Pediada and that of the south coast are insufficiently known in petrographic terms and it is highly likely that there existed local diversifications and recipes which cannot be identified with the comparative data available to date. There are two samples which could derive from the north coast but this comes as no surprise considering the connection of PFG 1 with the Phyllite-Quartzite series. Lastly, there are three possible off-island imports; although their origins cannot be assessed with certainty due to the lack of comparative material, the shapes (an amphora, an unguentarium, and a krater) are among the vessels frequently linked to off-island sources.

6.4. Ceramic Regionalism in Central and East Crete: Aspects of Continuity and Change

It is among the stated aims of this analysis to study continuity and change in the pottery traditions present at Syme Viannou and investigate patterns of pottery distribution and regionalism. The petrographic analysis of a range of Greek and Roman coarse and fine wares, complemented by previous analyses on wheel made and solid animal figurines from the sanctuary,[29] has established that:

a) All fabrics identified in the figurines find comparisons in the pottery assemblage. This indicates either that there were no specialized workshops, or that the clay recipes and the raw materials used for the manufacture of these ceramics were the same.

b) The attestation of micaceous fabrics at Syme Viannou, and hence the connection of the sanctuary with the Pediada, predates the 4th century BCE. This type of fabric is attested on wheelmade figurines from as early as the LM IIIC and persists into the G and AR periods. The presence of loners which may be geologically connected to the Pediada broadens the spectrum of the pottery of the area which reached the sanctuary and invites future investigation on the output of different production centers, beyond Lyktos/Lyttos.

c) Unlike the analysis of the animal figurines, the analysis of the pottery identified some

29. Nodarou et al. 2008; Nodarou and Rathossi 2008.

material (PFG 1) which may originate from the north coast of Crete; PFG 1 is connected to the Phyllite-Quartzite series, which is attested in the area of Syme Viannou, but the site has yielded no evidence for Greek and Roman pottery manufacture. Also, PFG 1 presents compositional similarity with Minoan fabrics of metamorphic composition which can be traced to the north coast of east Crete, especially in the broader area of Kavousi and Mochlos. This compositional similarity, and the possible provenance of sample SYM 17/11 from the far east of Crete (Palaikastro area) suggests the connections of Syme Viannou with the northeast part of the island.

d) All fine fabrics, including PFG 8 which is connected to the ECCW, as well as a few loners, are compositionally connected with the environment of the Ophiolite series and the Flysch mélange. The area of Myrtos on the south coast of east Crete is characterized by such outcrops and the plain of Myrtos should be considered as the closest source for such raw materials suitable for pottery manufacture (which are also attested further west, as far as the western Mesara). This observation opens future avenues for research in the direction of Hierapytna, which could have served as a center of production and distribution of pottery in the southeast part of Crete.

In conclusion, the analytical study of the Greek and Roman pottery of Syme Viannou has offered new insights into ceramic production and distribution in central and east Crete. The sanctuary seems to have been open to visitors bringing pottery from the Pediada (Lyktos/Lyttos) and the north coast of east Crete, whereas the role of the south coast and the possible connection of the site with Hierapytna needs to be further investigated. Future systematic analyses of post-Minoan pottery from Cretan settlement sites will enhance our understanding of routes of communication and regional dynamics in this part of the island.

6.5. Descriptions of the Coarse and Semi-Coarse Petrographic Fabric Groups

The petrographic analysis was carried out using a Leica DMLP polarizing microscope. The descriptions follow the system and terminology introduced by Whitbread.[30] The following abbreviations are used: a: angular, r: rounded, sa: subangular, sr: subrounded, wr: well rounded, tcf's: textural concentration features, PPL: plane polarized light, XP: cross polarized light, l.d.: long dimension. The following frequency labels are used: dominant: 50-70%, frequent: 30-50%, common: 15-30%, few: 5-15%, very few: 2-5%, rare: 0.5-2%, very rare: < 0.5%.

30. Whitbread 1995.

Petrographic Fabric Group 1: Coarse to semi-coarse metamorphic
Samples Subgroup a: SYM 17/3 (P41), SYM 17/34 (P832), SYM 17/42 (P427), SYM 17/71 (P565), SYM 17/72 (P564), SYM 17/82 (P704)
Subgroup b: SYM 17/81 (P751), SYM 17/84 (P701)

Microstructure

Subgroup a: Fcw to common macro and meso vughs (irregular voids) and planar voids single to open spaced. The porosity is rather open, especially in the coarser samples. Some vughs and voids as well as large elongate non-plastic inclusions display preferred orientation parallel to vessel margins; the majority are randomly oriented. On sample SYM 17/71 (P565) the voids indicate the presence of organic matter, but it does not seem to be a case of intentional tempering.

Subgroup b: very few meso and rare macro vughs, few meso vughs and planar voids, the latter occasionally surrounding the larger grains; open spaced. Vughs, voids and the large non-plastic inclusions display rough preferred orientation parallel to vessel margins. The smaller non-plastics are randomly oriented.

Groundmass

Homogeneous throughout the section. The colour of the matrix is brown to dark brown in PPL (x50) and dark brown to gray brown in XP. Optical activity: inactive.

Inclusions

$c:f:v_{10\mu m}$ = 30:55:15 (subgroup a) to 20:70:10
Coarse fraction: 4.8-0.1 mm l.d. Packing: close to single spaced. Sorting: poor.
Fine fraction: <0.1 mm l.d. Packing: single to open spaced.

Coarse Fraction

Frequent: Phyllite, elongate, ranging in color from dark brown, to golden brown. Some fragments are very fine grained, others are composed of small quartz fragments and biotite mica laths. Size: 4.8-0.16 l.d. In sample SYM 17/34 (P832) there is dark red brown shale; size: 2.4-0.4 mm l.d.

Common: Monocrystalline quartz fragments, equant or slightly elongate, a-sa. The larger fragments are rather rare smaller fragments are more common. Size: 1.2-0.1 mm l.d. Mode: 0.24 mm l.d.

Very few: Sandstone/quartz arenite/quartzite: equant, sa-sr. Size: 2.48-0.24 mm l.d. Quartzite-schist: equant to elongate, sa; occasionally grading into chert. Size: 4.8-0.24 mm l.d. Mode: 0.8 mm l.d.

Very rare to absent: Volcanic rock fragment (basalt), sr, seen in sample SYM 17/71 (P565). Size: 1.2 mm l.d.
Calcite fragment, equant, sa, seen in sample SYM 17/3 (P41). Size: 1.2 mm l.d.
Opaques (Fe-rich?)

Fine Fraction
Dominant: Monocrystalline quartz fragments
Common: Biotite mica laths
Few: Phyllite fragments
Rare: Polycrystalline quartz/chert

Textural Concentration Features
Very few to rare, equant, sr, ranging in color from dark red brown to dark brown and black. Clay pellets.

Petrographic Fabric Group 2: Coarse metamorphic micaceous
Samples: SYM 17/5 (P82), SYM 17/10 (P174), SYM 17/39 (P399), SYM 17/40 (P398), SYM 17/68 (P591), SYM 17/69 (P566), SYM 17/78 (P681), SYM 17/79 (P694), SYM 17/96 (P765)

Microstructure
In most samples the porosity is rather closed, with rare meso and micro vughs open spaced and randomly oriented. Only samples SYM 17/10 (P174), SYM 17/40 (P398) and SYM 17/79 (P694) show meso and macro planar voids, close to single spaced, oriented parallel to vessel margins, but these are not indicative of tempering with organic matter. The non-plastic inclusions are randomly oriented.

Groundmass
Homogeneous throughout the section. The colour of the matrix is brown to dark brown in PPL (x50) and dark brown to gray in XP. Only a few samples show a gray core and red-brown margins. Optical activity: inactive.

Inclusions
$c{:}f{:}v_{10\mu m} = 40{:}57{:}3$
Coarse fraction: 3.2-0.1 mm l.d. Packing: close to single spaced. Sorting: poor.
Fine fraction: <0.1 mm l.d. Packing: close to single spaced.

Coarse Fraction
Dominant: Mono and polycrystalline quartz fragments, equant or slightly elongate, a-sa. The coarse fragments are fairly dense but unevenly distributed in the clay matrix. Size: 1.2-0.1 mm l.d. Mode: 0.24 mm l.d.
Frequent: Quartzite/Quartzite-mica schist: equant to elongate, sa; most fragments contain muscovite mica, rare fragments are in intergrowth with phyllite. Size: 2.4-0.24 mm l.d.
Frequent to few: Altered yellow mineral, equant, sr. The color is gray brown in PPL and yellowish/orange brown in XP; its texture is fine and "grainy" like carbonates; some fragments seem to contain mica laths whereas in a few the color in XP is the translucent red seen in serpentinite. Could it be some kind of serpentinization? Size: 3.2-0.14 mm l.d.

Common to few: Phyllite, elongate, usually fine grained in a dark brown color. Most fragments contain biotite mica laths. Size: 2.0-0.15 mm l.d.

Few: Muscovite-mica schist, elongate, usually small fragments; this material is connected with the mica laths giving the vessels the characteristic sheen. Muscovite mica laths

Very few: Alkali feldspar, equant. Size: 0.16-0.8 mm l.d.

Very rare to absent: Volcanic rock fragment (basalt), sr, seen in sample SYM 17/40 (P398). Size: 0.48 mm l.d.
Epidote, equant, sa, seen in sample SYM 17/63. Size: 0.24 mm l.d.
Plagioclase feldspar, equant. Size: 0.64-0.16 mm l.d.

Fine Fraction
Dominant: Muscovite mica laths
Frequent: Monocrystalline quartz fragments
Common: Biotite mica laths
Few: Polycrystalline quartz/schist fragments
Very few: Altered yellow mineral
Rare: Alkali feldspar
Very rare: Plagioclase feldspar
Clinopyroxene

Textural Concentration Features
Very few to rare, equant to elongate, sa-sr, most of them in a dark brown/black color. Clay pellets; some might be Fe-rich concretions.

Petrographic Fabric Group 3: Coarse metamorphic micaceous with pellets in a quartz-rich matrix
Samples: SYM 17/7 (P130), SYM 17/9 (P158), SYM 17/14 (P281), SYM 17/19 (P142), SYM 17/53 (P557), SYM 17/59 (P839), SYM 17/60 (P838), SYM 17/63 (P626), SYM 17/73 (P556), SYM 17/85 (P697)

Microstructure
Closed porosity in most samples, with very rare meso and macro vughs, open spaced; in some samples there are few meso and macro planar voids, double spaced, oriented parallel to vessel margins but not indicative of tempering with organic matter. The non-plastic inclusions are randomly oriented.

Groundmass
Homogeneous throughout the section in most samples. The colour of the matrix is dark brown to gray brown in PPL (x50) and dark red brown to gray in XP. In a few samples the core is gray and the margins are red brown. Optical activity: moderately active (SYM 17/63 (P626)) to inactive.

Inclusions

c:f:v $_{10\mu m}$ = 45:53:2 to 45:48:7
Coarse fraction: 2.48-0.1 mm l.d. Packing: close to single spaced. Sorting: poor.
Fine fraction: <0.1 mm l.d. Packing: close to single spaced.

Coarse Fraction

Dominant: Monocrystalline quartz fragments, equant or slightly elongate, a-sa. The coarse fragments are rather rare and sparsely distributed; the smaller ones are densely packed. Size: 0.8-0.1 mm l.d. Mode: 0.16 mm l.d.

Few: Polycrystalline quartz/quartzite/quartzite-schist: equant to elongate, sa; some fragments are partly grading into chert, others in intergrowth with phyllite. Size: 2.48-0.2 mm l.d.
Muscovite mica laths

Very few: Phyllite, elongate, fine grained in a dark brown or golden-brown color containing biotite mica laths. Size: 1.5-0.24 mm l.d.

Very rare to absent: Altered yellow mineral, equant, sr. This component, which is so frequent in PFG 2, is seen only in sample SYM 17/60 in this group. Size: 0.8-0.15 mm l.d.
Clinopyroxene, equant, sa. Size: 0.4-0.16 mm l.d.

Fine Fraction

Dominant: Monocrystalline quartz fragments
Frequent: Muscovite mica laths
Rare: Phyllite
Very rare: Clinopyroxene
Polycrystalline quartz/quartzite-schist fragments

Textural Concentration Features

Common to few, equant to elongate, a-sa-sr; most are in a dark red brown color, with a compact texture either devoid of non-plastic inclusions or containing small quartz fragments and white mica laths. Most tcf's seem to be clay pellets. A few of them are black, more angular, probably Fe-rich concretions.

Petrographic Fabric Group 4: Red ophiolite-related
Samples: SYM 17/15 (P119), SYM 17/17 (P531), SYM 17/51 (P443), SYM 17/61 (P631)

Microstructure

Very rare to very few meso and macro planar voids, double spaced, most of them surrounding the larger non-plastic inclusions. The non-plastic inclusions and voids are randomly oriented. In sample SYM 17/61 (P631) there are a couple of voids that could be related to burnt out organics, but not indicative of organic tempering.

Groundmass

Homogeneous throughout the section. The colour of the matrix is brown in PPL (x50) and dark red brown in XP. Optical activity: inactive.

Inclusions
c:f:v$_{10\mu m}$ = 20:77:3
Coarse fraction: 2.2-0.1 mm l.d. Packing: single to open spaced. Sorting: poor.
Fine fraction: <0.1 mm l.d. Packing: close to open spaced.

Coarse Fraction
Common to few: Mudstone fragments, dark red brown to gray, equant to elongate, sr-r, with a very compact texture and almost concordant with the micromass. The smaller fragments could be clay pellets. Size: 1.6-0.24 mm l.d.

Few to rare: Polycrystalline quartz/quartzite: equant to elongate, sa. Size: 1.6-0.2 mm l.d.
Sandstone, equant, sr, composed of small fragments of quartz in a clayey matrix. Mode: 0.8 mm l.d. Size: 1.6-0.2 mm l.d.
Monocrystalline quartz fragments, equant or slightly elongate, a-sa. Size: 0.4-0.1 mm l.d.

Very few: Phyllite, elongate, fine grained in a dark brown or gray brown color. Size: 2.0-0.24 mm l.d.

Very rare to absent: Micritic limestone, equant, sr, altered. Size: 1.2-0.2 mm l.d.
Alkali feldspar, sa. Size: 0.8 mm l.d.
Chert, equant, sa. Size: 2.2-0.2 mm l.d.
Siltstone, elongate, gray, fine grained occasionally overfired. Some fragments could be metamorphic. Size: 2.0-0.54 mm l.d.
Volcanic rock fragment, equant, sr. Possibly basalt with plagioclase feldspar laths in a devitrified matrix. Size: 0.9 mm l.d. (in sample SYM 17/61 (P631)).).

Fine Fraction
Few: Monocrystalline quartz fragments
Rare: Phyllite
Very rare to absent: Epidote
Polycrystalline quartz/quartzite fragments

Textural Concentration Features
Common to few, equant, sr; most are in a dark red brown color, with a compact texture, concordant with the micromass. They are very similar to the texture of the mudstone fragments, but more plastic. They seem to be clay pellets. Mode: 0.3 mm l.d.

Λεπτομερής περίληψη στα ελληνικά
(Detailed Summary in Greek)

Λεπτομερής περίληψη στα ελληνικά
(Detailed Summary in Greek)

Το Κεφάλαιο 1 προσφέρει μια εισαγωγή στο ιερό της Σύμης Βιάννου και την ελληνική και ρωμαϊκή κεραμική του, και εξετάζει μεθοδολογικά ζητήματα σχετικά με τη δημοσίευση κεραμικής από ιερά. Τα ελληνικά ιερά είναι εμβληματικά μνημεία του αρχαίου κόσμου και η αρχαιολογία τους έχει προσελκύσει εκτεταμένες έρευνες. Ωστόσο, όπως εξηγείται στην ενότητα 1.1, η κεραμική από τα περισσότερα μεγάλα και από πολλά μικρά ελληνικά ιερά παραμένει σε μεγάλο βαθμό άγνωστη, εν μέρει επειδή απορριπτόταν μαζικά κατά το παρελθόν, εν μέρει επειδή δεν μελετάται συστηματικά δεδομένων των προκλήσεων που συνεπάγεται η επεξεργασία μεγάλων συνόλων υλικού, και εν μέρει επειδή οι μελετητές παραδοσιακά έδιναν προτεραιότητα σε άλλες κατηγορίες ευρημάτων. Ακόμα και όταν δημοσιεύεται κεραμικό υλικό από ιερά, οι μελετητές κατά κανόνα δεν συζητούν τη διαδικασία και τα κριτήρια επιλογής του, και σπανίως αναλύουν τα ανασκαφικά συμφραζόμενα, προσφέροντας κυρίως έναν κατάλογο αντικειμένων που επικεντρώνεται σε χρονολογικά και τυπολογικά ζητήματα. Η πρόσφατη βιβλιογραφία έχει επικρίνει αυτήν την προσέγγιση και η σχετική κριτική υπήρξε καθοριστική για τη μεθοδολογία της παρούσας μελέτης, η οποία δημοσιεύει 865 δείγματα ελληνικής και ρωμαϊκής κεραμικής από το ιερό της Σύμης Βιάννου.

Η ενότητα 1.2 προσφέρει μια επισκόπηση της ιστορίας της έρευνας και της αρχαιολογίας του ιερού, από την ίδρυσή του κατά τις αρχές της 2ης χιλιετίας π.Χ. ως τον 6ο, 7ο ή ίσως τον 8ο αιώνα μ.Χ. Εξετάζεται η οικοδομική δραστηριότητα στο ιερό και η εξέλιξη της λατρείας με έμφαση στις αλλαγές που συντελέστηκαν κατά τη μετάβαση στην 1η χιλιετία π.Χ., οπότε καθιερώθηκαν η λατρεία του Πρωτο-Ερμή και της Πρωτο-Αφροδίτης και οι τελετουργίες ενηλικίωσης για αγόρια, αλλά και σε άλλα κομβικά σημεία της ιστορίας του ιερού κατά τους ιστορικούς χρόνους.

Η παλαιότερη έρευνα για την ελληνική και ρωμαϊκή κεραμική του ιερού συνοψίζεται στην ενότητα 1.3. Έμφαση δίδεται στις προκαταρκτικές ανασκαφικές εκθέσεις της Αγγελικής Λεμπέση, στην εργασία της Αθανασίας Κάντα που προσφέρει μια διαχρονική επισκόπηση της κεραμικής του ιερού, και στο άρθρο του Brice Erickson που μελετά αρχαϊκή και κλασική κεραμική από το ιερό. Επίσης, παρουσιάζεται το ευρύτερο πρόγραμμα δημοσίευσης του κεραμικού υλικού από τη θέση, στο πλαίσιο του οποίου εντάσσεται το παρόν έργο.

Η ενότητα 1.4 συνοψίζει την ιστορία της έρευνας της ελληνικής και ρωμαϊκής κεραμικής από κρητικά ιερά. Έμφαση δίνεται στα ιερά με δημοσιευμένα μεγάλα σύνολα κεραμικής που παρουσιάζουν σημαντικό χρονολογικό εύρος, δηλαδή στο ιερό της Δήμητρας στην Κνωσό, στο ιερό του Κομμού, στο ιερό στην ακρόπολη της Γόρτυνας και δευτερευόντως στο ιερό στον λόφο Αρμί της Γόρτυνας και στο ιερό στη δυτική ακρόπολη της Δρήρου.

Η δομή και η μεθοδολογία της μελέτης και της δημοσίευσης της ελληνικής και ρωμαϊκής κεραμικής από το ιερό της Σύμης Βιάννου παρουσιάζονται στην ενότητα 1.5. Το Κεφάλαιο 1 κλείνει με μια ενότητα (1.6) αφιερωμένη σε ζητήματα σχετικής και απόλυτης χρονολόγησης της κρητικής κεραμικής και γενικότερα της κρητικής αρχαιολογίας των ιστορικών χρόνων.

Το εκτενέστατο Κεφάλαιο 2 παρουσιάζει τα ανασκαφικά συμφραζόμενα και τον κατάλογο της ελληνικής και ρωμαϊκής κεραμικής. Το κεφάλαιο χωρίζεται σε ενότητες που καλύπτουν διαφορετικές περιοχές του ιερού. Κάθε ενότητα εξετάζει τη στρωματογραφία της εν λόγω περιοχής, περιλαμβάνει τον κατάλογο του κεραμικού υλικού που προέρχεται από αυτή και – κατά περίπτωση – τα συνανήκοντα όστρακα που συνδέουν την εν λόγω περιοχή με άλλες. Στην ενότητα 2.1.1 παρουσιάζονται συνοπτικά οι διάφορες περιοχές του ιερού και τα στρωματογραφικά προβλήματα που παρουσιάζει η ανασκαφή. Η ενότητα 2.1.2 εξηγεί τη δομή των λημμάτων του καταλόγου και τις σχετικές συμβάσεις, ενώ η ενότητα 2.1.3 αφορά τον τρόπο παρουσίασης των οστράκων που συνανήκουν.

Η ενότητα 2.2. παρουσιάζει την ανασκαφή και τη στρωματογραφία της περιοχής του Βωμού και το πλούσιο κεραμικό υλικό που προήλθε από εκεί (λήμματα P1 ως P213). Ο Βωμός φαίνεται να κατασκευάστηκε κατά την πρωτογεωμετρική περίοδο και να έχει μια δεύτερη φάση που ανάγεται στον πρώιμο 7ο αιώνα. Η ενότητα 2.3 εξετάζει την ανασκαφή και τη στρωματογραφία στα Άνδηρα και το Χαντάκι Καθαρμών, καθώς και το εξαιρετικά πλούσιο κεραμικό υλικό που προήλθε από εκεί (λήμματα P214 ως P524). Οι κατασκευές αυτές χρονολογούνται στον 7ο αιώνα π.Χ. Δεδομένης της έκτασης της εξεταζόμενης περιοχής και της ποσότητας του κεραμικού υλικού που απέδωσε, η εξέτασή της οργανώνεται σε διαφορετικά μέρη: το ανατολικό τμήμα των Ανδήρων (ενότητα 2.3.2), το Χαντάκι Καθαρμών (2.3.3), το κεντρικό τμήμα των Ανδήρων (ενότητες 2.3.4 και 2.3.5) και το δυτικό τμήμα των Ανδήρων (2.3.6).

Η ενότητα 2.4 παρουσιάζει την ανασκαφή και τη στρωματογραφία του κεντρικού και νότιου τμήματος του νεοανακτορικού Κρηπιδώματος και το προερχόμενο από τη συγκεκριμένη περιοχή κεραμικό υλικό (λήμματα P525 ως P592). Στην ενότητα 2.5 εξετάζεται η ανασκαφή και η στρωματογραφία της περιοχής της Πρωτοαρχαϊκής Εστίας και του κεραμικού υλικού της (λήμματα P593 ως P636). Η κεραμική επιβεβαιώνει την πρόσφατη αναθεώρηση της χρονολόγησης της Εστίας από την αρχαϊκή στην πρωτοαρχαϊκή περίοδο. Το δυτικό τμήμα του Περιβόλου και το ελάχιστο κεραμικό υλικό των ιστορικών χρόνων που απέδωσε (λήμματα P637 ως P647) μελετώνται στην ενότητα 2.6. Η ενότητα 2.7 παρουσιάζει την ανασκαφή και τη στρωματογραφία του βόρειου τμήματος του νεοανακτορικού Κρηπιδώματος και Περιβόλου, καθώς και το κεραμικό υλικό που προήλθε από εκεί (λήμματα P648 ως P687). Η συζήτηση οργανώνεται σε χωρικές υποδιαιρέσεις (ενότητες 2.7.2, 2.7.3 και 2.7.4).

Ακολουθεί η εξέταση της ανασκαφής και της στρωματογραφίας των Κτιρίων E (ενότητα 2.8) και C-D (ενότητα 2.9) και των περιοχών τους, καθώς και του κεραμικού υλικού που προήλθε από εκεί (λήμματα P688 ως P758, και P759 ως P810 αντίστοιχα). Η συζήτηση της πρώτης περιοχής οργανώνεται σε χωρικές υποδιαιρέσεις (ενότητες 2.8.2 και 2.8.3) και προσφέρει στοιχεία που ενισχύουν την πρόσφατη πρόταση για τη χρονολόγηση της κατασκευής του Κτιρίου Ε στην αρχαϊκή περίοδο. Αντίστοιχα, στο Κτίριο C-D αναγνωρίζεται κεραμική που υποδεικνύει τη συνέχιση της χρήσης του πέρα από το όριο του 3ου αιώνα μ.Χ., το οποίο έχει προταθεί στο παρελθόν. Το κεφάλαιο ολοκληρώνεται με τον κατάλογο δειγμάτων που έχουν άγνωστη ή ασαφή ανασκαφική προέλευση (λήμματα P811 ως P865).

Το Κεφάλαιο 3, σε συνδυασμό με το Κεφάλαιο 6 (Παράρτημα) που παρουσιάζει τα αποτελέσματα της πετρογραφικής ανάλυσης της Ελένης Νοδάρου, προσφέρει μια ολιστική προσέγγιση στις κεραμικές ύλες του ελληνικού και ρωμαϊκού υλικού από τη Σύμη Βιάννου, εξετάζει την προέλευση της κεραμικής και αξιολογεί τη σημασία αυτού του υλικού για την κατανόηση των σχέσεων του ιερού με διαφορετικές κρητικές κοινότητες. Η προσέγγιση που ακολουθείται συνιστά την πιο πρωτότυπη συμβολή σε μεθοδολογικό επίπεδο, δεδομένης της περιορισμένης έρευνας στο ζήτημα των κεραμικών υλών του υλικού από τα ιερά του ελληνικού κόσμου (ενότητα 3.1). Η ίδια προσέγγιση αναδεικνύει τη Σύμη Βιάννου ως το πρώτο ιερό της Κρήτης – και ίσως και το πρώτο ιερό στον ελληνικό κόσμο – του οποίου η τελική δημοσίευση της ελληνικής και ρωμαϊκής κεραμικής περιλαμβάνει ένα συστηματικό πρόγραμμα χαρακτηρισμού της κεραμικής ύλης των ελληνικών και ρωμαϊκών αγγείων.

Οι κεραμικές ύλες μινωικών, ελληνικών και ρωμαϊκών πήλινων ευρημάτων από τη Σύμη Βιάννου έχουν προσελκύσει μακροσκοπικές και αναλυτικές προσεγγίσεις και κατά το παρελθόν. Μια επισκόπηση των προσεγγίσεων αυτών γίνεται στην ενότητα 3.2, που περιλαμβάνει ειδικές αναφορές στις πετρογραφικές αναλύσεις της Νοδάρου και των συνεργατών της πάνω στα συμπαγή και τροχήλατα πήλινα ειδώλια, καθώς και στις ιστορικές ερμηνείες που ο Erickson έχει αναπτύξει σχετικά με την κεραμική ύλη και την προέλευση αρχαϊκού και κλασικού υλικού από το ιερό.

Στην ενότητα 3.3, αναγνωρίζονται μακροσκοπικά δέκα κεραμικές ύλες (MFGs A ως J) στην ελληνική και ρωμαϊκή κεραμική από τη Σύμη Βιάννου και εξετάζεται η χωρική και χρονική κατανομή τους στο ιερό. Τα δέκα MFGs αντιπροσωπεύουν περίπου το 92% του υλικού που δημοσιεύεται σε αυτό το έργο (786 από τα 865 δείγματα του καταλόγου). Περίπου το ήμισυ του υλικού (462 δείγματα) αποδίδεται στο MFG C, ενώ το MFG A έρχεται δεύτερο με 130 δείγματα. Τα υπόλοιπα οκτώ MFGs περιλαμβάνουν περίπου 10 έως 50 δείγματα έκαστο. Τα δέκα MFGs εκπροσωπούνται στη Σύμη Βιάννου για περιόδους άνισης διάρκειας. Τα MFG A και C απαντώνται βασικά σε όλες τις περιόδους των ιστορικών χρόνων, οι περισσότερες άλλες ύλες απαντώνται για μισή έως μια χιλιετία (MFGs B, D, E, F, H, I και J), και μόνο το MFG G περιορίζεται σε μια μόνο περίοδο, την ελληνιστική. Ένα σημαντικό μέρος των MFGs απαντάται ήδη κατά την πρωτογεωμετρική περίοδο (MFGs A, B, C, D και E). Δύο νέα MFGs εισάγονται κατά την πρωτοαρχαϊκή περίοδο (MFGs I και J) και ένα άλλο (D) εξαφανίζεται κατά τη διάρκεια της κλασικής. Ο μεγαλύτερος αριθμός MFGs εμφανίζεται στην ελληνιστική περίοδο, οπότε αντιπροσωπεύονται τα εννέα από τα δέκα MFGs (A, B, C, E, F, G, H, I, J). Αυτός ο αριθμός

συρρικνώνεται σημαντικά κατά τους ρωμαϊκούς χρόνους, οπότε απαντώνται τέσσερα MFGs (Α, C, F, Η), τα περισσότερα από αυτά – εκτός από το MFG Η – πολύ αραιά. Το ένα τρίτο του υλικού που αποδίδεται στα δέκα MFGs (περίπου 270 από τα 865 δείγματα) παρουσιάζει χονδροειδείς έως σχετικά χονδροειδείς κεραμικές ύλες (MFGs Α, Β1 και Β2, C1 και D), ενώ τα υπόλοιπα δύο τρίτα παρουσιάζουν λεπτότεχνες έως σχετικά λεπτότεχνες. Όλα τα MFGs που εισάγονται από την πρωτοαρχαϊκή περίοδο και μετά (F, G, Η, Ι, J) παρουσιάζουν λεπτότεχνες έως σχετικά λεπτότεχνες ύλες. Το 8% του υλικού (69 από τα 865 δείγματα) που δεν αποδίδεται σε κάποια από τις δέκα προαναφερθείσες κεραμικές ύλες περιλαμβάνει: α) 47 δείγματα που παρουσιάζουν ιδιαίτερη κεραμική ύλη αλλά μάλλον προέρχονται από κυρίως απροσδιόριστα κρητικά εργαστήρια (αν και ορισμένα δείγματα αποδίδονται στην Κνωσό και τη Γόρτυνα)· β) ελάχιστα αγγεία, ίσως επτά (που ανέρχονται σε 1% του συνόλου του υλικού), εισηγμένα από περιοχές εκτός Κρήτης, κυρίως αγγεία από την Κόρινθο (αρχαϊκοί αρύβαλλοι) και την Αττική (αγγεία πόσης), καθώς και άλλες περιοχές της κυρίως Ελλάδας (συμπεριλαμβανομένου ενός λακωνικού αμφορέα)· γ) 15 δείγματα με ασαφή χαρακτηριστικά.

Η ενότητα 3.4 εξηγεί τους λόγους για τους οποίους θεωρείται ότι δεν υπήρχαν εργαστήρια κεραμικής παραγωγής στο ιερό κατά τους ελληνικούς και ρωμαϊκούς χρόνους και αναλύει τα στοιχεία που παρέχουν οι κεραμικές ύλες σχετικά με τη σύνδεση του ιερού με κοινότητες της κεντρικής και ανατολικής Κρήτης, λαμβάνοντας υπόψη και τις επιγραφικές μαρτυρίες που έχει δώσει το ιερό σχετικά με τη σύνδεση αυτή. Κατά το παρελθόν ο Erickson υπέθεσε ότι μια κεραμική ύλη που απαντάται στο ιερό και ταυτίζεται με το MFG C2, προέρχεται από το Αφρατί, ενώ μια άλλη ύλη που ταυτίζεται με το MFG Α προέρχεται από τη Λύκτο/Λύττο. Σε αυτή τη βάση ο Erickson υπέθεσε ότι το ιερό ήταν συνδεδεμένο με το Αφρατί κατά τον 6ο και 5ο αιώνα π.Χ., ενώ τον 4ο αιώνα, οπότε – κατά τη γνώμη του – το MFG C2 αντικαθίσταται από το MFG Α, το ιερό κατέλαβε η Λύκτος/Λύττος. Κατά τη γνώμη μου η σύνδεση του MFG Α με την πόλη αυτή είναι πειστική αλλά όχι και η σύνδεση του MFG C2 με το Αφρατί, ενώ η χρονική αλληλουχία των δύο κεραμικών υλών δεν ευσταθεί. Πάντως, κατά τον 4ο αιώνα π.Χ. το MFG Α, κυριαρχεί αδιαμφισβήτητα στο πολύ συρρικνωμένο κεραμικό σύνολο που απαντάται στο ιερό. Τέλος, προτείνεται η σύνδεση του MFG F με την Ιεράπυτνα (και συγκεκριμένα με το East Cretan Cream Ware που χαρακτηρίζει την ελληνιστική παραγωγή της πόλης). Το ζήτημα της προέλευσης των κεραμικών που βρέθηκαν στη Σύμη Βιάννου και της σύνδεσης της θέσης με διάφορες κρητικές κοινότητες διερευνάται περαιτέρω στη βάση των πιθανών διαδρομών που συνέδεαν τις κοινότητες αυτές με το ιερό. Η μελέτη βασίζεται σε συνεργασία του συγγραφέα με τον Βύρωνα Αντωνιάδη και ενσωματώνει ιστορική τεκμηρίωση και υπολογιστική πρόβλεψη στη βάση της ανάλυσης Least Cost Path (LCP) προκειμένου να αποδώσει τις πιθανές διαδρομές που πιθανώς ακολουθούσαν οι προσκυνητές αλλά και εκτιμήσεις σχετικά με τον ελάχιστο χρόνο που απαιτούσαν αυτές.

Τα επιγραφικά και κεραμικά στοιχεία που ρίχνουν φως στη σύνδεση της Σύμης Βιάννου με διαφορετικές κοινότητες συμβάλλουν σε ευρύτερες συζητήσεις σχετικά με τον διασυνοριακό ρόλο του ιερού. Η Λεμπέση και οι συνεργάτες της έχουν υποστηρίξει ότι το ιερό της Σύμης Βιάννου είχε διασυνοριακό ρόλο από την Πρώιμη Εποχή του Σιδήρου έως την ελληνιστική περίοδο. Η Mieke Prent, όμως, έχει υποθέσει ότι μια συγκεκριμένη πόλη ανέλαβε τον έλεγχο

του ιερού γύρω στο 700 π.Χ., κρίνοντας από την έντονη οικοδομική δραστηριότητα που παρατηρείται τότε, καθώς και την εμφάνιση δύο νέων κατηγοριών υλικού (χάλκινα ελάσματα και πήλινα πλακίδια φτιαγμένα με μήτρα). Ωστόσο, η άποψη αυτή δεν βρίσκει έρεισμα στο ευρύ φάσμα των MFGs που απαντώνται στην κεραμική της Σύμης Βιάννου μετά το 700 π.Χ. περίπου. Το φάσμα αυτό ήταν αρκετά ευρύ ήδη κατά την πρωτογεωμετρική περίοδο (MFGs A, B, C, D, E) αλλά αυξήθηκε με την εισαγωγή δύο νέων MFGs κατά την πρωτοαρχαϊκή (I και J), εξέλιξη που υποδηλώνει τη διευρυμένη σύνδεση του ιερού με διαφορετικές κοινότητες.

Κατά την αρχαϊκή και την κλασική περίοδο, ο Erickson υπέθεσε ότι το ιερό είχε προνομιακή σχέση με το Αφρατί και, κατά τον 4ο αιώνα π.Χ., με τη Λύκτο/Λύττο. Η υπόθεση αυτή δεν υποστηρίζεται από τη μελέτη των MFGs, που κατέδειξε ότι οι δύο ύλες που συζητήθηκαν από τον Erickson δεν εμφανίζονται σε διακριτές φάσεις, ενώ από την αρχαϊκή ως τη μέση κλασική περίοδο απαντώνται αρκετά ακόμα MFGs. Η σχεδόν μονοπωλιακή αντιπροσώπευση του MFG A στο υλικό της ύστερης κλασικής περιόδου θα μπορούσε να στηρίξει την ιδέα του Erickson για μια στενότερη σχέση μεταξύ της Σύμης Βιάννου και της Λύκτου/Λύττου. Ωστόσο, αυτή η ιδέα υπονομεύεται από την ισχνή αντιπροσώπευση του MFG A κατά τον 2ο αιώνα π.Χ., οπότε υπάρχουν επιγραφικές ενδείξεις ότι η πόλη έλεγχε το ιερό για απροσδιόριστο διάστημα. Σε κάθε περίπτωση, κατά την ελληνιστική περίοδο οι κεραμικές ύλες που απαντώνται στο ιερό παρουσιάζουν τη μέγιστη ποικιλία: εισάγονται δύο νέα MFGs (G και H) και αυτό ανεβάζει το σύνολο των MFGs που αντιπροσωπεύονται σε εννέα (A, B, C, E, F, G, H, I, J). Η εικόνα αυτή συνάδει με το συμπέρασμα της Λεμπέση ότι το ιερό της Σύμης Βιάννου είχε διασυνοριακό ρόλο κατά την περίοδο αυτή, όπως τεκμηριώνεται από αναθηματικές επιγραφές σε κεραμικά της εποχής.

Θεωρείται ότι η ρωμαϊκή κατάκτηση της Κρήτης επέφερε την παρακμή του διασυνοριακού ρόλου του ιερού και τη διακοπή των τελετουργιών ενηλικίωσης. Η μελέτη των κεραμικών υλών επιβεβαιώνει την εικόνα παρακμής του ιερού. Σχεδόν τα μισά από τα MFGs (B, E, G, I) εξαφανίζονται μετά την ελληνιστική περίοδο, και η πορεία αυτή κλιμακώνεται από του μέσους ρωμαϊκούς χρόνους, οπότε μόνο το MFG H αντιπροσωπεύεται επαρκώς.

Στην ενότητα 3.5 εξετάζονται οι κεραμικές εισαγωγές από περιοχές εκτός Κρήτης, οι οποίες αποτελούν μόλις το 1% του συνόλου του υλικού και πιθανότατα όλες προέρχονται από τη νότια ηπειρωτική Ελλάδα. Εισαγωγές κεραμικών από πιο απομακρυσμένες περιοχές δεν εντοπίστηκαν στη Σύμη Βιάννου, παρότι η θέση έχει δώσει εισαγωγές από την Ανατολική Μεσόγειο σε διάφορα άλλα υλικά. Το ποσοστό των εισηγμένων αγγείων φαίνεται πενιχρό και έχει οδηγήσει σε συμπεράσματα για τον τοπικό χαρακτήρα της λατρείας στη Σύμη Βιάννου. Παρά ταύτα, μια συγκριτική εξέταση του εισηγμένου κεραμικού υλικού που βρέθηκε σε διάφορα ιερά της Κρήτης αποδεικνύει ότι ανάλογα πενιχρά ποσοστά έχουν δώσει τα περισσότερα κρητικά ιερά που είναι επαρκώς γνωστά (εξαίρεση αποτελούν τα ιερά στον Κομμό, τον Ολούντα και στο σπήλαιο Λερά, που είναι όλα παραθαλάσσια). Τα συμπεράσματα της έρευνας που παρουσιάζεται στο κεφάλαιο 3 συνοψίζονται στην ενότητα 3.6.

Το Κεφάλαιο 4 εξετάζει τη μορφολογία της ελληνικής και ρωμαϊκής κεραμικής από τη Σύμη Βιάννου με βάση το σχήμα των αγγείων. Οι μελέτες κεραμικής από ελληνικά ιερά παραδοσιακά δίνουν έμφαση στο σχήμα, καθότι αυτό σχετίζεται με τη λειτουργία των

αγγείων αλλά και αποτελεί εύχρηστο κριτήριο για την ταξινόμηση του υλικού. Στην ενότητα 4.1 παρουσιάζεται η γενική δομή του κεφαλαίου και των επιμέρους ενοτήτων του, οι οποίες επικεντρώνονται σε επιμέρους κατηγορίες σχημάτων και εξετάζουν την κεραμική ύλη, τη μορφή και την τυπολογία, καθώς και τη χρονική και χωρική κατανομή των δειγμάτων κάθε κατηγορίας. Η ανάλυση περιλαμβάνει συστηματικές συγκρίσεις του υλικού από τη Σύμη Βιάννου με υλικό από άλλα κρητικά ιερά, και κυρίως του Κομμού, της Δήμητρας στην Κνωσό, της ακρόπολης και του λόφου Αρμί της Γόρτυνας και της δυτικής ακρόπολης της Δρήρου (βλ. ενότητα 1.4). Η ίδια ενότητα εξετάζει και τους πιθανούς ρόλους των αγγείων από τη Σύμη Βιάννου. Διαπιστώνεται ότι το ιερό έχει αποδώσει σχετικά φτωχά επιγραφικά, εικονογραφικά και ανασκαφικά στοιχεία για την αναγνώριση και διάκριση των ρόλων αυτών. Πολλά από τα σχήματα που αντιπροσωπεύονται στη Σύμη Βιάννου απαντώνται όχι μόνο σε άλλα ιερά αλλά και σε οικισμούς και νεκροταφεία της Κρήτης. Παρά ταύτα, η μορφολογία ορισμένων σχημάτων είναι ενδεικτική του ρόλου των αγγείων ως αναθήματα (βλ. τα πώματα/ασπίδια στην ενότητα 4.12) ή/και ως τελετουργικά σκεύη (βλ. τους κέρνους στην ενότητα 4.13).

Η ελληνική και ρωμαϊκή κεραμική από τη Σύμη Βιάννου καλύπτει ένα ευρύ φάσμα σχημάτων, όπως συμβαίνει συχνά με τα μακρόβια ιερά. Περισσότερο από το ένα τρίτο του υλικού συνίσταται σε βαθιά ανοιχτά αγγεία μικρού μεγέθους, ειδικά κύπελλα και – σε πολύ μικρότερο βαθμό – άλλα σχήματα (ενότητα 4.2). Αυτά τα δεδομένα είναι ενδεικτικά μιας τοπικής παράδοσης που ανάγεται στη 2η χιλιετία π.Χ. Τα άλλα σχήματα απαντώνται πολύ πιο αραιά και κανένα τους δεν αντιστοιχεί σε περισσότερο από το ένα δέκατο του υλικού με μοναδική εξαίρεση τα πώματα/ασπίδια (ενότητα 4.12). Τα άλλα σχήματα που εκπροσωπούνται επαρκώς περιλαμβάνουν τα ρηχά μεγάλα ανοιχτά αγγεία (λεκάνες κ.ά., για τα οποία βλ. ενότητα 4.5) και τα αγγεία ανάμιξης (κρατήρες κ.ά., βλ. ενότητα 4.3). Σώζονται πολλά θραύσματα κέρνων, αλλά αυτά πιθανώς αντιπροσωπεύουν πολύ λιγότερα αγγεία (ενότητα 4.13). Όλες οι άλλες κατηγορίες κεραμικής, συμπεριλαμβανομένης ολόκληρης της γκάμας κλειστών αγγείων, υπάρχουν σαφώς πιο αραιά.

Τα ανοιχτά αγγεία μελετώνται στις ενότητες 4.2 ως 4.6. Η ενότητα 4.2 εξετάζει τα βαθιά ανοιχτά αγγεία μικρού μεγέθους (κύπελλα, σκύφοι κ.α.), η ενότητα 4.3 τα βαθιά ανοιχτά αγγεία μεγάλου έως μεσαίου μεγέθους (κρατήρες κ.α.), η ενότητα 4.4 τα ρηχά ανοιχτά αγγεία μικρού μεγέθους (πινάκια κ.α.), η ενότητα 4.5. τα ρηχά ανοιχτά αγγεία μεγάλου έως μεσαίου μεγέθους (λεκάνες κ.α.) και η ενότητα 4.6. τα ανοιχτά αγγεία αβέβαιου σχήματος και λειτουργίας. Περνώντας στα κλειστά σχήματα, η ενότητα 4.7 εξετάζει τα αγγεία μετάγγισης με στενό λαιμό (αρύβαλλοι κ.α.), η ενότητα 4.8 τα αγγεία μετάγγισης με ευρύ λαιμό (πρόχοι κ.α.), η ενότητα 4.9 τα αποθηκευτικά αγγεία (αμφορείς, πίθοι κ.α.) και η ενότητα 4.10. τα κλειστά αγγεία αβέβαιου σχήματος και λειτουργίας. Τελευταίες έρχονται οι ειδικές κατηγορίες κεραμικής. Η ενότητα 4.11 εξετάζει τα μαγειρικά σκεύη, η ενότητα 4.12 τα πώματα/ασπίδια και συναφή σχήματα, η ενότητα 4.13 τους κέρνους (δαχτυλιόσχημους και μη), και η ενότητα 4.14 διάφορα ιδιαίτερα σκεύη που αντιπροσωπεύονται ελάχιστα.

Η ενότητα 4.15 συνθέτει τα πορίσματα της έρευνας για τη μορφή και τη λειτουργία της κεραμικής της Σύμης Βιάννου σε μια χρονολογική επισκόπηση που περιλαμβάνει συγκριτικές προσεγγίσεις στο υλικό από άλλα κρητικά ιερά. Φαίνεται ότι οι κρατηρίσκοι κυριαρχούν

στο ιερό κατά την πρωτογεωμετρική περίοδο, ενώ απαντώνται περιορισμένα δείγματα από άλλες κατηγορίες αγγείων (ανοιχτά, κλειστά, μαγειρικά). Αυτό το ρεπερτόριο είναι ενδεικτικό δραστηριοτήτων που επικεντρώνονται στην προετοιμασία και την κατανάλωση φαγητού και ποτού. Οι κρατηρίσκοι κυριαρχούν και στο πρωτογεωμετρικό υλικό από τα ιερά στον Κομμό και στον λόφο Αρμί της Γόρτυνας.

Η ποσότητα και η ποικιλία των σχημάτων αγγείων αυξήθηκε σημαντικά κατά τη γεωμετρική (συγκεκριμένα την υστερογεωμετρική) και την πρωτοαρχαϊκή περίοδο. Οι κρατηρίσκοι αντικαταστάθηκαν από κύπελλα, ενώ η εναπόθεση μεγαλύτερων αγγείων διαφόρων σχημάτων αυξήθηκε σημαντικά. Οι αρύβαλλοι και οι πίθοι απαντώνται σχεδόν αποκλειστικά κατά την περίοδο αυτή. Η αυξημένη ποσότητα και ποικιλία της κεραμικής στη Σύμη Βιάννου κατά την πρωτοαρχαϊκή περίοδο απαντάται και σε άλλα κρητικά ιερά, όπως ο Κομμός, το ιερό της Δήμητρας στην Κνωσό και το ιερό στην ακρόπολη της Γόρτυνας και στη δυτική ακρόπολη της Δρήρου. Επίσης, η ίδια περίοδος είναι η μόνη των ιστορικών χρόνων κατά την οποία αγγεία με περίτεχνη διακόσμηση – κυρίως πώματα/ασπίδια – εναποτέθηκαν στη Σύμη Βιάννου σε σημαντικό αριθμό. Σε πρωιμότερες και υστερότερες περιόδους των ιστορικών χρόνων, κυριαρχούν τα ακόσμητα και μονόχρωμα αγγεία, όπως συμβαίνει σε πολλά ελληνικά ιερά. Κατά τη (γεωμετρική) και πρωτοαρχαϊκή περίοδο πλεονάζουν στη Σύμη Βιάννου δύο σχήματα τελετουργικών αγγείων, πώματα/ασπίδια και κέρνοι. Οι κέρνοι ίσως εμπνέονται από ανάλογα μινωικά ευρήματα της συγκεκριμένης θέσης και πάντως απαντώνται και σε άλλα κρητικά ιερά, συχνά ευρισκόμενα δίπλα σε πηγές. Ο συνδυασμός πωμάτων/ασπιδίων και κέρνων που παρατηρείται στη Σύμη Βιάννου βρίσκει παράλληλο μόνο στο ιερό της ακρόπολης της Γόρτυνας και ενδεχομένως στο Ιδαίο Άντρο.

Η αρχαϊκή και κλασική περίοδος παρουσιάζουν ανομοιομορφία. Αφενός τα μικρά βαθιά ανοιχτά αγγεία, σχεδόν αποκλειστικά κύπελλα, εκτινάσσονται αριθμητικά, ενώ και τα αγγεία μετάγγισης με ευρύ λαιμό παρουσιάζουν σημαντική αύξηση, συνδυασμός που παραπέμπει σε σπονδές. Αντίθετα, οι περισσότερες άλλες κατηγορίες αντιπροσωπεύονται πολύ αραιά. Τα μεγάλα βαθιά ανοιχτά αγγεία και τα μαγειρικά σκεύη παραμένουν λίγα. Το υλικό επιβεβαιώνει ότι η Σύμη Βιάννου δεν παρουσιάζει το λεγόμενο αρχαϊκό κενό που χαρακτηρίζει τα περισσότερα κρητικά ιερά κατά τον 6ο αιώνα π.Χ. Κατά την κλασική περίοδο, ο αριθμός των κυπέλλων και των λεκανών μειώθηκε σημαντικά αλλά το κύπελλο παρέμεινε το πιο δημοφιλές σχήμα. Το υπόλοιπο ρεπερτόριο συρρικνώθηκε περαιτέρω και τα αποθηκευτικά δοχεία, τα αγγεία μετάγγισης με στενό λαιμό, και τα μικρά ρηχά ανοιχτά αγγεία σχεδόν εξαφανίστηκαν. Οι τάσεις αυτές απαντώνται και σε άλλα κρητικά ιερά κατά την ίδια περίοδο.

Η ποσότητα και η ποικιλία των κεραμικών αυξήθηκε σημαντικά κατά την ελληνιστική περίοδο στη Σύμη Βιάννου, όπως και σε άλλα κρητικά ιερά. Το κύπελλο παρέμεινε το πιο δημοφιλές σχήμα αλλά εμφανίστηκαν και άλλοι τύποι βαθιών ανοιχτών αγγείων μικρού μεγέθους. Τα αγγεία μετάγγισης με ευρύ λαιμό και τα μικρά ρηχά ανοιχτά αγγεία είναι περισσότερα από οποιαδήποτε άλλη περίοδο των ιστορικών χρόνων, οι λεκάνες παρουσιάζουν αξιόλογη αύξηση, ενώ οι κρατήρες εξαφανίζονται, όπως έχει διαπιστωθεί και αλλού στον ελληνικό κόσμο. Κατά την ύστερη ελληνιστική περίοδο παρουσιάζονται δύο εξαιρετικές, αν και βραχύβιες τάσεις: τα μαγειρικά σκεύη παρουσιάζουν μια αξιοσημείωτη άνοδο, ενώ και οι

δακρυδόχες εμφανίζονται σε σημαντικό αριθμό. Η δεύτερη τάση απαντάται και στον Κομμό αλλά δεν έχει προφανή εξήγηση.

Η ρωμαϊκή περίοδος αντιπροσωπεύει την πιο δραματική αλλαγή στο κεραμικό ρεπερτόριο της Σύμης Βιάννου. Ο αριθμός των αγγείων μειώθηκε αισθητά και η αντιπροσώπευση των περισσότερων κατηγοριών κεραμικής συρρικνώθηκε, φαινόμενο που κλιμακώθηκε μετά την πρώιμη ρωμαϊκή περίοδο. Παρά τις τάσεις αυτές, ο αριθμός των αποθηκευτικών αγγείων κορυφώθηκε κατά τη μέση και ύστερη ρωμαϊκή περίοδο.

Το Κεφάλαιο 5 συνδυάζει τα συμπεράσματα από τη μελέτη της κεραμικής με εκείνα που αντλούνται από άλλες κατηγορίες υλικού από τη Σύμη Βιάννου αλλά και από την οικοδομική δραστηριότητα στη θέση κατά την ελληνική και ρωμαϊκή περίοδο, προσφέροντας έτσι ένα διαχρονικό πανόραμα της ιστορίας του ιερού, διανθισμένο με αναφορές σε ευρύτερα ζητήματα της ιστορίας και της αρχαιολογίας της Κρήτης (ενότητα 5.1). Η Σύμη Βιάννου έχει διαδραματίσει καθοριστικό ρόλο στις συζητήσεις για τις συνέχειες και τις ασυνέχειες των λατρευτικών πρακτικών στο Αιγαίο κατά την ταραγμένη μετάβαση από την Ύστερη Εποχή του Χαλκού στην Πρώιμη Εποχή του Σιδήρου (ενότητα 5.2). Θεωρείται ότι το ιερό επιβίωσε της γενικής κατάρρευσης επειδή δεν ήταν συνδεδεμένο με κάποιο συγκεκριμένο ανακτορικό ή άλλο κέντρο και επειδή εξυπηρετούσε βασικές ανάγκες των κοινοτήτων της γύρω περιοχής. Η Λεμπέση έχει παρατηρήσει ότι κατά την περίοδο αυτή στο ιερό συνεχίστηκαν οι θυσίες αλλά μεταβλήθηκε η σχέση του ανθρώπινου με το θείο, όπως φαίνεται από την έντονη αύξηση των ανθρωπόμορφων αναθημάτων. Επιπρόσθετα, καθιερώθηκαν τελετουργίες ενηλικίωσης για νεαρά αγόρια κατά τον 11ο ή τον 10ο αιώνα π.Χ. Κατά τον 10ο ή μάλλον τον 9ο αιώνα π.Χ. ανάμεσα στα ερειπωμένα προϊστορικά κτίρια ιδρύθηκε ένας βωμός. Πρωτογεωμετρική κεραμική εντοπίστηκε γύρω από τον βωμό αλλά και στο μεγαλύτερο μέρος του ιερού. Πρόκειται κυρίως για κρατηρίσκους, οι οποίοι συνεχίζουν την παράδοση των κυπέλλων της Εποχής του Χαλκού αλλά αντιπροσωπεύονται σε πολύ μικρότερους αριθμούς. Απαντώνται όμως και άλλα σχήματα που παραπέμπουν στην προετοιμασία και την κατανάλωση φαγητού και ποτού. Κατά την πρωτογεωμετρική περίοδο παρατηρείται μια ραγδαία αύξηση στην ποσότητα και την ποικιλία των αναθημάτων, που θεωρείται ενδεικτική της αναβίωσης του διασυνοριακού ρόλου του ιερού. Με την ερμηνεία αυτή συνάδει η ποικιλία των κεραμικών υλών που απαντώνται στην κεραμική της εποχής (MFGs A, B, C, D, E) αλλά και οι τεχνοτροπίες διαφορετικών κρητικών εργαστηρίων που αναγνωρίζονται στα χάλκινα αναθήματα της περιόδου.

Η ιστορία του ιερού κατά την περίοδο της ελληνικής αναγέννησης του 8ου και 7ου αιώνα π.Χ. αποτελεί το αντικείμενο της ενότητας 5.3. Η οικοδομική δραστηριότητα του 7ου αιώνα περιλαμβάνει μια δεύτερη φάση του Βωμού, τα Άνδηρα, το Χαντάκι Καθαρμού, τις διαμορφώσεις στο κεντρικό και νότιο τμήμα του Κρηπιδώματος και την Πρωτοαρχαϊκή Εστία. Στις αρχές του ίδιου αιώνα φαίνεται πως καθιερώθηκαν οι τελετές ενηλικίωσης για νεαρά κορίτσια. Μολονότι η ύστερη γεωμετρική και ιδιαίτερα η πρωτοαρχαϊκή κεραμική αντιπροσωπεύεται άφθονα, το πρώιμο και μέσο γεωμετρικό υλικό απουσιάζει σχεδόν πλήρως, φαινόμενο που αποδίδεται στο πρόβλημα αναγνώρισης των εν λόγω ρυθμών και όχι σε κάποια πραγματική διακοπή στη χρήση κεραμικής στο ιερό. Κατά τον 7ο αιώνα αυξάνεται η ποικιλία των κεραμικών υλών με την προσθήκη των MFGs I και J, ενώ πληθαίνουν και τα δείγματα

σπάνιων κεραμικών υλών. Ανάλογη αύξηση των κεραμικών υλών παρατηρείται και στα πήλινα ειδώλια κατά τον 8ο και 7ο αιώνα π.Χ. Κατά την ίδια περίοδο οι κρατηρίσκοι δίνουν τη θέση τους στα κύπελλα, που όμως παραμένουν λίγα. Το ρεπερτόριο των σχημάτων διευρύνεται σημαντικά και απαντώνται δύο σχήματα με αναθηματικό και τελετουργικό ρόλο, τα πώματα/ ασπίδια και οι κέρνοι. Ο συνδυασμός των δύο αυτών σχημάτων απαντάται και στο ιερό στην ακρόπολη της Γόρτυνας και πιθανώς στο Ιδαίο Άντρο. Ο ύστερος 8ος και 7ος αιώνας π.Χ. είναι η μόνη περίοδος κατά την οποία απαντάται αξιόλογος αριθμός αγγείων με περίτεχνο διάκοσμο, καθώς στις άλλες περιόδους κυριαρχούν σχεδόν πλήρως τα ακόσμητα και μονόχρωμα αγγεία. Επίσης, κατά την ίδια περίοδο κορυφώνεται η προσφορά χάλκινων αναθημάτων στο ιερό. Ανάλογες τάσεις αύξησης της ποσότητας και της ποικιλίας του κεραμικού και άλλου υλικού παρατηρούνται και σε άλλα ιερά εντός και εκτός Κρήτης κατά την ίδια περίοδο. Στην περίπτωση της Σύμης Βιάννου, το φαινόμενο αυτό συνδέεται με την ανάπτυξη του διασυνοριακού ρόλου του ιερού.

Η αρχαϊκή και κλασική περίοδος στη Σύμη Βιάννου και γενικά στην Κρήτη συνδέονται με καίρια προβλήματα της έρευνας, με πιο έντονο εκείνο του λεγόμενου αρχαϊκού κενού του 6ου αιώνα π.Χ. Όπως σημειώνεται στην ενότητα 5.4, η εν λόγω περίοδος έχει γενικά θεωρηθεί εποχή παρακμής του ιερού, στη βάση της ένδειας ενδείξεων για οικοδομική δραστηριότητα αλλά και της δραστικής μείωσης των χάλκινων αναθημάτων. Η εντύπωση αυτή χρήζει μερικής αναθεώρησης, καθότι η επισκεψιμότητα στο ιερό δεν παρουσιάζει κενό κατά τον 6ο αιώνα π.Χ., στον οποίο χρονολογείται το Κτίριο Ε σύμφωνα με τα νέα πορίσματα της έρευνας. Επίσης, το άφθονο κεραμικό υλικό από διάφορες περιοχές του ιερού παρουσιάζει ραγδαία αύξηση στον αριθμό των κυπέλλων και δευτερευόντως των αγγείων μετάγγισης με ευρύ λαιμό, συνδυασμός που παραπέμπει σε σπονδές. Αντίθετα κατά την κλασική περίοδο παρατηρείται βαθμιαία συρρίκνωση της ποσότητας και της χωρικής διασποράς της κεραμικής, που κορυφώνεται κατά τον 4ο αιώνα π.Χ. Το κεραμικό υλικό του αιώνα αυτού κυριαρχείται από μια κεραμική ύλη (MFG A), εξέλιξη την οποία ο Erickson έχει θεωρήσει ενδεικτική της κατάληψης του ιερού από τη Λύκτο/Λύττο. Η ερμηνεία αυτή δεν είναι απίθανη, όμως οι υποθέσεις του Erickson για τη σχέση των κεραμικών υλών που αντιπροσωπεύονται κατά την αρχαϊκή και κλασική περίοδο με συγκεκριμένες κοινότητες που έλεγχαν το ιερό παρουσιάζουν προβλήματα που αναδείχθηκαν με τη συστηματική και διαχρονική μελέτη του υλικού. Η ίδια μελέτη κατέδειξε ότι μολονότι τα εισηγμένα αγγεία από περιοχές εκτός Κρήτης (τα οποία πρωτοεμφανίζονται αυτή την περίοδο) παραμένουν λιγοστά σε απόλυτη τιμή, δεν είναι λιγότερα από αυτά που απαντώνται στα περισσότερα κρητικά ιερά της εποχής, και επομένως δεν μπορούν να θεωρηθούν ενδεικτικά της εσωστρέφειας της Σύμης Βιάννου.

Από την ελληνιστική περίοδο (για την οποία βλ. ενότητα 5.5) βεβαιώνεται η μεταφορά της λατρείας στο εσωτερικό ενός ιερού οίκου (Κτίριο C-D), που πιθανότατα ταυτίζεται με τον ναό που αναφέρεται σε επιγραφή του ύστερου 2ου –πρώιμου 3ου αιώνα μ.Χ. Το κτίριο κατασκευάστηκε κατά την πρώιμη ελληνιστική περίοδο (3ος αιώνας π.Χ.), επισκευάστηκε δύο φορές και παρέμεινε σε χρήση ως την ύστερη ρωμαϊκή περίοδο. Η πιο αξιοσημείωτη εξέλιξη που παρατηρείται στο ελληνιστικό υλικό από το ιερό είναι η εμφάνιση άφθονων ενεπίγραφων αντικειμένων, που αναφέρουν τα ονόματα και την προέλευση αναθετών από διάφορες πόλεις

της κεντρικής και της ανατολικής Κρήτης και συνθέτουν την πιο εύγλωττη μαρτυρία για τον διασυνοριακό χαρακτήρα του ιερού. Σε αυτή την ερμηνεία συνάδει και η κορύφωση της ποικιλίας των κεραμικών υλών που αντιπροσωπεύονται στο ιερό, μία εκ των οποίων (MFG F) συνδέεται μάλλον με την Ιεράπυτνα. Παρά τις διάφορες ενδείξεις για την αναβίωση της λατρείας στην ελληνιστική περίοδο (μεταξύ των οποίων και η αξιοσημείωτη αύξηση της ποσότητας και της ποικιλίας της κεραμικής), η χωρική διασπορά του υλικού παρουσιάζει συρρίκνωση, συνεχίζοντας την τάση που πρωτοεμφανίστηκε κατά την κλασική περίοδο. Κατά την ελληνιστική περίοδο τα εισηγμένα αγγεία σχεδόν εξαφανίζονται, όπως και τα μεταλλικά αναθήματα, ενώ πλεονάζουν τα πήλινα ειδώλια και πρωτοεμφανίζεται η ανάθεση νομισμάτων στο ιερό.

Η ρωμαϊκή κατάκτηση της Κρήτης επέφερε την παρακμή του ιερού και πιθανότατα τη διακοπή των τελετουργιών ενηλικίωσης (ενότητα 5.6). Η παρακμή αποτυπώνεται στην έντονη μείωση της ποσότητας των αγγείων, στην περαιτέρω συρρίκνωση της χωρικής τους διασποράς (που επικεντρώνεται στο Κτίριο C-D και στον τμήμα των Ανδήρων που βρίσκεται αμέσως νότιά του), καθώς και στον περιορισμό των κεραμικών υλών και του ρεπερτορίου των σχημάτων που αντιπροσωπεύονται. Κάποιες από αυτές τις τάσεις κλιμακώνονται μετά την πρώιμη ρωμαϊκή περίοδο. Παρά ταύτα, παρατηρείται μια μοναδική κορύφωση στην αντιπροσώπευση μεγάλων κλειστών αγγείων, που δεν βρίσκει παράλληλο σε άλλα κρητικά ιερά, και ίσως συνδέεται με νέες προτεραιότητες της λατρείας στη Σύμη Βιάννου.

Στην τελευταία ενότητα (5.7) εξετάζεται σύντομα η ιστορία του ιερού που ακολουθεί την αρχαιότητα. Δυο επάλληλα πρώιμα χριστιανικά ναΰδρια και ένας τάφος σε επαφή με το βορειοδυτικό τμήμα του νεώτερου ναϋδρίου, αποδεικνύουν μια μεγάλη τομή στην ιστορία της λατρείας στον χώρο. Λύχνοι του 6ου ως 8ου αιώνα μ.Χ. εντοπίστηκαν ανάμεσα στο Κτίριο C-D και την πηγή, ενώ από θέσεις κοντά στην πηγή προέρχονται και τα πενιχρά μεσαιωνικά και νεότερα ευρήματα, που συνίστανται σε ένα πήλινο σκεύος και τρία ενετικά νομίσματα. Κατά την περίοδο αυτή, η ιστορική σημασία του χώρου είχε πλέον λησμονηθεί αλλά η πηγή παρέμενε πόλος έλξης για αγρότες, κυνηγούς και οδοιπόρους.

Στο Κεφάλαιο 6 (Παράρτημα) παρουσιάζονται τα αποτελέσματα των πετρογραφικών αναλύσεων της Νοδάρου επί 92 δειγμάτων ελληνικής και ρωμαϊκής κεραμικής από τη Σύμη Βιάννου. Τα δείγματα αποτελούν περίπου το 10.6% του συνόλου του υλικού, και αντιπροσωπεύουν διαφορετικές κεραμικές ύλες και σχήματα που χρονολογούνται σε διαφορετικές περιόδους και προέρχονται από διάφορες περιοχές του ιερού, όπως εξηγείται στην ενότητα 6.1. Η στρατηγική της δειγματοληψίας διαμορφώθηκε με βάση τέσσερα βασικά ερευνητικά ζητήματα: α) τον προσδιορισμό της διαφοροποίησης που αναγνωρίζεται πετρογραφικά, και τη διερεύνηση της σχέση της με τη διαφοροποίηση που αναγνωρίζεται μακροσκοπικά· β) τον καθορισμό της τοπικής παραγωγής (με την ευρεία έννοια του όρου) και την αναγνώριση εισαγωγών από πιο μακρινές περιοχές· γ) τον προσδιορισμό της σχέσης των κεραμικών υλών με τα σχήματα και τη λειτουργία των αγγείων· και δ) την κατανόηση ορισμένων πτυχών της χρήσης της κεραμικής στο ιερό και την περιοχή του.

Στην ενότητα 6.2 περιγράφονται οκτώ βασικές κεραμικές ύλες που αναγνωρίσθηκαν πετρογραφικά (PFGs 1 ως 8). Κάποιες εξ αυτών αφορούν τη χονδροειδή έως σχετικά χονδροειδή

κεραμική (ενότητα 6.2.1) και άλλες τη λεπτότεχνη (ενότητα 6.2.2), ενώ αναγνωρίσθηκε επιπλέον και μια σπανιότερη κεραμική ύλη και μεμονωμένα δείγματα άλλων κεραμικών υλών (ενότητα 6.2.3).

Όπως εξηγείται στην ενότητα 6.3, για τα PFGs 2 και 3, τα οποία αντιπροσωπεύονται από πολλά δείγματα, έχουν χρησιμοποιηθεί παρόμοιες πρώτες ύλες που χαρακτηρίζονται από ερυθρό πηλό με άφθονη μίκα και προσμίξεις από μεταμορφωμένα πετρώματα. Τα χαρακτηριστικά αυτά παραπέμπουν στην περιοχή της Πεδιάδας, όπως επιβεβαιώνεται από αναλύσεις δειγμάτων χώματος και κεραμικής. Το συμπέρασμα αυτό συνάδει με τη μακροσκοπική σύνδεση της κεραμικής που παρουσιάζει αυτά τα χαρακτηριστικά με τη Λύκτο/Λύττο (MFGs A1 και A2). Άφθονα δείγματα αποδόθηκαν στο PFG 1, το οποίο παρουσιάζει ερυθρό πηλό και προσμίξεις από μεταμορφωμένα πετρώματα αλλά χωρίς μίκα. Η κεραμική αυτή ύλη ίσως προέρχεται από τη βόρεια ακτή της ανατολικής Κρήτης και πάντως συνδέεται με τα MFGs B1 and B2. Το PFG 4 αντιπροσωπεύεται από σαφώς λιγότερα δείγματα και συνδέεται με το MFG C1. Το αργιλικό υπόβαθρο είναι αρκετά λεπτότεχνο αλλά περιέχει μη πλαστικά εγκλείσματα (κυρίως ιλυόλιθο και λίγα μεταμορφωμένα πετρώματα), τα οποία προστέθηκαν από τους αρχαίους κεραμείς. Η ύλη αυτή σχετίζεται με τη γεωλογία μια ζώνης που εκτείνεται από την περιοχή του Μύρτους ως τη δυτική Μεσαρά. Τα PFGs 5 έως 7, τα οποία περιλαμβάνουν την πλειονότητα των λεπτότεχνων αγγείων της δειγματοληψίας, θεωρούνται ως λεπτότεχνες παραλλαγές του PFG 4. Το PFG 6, που χαρακτηρίζεται από ερυθρό πηλό με χαλαζιτικές προσμίξεις, περιλαμβάνει δείγματα που αποδίδονται σε διάφορα MFGs και εγείρει ζητήματα προέλευσης που χρήζουν περαιτέρω διερεύνησης με χημικές αναλύσεις. Το PFG 7 συνδέεται στενά με το MFG 6 και τα δύο τους αφορούν δείγματα από δακρυδόχες. Το PFG 8 διαφέρει από την υπόλοιπη λεπτή κεραμική καθώς χαρακτηρίζεται από πρασινωπό αργιλικό υπόβαθρο σχεδόν υαλοποιημένο, χαρακτηριστικό της ασβεστιούχου πρώτης ύλης και της υψηλής θερμοκρασίας όπτησης. Η παρουσία αμφιβολίτη συνδέει την κεραμική αυτή ύλη με την περιοχή του Μύρτους. Η σύνδεση αυτή βρίσκει στήριξη στη μακροσκοπική μελέτη του υλικού, η οποία συνδέει τις σχετικές μακροσκοπικές κεραμικές ύλες (MFGs E και κυρίως F) με την παραγωγή της Ιεράπυτνας (και συγκεκριμένα με το East Cretan Cream Ware). Στο υλικό απαντώνται και άφθονα μεμονωμένα δείγματα διάφορων κεραμικών υλών. Τα περισσότερα από αυτά συνδέονται με την περιοχή της Πεδιάδας, ορισμένα δύναται να αποδοθούν σε άλλες περιοχές της Κρήτης, ενώ ελάχιστα δείγματα προέρχονται από περιοχές εκτός του νησιού.

Η ενότητα 6.4 συνδέει τα πορίσματα της πετρογραφικής ανάλυσης της κεραμικής με εκείνη των πήλινων ειδωλίων με την οποία έχει επίσης ασχοληθεί η Νοδάρου. Η συνδυαστική αυτή προσέγγιση προσφέρει πλούσια συμπεράσματα: α) οι κεραμικές ύλες που χαρακτηρίζουν τα ειδώλια απαντώνται και στην κεραμική· β) οι κεραμικές ύλες με μίκα, που προέρχονται πιθανότατα από τη Λύκτο/Λύττο και την Πεδιάδα, απαντώνται σε τροχήλατα ειδώλια των υστερομινωικών ΙΙΙΓ χρόνων και της Πρώιμης Εποχής του Σιδήρου, και δεν πρωτοεμφανίζονται στην υστεροκλασική περίοδο· γ) συνδέσεις με τη βόρεια ακτή της ανατολικής Κρήτης ανιχνεύονται μόνο στην κεραμική (PFG 1)· δ) για τις λεπτές κεραμικές ύλες οι πλησιέστερες πηγές πρώτων υλών απαντούν στην περιοχή του Μύρτους εγείροντας ζητήματα ως προς τη σχέση του ιερού με την Ιεράπυτνα τα οποία χρήζουν περαιτέρω διερεύνησης (ωστόσο

παρόμοιες πηγές υπάρχουν και δυτικότερα ως την πεδιάδα της Μεσαράς). Τέλος, η ενότητα 6.5 παρουσιάζει τις περιγραφές των πετρογραφικών χαρακτηριστικών των χονδροειδών έως σχετικά χονδροειδών κεραμικών υλών, και συγκεκριμένα των PFGs 1 έως 4.

References

References

Abadie-Reynal, C. 2007. *La céramique romaine d'Argos d'Argos: Fin du IIe siécle avant J.-C.–fin du IVe siécle aprés J.-C.* (Études Péloponnésiennes 13). Paris: De Boccard.

Albertocchi, M., and R. Perna. 2001. Ceramica comune: vasi da mensa e da dispensa. In A. Di Vita (ed.), *Gortina V.3: Lo Scavo del Pretorio (1989-1995), vol. 3 t. I. I materiali*. Padova: Bottega d'Erasmo, 411-536.

Alcock, S. 2002. *Archaeologies of the Greek Past: Landscape, Monuments and Memories*. Cambridge: Cambridge University Press.

Allegro, N., and J. Papadopoulos. 1997. Gortina (Creta). Un deposito votivo sulla collina di Profitis Ilias. In *Δ΄ Επιστημονική συνάντηση για την ελληνιστική κεραμική. Χρονολογικά προβλήματα – κλειστά σύνολα – εργαστήρια*. Athens: Υπουργείο Πολιτισμού, 275-281.

Allegro, N., V. Cosentino, L. Leggio, S. Masala, and S. Svanera. 2008. Lo scarico del *thesmophorion* di Gortina. In C. A. Di Stefano (ed.), *Demetra. La divinità, i santuari, il culto, la leggenda. Atti del I congresso internazionale, Enna, 1-4 Luglio 2004*. Pisa and Rome: F. Serra, 107-121.

Andreadaki-Vlasaki, M. 1985. *Γεωμετρικά νεκροταφεία στο νομό Χανίων*. In T. Detorakis (ed.), *Πεπραγμένα του Ε' Διεθνούς Κρητολογικού Συνεδρίου, vol. Α, Άγιος Νικόλαος, 25 Σεπτεμβρίου – 1 Οκτωβρίου 1981*. Heraklion: Society of Cretan Historical Studies, 10-35.

———. 1997. The Geometric Period: The Pottery. In E. Hallager and B. P. Hallager (eds), *The Greek-Swedish Excavations at the Agia Aikaterini Square Kastelli, Khania 1970-1987, vol. I:1-2: From the Geometric to the Modern Greek Period*. Stockholm: Swedish Institute at Athens, 229-240.

Antoniadis, V., and A. Kotsonas. Forthcoming. Pots, People, and Least Cost Paths to the Interregional Sanctuary of Syme Viannou, Crete. In E. Angliker and J. T. Jensen (eds), *The Archaeology of Traveling and Cult Practices in the Ancient Mediterranean*.

Anzalone, M. 2013. Una nuova area sacra di Gortina preromana. L'Edifizio A sulla collina di Armì. *ASAA* 91, 229-285.

Apostolakou, V., and V. Zografaki. 2006. *Εικονιστική κεραμική από τον αποθέτη της Ολούντος*. In T. Detorakis and A. Kalokairinos (eds), *Πεπραγμένα του Θ' Διεθνούς Κρητολογικού Συνεδρίου, Ελούντα, 1-6 Οκτωβρίου 2001*, vol. A5. Heraklion: Society of Cretan Historical Studies, 95-114.

Archontaki, K. 2012. *Νεοανακτορικά κύπελλα κοινωνίας από το ιερό της Σύμης, Κρήτη. Κρητικά Χρονικά* 32, 11-40.

Barfoed, S. 2018. The Use of Miniature Pottery in Archaic–Hellenistic Greek Sanctuaries: Considerations on Terminology and Ritual Practice. *Opuscula: Annual of the Swedish Institutes at Athens and Rome* 11, 111-126.

Bergquist, B. 1988. The Archaeology of Sacrifice: Minoan-Mycenaean versus Greek. In R. Hägg, N. Marinatos and G. C. Nordquist (eds), *Early Greek Cult Practice: Proceedings of the Fifth International Symposium at the Swedish Institute at Athens, 26-29 June 1986*. Stockholm: Swedish Institute at Athens, 21-34.

Bignasca, A. M. 2000. *I kernoi circolari in Oriente e in Occidente: Strumenti di culto e immagini cosmiche* (Orbis Biblicus et Orientalis 19). Gottingen and Freiburg: Vandenhoeck & Ruprecht and Universitatsverlag Freiburg Schweiz.

Bikai, P. 2000. Phoenician Ceramics from the Greek Sanctuary. In J. W. Shaw and M. C. Shaw (eds), *Kommos IV: The Greek Sanctuary*. Princeton: Princeton University Press, 302-312.

Biondi, G. 2013. La necropoli di Aphratì-Arkades dopo l'orientalizzante tardo. In W.-D. Niemeier, O. Pilz and I. Kaiser (eds), *Kreta in der geometrischen und archaischen Zeit* (Athenaia 2). Munich: Hirmer, 187-200.

Biondi, G., and N. Oikonomaki. 2020. The Patela and the Area of Prinias in Hellenistic Times. In R. Cantilena and F. Carbone (eds), *Monetary and Social Aspects of Hellenistic Crete (ASAA Supplemento 8)*. Florence: All'Insegna del Giglio, 97-107.

Blinkenberg, C. 1931. *Lindos: Fouilees de l'acropole 1902-1914. Vol. I: Les petits objets*. Berlin: Walter De Gruyter.

Boardman, J. 1960. Protogeometric Graves at Agios Ioannis near Knossos. *BSA* 55, 128-148.

———. 1961. *The Cretan Collection in Oxford: The Dictaean Cave and Iron Age Crete*. Oxford: Clarendon Press.

Boardman, J., with T. Mannack, and C. Wagner. 2004. Dedications: Other Vessels. In V. Lambrinoudakis and J. Ch. Balty (eds), *Thesaurus Cultus et Rituum Antiquorum*, vol. I. Los Angeles: The J. Paul Getty Museum, 306-308.

Bocher, S. 2015. Ash, Bones, Votives – Analysis of the *Black Strata* in Early Greek Sanctuaries. Two Examples from Olympia – the *Schwarze Schicht* and the Altar of Artemis. In P. Pakkanen and S. Bocher (eds), *Cult Material: From Archaeological Deposits to Interpretation of Early Greek Religion* (Papers and Monographs of the Finnish Institute at Athens, Vol. 21). Helsinki: Finnish Institute at Athens, 49-64.

Boileau, M.-C., and J. Whitley. 2010. Patterns of Production and Consumption of Coarse to Semi-fine Pottery at Early Iron Age Knossos. *BSA* 105, 225-268.

Brisart, T. 2007. L'atelier de pithoi à reliefs d'Aphrati. Les fragments du musée Bénaki. *BCH* 131, 95-137.

———. 2009. Les pithoi à reliefs de l'atelier d'Aphrati. Fonction et statut d'une production orientalisante. In A. Tsingarida (ed.), *Shapes and Uses of Greek Vases (7th – 4th centuries B.C.). Proceedings of the Symposium Held at the Université de Bruxelles, 27-29 April 2006* (Études d'Archéologie 3). Brussels: Centre de Recherches en Archeologie et Patrimoine, 145-159.

———. 2014. Isolation, Austerity and Fancy Pottery. Acquiring and Using Overseas Imported Fine Wares in 6th- and 5th-Century Eastern Crete. In O. Pilz and G. Seelentag (eds), *Cultural Practices and Material Culture in Archaic and Classical Crete. Proceedings of the International Conference, Mainz, May 20-21, 2011*. Berlin: De Gruyter, 263-283.

Brock, J. K. 1957. *Fortetsa: Early Greek Tombs near Knossos*. Cambridge: University Press.

Cadogan, G., and A. Chaniotis. 2010. Inscriptions from Crete. *BSA* 105, 291-304.

Callaghan, P. J. 1978. KRS 1976: Excavations at a Shrine of Glaukos, Knossos. *BSA* 73, 1-30.

———. 1981. The Little Palace Well and Knossian Pottery of the Later Third and Second Centuries B.C. *BSA* 76, 35-58.

———. 1992. Archaic to Hellenistic Pottery. In L. H. Sackett (ed.), *Knossos: From Greek city to Roman Colony. Excavations at the Unexplored Mansion II* (BSA Supplementary Vol. 21). London: British School at Athens, 89-136.

———. Forthcoming. Archaic to Hellenistic Pottery from Little Palace North.

Callaghan, P. J., and A. W. Johnston. 2000. The Pottery from the Greek Temples at Kommos. In J. W. Shaw and M. C. Shaw (eds), *Kommos IV: The Greek Sanctuary*. Princeton: Princeton University Press, 210-301.

Callaghan, P. J., and R. E. Jones. 1985. Hadra Hydriae and Central Crete: A Fabric Analysis. *BSA* 80, 1-17.

Campbell, M. T. 1938. A Well of the Black-Figured Period at Corinth. *Hesperia* 7.4, 557-611.

Cantilena, R., and F. Carbone. 2020. *Monetary and Social Aspects of Hellenistic Crete* (ASAtene Supplemento 8). Athens: Italian School of Archaeology at Athens.

Chaniotis, A. 1988. Habgierige Götter - habgierige Städte. Heiligtumsbesitz und Gebietsanspruch in den kretischen Staatsverträgen. *Ktema* 13, 21-39.

———. 1996. *Die Verträge zwischen kretischen Poleis in der hellenistischen Zeit*. Stuttgart: Franz Steiner.

———. 1999. Milking the Mountains: Economic Activities on the Cretan Uplands in the Classical and Hellenistic Period. In A. Chaniotis (ed.), *From Minoan Farmers to Roman Traders. Sidelights on the Economy of Ancient Crete*. Stuttgart: Franz Steiner, 181-220.

———. 2001. Heiligtum und Stadtgemeinde im klassischen und hellenistischen Kreta. In A. Kyriatsoulis (ed.), *Kreta und Zypern: Religion und Schrift von der Frühgeschichte bis zum Ende der archaischen Zeit, 26.-28. 2. 1999, Ohlstadt/Oberbayern*. Altenburg: Verlag für Kultur und Wissenschaft, 319-322.

———. 2006. Heiligtümer überregionaler Bedeutung auf Kreta. In K. Freitag, P. Funke and M. Haak (eds), *Kult - Politik - Ethnos. Überregionale Heiligtümer im Spannungsfeld von Kult und Politik*. Stuttgart: Franz Steiner, 196-209.

———. 2008. What Difference Did Rome Make? The Cretans and the Roman Empire. In B. Forsén and G. Salmeri (eds), *The Provinces Strike Back: Imperial Dynamics in the Eastern Mediterranean*. Helsinki: Suomen Ateenan-Inst, 83-105.

———. 2009. Extra-Urban Sanctuaries in Classical and Hellenistic Crete. In G. Deligiannakis and Y. Galanakis (eds), *The Aegean and Its Cultures. Proceedings of the first Oxford-Athens Graduate Student Workshop Organized by the Greek Society and the University of Oxford Taylor Institution, 22-23 April 2005*. Oxford: Archaeopress, 59-67.

Chatzi-Vallianou, D. 2000. Δείγματα ελληνιστικής κεραμικής από ταφικά σύνολα της κεντρικής Κρήτης. In *Ε΄ Επιστημονική Συνάντηση για την ελληνιστική κεραμική. Χρονολογικά προβλήματα – κλειστά σύνολα – εργαστήρια*. Athens: Archaeological Receipts and Expropriations Fund, 87-101.

———. 2016. The acropolis of Smari: Homeric Lyktos. *Creta Antica* 17, 219-271.

Chlouveraki, S., E. Nodarou, K. Zervaki, G. Kostopoulou, and M. Tsipopoulou. 2010. Technological Observations on the Manufacture of the Late Minoan IIIC Goddesses from Halasmenos, East Crete, as Revealed during the Process of Conservation. *Studies in Conservation* 55.2, 190-194.

Christakis, K. 2013. The Syme Sanctuary at the Transition from the Protopalatial to the Early Neopalatial Periods: The Evidence of the Pottery. In C. F. Macdonald and C. Knappett (eds), *INTERMEZZO: Intermediacy and Regeneration in Middle Minoan III Palatial Crete* (BSA Studies Vol. 21). London: British School at Athens, 169-177.

———. 2014. *The Sanctuary of Hermes and Aphrodite at Syme Viannou V: Σημεία κεραμέων*. Athens: Archaeological Society at Athens.

———. Forthcoming. *The Sanctuary of Hermes and Aphrodite at Syme Viannou. The Bronze Age Complexes: Stratigraphy and Chronology*.

Christie, A. 1974. *Death in the Clouds* (The Greenway Edition). New York: Dodd, Mead & Company.

Coldstream, J. N. 1960. A Geometric Well at Knossos. *BSA* 55, 159-171.

———. 1972. Knossos 1951-61: Protogeometric and Geometric Pottery from the Town. *BSA* 67, 63-98.

———. 1973a. Knossos 1951-61: Orientalizing and Archaic Pottery from the Town. *BSA* 68, 33-63.

———. 1973b. The Pottery. In J. N. Coldstream (ed.), *The Sanctuary of Demeter* (BSA Supplementary Vol. 8). Oxford: British School at Athens, 18-55.

———. 1992. Early Hellenic Pottery. In L. H. Sackett (ed.), *Knossos: From Greek city to Roman Colony. Excavations at the Unexplored Mansion II* (BSA Supplementary Vol. 21). London: British School at Athens, 67-88.

———. 1994. Urns with Lids: The Visible Face of the Knossian 'Dark Age'. In D. Evely, H. Hughes-Brock and N. Momigliano (eds), *Knossos: A Labyrinth of History. Papers Presented in Honour of S. Hood*. Athens: British School at Athens, 105-121.

———. 1996. The Protogeometric and Geometric Pottery. In J. N. Coldstream and H. W. Catling (eds), *Knossos North Cemetery: Early Greek Tombs*, Vol. II (BSA Supplementary Vol. 28). London: British School at Athens, 311-420.

———. 1999. Knossos 1951-61: Classical and Hellenistic Pottery from the Town. *BSA* 94, 321-351.

———. 2000. Evans's Greek Finds: The Early Greek Town of Knossos, and its Encroachment on the Borders of the Minoan Palace. *BSA* 95, 251-299.

———. 2001. The Early Greek Period. In J. N. Coldstream, L. J. Eiring and G. Forster (eds), *Knossos Pottery Handbook: Greek and Roman* (BSA Studies 7). London: British School at Athens, 23-76.

———. 2008. *Greek Geometric Pottery. A Survey of Ten Local Styles and their Chronology*. 2nd ed. Exeter: Bristol Phoenix Press.

Coldstream, J. N., and H. W. Catling (eds). 1996. *Knossos North Cemetery: Early Greek Tombs*, Vol. I-IV (BSA Supplementary Vol. 28). London: British School at Athens.

Coldstream, J. N., and L. J. Eiring. 2001. The Late Archaic and Classical Periods. In J. N. Coldstream, L. J. Eiring and G. Forster (eds), *Knossos Pottery Handbook: Greek and Roman* (BSA Studies 7). London: British School at Athens, 77-87.

Coldstream, J. N., L. J. Eiring, and G. Forster (eds). 2001. *Knossos Pottery Handbook: Greek and*

Roman (BSA Studies 7). London: British School at Athens.

Coldstream, J. N., and E. M. Hatzaki. 2003. Knossos: Early Greek Occupation under the Roman Villa Dionysos. *BSA* 98, 279-306.

Coldstream, J. N., and R. A. Higgins. 1973. Conclusions: The Cult of Demeter at Knossos. In J.N. Coldstream (ed.), *The Sanctuary of Demeter* (BSA Supplementary Vol. 8). Oxford: British School at Athens, 180-187.

Coldstream, J. N., and C. F. Macdonald. 1997. Knossos: Area of South-West Houses, Early Hellenic Occupation. *BSA* 92, 189-245.

Coldstream, J. N., and L. H. Sackett. 1978. Knossos: Two Deposits of Orientalizing Pottery. *BSA* 73, 45-60.

Coutsinas, N. 2013. *Défenses crétoises: fortifications urbaines et défense du territoire en Crète aux époques classique et hellénistique.* Paris: Publications de la Sorbonne.

Csapo, E., A. W. Johnston, and D. Geagan. 2000. The Iron Age Inscriptions. In J. W. Shaw, and M. C. Shaw (eds), *Kommos IV: The Greek Sanctuary.* Princeton: Princeton University Press, 101-134.

D'Agata, A. L. 1998. Changing Patterns in a Minoan and Post-Minoan Sanctuary: The Case of Agia Triada. In W. G. Cavanagh and M. Curtis (eds), *Post-Minoan Crete: Proceedings of the First Colloquium on Post-Minoan Crete Held by the British School at Athens and the Institute of Archaeology, University College London, 10-11 November 1995.* London: British School at Athens, 19-26.

———. 1999a. Defining a Pattern of Continuity during the Dark Age in Central-Western Crete: Ceramic Evidence from the Settlement of Thronos/Kephala (Ancient Sybrita). *SMEA* 41, 181-218.

———. 1999b. *Haghia Triada II: Statuine minoiche e post-minoiche dai vecchi scavi di Haghia Triada (Creta).* Padova: Bottega d'Erasmo.

Day, L. P. 2011. *The Pottery from Karphi: A Re-Examination* (BSA Studies 19). London: British School at Athens.

———. 2016. The Pottery. In G. C. Gesell and L. P. Day (eds), *Kavousi IIC: The Late Minoan IIIC Settlement at Vronda. Specialist Reports and Analyses* (Prehistory Monographs 52). Philadelphia: INSTAP Academic Press, 47-116.

Day, P. M., L. Joyner, V. Kilikoglou, and G. C. Gesell. 2006. Goddesses, Snake Tubes, and Plaques: Analysis of Ceramic Ritual Objects from the LM IIIC Shrine at Kavousi. *Hesperia* 75.2, 137-175.

de Barbarin, L. 2020. Crete and Sicily: Late Geometric and Orientalizing pottery from Megara Hyblaea. In N. C. Stampolidis and M. Giannopoulou (eds), *Eleutherna, Crete and the Outside World.* Athens and Rethymnon: University of Crete, 440-455.

———. 2021. *La céramique mégarienne archaïque: productions et styles. Contribution à l'histoire des communautés grecques de Sicile orientale aux VIIIe et VIIe s. av. J.-C.* Unpublished Ph.D. Thesis, Centre Camille-Jullian (Maison méditerranéenne des sciences de l'homme), Aix Marseille University.

de Domingo, C., and A. Johnston. 2003. A Petrographic and Chemical Study of East Greek and

Other Archaic Transport Amphorae. *Eulimene* 4, 27-60.

Demargne, P. 1947. *La Crète dédalique: études sur les origines d'une renaissance*. Paris: de Boccard.

Denti, M., and M. Tuffreau-Libre. 2013. *La céramique dans les contextes rituels: fouiller et comprendre les gestes des anciens. Actes de la table ronde de Rennes, 16-17 juin 2010*. Rennes: Presses Universitaires de Rennes.

De Souza, P. 1998. Late Hellenistic Crete and the Roman Conquest. In W. G. Cavanagh and M. Curtis (eds), *Post-Minoan Crete: Proceedings of the First Colloquium on Post-Minoan Crete Held by the British School at Athens and the Institute of Archaeology, University College London, 10-11 November 1995*. London: British School at Athens, 112-116.

De Tommaso, G. D. 2001. Ceramica a vernice nera. In A. Di Vita (ed.), *Gortina V.3: Lo Scavo del Pretorio (1989-1995), vol. 3 t. I. I materiali*. Padova: Bottega d'Erasmo, 2-17.

———. 2011. Ceramiche fini di età ellenistica. In A. Di Vita and M. A. Rizzo (eds), *Gortina IX: Gortina Agorà. Scavi 1996-1997*. Padova: Bottega d'Erasmo, 73-81.

Dickinson, O. 2006. *The Aegean from Bronze Age to Iron Age*. Oxford and New York: Routledge.

Driessen, J. 2019. A New Ceremonial Centre at Sissi (Nomos Lassithiou). In K. Mitsotaki and L. Tzedaki-Apostolaki (eds), *Proceedings of the 12th International Cretological Conference*. Heraklion: Society of Cretan Historical Studies – Historical Museum of Crete (https://12iccs.proceedings.gr/en/proceedings/category/38/32/159)

Drillat, Q. 2022. Long-Term Spatial Dynamics and City-State Development in the Anapodaris Catchment (South-Central Crete, Greece). *BaBesch* 97, 1-22.

Ducat, J. 1971. *Les Kouroi du Ptoion: Le sanctuaire d'Apollon Ptoieus a l'époque archaïque*. Paris: De Boccard.

Ducrey, P., and O. Picard. 1969. Recherches à Latô. *BCH* 93.2, 792-822.

Ducrey, P., V. Hadjimichali, and O. Picard. 1971. Recherches à Latô VI: Céramique hellénistique. *BCH* 100, 253-267.

Efstathiou, I., A. Kanta, and D. Z. Kontopodi. 2021. Σπήλαια της περιφερειακής ενότητας Ηρακλείου. *AEK* 4B, 59-70.

Eiring, L. J. 2000. Hellenistic Pottery from Pyrgos at Myrtos. In *Ε' Επιστημονική συνάντηση για την ελληνιστική κεραμική. Χρονολογικά προβλήματα – κλειστά σύνολα – εργαστήρια*. Athens: Archaeological Receipts and Expropriations Fund, 53-60.

———. 2001. The Hellenistic Period. In J. N. Coldstream, L. J. Eiring, and G. Forster (eds), *Knossos Pottery Handbook: Greek and Roman* (BSA studies 7). London: British School at Athens, 89-135.

Ekroth, G. 2003. Small Pots, Poor People? The Use and Function of Miniature Pottery as Votive Offerings in Archaic Sanctuaries in the Argolid and Corinthia. In B. Schmaltz and M. Söldner (eds), *Griechische Keramik im kulturellen Kontext*. Münster: Scriptorium, 35-37.

———. 2017a. Bare Bones: Zooarchaeology and Greek Sacrificial Ritual. In S. Hitch and I. Rutherford (eds), *Animal Sacrifice in the Ancient Greek World*. Cambridge: Cambridge University Press, 15-47.

———. 2017b. "Don't Throw Any Bones in the Sanctuary!" On the Handling of Sacred Waste in Ancient Greek Cult Places. In J. Knust and C. Moser (eds), *Ritual Matters: Material Remains and Ancient Religion* (Memoirs of the American Academy in Rome. Supplementary Vol. 13). Ann Arbor: University of Michigan Press, 33-55.

Empereur, J.-Y., Ch. Kritzas, and A. Marangou. 1991. Recherches sur les amphores crétoises II: Les centres de fabrication d'amphores en Crète centrale. *BCH* 115, 481-523.

Englezou, M. 2000. Ελληνιστική κεραμική από την αρχαία Λύττο. In *Ε΄ Επιστημονική συνάντηση για την ελληνιστική κεραμική. Χρονολογικά προβλήματα – κλειστά σύνολα – εργαστήρια*. Athens: Archaeological Receipts and Expropriations Fund, 61-68.

———. 2004. Η σχέση της Έλτυνας με την Κνωσό. In G. Cadogan, E. Hatzaki and A. Vasilakis (eds), *Knossos: Palace, City, State. Proceedings of the Conference in Herakleion Organised by The British School at Athens and the 23rd Ephoreia of Prehistoric and Classical Antiquities of Herakleion, in November 2000, for the Centenary of Sir Arthur Evans's Excavations at Knossos*. London: British School at Athens, 421-431.

———. 2005. *Ελληνιστική κεραμική: Κεντρική Κρήτη*. Athens: Archaeological Receipts and Expropriations Fund.

———. 2011. Κεραμική Γεωμετρικής – Πρώιμης Ανατολίζουσας περιόδου από την περιοχή Λιγόρτυνος Μονοφατσίου. In G. Rizza (ed.), *Convegno di studi Identità culturale, etnicità, processi di formazione a Creta fra Dark Age e Arcaismo*. Catania: Consiglio Nazionale delle Ricerche (I.B.A.M.) – Università di Catania, 281-308.

Erickson, B. L. 2002. Aphrati and Kato Syme: Pottery, Continuity, and Cult in Late Archaic and Classical Crete. *Hesperia* 71.1, 41-90.

———. 2005. Archaeology of Empire: Athens and Crete in the Fifth Century B.C. *AJA* 109.4, 619-663.

———. 2010a. *Crete in Transition: The Pottery Styles and Island History in the Archaic and Classical Periods* (Hesperia Supplement 45). Princeton: American School of Classical Studies at Athens.

———. 2010b. Roussa Ekklesia, Part 2: Lamps, Drinking Vessels, and Kernoi. *AJA* 114.2, 217-252.

———. 2010c. Priniatikos Pyrgos and the Classical Period in Eastern Crete: Feasting and Island Identities. *Hesperia* 79.3, 305-349.

———. 2011. Public Feasts and Private Symposia in the Archaic and Classical Periods. In K. T. Glowacki and N. Vogeikoff-Brogan (eds), STEGA: *The Archaeology of Houses and Households in Ancient Crete from the Neolithic Period through the Roman Era* (Hesperia Supplement Series 44). Princeton: American School of Classical Studies at Athens, 381-391.

———. 2013. Island Archaeologies and the Economy of the Athenian Empire. In A. Slawisch (ed.), *Trade and Finance in the 5th c. BC Aegean World* (BYZAS 18). Istanbul: Ege Yayınları, 67-83.

———. 2017. Appendix F. Protogeometric to Hellenistic Pottery. In L. V. Watrous, D. M. Buell, E. Kokinou, P. Soupios, A. Sarris, S. Beckmann, G. Rethemiotakis, L. A. Turner, S.

Gallimore and M. D. Hammond. *The Galatas Survey: The Socio-Economic and Political Development of a Contested Territory in Central Crete during the Neolithic to Ottoman Periods*. Philadephia: INSTAP Academic Press, 227-233.

Evans, A. J. 1912. The Minoan and Mycenaean Element in Hellenic Life. *JHS* 32, 277-297.

Farnoux, A., N. Kyriakidis, and V. Zographaki. 2012. Nouvelles recherches à Dréros. *RA* 53, 179-183.

Flevari, L. 2016. Μικρογραφικά αγγεία. In I. Tzachili, *ΒΡΥΣΙΝΑΣ II: Η κεραμεική της ανασκαφής 1972-1973. Συμβολή στην ιστορία του ιερού κορυφής*. Athens: *Τα Πράγματα*, 167-188.

Forster, G. 2001. The Roman Period. In J. N. Coldstream, L. J. Eiring and G. Forster (eds), *Knossos Pottery Handbook: Greek and Roman* (BSA Studies 7). London: British School at Athens, 137-157.

―――――. 2009. *Roman Knossos: The Pottery in Context. A Presentation of Ceramic Evidence Provided by the* Knossos 2000 Project *(1993-95)*. Unpublished Ph.D. Thesis, University of Birmingham.

Fragnoli, P. 2020. Compositional and Technological Characterization of Geometric and Archaic Pottery from the Sanctuary of Artemis Hemera in Lousoi. Paper Delivered at the Online Symposium *Interpreting the Pottery Record from Geometric and Archaic Sanctuaries in the Northern Peloponnese: Cult and Votive Practices, Provenance, and Production Methods*, Organized by the Austrian Archaeological Institute and the Austrian Academy of Sciences on 5-6 November 2020.

Francis, J., S. Price, J. Moody, and L. Nixon. 2000. Agiasmatsi: A Greek Cave Sanctuary in Sphakia, SW Crete. *BSA* 95, 427-471.

Gagarin, M., and P. Perlmann. 2016. *The Laws of Ancient Crete c. 650-400 BC*. Oxford: Oxford University Press.

Galanaki, R. 2002. *Ο Αιώνας των Λαβυρίνθων*. Athens: Kastaniotis.

Galanaki, K., Ch. Papadaki, K. Sidiropoulos, and M. Spyridakis. 2017. Ταφικές πρακτικές στο αρχαίο Ρύτιο: Ανασύνθεση παλαιών και νέων ανασκαφικών δεδομένων. In K. D. Moutzouris (ed.), *Πρακτικά του συνεδρίου Τα Αστερούσια της Παράδοσης και της Ιστορίας*. Heraklion: Κέντρο Κρητικής Λογοτεχνίας, 96-112.

Gallimore, S. 2015. *An Island Economy: Hellenistic and Roman Pottery from Hierapytna, Crete*. New York: Peter Lang.

―――――. 2017. Abandonment and Assimilation in the Roman Period. In L. V. Watrous, D. M. Buell, E. Kokinou, P. Soupios, A. Sarris, S. Beckmann, G. Rethemiotakis, L. A. Turner, S. Gallimore and M. D. Hammond. *The Galatas Survey: The Socio-Economic and Political Development of a Contested Territory in Central Crete during the Neolithic to Ottoman Periods*. Philadephia: INSTAP Academic Press, 227-233.

―――――. 2019. An Island in Crisis? Reconsidering the Formation of Roman Crete. *AJA* 123.4, 589-617.

Gardner, E. 1888. *Naukratis. Part II*. London: Trübner & Co.

Gardner, P. 1911. Presidential Address to the Society for the Promotion of Hellenic Studies. *JHS* 31, lii-lxi.

Gauer, W. 1975. *Olympische Forschungen VIII: Die Tongefässe aus den Brunnen unterm Stadion-Nordwall und im südost-Gebiet*. Berlin: de Gruyter.

Gauss, W., and F. Ruppenstein. 1998. Die Athener Akropolis in der Frühen Eisenzeit. *AA* 113, 1-60.

Gebhard, E., and D. S. Reese. 2005. Sacrifices for Poseidon and Melikertes-Palaimon at Isthmia. In R. Hägg and B. Alroth (eds), *Greek Sacrificial Ritual, Olympian and Chthonian. Proceedings of the Sixth International Seminar on Ancient Greek Cult, Organized by the Department of Classical Archaeology and Ancient History, Göteborg University, 25-27 April 1997*. Stockholm: Swedish Institute at Athens, 125-154.

Georgiou, H. S. 1986. *Keos VI: Ayia Irini. Specialized Domestic and Industrial Pottery*. Mainz am Rhein: Philipp von Zabern.

Gilboa, A., P. Waiman-Barak, and R. Jones. 2015. On the Origin of Iron Age Phoenician Ceramics at Kommos, Crete: Regional and Diachronic Perspectives across the Bronze Age to Iron Age Transition. *Bulletin of the American Schools of Oriental Research* 374, 75-102.

Gilboa, A., Y. Shalev, G. Lehmann, H. Mommsen, B. Erickson, E. Nodarou, and D. Ben-Shlomo. 2017. Cretan Pottery in the Levant in the Fifth and Fourth Centuries B.C.E. and Its Historical Implications. *AJA* 121.4, 559-593.

Girella, L. 2003. Vasi rituali con elementi miniaturizzati a Creta, in Egeo e nel Mediterraneo orientale alla fine dell'età del Bronzo. Indicatori archeologici ed etnici. *Creta Antica* 3, 167-216.

Graybehl, H. 2014. *The Production and Distribution of Hellenistic Ceramics from the Northeast Peloponnese at the Panhellenic Sanctuary at Nemea: A Petrographic Study*. Unpublished Ph.D. Thesis, University of Sheffield.

Grigoropoulos, D. 2011. Κεραμεική ρωμαϊκής περιόδου. In A. Κάντα and K. Δαβάρας (eds), *ΕΛΟΥΘΙΑ ΧΑΡΙΣΤΗΙΟΝ: Το ιερό σπήλαιο της Ειλειθυίας στον Τσούτσουρο*. Heraklion: Dimos Minoa Pediadas, 80-83.

Guest-Papamanoli, A., and A. Lambraki. 1980. Les grottes de Lera et d l'Arkoudia en Crete occidentale aux epoches prehistoriques et historiques. *ArchDelt* 31A: 178-293.

Guizzi, F. 2001. Hierapytna: Storia di una polis cretese dalla fondazione alla conquista romana. *Atti dell'Accademia Nazionale dei Lincei: Classe di scienze morali, storiche e filologiche, Memorie*, Serie IX, Vol. XII, Fascicolo 3, 276-444.

Hadjimichali, V. 1971. Recherches à Latô III: Maisons. *BCH* 95.1, 167-222.

Hadjisavvas, S., and V. Karageorghis (eds). 2000. *The Problem of Unpublished Excavations. Proceedings of a Conference Organized by the Department of Antiquities, Cyprus and the Anastasios G. Leventis Foundation, Nicosia, 25-26 November, 1999*. Nicosia: Department of Antiquities Cyprus and Leventis Foundation.

Haggis, D. C. 2005. *Kavousi I: The Archaeological Survey of the Kavousi Region*. Philadelphia: INSTAP Academic Press.

———. 2012. Late Minoan IIIC-Orientalizing Pottery. In L.V. Watrous, D. Haggis, K. Nowicki, N. Vogeikoff-Brogan and M. Schultz, *An Archaeological Survey of the Gournia Landscape: A Regional History of the Mirabello Bay, Crete, in Antiquity* (Prehistory Monographs).

Philadelphia: INSTAP Academic Press, 155-161.

———. 2014. Azoria and Archaic Urbanization. In F. Gaignerot-Driessen and J. Driessen (eds), *Cretan Cities: Formation and Transformation* (Aegis. Actes de colloques 7). Louvain-la-Neuve: Presses universitaires de Louvain, 119-139.

———. 2018. In Defense of a Contextual Classical Archaeology: A Response to Robin Osborne's 'De-Contextualising and Re-Contextualising: Why Mediterranean Archaeology Needs to Get Out of the Trench and Back into the Museum'. *JMA* 31.1, 101-119.

Haggis, D. C., M. S. Mook, C. M. Scarry, L. M. Snyder, and W. C. West III. 2004. Excavations at Azoria, 2002. *Hesperia* 73.3, 339-400.

Haggis, D. C., M. S. Mook, R. D. Fitzsimons, C. M. Scarry, and L. M. Snyder. 2007. Excavations at Azoria, 2003-2004, Part 1. The Archaic Civic Complex. *Hesperia* 76.2, 243-321.

———. 2011. The Excavation of Archaic Houses at Azoria in 2005-2006. *Hesperia* 80.3, 431-489.

Hahn, M. 1997. Modern Greek, Turkish and Venetian Periods. The Pottery and the Finds. In E. Hallager and B. P. Hallager (eds), *The Greek-Swedish Excavations at the Agia Aikaterini Square Kastelli, Khania 1970-1987, Vol. I. From the Geometric to the Modern Greek Period*. Stockholm: Paul Åström Förlag, 170-196.

Halbherr, F. 1901. Cretan Expedition XVI: Report on the Researches at Praisos. AJA 5.4, 371-392.

Halbherr, F., and P. Orsi. 1888. *Antichità dell'Antro di Zeus Ideo in Creta*. Torino and Rome: Ermanno Loescher.

Hartley, M. 1930-1931. Early Greek Vases from Crete. *BSA* 31, 56-114.

Hayden, B. J. 2003. *Reports on the Vrokastro Area, Eastern Crete. Vol. 1: Catalogue of Pottery from the Bronze and Early Iron Age Settlement of Vrokastro in the Collections of the University of Pennsylvania Museum of Archaeology and Anthropology and the Archaeological Museum, Herakleion, Crete*. Philadelphia: University of Pennsylvania, Museum of Archaeology and Anthropology.

———. 2005. *Reports on the Vrokastro Area, Eastern Crete. Vol. 3: The Vrokastro Regional Survey Project. Sites and Pottery*. Philadelphia: University of Pennsylvania, Museum of Archaeology and Anthropology.

Hayes, J. W. 1983. The Villa Dionysos Excavations, Knossos: The Pottery. *BSA* 78, 97-169.

———. 2000a. Roman Pottery from the Sanctuary. In J. W. Shaw and M. C. Shaw (eds), *Kommos IV: The Greek Sanctuary*. Princeton: Princeton University Press, 312-320.

———. 2000b. The Roman Lamps from the Sanctuary. In J. W. Shaw and M. C. Shaw (eds), *Kommos IV: The Greek Sanctuary*. Princeton: Princeton University Press, 320-330.

Haysom, M. 2011. The Strangeness of Crete. In M. Haysom and J. Wallensten (eds), *Current Approaches to Religion in Ancient Greece: Papers Presented at a Symposium at the Swedish Institute at Athens, 17–19 April 2008* (Skrifter utgivna av Svenska institutet i Athen 8o, 21). Stockholm: Swedish Svenska institutet i Athen, 95-109.

Homann-Wedeking, B. 1950. A Kiln Site at Knossos. *BSA* 45, 165-192.

Hood, S., P. Warren, and G. Cadogan. 1964. Travels in Crete, 1962. *BSA* 59, 50-99.

Hoppin, J. C. 1905. The Vases and Vase Fragments. In C. Waldstein, *The Argive Heraeum 2: Terra-cotta Figurines, Terra-cotta Reliefs, Vases and Vase Fragments, Bronzes, Engraved Stones, Gems and Ivories, Coins, Egyptian or Graeco-Egyptian Objects*. Boston and New York: Houghton, Mifflin and Company, 57-184.

Horejs, B., R. Jung, and P. Pavúk (eds). 2010. *Analysing Pottery: Processing – Classification – Publication*. Bratislava: Comenius University.

Hutchinson, R. W., and J. Boardman. 1954. The Khaniale Tekke Tombs. *BSA* 49, 215-228.

I.G.M.E. 1989. *Geological Map of Greece: Mochos Sheet*, 1:50.000. Athens: Institute for Geology and Mining Exploration.

———. 1993. *Geological Map of Greece: Ierapetra Sheet*, 1:50.000. Athens: Institute for Geology and Mining Exploration.

Ilan, D. 2021. The Ring-Kernoi and Psychotropic Substances. In D. Stein, S. K. Costello and K. Polinger (eds), *The Routledge Companion to Ecstatic Experience in the Ancient World*. Milton: Taylor & Francis Group, 173-186.

James, S. 2018. *Corinth VII.7: The Hellenistic Pottery: The Fine Wares*. Princeton: The American School of Classical Studies at Athens.

———. 2019. Kraters and Drinking Practices in Hellenistic Corinth. In A. Peignard-Giros (ed.), *Daily Life in a Cosmopolitan World: Pottery and Culture during the Hellenistic Period. Proceedings of the 2nd Conference of the International Association for Research on Pottery in the Hellenistic Period, Lyon, November 2015*, 5-8. Vienna: Phoibos, 511-517.

Johannowsky, W. 2002. *Il santuario sull'acropoli di Gortina*, vol. II. Athens: Italian School of Archaeology at Athens.

Johnston, A. W. 1990. Anfore laconiche a Kommos? In P. Pelagatti and C. M. Stibbe (eds), *Lakonikà I: Ricerche e nuovi materiali di ceramica Laconica* (Bollettino D'Arte Supplemento 64). Rome: Ministero per i Beni Culturali e Ambientali, 115-116

———. 1993. Pottery from Archaic Building Q at Kommos. *Hesperia* 62.3, 339-382.

———. 2000. Building Z at Kommos: An 8th-Century Pottery Sequence. *Hesperia* 69.2, 189-226.

———. 2005. Kommos: Further Iron Age Pottery. *Hesperia*, 74.3, 309-393.

Jones, D. W. 2000. *External Relations of Early Iron Age Crete, 1100-600 B.C.* Boston: Archaeological Institute of America.

Jones, R. E. 2000. Chemical Analysis of Phoenician Imports at Kommos. In J. W. Shaw and M. C. Shaw (eds), *Kommos IV: The Greek Sanctuary*. Princeton: Princeton University Press, 331-332.

Kallini, C. 2007. *Ο ελληνιστικός "κάνθαρος". Συμβολή στη μελέτη της ελληνιστικής κεραμικής*. Unpublished Ph.D. Thesis, Aristotle University of Thessaloniki.

Kalopisi-Verti, S. 2003. *Πανεπιστήμιο Αθηνών, Μουσείο Αρχαιολογίας και Ιστορίας της Τέχνης: Διδακτική συλλογή βυζαντινής και μεταβυζαντινής κεραμικής*. Athens: Πανεπιστήμιο Αθηνών, Τομέας Αρχαιολογίας και Ιστορίας της Τέχνης.

Kalpaxis, Th., A. Furtwängler, A. Schnapp, A. Georgiadou, E. Gialouri, M. Guy, P. Ioannidou, N. Karamaliki, D. Neisius, M.-F. Matheron, B. Sahm, A. Sarpaki, H. Seilheimer, N. Tsatsaki,

C. Tsigonaki, and E. Villa. 1994. *Ελεύθερνα II, 2: Ένα ελληνιστικό σπίτι («Σπίτι Α») στη θέση Νησί*. Rethymno: Εκδόσεις Πανεπιστημίου Κρήτης.

Kalpaxis, Th., and N. Tsatsaki. 2000. Eleutherna. Zufallsfunde aus einer der hellenistischen Nekropolen der Stadt. *AA*, 117-128.

Kalomenopoulos, N. 1894. *Κρητικά: ήτοι τοπογραφία και οδοιπορικά της νήσου Κρήτης. Επιτόπιος μελέτη*. Athens: S. K. Vlastos.

Kanta, A. 1991. Cult, Continuity and the Evidence of Pottery at the Sanctuary of Syme Viannou, Crete. In D. Musti, A. Sacconi, L. Rocchetti, M. Rocchi, E. Scafa, L. Sportiello and M. E. Giannotta (eds), *La transizione dal Miceneo all'alto Arcaismo: Dal palazzo alla città. Atti del Convegno internazionale, Roma, 14-19 marzo 1988*. Rome, 479-505.

———. 2011. Μικροαντικείμενα – Κοσμήματα – Χάλκινες φιάλες. In A. Kanta and K. Davaras (eds), *ΕΛΟΥΘΙΑ ΧΑΡΙΣΤΗΙΟΝ: Το ιερό σπήλαιο της Ειλειθυίας στον Τσούτσουρο*. Heraklion: Dimos Minoa Pediadas, 156-167.

Kanta, A., and D. Z. Kontopodi. 2011a. Δείγματα της κεραμικής του σπηλαίου. In A. Kanta and K. Davaras (eds), *ΕΛΟΥΘΙΑ ΧΑΡΙΣΤΗΙΟΝ: Το ιερό σπήλαιο της Ειλειθυίας στον Τσούτσουρο*. Heraklion: Dimos Minoa Pediadas, 44-83.

———. 2011b. Αιγυπτιακού τύπου αναθήματα στο σπήλαιο της Ειλειθυίας. In A. Kanta and K. Davaras (eds), *ΕΛΟΥΘΙΑ ΧΑΡΙΣΤΗΙΟΝ: Το ιερό σπήλαιο της Ειλειθυίας στον Τσούτσουρο*. Heraklion: Dimos Minoa Pediadas, 168-170.

Karageorghis, V., A. Kanta, N. C. Stampolidis, and G. Sakellarakis (eds). 2014. *Kypriaka in Crete: From the Bronze Age to the End of the Archaic Period*. Nicosia: INSTAP Academic Press and A.G. Leventis Foundation.

Karamaliki, N. 2010. Ελληνιστικός οικισμός στην Αγία Ειρήνη Ρεθύμνου. *ΑΕΚ* 1, 512-524.

Karetsou, A., M. Andreadaki-Vlazaki, and N. Papadakis (eds). 2000. *Κρήτη – Αίγυπτος: Πολιτισμικοί δεσμοί τριών χιλιετιών*. Heraklion: Ministry of Culture.

Kitchell, K. F. 1977. *Topographica Cretica: Topoi of Classical Crete with Testimonia*. Unpublished Ph.D. Thesis, Loyola University of Chicago.

Klebinder-Gauss, G. 2012. *Keramik aus klassischen Kontexten im Apollon-Heiligtum von Ägina-Kolonna. Locale Produktion und Importe*. Vienna: Austrian Academy of Science.

Koehl, R. B. 1986. The Chieftain Cup and a Minoan Rite of Passage. *JHS* 106, 99-110.

Kordatzaki, G. 2007. *Κεραμική από το ιερό κορυφής του Βρύσινα. Ένα σύνθετο τεχνοσύστημα παραγωγής και χρήσης την 2η χιλιετία π.Χ.* Unpublished Ph.D. Thesis, University of Crete.

———. 2016. Μελέτη Τεχνολογίας και Προέλευσης της Κεραμεικής. In I. Tzachili, *ΒΡΥΣΙΝΑΣ II: Η κεραμεική της ανασκαφής 1972-1973. Συμβολή στην ιστορία του Ιερού Κορυφής*. Athens: *Τα Πράγματα*, 263-304.

Kordatzaki, G., E. Kiriatzi, N.S. Müller, M. Voyatzis, D. Romano, S. Petrakis, J. Forsén, G. Nordquist, E. Rodriguez-Alvarez, and S. Linn. 2016. A Diachronic Investigation of 'Local' Pottery Production and Supply at the Sanctuary of Zeus, Mount Lykaion, Arcadia, Peloponnese. *Journal of Archaeological Science* 7: 526-529.

Kotsonas, A. 2002. The Rise of the Polis in Central Crete. *Eulimene* 3, 37-74.

———. 2005. *Ceramic Styles in Iron Age Crete: Production, Dissemination and Consumption.*

A Study of Pottery from the Iron Age Necropolis of Orthi Petra in Eleutherna. Unpublished Ph.D. Thesis, University of Edinburgh.

———. 2008. *The Archaeology of Tomb A1K1 of Orthi Petra in Eleutherna: The Early Iron Age Pottery*. Athens: Publications of the University of Crete.

———. 2011a. Ceramic Variability and Drinking Habits in Iron Age Crete. In A. Mazarakis-Ainian (ed.), *Acts of the "Dark Ages" Revisited: An International Conference in Memory of William D.E. Coulson*. Volos: University of Thessaly, 943-955.

———. 2011b. Foreign Identity and Ceramic Production in Early Iron Age Crete. In G. Rizza (ed.), *Convegno di studi Identità culturale, etnicità, processi di formazione a Creta fra Dark Age e Arcaismo*. Catania: Consiglio Nazionale delle Ricerche (I.B.A.M.) – Università di Catania, 133-155.

———. 2012a. Η ενεπίγραφη κεραμική του 'Υπογείου': προέλευση, τυπολογία, χρονολόγηση και ερμηνεία. In M. Bessios, Y. Tzifopoulos and A. Kotsonas, *ΜΕΘΩΝΗ ΠΙΕΡΙΑΣ Ι: Επιγραφές, χαράγματα και εμπορικά σύμβολα στη Γεωμετρική και Αρχαϊκή κεραμική από το 'Υπόγειο' της Μεθώνης Πιερίας στη Μακεδονία*. Thessaloniki: Centre for the Greek Language, 113-304.

———. 2012b. 'Creto-Cypriot' and 'Cypro-Phoenician' Complexities in the Archaeology of Interaction between Crete and Cyprus. In M. Iacovou (ed.), *Cyprus and the Aegean in the Early Iron Age: The legacy of Nicolas Coldstream. Proceedings of an Archaeological Workshop Held in Memory of Professor J.N. Coldstream (1927–2008)*. Nicosia: Bank of Cyprus Cultural Foundation, 155-179.

———. 2013. Orientalizing Ceramic Styles and Wares in Early Iron Age Crete. In W.-D. Niemeier, O. Pilz and I. Kaiser (eds), *Kreta in der geometrischen und archaischen Zeit* (Athenaia 2). Munich: Hirmer, 233-252.

———. (ed.). 2014. *Understanding Standardization and Variation in Mediterranean Ceramics: Mid 2nd to Late 1st Millennium BC* (BABesch Supplements Series vol. 25). Leuven: Peeters.

———. 2016a. Politics of Periodization and the Archaeology of Early Greece. *AJA* 120.2, 239-270.

———. 2016b. Review of F. Gaignerot-Driessen and Jan Driessen (eds) 2014. *Cretan Cities: Formation and Transformation*. Louvain-la-Neuve: Presses Universitaires de Louvain. *JHS* 136, 268-269.

———. 2017a. Ceramics, Analytical Scales and Cultural Histories of 7th Century Crete. In C. Morgan and X. Charalambidou (eds), *Interpreting the Seventh Century BC: Tradition and Innovation*. Athens: British School at Athens, 15-23.

———. 2017b. Sanctuaries, Temples and Altars in the Early Iron Age: A Chronological and Regional Accounting. In A. Mazarakis Ainian, A. Alexandridou and X. Charalambidou (eds), *Regional Stories towards a New Perception of the Early Greek World. An International Symposium in Honour of Professor Jan Bouzek, Volos, 18-21 June 2015*. Volos: University of Thessaly, 55-66.

———. 2019a. The Iconography of a Protoarchaic Cup from Kommos: Myth and Ritual in Early Cretan Art. *Hesperia* 88.4, 595-624.

———. 2019b. Politics, Research Agendas and Abortive Fieldwork Plans over Lyktos, Crete: A History of Archaeological Research. *BSA* 114, 399-433.

———. 2019c. Early Iron Age Knossos and the Development of the City of the Historical Period. In K. Mitsotaki and L. Tzedaki-Apostolaki (eds), *Proceedings of the 12th International Cretological Conference*. Heraklion: Society of Cretan Historical Studies – Historical Museum of Crete https://12iccs.proceedings.gr/en/proceedings/category/39/35/811)

———. 2020. An Archaeology of Ancient Greece – A War for Modern Greece: The Life and Work of Thomas J. Dunbabin. *Bulletin of the Australian Archaeological Institute at Athens* 16, 30-39.

———. 2022. Crete: Early Iron Age to Classical. *AR* 68, 133-167.

———. Forthcoming. The Early Iron Age to Hellenistic, and the Medieval and Modern pottery from Dreros Temple A. *BCH*.

Kotsonas, A., V. Sythiakaki, and A. Chaniotis. 2021. Ανασκαφή Λύκτου. *ΠΑΕ*, 213-264.

———. Forthcoming. Ανασκαφή Λύκτου. *ΠΑΕ*.

Kotsonas, A., T. Whitelaw, A. Vasilakis, and M. Bredaki. 2018. Early Iron Age Knossos: An Overview Based on the Surface Investigations of the Knossos Urban Landscape Project (KULP). In E. Gavrilaki (ed.), *Πεπραγμένα ΙΑ΄ Διεθνούς Κρητολογικού Συνεδρίου (Ρέθυμνο 21-27 Οκτωβρίου 2011)*, vol. A2.1. Rethymno: Ιστορική και Λαογραφική Εταιρεία Ρεθύμνης, 61-77.

Kowalzig, B. 2020. Festivals, Fairs and Foreigners: Towards an Economics of Religion in the Mediterranean *Longue Durée*. In A. Collar and T. Myrup Kristensen (eds), *Pilgrimage and Economy*. Leiden: Brill, 287-328.

Kritzas, Ch. 2000. Νέα επιγραφικά στοιχεία για την ετυμολογία του Λασυθίου. In A. Karetsou (ed.), *Πεπραγμένα του Η΄ Διεθνούς Κρητολογικού Συνεδρίου, Ηράκλειο, 9–14 Σεπτεμβρίου 1996*, vol. A2. Heraklion: Society of Cretan Historical Studies, 81-97.

———. 2006. Ενδείξεις αρχαίας λατρείας στην κορυφή της Ίδης. In E. Gavrilaki and Y. Z. Tzifopoulos (eds), *Ο Μυλοπόταμος από την αρχαιότητα ως σήμερα*, vol. III. Rethymnon. Ιστορική και Λαογραφική Εταιρεία Ρεθύμνου, 183-202.

———. V. 2015. Κρητωνυμικά. *Γραμματείον* 4, 53-58.

Kyrieleis, H. 2000. Vorwort des Herausgebers. In Erika Kunze-Götte, J. Heidin and J. Burow, *Olympische Forschungen 28: Archaische Keramik aus Olympia*. Berlin and New York: De Gruyter, V-VI.

———. 2006. *Olympische Forschungen 31: Olympisch Anfänge ind Frühzeit des Heiligtums von Olympia: Die Ausgrabungen am Pelopion 1987–1996*. Berlin: De Gruyter.

Laftsidis, A. 2018. *The Hellenistic Ceramic "Koine" Revisited*. Unpublished Ph.D. Thesis, University of Cincinnati.

Lambropoulou, A. 1999. A Bronze Sistrum from the Sanctuary of Syme/Crete. *AA*, 515-521.

Lang, F., and C. Rathossi. 2020. Archaeometric Investigation of Geometric and Archaic Pottery Unearthed at the Archaeological Site of Ancient Olympia. Paper Delivered at the Online Symposium *Interpreting the Pottery Record from Geometric and Archaic Sanctuaries in the Northern Peloponnese: Cult and Votive Practices, Provenance, and Production Methods,*

organized by the Austrian Archaeological Institute and the Austrian Academy of Sciences on 5-6 November 2020.

Langmuir, E. 1984. *Mountaincraft and Leadership: A Handbook for Mountaineers and Hillwalking Leaders in the British Isles*. Leicester: Scottish Sports Council/MLTB.

La Rosa, V., and E. C. Portale. 1996-1997. Le case ellenistiche ad ovest del Piazzale I a Festòs. *ASAtene* 74-75, 215-395.

Laughy, M. 2018. Figurines in the Road: A Protoattic Votive Deposit from the Athenian Agora Reexamined. *Hesperia* 87.4, 633-679.

Laumonier, A. 1977. *Délos XXXI: La céramique hellénistique à reliefs 1. Ateliers «ioniens»*. Paris: De Boccard.

Lebessi, A. 1970. Αρχαιότητες και μνημεία κεντρικής και Ανατολικής Κρήτης: Αφρατί. *ArchDelt* 25 B2, 455-461.

———. 1972. Ιερόν Ερμού και Αφροδίτης εις Σύμην Κρήτης. *ΠΑΕ*, 193-203.

———. 1973a. Ιερόν Ερμού και Αφροδίτης εις Σύμην Κρήτης. *ΠΑΕ*, 188-199.

———. 1973b. Ιερόν Ερμού και Αφροδίτης παρά την Κάτω Σύμην Βιάννου. *ΑΑΑ* 6, 104-114.

———. 1974. Ιερόν Ερμού και Αφροδίτης εις Σύμην Κρήτης. *ΠΑΕ*, 222-227.

———. 1975. Ιερόν Ερμού και Αφροδίτης εις Σύμην Κρήτης. *ΠΑΕ*, 322-329.

———. 1976a. Ιερό Ερμή και Αφροδίτης στη Σύμη Βιάννου. *ΠΑΕ*, 401-407.

———. 1976b. A Sanctuary of Hermes and Aphrodite in Crete. *Expedition* 18.3, 2-13.

———. 1977. Το ιερό του Ερμή και της Αφροδίτης στη Σύμη της Βιάννου. *ΠΑΕ*, 403-418.

———. 1981a. Το ιερό του Ερμή και της Αφροδίτης στη Σύμη της Βιάννου. *ΠΑΕ*, 380-396.

———. 1981b. Η συνέχεια της κρητομυκηναϊκής λατρείας. Επιβιώσεις και αναβιώσεις. *ArchEph*, 1-24.

———. 1983. Ιερό του Ερμή και της Αφροδίτης στη Σύμη Βιάννου. *ΠΑΕ*, 348-366.

———. 1984. Ιερό του Ερμή και της Αφροδίτης στη Σύμη Βιάννου. *ΠΑΕ*, 440-463.

———. 1985a. Ιερό του Ερμή και της Αφροδίτης στη Σύμη Βιάννου. *ΠΑΕ*, 263-285.

———. 1985b. *Το ιερό του Ερμή και της Αφροδίτης στη Σύμη Βιάννου, vol. I. Χάλκινα κρητικά τορεύματα*. Athens: Archaeological Society at Athens.

———. 1987. Το ιερό του Ερμή και της Αφροδίτης στη Σύμη Βιάννου. *ΠΑΕ*, 269-289.

———. 1988. Το ιερό του Ερμή και της Αφροδίτης στη Σύμη Βιάννου. *ΠΑΕ*, 244-263.

———. 1991a. Το ιερό του Ερμή και της Αφροδίτης στη Σύμη Βιάννου. *ΠΑΕ*, 306-330.

———. 1991b. Ανασκαφές της Αρχαιολογικής Εταιρείας: Οι λόγοι ακτινοβολίας ενός κρητικού ιερού. *Η εν Αθήναις Αρχαιολογική Εταιρεία, Ενημερωτικό Δελτίο* 18, 160-165.

———. 1992a. Το ιερό του Ερμή και της Αφροδίτης στη Σύμη Βιάννου. *ΠΑΕ*, 211-230.

———. 1992b. Syme. In J. W. Myers, E. E. Myers and G. Cadogan (eds), *The Aerial Atlas of Ancient Crete*. Berkeley and Los Angeles, CA: University of California Press, 268-275.

———. 1993. Το ιερό του Ερμή και της Αφροδίτης στη Σύμη Βιάννου. *ΠΑΕ*, 209-230.

———. 1995. Το ιερό του Ερμή και της Αφροδίτης στη Σύμη της Βιάννου. *ΠΑΕ*, 245-260.

———. 1996. Το ιερό του Ερμή και της Αφροδίτης στη Σύμη της Βιάννου. *ΠΑΕ*, 303-317.

———. 1997. Το ιερό του Ερμή και της Αφροδίτης στη Σύμη Βιάννου. *ΠΑΕ*, 191-209.

———. 2000a. Το ιερό του Ερμή και της Αφροδίτης στη Σύμη Βιάννου. *ΠΑΕ*, 181-191.

———. 2000b. Αντιφεγγίσματα και διαθλάσεις απο την Αίγυπτο στο ιερό της Σύμης (Κρήτη). In A. Karetsou (ed.), *Κρήτη-Αίγυπτος: Πολιτιστικοί δεσμοί τριών χιλιετιών*. Athens: Kapon, 174-183.

———. 2001. Σκήπτρο εξουσίας από το ιερό της Σύμης (Κρήτη). In D. Pandermalis, M. Tiverios and E. Voutyras (eds), *ΆΓΑΛΜΑ. Μελέτες για την αρχαία πλαστική προς τιμήν του Γιώργου Δεσπίνη*. Thessaloniki: Ministry of Culture and Aristotle University of Thessaloniki, 1-12.

———. 2002a. Το ιερό του Ερμή και της Αφροδίτης στη Σύμη Βιάννου. *ΠΑΕ*, 107-121.

———. 2002b. *Ιερό του Ερμή και της Αφροδίτης στη Σύμη Βιάννου ΙΙΙ: Τα χάλκινα ανθρωπόμορφα ειδώλια*. Athens: Archaeological Society at Athens.

———. 2003. Το ιερό του Ερμή και της Αφροδίτης στη Σύμη Βιάννου. *ΠΑΕ*, 79-97.

———. 2009. The Erotic Goddess of the Syme Sanctuary, Crete. *AJA* 113.4, 521-545.

———. 2010a. Hermes as Master of Lions at the sanctuary, Crete. In O. Krzyszkowska (ed.), *Cretan Offerings: Studies in Honour of Peter Warren* (BSA Studies 18). London: British School at Athens, 195-202.

———. 2010b. *Ο θρήνος στην κρητική κοινωνία της 1ης χιλιετίας*. ArchEph, 61-82.

———. 2018-2019. Το προβάδισμα των κρητικών εργαστηρίων στη διαμόρφωση εικονογραφικών τύπων κατά την πρώτη χιλιετία π.Χ. *Eulimene* 19-20, 24-38.

———. 2021. *Ιερό του Ερμή και της Αφροδίτης στη Σύμη Βιάννου VI: Τα πήλινα ανθρωπόμορφα αναθήματα*. Athens: Archaeological Society at Athens.

———. Forthcoming. Additions and Corrections to a 2009 Article. *Eulimene*.

Lebessi, A. and P. Muhly. 1987. The Sanctuary of Hermes and Aphrodite at Syme, Crete. *National Geographic Research* 3, 102-113.

———. 1990. Aspects of Minoan Cult: Sacred Enclosures, the Evidence from the Syme Sanctuary (Crete). *AA*, 315-336.

———. 2003. Ideology and Cultural Interaction; Evidence from the Syme Sanctuary, Crete. *Cretan Studies* 9 [=Y. Duhoux, Y. (ed.), *Briciaka. A Tribute to W. C. Brice*], 95-103.

Lebessi, A., P. Muhly, and J.-P. Olivier. 1995. An Inscription in the Hieroglyphic Script from the Syme Sanctuary, Crete (SY Hf01). *Kadmos* 34: 63-77.

Lebessi, A., P. Muhly, and G. Papasavvas. 2004. The Runner's Ring, a Minoan Athlete's Dedication at the Syme Sanctuary, Crete. *AM* 119, 1-31.

Lebessi, A., and D. S. Reese. 1986. Recent and Fossil Shells from the Sanctuary of Hermes and Aphrodite, Syme Viannou, Crete. *ArchEph*, 183-188.

Lebessi, A., and M. I. Stefanakis. 2004. Τα νομίσματα από την ανασκαφή του Ιερού του Ερμή και της Αφροδίτης στη Σύμη Βιάννου, Κρήτη. *ArchEph* 143, 179-203.

Lefèvre-Novaro, D. 2014. *Du massif de l'Ida aux pentes du mont Diktè: peuples, territoires et communautés en Messara*. Paris: Éditions de Boccard.

———. 2018. Osservazioni preliminari sui cosiddetti kernoi scoperti a Creta in contesti dell'età del ferro. In E. Gavrilaki (ed.), *Πεπραγμένα ΙΑ΄ Διεθνούς Κρητολογικού Συνεδρίου, Ρέθυμνο 21-27 Οκτωβρίου 2011*, vol. A2.3, Rethymnon: Ιστορική και Λαογραφική Εταιρεία Ρεθύμνης, 163-172.

Lemos, I. S., and A. Kotsonas (eds). 2020. *A Companion to the Archaeology of Early Greece and*

the Mediterranean. Hoboken, NJ: Wiley Blackwell.

Levi, D. 1927-29. Arkades. Una città cretese all'alba della civiltà ellenica. *ASAtene* 10-12, 1-710.

Liddy, D. J. 1996. A Chemical Study of Decorated Iron Age Pottery from the Knossos North Cemetery. In J. N. Coldstream and H. W. Catling (eds), *Knossos North Cemetery: Early Greek Tombs*, vol. II (BSA Supplementary Vol. 28). London: British School at Athens, 465-514.

Lynch, K. M. 2015. Drinking Cups and the Symposium at Athens in the Archaic and Classical Periods. In K. F. Daly and L. A. Riccardi (eds), *Cities Called Athens: Studies Honoring John McK. Camp II*. Lewisburg: Bucknell University Press, 231-271.

———. 2018. The Hellenistic Symposium as Feast. In F. van den Eijnde (ed.), *Feasting and Polis Institutions* (Mnemosyne Supplements 414). Leiden and Boston: Brill, 233-256.

Majcherek, G. 1995. Gazan Amphorae: Typology Reconsidered. In H. Meyza and J. Mlynarczyk (eds), *Hellenistic and Roman Pottery in the Eastern Mediterranean. Advances in Scientific Studies. Acts of the II Nieborów Pottery Workshop, 18-20 November 1993)*. Warsaw: Research Center for Mediterranean Archaeology, Polish Academy of Sciences, 163-178

Mandalaki, A. 2004. *Κοινωνία και οικονομία στην Κρήτη κατά την αρχαϊκή και την κλασική εποχή*. Heraklion: Βικελαία Δημοτική Βιβλιοθήκη.

Marangou-Lerat, A. 1995. *Le vin et les amphores de Crète de l'époque classique à l'époque impériale* (Études crétoises 30). Athens and Paris: École Française d'Athènes.

Marinatos, S. 1936. La temple géométrique de Dréros. *BCH* 60, 214-285.

———. 1956. Ἐργασίαι ἐν Βαθυπέτρῳ, Ἀρχάναις καὶ Ἰδαίῳ ἄντρῳ. *ΠΑΕ*, 223-225.

Markoulaki, S., and V. Niniou-Kindeli. 1982. Ελληνιστικός λαξευτός τάφος Χανίων. Ανασκαφή οικοπέδου Μαθιουλάκη. *ArchDelt* 37Α, 7-118.

Márquez-Pérez, J., I. Vallejo-Villalta, and J.I. Álvarez-Francoso. 2017. Estimated Travel Time for Walking Trails in Natural Areas. *Geografisk Tidsskrift-Danish Journal of Geography* 117.1, 53-62.

Matthäus, H. 2000. Die idäische Zeus-Grotte auf Kreta: Griechenland und der Vordere Orient im frühen 1. Jahrtausend v. Chr. *AA*, 517-547.

———. 2011. The Idaean Cave of Zeus: The Most Important Pan-Cretan Sanctuary. Evidence of Metalwork. In G. Rizza (ed.), *Convegno di studi Identità culturale, etnicità, processi di formazione a Creta fra Dark Age e Arcaismo*. Catania: Consiglio Nazionale delle Ricerche (I.B.A.M.) – Università di Catania, 109-132.

Mazzocchin, S. 2019. La ceramica di uso quotidiano. In J. Bonetto, D. Francisci and S. Mazzocchin (eds), *Gortina IX.2: Il teatro del Pythion. Scavi e ricerche 2001-2013*. Padova: Bottega d'Erasmo, 673-699.

Mercando, L. 1974-1975. Lampade, lucerne, bracieri di Festòs (scavi 1950-1970). *ASAA* 52-53, 15-167.

Moignard, E. 1996. The Orientalizing Pottery. In J. N. Coldstream and H. W. Catling (eds), *Knossos North Cemetery: Early Greek Tombs*, vol. II (BSA Supplementary Vol. 28). London: British School at Athens, 421-462.

Mook, M. S. 1993. T*he Northwest Building: Houses of the Late Bronze and Early Iron Ages on the*

Kastro at Kavousi, East Crete. Unpublished Ph.D. Thesis, University of Minnesota.

———. 2004. From Foundation to Abandonment: New Ceramic Phasing for the Late Bronze Age and Early Iron Age on the Kastro at Kavousi. In L. P. Day, M. S. Mook and J. D. Muhly (eds), *Crete Beyond the Palaces. Proceedings of the Crete 2000 Conference*. Philadelphia: INSTAP Academic Press, 163-179.

Morgan, C. 1999. *Isthmia VIII: The Late Bronze Age Settlement and Early Iron Age Sanctuary*. Princeton: American School of Classical Studies at Athens.

———. 2011. Isthmia and beyond. How Can Quantification Help the Analysis of EIA Sanctuary Deposits? In T. Theurrillat, S. Verdan and A. Kenzelmann Pfyffer (eds), *Early Iron Age Pottery. A Quantitative Approach*. Geneva: École Suisse d'Archéologie, 11-18.

———. 2017. Corinthian Sanctuaries and the Question of Cult Buildings. In C. Morgan and X. Charalambidou (eds), *Interpreting the Seventh Century BC: Tradition and Innovation*. Athens: British School at Athens, 193-211.

Morgan II, C. H. 1942. *Corinth XI: The Byzantine Pottery*. Princeton: The American School of Classical Studies at Athens.

Morris, I. 1998. Archaeology and Archaic Greek History. In N. Fisher and H. van Wees (eds), *Archaic Greece: New Approaches and New Evidence*. London: Duckworth, 1-91.

Mortzos, C. 1985. Ανασκαφή Βρυσών Κυδωνίας: Το ελληνικό ιερό στον Κάστελο. Athens: Apodexis.

Muhly, P. 2008. *The Sanctuary of Hermes and Aphrodite at Syme Viannou IV: Animal Images of Clay*. Athens: Archaeological Society at Athens.

———. 2013. Attic Influence on Cretan Zoomorphic Terracottas of the Geometric Period. In W.-D. Niemeier, O. Pilz and I. Kaiser (eds), *Kreta in der geometrischen und archaischen Zeit* (Athenaia 2). Munich: Hirmer, 297-302.

Muhly, P., and J.-P. Olivier. 2008. Linear A Inscriptions from the Syme Sanctuary, Crete. *ArchEph*, 197-223.

Muhly, P., and J. Muhly. 2018. The Syma Sanctuary: Metal Analysis and the Work of Professor Robert Maddin. In A. Giumlia-Mair and F. Lo Schiavo (eds), *Bronze Age Metallurgy on Mediterranean Islands: Volume in Honor of Robert Maddin and Vassos Karageorgis*. Drémil-Lafage: Editions Mergoil, 542-551.

Niniou-Kindeli, V. 1995. Υπαίθριο ιερό στα Τσισκιανά Σελίνου (Ν. Χανίων). In N. E. Papadogiannakis (ed.), *Πεπραγμένα του Ζ' Διεθνούς Κρητολογικού Συνεδρίου*, vol. Α2. Rethymno: Ιστορική και Λαογραφική Εταιρεία Ρεθύμνης, 681-689.

———. 2002. Τσισκιανά. *Κρητική Εστία* 9, 263-266.

Nobis, G., 1988. Die Haus- und Wildtiere aus dem Berheiligtum Kato Syme/SO Kreta Grabungen 1972–1984. *Tier und Museum* 1, 42-47.

Nodarou, E. 2008. Petrographic Analysis of Selected Early Iron Age Pottery from Eleutherna. In A. Kotsonas, *The Archaeology of Tomb A1K1 of Orthi Petra in Eleutherna: The Early Iron Age Pottery*. Athens: Publications of the University of Crete, 345-362.

———. 2020. Results of the Petrographic Study. In S. Wallace, *Karphi Revisited: A Settlement and Landscape of the Aegean Crisis Period c. 1200–1000 BC* (BSA Supplementary Vol. 50).

London: British School at Athens, 195-201.

———. 2022. Εδώ στο Νότο: South Coast Fabrics and Patterns of Pottery Production in South–Southeast Crete. In K. Chalikias and E. Oddo (eds), *South by Southeast: The History and Archaeology of Southeast Crete from Myrtos to Kato Zakros*. Oxford: Archaeopress, 92-100.

———. Forthcoming. Petrographic Analysis of the Grave Ceramic Assemblage. In L. P. Day and M. A. Liston, *Kavousi IV. The Early Iron Age Cemeteries at Vronda* (Prehistory Monographs). Philadelphia: INSTAP Academic Press.

Nodarou, E., and C. Rathossi. 2008. Petrographic Analyses. In P. Muhly, *The Sanctuary of Hermes and Aphrodite at Syme Viannou IV: Animal Images of Clay*. Athens: Archaeological Society at Athens, 165-182.

Nodarou, E., C. Rathossi, A. Kanta, and A. Spiliotopoulou. 2008. Pilgrims at Symi Viannou: Preliminary Results of the Petrographic Analysis of Hollow Zoomorphic Figurines. *Kentro: The Newsletter of the INSTAP Study Center for East Crete*, 3-5.

Nodarou, E., and I. Iliopoulos. 2011. Analysis of Postpalatial Pottery from Karphi. In L. Preston Day, *The Pottery from Karphi: A Re-examination* (BSA Studies 19). London: British School at Athens, 337-348.

Nowicki, K. 2000. *Defensible sites in Crete c. 1200 – 800 B.C.* (AEGAEUM 21). Liège: Université de Liège.

Orton, C., and M. Hughes. 2013. *Pottery in Archaeology: Second Edition*. New York: Cambridge University Press.

Osborne, R. 1987. *Classical Landscape with Figures: The Ancient City and Its Countryside*. London: George Philip.

———. 2004. Hoards, Votives, Offerings: The Archaeology of the Dedicated Object. *World Archaeology* 36.1, 1-10.

Paizi, E. 2023. Overseas Connections of Knossos and Crete in the Sixth and Fifth Centuries BC: Insights from the Unexplored Mansion. *BSA* 118.

Pakkanen, P. 2015. Depositing Cult – Considerations on What Makes a Cult Deposit. In P. Pakkanen and S. Bocher (eds), *Cult Material: From Archaeological Deposits to Interpretation of Early Greek Religion* (Papers and Monographs of the Finnish Institute at Athens, Vol. 21). Helsinki: Finnish Institute at Athens, 25-48.

Palermo, D. 1992. L'edificio e i materiali. In G. Rizza, D. Palermo and F. Tomasello, *Mandra di Gipari: Una officina protoarcaica di vasai nel territorio di Priniàs*. Catania: Università di Catania, Istituto di Archeologia, and Consiglio Nazionale delle Ricerche, Centro di Studi per l'Archeologia Greca, 29-106.

———. 2002. La cronologia dei cosiddetti kernoi e il problema delle origini del culto sull'acropoli di Gortyna. *Creta Antica* 3, 255-262.

———. 2004. Ancora sui kernoi e il problema dell'acropoli di Gortyna. *Creta Antica* 5, 279-282.

Papadopoulos, J. 1999. La ceramica. In N. Allegro and M. Ricciardi (eds), *Gortina IV: Le fortificazioni di età ellenistica*. Padova: Bottega d'Erasmo, 194-241.

———. 2001. The Early Iron Age Pottery and Other Small Finds. In A. Cambitoglou, J. K. Papadopoulos and O. Tudor Jones (eds), *Torone I: The Excavations of 1975, 1976, and 1978.* Athens: Archaeological Society at Athens, 293-308.

———. 2005. *The Early Iron Age Cemetery at Torone.* Los Angeles: Cotsen Institute.

Papasavvas, G. 2001. *Χάλκινοι υποστάτες από την Κύπρο και την Κρήτη: Τριποδικοί και τετράπλευροι υποστάτες από την Ύστερη Εποχή του Χαλκού εώς την Πρώιμη Εποχή του Σιδήρου.* Nicosia: A. G. Leventis Foundation.

———. 2012. Cretan Bronze Stands of Cypriot Types from Sanctuaries and Cemeteries: Cretan Society in the Early Iron Age. In M. Iacovou (ed.), *Cyprus and the Aegean in the Early Iron Age: The Legacy of Nicolas Coldstream. Proceedings of an Archaeological Workshop Held in Memory of Professor J. N. Coldstream (1927–2008).* Nicosia: Bank of Cyprus Cultural Foundation, 129-153.

———. 2019. Sacred Space and Ritual Behaviour in Early Iron Age Crete: The Case of the Sanctuary of Hermes and Aphrodite at Syme. In G. Papantoniou, C. E. Morris and A. K. Vionis (eds), *Unlocking Sacred Landscapes: Spatial Analysis of Ritual and Cult in the Mediterranean* (SIMA 151). Nicosia: Astrom Editions, 237-256.

Papasavvas, G., and S. Fourrier. 2012. Votives from Cretan and Cypriot Sanctuaries: Regional versus Island-Wide Influence. In G. Cadogan, M. Iacovou, K. Kopaka and J. Whitley (eds), *Parallel Lives: Ancient Island Societies in Crete and Cyprus* (British School at Athens Studies, Vol. 20). London: British School at Athens, 289-305.

Pappalardo, E. 2012. *Importazioni orientali a Creta: I livelli dei contatti.* Florence: Le lettere.

Patera, I. 2012. *Offrir en Grèce ancienne Gestes et contextes.* (Potsdamer altertumswissenschaftliche Beiträge 41). Stuttgart: Franz Steiner.

Patitucci Uggeri, S. 2004. Gortyna, scavi 1978-1980: La ceramica di eta medio bizantina e veneziana. In A. Di Vita (ed.), *Gortina VI: Scavi 1979-1982.* Padova: Bottega d'Erasmo, 493-542.

Pautasso, A., S. Rizza, E. Pappalardo, A. Hein, G. Biondi, R. Gigli Patanè, K. Perna, and V. Guarnera. 2021. Priniàs: Scavi e ricerche nel 2021. *ASAtene* 99.II, 9-53.

Payne, H. G. G. 1927-1928. Early Greek Vases from Knossos. *BSA* 29, 224-298.

Pedley, J. 2005. *Sanctuaries and the Sacred in the Ancient Greek World.* Cambridge: Cambridge University Press.

Pemberton, E. 2020. Small and Miniature Vases at Ancient Corinth. *Hesperia* 89.2, 281-338.

Pendlebury, J. D. S. 1939. *The Archaeology of Crete: An Introduction,* London: Methuen.

Pentedeka, A., M. Georgakopoulou, and E. Kiriatzi 2012. Understanding Local Products and Exploring Sources of Imports: Petrographic and Chemical Analysis of Classical Pottery from Kolonna, Aegina. In G. Klebinder-Gauss, *Keramik aus Klassischen Kontexten im Apollon-Heiligtum von Ägina Kolonna: Lokale Produktion und Importe* (Österreichische Akademie der Wissenschaften, Band 30). Wien: Verlag der Österreichischen Akademie der Wissenschaften, 102-172.

Perlman, P. 2005. Crete. In M. H. Hansen and T. H. Nielsen (eds), *An Inventory of Archaic and Classical Poleis.* Oxford). Oxford: Oxford University Press, 1144-1195.

Pernier, L. 1914. Templi arcaici sulla Patela di Priniàs. Contributo allo studio dell'arte dedalica. *ASAtene* 1, 9-111.

Petrakos, V. 2021. Λύκτος Ηρακλείου Κρήτης. *Ergon*: 43-47.

———. 2022. Λύκτος Ηρακλείου Κρήτης. *Ergon*: 40-46.

Pilz, O., and G. Seelentag (eds). 2014. *Cultural Practices and Material Culture in Archaic and Classical Crete. Proceedings of the International Conference, Mainz, May 20-21, 2011.* Berlin: De Gruyter.

Popham, M. 1978. Notes from Knossos, Part II. *BSA* 73, 179-187.

Portale, E.-C. 2000. Ceramica comune e da fuoco da contesti della metà del II secolo a.C. a Festòs. La c.d. "officina del figulo" e i vani adiacenti. In *Ε΄ Επιστημονική Συνάντηση για την ελληνιστική κεραμική. Χρονολογικά προβλήματα – κλειστά σύνολα – εργαστήρια*. Athens: Archaeological Receipts and Expropriations Fund, 75-86.

Portale, C., and I. Romeo. 2000. Le anfore locali di Gortyna ellenistica e romana. *Rei Cretariae Romanae Fautorum Acta* 36, 417-426.

———. 2001. Contenitori da trasporto. In A. Di Vita (ed.), *Gortina V.3: Lo Scavo del Pretorio (1989-1995), vol. 3 t. I. I materiali*. Padova: Bottega d'Erasmo, 260-410.

Poulou-Papadimitriou, N. 2003. Μεσοβυζαντινή κεραμική από την Κρήτη: 9ος-12ος αιώνας. In C. Bakirtzis (ed.), *7ο συνέδριο μεσαιωνικής κεραμικής της Μεσογείου, Θεσσαλονίκη, 11-16 Οκτωβρίου 1999*. Athens: Archaeological Receipts and Expropriations Fund, 211-226.

———. 2008. Στιγμές από την ιστορία του Ηρακλείου. Από την πρωτοβυζαντινή εποχή έως την περίοδο της οθωμανικής κυριαρχίας (7ος – 19ος αι.). In A. Ioannidou-Karetsou (ed.), *Ηράκλειο. Η άγνωστη ιστορία της αρχαίας πόλης*. Heraklion: *Νέα Κρήτη*, 151-201.

Pratt, C. E. 2015. The 'SOS' Amphora: An Update. *BSA* 110, 213–245.

Prent, M. 2005. *Cretan Sanctuaries and Cults: Continuity and Change from Late Minoan IIIC to the Archaic Period* (Religions in the Graeco-Roman World 154). Leiden: Brill.

Psaroudakis, K. 2012-2013. The Faience Finds of the Idaean Cave. *AM* 127-128, 91-142.

Rabinowitz, A. 2014. Drinkers, Hosts, or Fighters? Masculine Identities in Pre-Classical Crete. In O. Pilz and G. Seelentag (eds), *Cultural Practices and Material Culture in Archaic and Classical Crete. Proceedings of the International Conference, Mainz, May 20-21, 2011.* Berlin: De Gruyter, 91-119.

Rehak, P., and J. G. Younger. 1998. Review of Aegean Prehistory VII: Neopalatial, Final Palatial, and Postpalatial Crete. *AJA* 102.1, 91-173.

Rendini, P. 1990. *Ceramica comune e da cucina a Gortina. Presenze e cronologia*. In *Β΄ Επιστημονική συνάντηση για την ελληνιστική κεραμική: χρονολογικά προβλήματα*. Athens: Υπουργείο Πολιτισμού και Πανεπιστήμιο Αιγαίου, 195-198.

———. 2004a. Ceramica acroma. In A. Di Vita (ed.), *Gortina VI: Scavi 1979-1982*. Padova: Bottega d'Erasmo, 208-224.

———. 2004b. Ceramica da cucina. In A. Di Vita (ed.), *Gortina VI: Scavi 1979-1982*. Padova: Bottega d'Erasmo, 229-240.

Rethemiotakis, G. 1984. Ανασκαφική έρευνα στη Λύττο. *Λύκτος* 1, 49-65.

———. 1986. Λύκτος. *ArchDelt* 41.B, 222-224.

———. 2001-2004. Κρουσώνας-Κυνηγότα<0xCF>κος. *ArchDelt* 56-59Β5, 345.

Rethemiotakis, G., and M. Englezou. 2010. *Το Γεωμετρικό νεκροταφείο της Έλτυνας*. Heraklion: Ministry of Culture, Archaeological Institute of Cretological Studies.

Rice, P. 1987. *Pottery Analysis: A Sourcebook*. Chicago and London: The University of Chicago Press.

Riley, J. A. 1979. The Coarse Pottery from Berenice. In J. A. Lloyd (ed.), *Excavations at Sidi Khrebish, Benghazi (Berenice)* (Libya Antiqua Supplement 5, Vol. 2). Tripoli: Department of Antiquities, 91-467.

Risser, M. K. 2015. City, Sanctuary, and Feast: Dining Vessels from the Archaic Reservoir in the Sanctuary of Poseidon. In E. R. Gebhard and T. E. Gregory (eds), *Bridge of the Untiring Sea: The Corinthian Isthmus from Prehistory to Late Antiquity* (Hesperia Supplement 48). Princeton, NJ: American School of Classical Studies at Athens, 83-96.

Rizza, G., and V. S. M. Scrinari. 1968. *Il santuario sull'acropoli di Gortina*. Rome: Istituto poligrafico dello stato.

Rotroff, S. I. 1982. *The Athenian Agora 22: Hellenistic Pottery. Athenian and Imported Moldmade Bowls*. Princeton: American School of Classical Studies at Athens.

———. 1996. *The Missing Krater and the Hellenistic Symposium: Drinking in the Age of Alexander the Great*, Broadhead Classical Lecture no 7, University of Canterbury. Christchurch: University of Cantebury.

———. 1997. *The Athenian Agora 29: Hellenistic Pottery Athenian and Imported Wheelmade Table Ware and Related Material*. Princeton: American School of Classical Studies at Athens.

———. 2006. *The Athenian Agora 33: Hellenistic Pottery. The Plain Wares*. Princeton: American School of Classical Studies at Athens.

Sackett, L. H. 1992. The Roman Pottery. In L. H. Sackett (ed.), *Knossos: From Greek City to Roman Colony. Excavations at the Unexplored Mansion II* (BSA Supplementary Vol. 21). London: British School at Athens, 147-256.

Sakellarakis, Y.A. 1987. Εκατό χρόνια έρευνας στο Ιδαίο Άντρο. *ArchEph*, 239-263.

Sakellarakis, J. A. 1988. Some Geometric and Archaic Votives from the Idaean Cave. In R. Hägg, N. Marinatos and G. C. Nordquist (eds), *Early Greek Cult Practice. Proceedings of the Fifth International Symposium at the Swedish Institute at Athens, 26-29 June 1986* (SkrAth 4°, 38). Stockholm: Swedish Institut at Athens 173-193.

———. 1992. The Idaean Cave Ivories. In J. L. Fitton (ed.), *Ivory in Greece and the Eastern Mediterranean from the Bronze Age to the Hellenistic Period* (British Museum Occasional Paper 85). London: British Museum, 113-140.

Sakellarakis, G., and E. Sapouna-Sakellaraki. 2013. *Το Ιδαίο Άντρο: Ιερό και μαντείο*, vol. Α to Γ. Athens: Archaeological Society at Athens.

Santaniello, E. 2004. Produzione ceramica a Gortyna tra età orientalizzante e arcaica: I rinvenimenti dell'oikopedo SAIA. *ASAtene* 82, 443-475.

———. 2013. Gortyn between the 10th and the 6th Century B.C. Local Pottery, Imports and Imitations. In W.-D. Niemeier, O. Pilz and I. Kaiser (eds), *Kreta in der geometrischen und*

archaischen Zeit (Athenaia 2). Munich: Hirmer, 253-262.

Sapouna, P. 1998. *Die Bildlampen römischer Zeit aus der Idäischen Zeusgrotte auf Kreta* (BAR International Series 696). Oxford: BAR.

Schaus, G. P., and J. L. Benson. 1995. *CVA, U.S.A. Fascicule 29: The University Museum Philadelphia Fascicule 2*. Philadelphia: The University Museum.

Schürmann, W. 1996. *Das Heiligtum des Hermes und der Aphrodite in Syme Viannou II: Die Tierstatuetten aus Metal*. Athens: Archaeological Society at Athens.

Seifried, R. M., and C. A. M. Gardner. 2019. Reconstructing Historical Journeys with Least-Cost Analysis: Colonel William Leake in the Mani Peninsula, Greece. *JAS Reports* 24, 391-411.

Seiradaki, N. 1960. Pottery from Karphi. *BSA* 55, 1-37.

Shaw, J. W., and M. C. Shaw (eds). 2000. *Kommos IV: The Greek Sanctuary*. Princeton: Princeton University Press.

Shaw, M. C. 1983. Two Cups with Incised Decoration from Kommos, Crete. *AJA* 87.4, 443-452.

Siapkas, J. 2015. Worshipping Archaeologies – Theoretical Landscape in the Archaeological Study of Greek Religion and Cult Deposits. In P. Pakkanen and S. Bocher (eds), *Cult Material: From Archaeological Deposits to Interpretation of Early Greek Religion* (Papers and Monographs of the Finnish Institute at Athens, Vol. 21). Helsinki: Finnish Institute at Athens, 9-24.

Simantoni-Bournia, E. 2004. *La céramique grecque à reliefs: ateliers insulaires du VIIIe au VIe siècle avant J.-C.* Geneva: Droz.

Simon, C. G. 1986. *The Archaic Votive Offerings and Cults of Ionia*. Unpublished Ph.D. Thesis, University of California Berkeley.

Sinn, U. 1988. Der Kult der Aphaia auf Aegina. In R. Hägg, N. Marinatos and G. C. Nordquist (eds), *Early Greek Cult Practice: Proceedings of the Fifth International Symposium at the Swedish Institute at Athens, 26-29 June 1986*. Stockholm: Swedish Institute at Athens, 147-160.

———. 1992. Sounion. Das befestigte Heiligtum der Athena und des Poseidon an der «Heiligen Landspitze Attikas». *Antike Welt* 23.3, 175-190.

———. 2005. Kultorte: Grichenland. Temenos. In V. Lambrinoudakis and J. Ch. Balty (eds), *Thesaurus Cultus et Rituum Antiquorum*, Vol. IV. Los Angeles: The J. Paul Getty Museum, 1-12.

Sjögren, L. 2003. *Cretan Locations: Discerning Site Variations in Iron Age and Archaic Crete (800-500 B.C.)* (BAR International Series 1195). Oxford: British Archaeological Reports.

Skordou, M. 2000. Ελληνιστική κεραμική από το Καστέλι Κισάμου. In *Ε΄ Επιστημονική συνάντηση για την ελληνιστική κεραμική. Χρονολογικά προβλήματα – κλειστά σύνολα – εργαστήρια*. Athens: Archaeological Receipts and Expropriations Fund, 25-36.

Slane, K. W. 1990. *Corinth XVIII.2: The Sanctuary of Demeter and Kore: The Roman Pottery and Lamps*. Princeton: The American School of Classical Studies at Athens.

Smith, T. J. 2021. *Religion in the Art of Archaic and Classical Greece*. Philadelphia: University of Pennsylvania Press.

Sofianou, C. 2006. Πραισός Σητείας. *ArchDelt* 61 B2, 1172-1173.

———. 2010. Ανασκαφές Πραισού 2005-2006. Ειδώλιο Κυβέλης. *AEK* 1, 179-187.

Sokolowski, F. 1969. *Lois sacrées des cités grecques*. Paris: E. de Boccard.

Sparkes, B. A., and L. Talcott 1970. *Black and Plain Pottery of the 6th, 5th and 4th Centuries B.C.* Princeton: American School at Classical Studies at Athens.

Spiliotopoulou, A. 2015. Νέα ματιά στο υλικό της κεραμεικής και των ανθρωπόμορφων ειδωλίων από το ιερό κορυφής Κόφινα Αστερουσίων. *AEK* 3, 281-292.

Sporn, K. 2002. *Heiligtümer und Kulte Kretas in klassischer und hellenistischer Zeit.* Heidelberg: Verlag Archäologie und Geschichte.

———. 2018. The Hellenistic Terracotta Figurines from Syme Viannou. In E. Gavrilaki (ed.), *Πεπραγμένα ΙΑ΄ Διεθνούς Κρητολογικού Συνεδρίου, Ρέθυμνο 21-27 Οκτωβρίου 2011*, vol. A2.2. Rethymnon: Ιστορική και Λαογραφική Εταιρεία Ρεθύμνης, 125-136.

Stampolidis, N. C. 1994. *Ελεύθερνα: Από τη γεωμετρική και αρχαϊκή νεκρόπολη. Ταφικές πυρές και ομηρικά έπη*. Rethymno: Typokreta.

Stampolidis, N. C., and A. Kotsonas. 2013. Cretan Cave Sanctuaries of the Early Iron Age to the Roman Period. In F. Mavridis and J. Jensen (eds), *Stable Places and Changing Perceptions: Cave Archaeology in Greece and Adjacent Areas*, Oxford: Archaeopress, 188-200.

Stillwell, A. N. 1952. *Corinth XV.2: The Potter's Quarter: The Terracottas*. Princeton: The American School of Classical Studies at Athens.

Stissi, V. V. 2002. *Pottery to the People. The Production, Distribution and Consumption of Decorated Pottery in the Greek World in the Archaic Period (650-480 BC)*. Ph.D. Thesis, University of Amsterdam.

———. 2003. From Catalogue to Cultural Context: Bringing Life to Greek Sanctuary Pottery. In B. Schmaltz and M. Söldner (eds), *Griechische Keramik im kulturellen Kontext*. Münster: Scriptorium, 77-79.

———. 2009. Does Function Follow Form? Archaic Greek Pottery in its Find Contexts: Uses and Meanings. In V. Nørskov, L. Hannestad, C. Isler-Kerényi and S. Lewis (eds), *The World of Greek Vases*. Rome: Edizioni Quasar, 23-43.

Theurrillat, T., S. Verdan, and A. Kenzelmann Pfyffer (eds). 2011. *Early Iron Age Pottery. A Quantitative Approach*. Geneva: École Suisse d'Archéologie.

Tobler, W. 1993. *Three Presentations on Geographical Analysis and Modeling: Non–Isotropic Modeling, Speculations on the Geometry of Geography, Global Geographical Analysis (93–1)*. Santa Barbara: National Center for Geographic Information and Analysis, Santa Barbara, UC Santa Barbara. https://escholarship.org/uc/item/05r820mz.

Tomlinson, J. E., and V. Kilikoglou. 1998. Neutron Activation Analysis from the Early Orientalizing Kiln at Knossos. *BSA* 93, 385-388.

Trantalidou, K. 2010. Μελέτες αρχαιοζωολογικού υλικού: Ιερό Ερμή και Αφροδίτη Σύμης Βιάννου στη νοτιοανατολική Κρήτη. *ArchDelt* 65, 1794.

———. 2013. Dans l'ombre du rite: vestiges d'animaux et pratiques sacrificielles en Grèce antique. Note sur la diversité des contextes et les difficultés de recherche rencontrées. In G. Ekroth and J. Wallensten (eds), *Bones, Behaviour and Belief. The Zooarchaeological*

Evidence as a Source for Ritual Practice in Ancient Greece and beyond. Stockholm: Swedish Institute at Athens, 61-86.

———. 2017. Active Responses of Early Iron Age Communities to their Natural and Social Environment: The Evidence from the Animal Bones. In A. Mazarakis Ainian, A. Alexandridou and X. Charalambidou (eds), *Regional Stories towards a New Perception of the Early Greek World. Acts of an International Symposium in Honour of Professor Jan Bouzek, Volos 18–21 June 2015*. Volos: University of Thessaly Press, 633-667.

Trinkl, E. 2009. Sacrificial and Profane Use of Greek Hydriai. In A. Tsingarida (ed.), *Shapes and Uses of Greek Vases (7th – 4th Centuries B.C.): Proceedings of the Symposium Held at the Université libre de Bruxelles 27-29 April 2006*. Brussels: CreA-Patrimoine, 153-171.

Tsatsaki, N., and E. Nodarou. 2014. A New Hellenistic Amphora Production Centre in West Crete (Loutra, Rethymnon): Study and Petrographic Analysis of the Pottery Assemblage. *BSA* 109, 287-315.

Tsigkou, A. 2010. Χανιά: Οδός Παρθενίου Κελαϊδή 21-25. *ArchDelt* 65.B2, 1689-1692.

Tsipopoulou, M. 2005. *Η Ανατολική Κρήτη στην Πρώιμη Εποχή του Σιδήρου*. Heraklion: Archaeological Institute of Cretological Studies.

Tzachili, I. 2016. *ΒΡΥΣΙΝΑΣ II: Η κεραμεική της ανασκαφής 1972-1973. Συμβολή στην ιστορία του Ιερού Κορυφής*. Athens: *Τα Πράγματα*.

Tzanakaki, K. 2018. Η διακίνηση των αττικών ερυθρόμορφων αγγείων στην Κρήτη. Συμβολή στη μελέτη της κλασικής περιόδου του νησιού. In E. Gavrilaki (ed.), *Πεπραγμένα ΙΑ΄ Διεθνούς Κρητολογικού Συνεδρίου (Ρέθυμνο 21-27 Οκτωβρίου 2011)*, vol. A2.1. Rethymno: Ιστορική και Λαογραφική Εταιρεία Ρεθύμνης, 351-366.

Tuchelt, K. 1970. *Die archaischen Skulpturen von Didyma. Beiträge zur frühgriechischen Plastik in Kleinasien*. Berlin: Gebr. Mann.

Vallianou, D. 1987. Φαλαγκάρι. *ArchDelt* 42, 538-542.

van Effenterre, H., and M. van Effenterre. 1994. La terminologie des bornages frontaliers. In E. Olshausen and H. Sonnabend (eds), *Stuttgarter Kolloquium zur Historischen Geographie des Altertums 4*. Amsterdam: Hakkert, 111-125.

Verdan, S. 2013. *Eretria XXII: Le sanctuaire d'Apollon Daphnéphoros à l'époque géométrique*, vol. I and II. Gollion: Infolio éditions.

Villing, A., and E. G. Pemberton. 2010. Mortaria from Ancient Corinth: Form and Function. *Hesperia* 79.4, 555-638.

Viviers D. 1994. La cité de Dattalla et l'expansion territoriale de Lyktos en Crète centrale. *BCH* 118, 229-259.

Vogeikoff, N. 2000. Late Hellenistic Pottery from Mochlos in East Crete. In *Ε΄ Επιστημονική συνάντηση για την ελληνιστική κεραμική. Χρονολογικά προβλήματα – κλειστά σύνολα – εργαστήρια*. Athens: Archaeological Receipts and Expropriations Fund, 69-74.

Vogeikoff-Brogan, N. 2011. Domestic Pottery from Trypitos Siteias in East Crete. In *Ζ΄ Επιστημονική συνάντηση για την ελληνιστική κεραμική, Αίγιο, 4-9 Απριλίου 2005*. Athens: Archaeological Receipts and Expropriations Fund, 549-560.

———. 2014. *Mochlos III: The Late Hellenistic Settlement. The Beam-Press Complex.*

Philadelphia: INSTAP Academic Press.

———. 2020. The Lamps from the Sanctuary of Hermes and Aphrodite at Syme Viannou, Crete. *Eulimene* 21, 101-150.

Vogeikoff-Brogan, N., J. Eiring, M.-C. Boileau, and I. K. Whitbread. 2004. Transport Amphoras and Wine Trade in East Crete in the Late Hellenistic Period: Evidence from Mochlos and Pyrgos Myrtos. In *ΣΤ' Επιστημονική Συνάντηση για την ελληνιστική κεραμική, Βόλος, 17–23 Απριλίου 2000*. Athens: Archaeological Receipts and Expropriations Fund, 327-332.

Vogeikoff-Brogan, N., E. Nodarou, and M.-C. Boileau. 2008. New Evidence for Wine Production in East Crete in the Hellenistic Period: An Integrated Approach of Stylistic Study and Thin Section Petrography. In Y. Facorellis, N. Zacharias and K. Polikreti (eds), *Proceedings of the 4th Symposium of the Hellenic Society for Archaeometry, National Hellenic Research Foundation, Athens, 28–31 May 2003* (BAR-IS 1746). Oxford: Hadria Books, 327-334.

Vroom, J. 2005. *Byzantine to Modern Pottery in the Aegean: 7th to 20th century. An Introduction and Field Guide*. Bijleveld: Parnassus Press.

Wallace S. 2010a. *Ancient Crete from Successful Collapse to Democracy's Alternatives. Twelfth to Fifth Centuries BC*. Cambridge and New York: Cambridge University Press.

———. 2010b. The Roots of the Cretan Polis. Surface Evidence for the History of Large Settlements in Central Crete. *AA* 2010/1, 13-89.

———. 2012. Surviving Crisis: Insights from New Excavation at Karphi, 2008. *BSA* 107, 1-85.

———. 2020. *Karphi Revisited: A Settlement and Landscape of the Aegean Crisis Period c. 1200–1000 BC* (BSA Supplementary Vol. 50). London: British School at Athens.

Watrous, L. V. 1996. *The Cave Sanctuary of Zeus at Psychro: A Study of Extra-Urban Sanctuaries in Minoan and Early Iron Age Crete* (AEGAEUM 15). Liège – Austin: Université de Liège and University of Texas at Austin.

Wecowski, M. 2014. *The Rise of the Greek Aristocratic Banquet*. Oxford: Oxford University Press.

Welch, F. B. 1899-1900. Knossos. Summary Report of the Excavations in 1900: III. Notes on the Pottery. *BSA* 6, 85-92.

Whitbread, I. K. 1992. Petrographic Analysis of Barbarian Ware from the Menelaion, Sparta. In J. M. Sanders (ed.), *PHILOLAKON: Lakonian Studies in Honour of Hector Catling*. London: British School at Athens, 297-306.

———. 1995. *Greek Transport Amphorae: A Petrological and Archaeological Study* (Fitch Laboratory Occasional Paper 4). Athens: The British School at Athens.

Whitley, J. 2001. *The Archaeology of Ancient Greece*. Cambridge: Cambridge University Press.

———. 2004. Style Wars: Towards an Explanation of Cretan Exceptionalism. In G. Cadogan, E. Hatzaki and A. Vasilakis (eds), *Knossos: Palace, City, State. Proceedings of the Conference in Herakleion Organised by The British School at Athens and the 23rd Ephoreia of Prehistoric and Classical Antiquities of Herakleion, in November 2000, for the Centenary of Sir Arthur Evans's Excavations at Knossos*. London: British School at Athens, 433-442.

———. 2005. Before the Great Code: Public Inscriptions and Material Practice in Archaic Crete. In E. Greco and N. Lombardo (eds), *La grande iscrizione di Gortyna: Centoventi*

anni dopo la scoperta. Atti del I Convegno Internazionale di Studi sulla Messarà (Tripodes 4). Athens: Italian School of Archaeology at Athens, 41-56.

―――――. 2009a. The Chimera of Continuity: What Would "Continuity of Cult" Actually Demonstrate? In A. L. D'Agata and A. Van de Moortel (eds), *Essays on Ritual and Cult in Crete in Honor of Geraldine C. Gesell* (Hesperia Supplements, Vol. 42), Princeton: American School of Classical Studies at Athens, 279-288.

―――――. 2009b. Crete. In K. Raaflaub and H. van Wees (eds), *A Companion to Archaic Greece*. Malden, MA, Oxford and Chichester: Wiley-Blackwell, 273-293.

―――――. 2010. La Crête au VIIe s. In R. Étienne (ed.), *La Méditerranée au VIIe siècle av. J. C. (essais d'analyses archéologiques)* (Travaux de la Maison René Ginouvès 7), Paris: De Boccard, 170-182.

―――――. 2014. Commensality and the 'Citizen State': The Case of Praisos. In F. Gaignerot-Driessen and J. Driessen (eds), *Cretan Cities: Formation and Transformation* (Aegis. Actes de colloques 7). Louvain-la-Neuve: Presses universitaires de Louvain, 141-163.

―――――. 2015. Agonistic Aristocrats? The Curious Case of Archaic Crete. In H. Van Wees and N. Fisher (eds), *'Aristocracy' in Antiquity: Redefining Greek and Roman Elites*. Swansea: Classical Press of Wales, 287-312.

―――――. 2018. Citizenship and Commensality in Archaic Crete: Searching for the Andreion. In A. Duplouy and R. Brock (eds), *Defining Citizenship in Archaic Greece*, Oxford: Oxford University Press, 227-248.

―――――. 2023. Κατέσκαψαν Ιεραπύτνιοι: The Destruction of Political Communities in Crete in the 2nd Century BC and the Resilience of the Cretan Polis. *BSA*.

Wiegand, T. 1929. *Milet II.2: Ergebnisse der Ausgrabungen und Untersuchungen seit dem Jahre 1899. Die Milesische Landschaft*. Berlin: Hans Schoetz und Co.

Wilkinson, R. 2011. Τα αιγυπτιακά τύπου τέχνεργα. In A. Kanta and K. Davaras (eds), *ΕΛΟΥΘΙΑ ΧΑΡΙΣΤΗΙΟΝ: Το ιερό σπήλαιο της Ειλειθυίας στον Τσούτσουρο*. Heraklion: Dimos Minoa Pediadas, 171-187.

Xanthoudides, S. 1905-1906. Cretan kernoi. *BSA* 12, 9-23.

Ximeri, S. 2021. *Cultural Biographies of Cretan Storage Jars (Pithoi) from Antiquity to Postmodernity*. Unpublished Ph.D. Thesis, University of Amsterdam.

Yangaki, A. G. 2004. Amphores crétoises: le cas d'Éleutherna, en Crète. *BCH* 128-129.1, 503-523.

―――――. 2005. *La céramique des IVe – VIIIe siècles ap. J.-C. d'Eleutherna*. Athens: University of Crete Editions.

Yangaki, A., and O. Gratziou, 2012. *Εκπαιδευτική συλλογή μεσαιωνικής και νεότερης κεραμικής*. Rethymno: Εκδόσεις Φιλοσοφικής Σχολής Πανεπιστημίου Κρήτης.

Yavis, C. G. 1949. *Greek Altars: Origins and Typology*. Saint Louis MO: Saint Louis University Press.

Young, G. M. 1937. Archaeology in Greece, 1936-1937. *JHS* 57, 119-146.

Zarifis, N. 2007. *Η αρχιτεκτονική του ιερού του Ερμή και της Αφροδίτης στην Κάτω Σύμη Βιάννου*. Unpublished Ph.D. Thesis, Aristotle University of Thessaloniki.

_____. 2020. *Το Ιερό του Ερμή και της Αφροδίτης στη Σύμη Βιάννου: Παρατηρήσεις στην τυπολογία και την εξέλιξη των κεραμίδων (Ευλιμένη, Σειρά Αυτοτελών Εκδόσεων 4)*. Rethymno: Mediterranean Archaeological Society.

Zographaki, V., and A. Farnoux. 2011. Dréros: mission franco-hellenique de Dréros. *BCH* 135.2, 625-646.

_____. 2014. Dréros: cité et sanctuaries. In F. Gaignerot-Driessen and J. Driessen (eds), *Cretan Cities: Formation and Transformation* (Aegis. Actes de colloques 7). Louvain-la-Neuve: Presses universitaires de Louvain, 103-117.

Zois, A. A. 1976. *Ανασκαφή Βρυσών Κυδωνίας, vol. 1, 1974*. Athens: Historical and Archaeological Society of Western Crete.